THE ROOTS & ROUTES OF ART IN THE 20TH CENTURY

THE ROOTS & ROUTES OF ART IN THE 20TH CENTURY

Michèle Cone

Horizon Press / New York

Copyright © 1975 by Michèle Cone

Library of Congress Cataloging in Publication Data

Cone, Michèle.
The roots & routes of art in the 20th century.

Bibliography: p.
Includes index.
1. Art, Modern—20th century. I. Title.
N6490.C6563 709'.04 74-28175
ISBN 0-8180-0123-2

Manufactured in the United States of America

To my family

ACKNOWLEDGMENTS

I should like to thank Dore Ashton, Timothy Baum, Eunice Lipton, Margaret Potter, Eliane Radigue, Harold Rosenberg, Phyllis Tuchman and Bitita Vinklers for reading portions of my manuscript and making helpful comments. For their assistance in my research, I should like to thank Joan Hall, Daniel Pearl and, generally, the librarians at The Museum of Modern Art, The Guggenheim Museum, The New York Public Library and, in Paris, at the Bibliothèque Nationale, the Galeries Nationales du Grand Palais and the Musée National d'Art Moderne. For their encouragement, Stanley Boxer, Isabelle Hyman and Joyce Weinstein deserve my gratitude. To my very patient copy editor, John Shepley, I also say thank you. I am grateful to Aurora Fortunato for the able typing of the manuscript. And to my husband, whose editorial eye hovers over these pages, I owe a special debt and many thanks.

CONTENTS

INDEX TO ILLUSTRATIONS

Many of the reproductions are accompanied by the author's explanatory remarks. Comments quoted by the author are identified by quotation marks and sources.

There is no Literature without a Morality of Language.
—Roland Barthes

A society that lacks the presence of self-developing individuals—but in which passive people are acted upon by their environment—hardly deserves to be called a human society. *It is the greatness of art that it does not permit us to forget this.*
—Harold Rosenberg

MOMENTS OF THE NEW IN PARIS,
c. 1900-1907 chapter 1

Right Bank: Montmartre,
the Bateau Lavoir and Picasso
Left Bank: Schools and Salons; Matisse
Matisse and Picasso Compete for Wall Space at the Steins
Summing Up

Paris inaugurates the new century with a World's Fair. On its grounds, ladies in impractical floor-length skirts trip and get caught climbing aboard electrically moving sidewalks. While the Hall of Machines exhibits the latest inventions in wireless communication, electricity, photography and radio-activity, while an illusionary voyage into outer space can be had from an easy chair and a drop of Seine water can be seen magnified one thousand times, the Hall of Art or Grand Palais presenting nineteenth-century French art has few Impressionists. The sculpture of Rodin is shown in a rarely visited part of the Fair. On the new Pont Alexandre III, finished in 1900, Rococo angels brandish electric bulbs; Hector Guimard's elegant arabesques adorn the iron gates of the first subway line, opened in 1900. As for the droves of tourists who venture to Montmartre at night, they are mostly unaware that the hill in the daytime has quite another face.

Right Bank: Montmartre, the Bateau Lavoir and Picasso

In 1900, Renoir could no longer be seen setting up his easel in the garden of the Moulin de la Galette, the popular dance hall of Montmartre. The aging painter lived in the south of France, his production safely in the hands of Durand Ruel, the dealer of the Impressionists. Pastoral Montmartre, which Van Gogh had once depicted from his room in a new light palette, was becoming urbanized, while that artist was buried not far away at Auvers-sur-Oise, where he had died in 1890. The Chat Noir, the Moulin Rouge and other alluring nightspots of Montmartre celebrated in Toulouse-Lautrec's posters and paintings were thriving, but Lautrec, dying of syphilis, had left for the family château in southwestern France. Degas,

nearly blind, still occupied his old studio at the foot of the hill. Replete with nostalgic landmarks, haunted by the ghosts of its former heroes, Montmartre in 1900 remained the heart of Bohemia.

If Paul Gauguin, who saw the heavens as red rather than blue like the crowd, no longer knocked on the doors of his neighbors' ateliers to admonish them to become Symbolists like himself—he had fled from civilization to a remote island in the Pacific—the Maison des Trappeurs where he had lived in Montmartre still harbored many painters and poets who revered him. Yet when the Maison des Trappeurs, with its complicated corridors and rickety stairways leading downward from street level, was renamed around 1900, it was called not Le Bateau Ivre, or drunken boat, after Arthur Rimbaud's Symbolist poem, but Bateau Lavoir (laundry boat), the name given to those Seine barges where life functioned below deck. Originally a piano factory, the structure owed its unusual access to the steep hill against which it was built. There, much laundering of past art and ideas would indeed take place within the next few years. For, around 1904, there arrived on its premises a new tenant, a very young Spaniard of short, stocky build, with intense dark eyes, who was no stranger to the neighborhood. In fact, Ambroise Vollard, who ran a dingy little gallery, known to a small circle for its Cézannes and Gauguins, had already given a show for the twenty-year-old prodigy whose bright palette and informal subject matter had none of the traits of a zealous art student. The artist's father, a painter and art professor in Spain, had long ago put his son through the rigors of academic training.

Now, in 1904, the canvases that this young man unpacked were all dominated by a strange single hue, as though a blue-gray filter had interposed itself between the painter and his vision. Clothed in blue, the blue of a mechanic's overalls, Picasso was painting in blue, by candlelight, reports André Salmon,[1] who was one of the first to visit the new tenant at the Bateau Lavoir. The celestial blue of night, the romantic blue of spleen, the blue light of the dark cheap cafés, the blue flame of candlelight, the blue of syphilitic skin?—Salmon does not explain. Blue for the painter El Greco, then recently rehabilitated; blue for Cézanne, slowly becoming the most closely studied creator of his generation? Blue for "O, Bugle sound full of mysterious stridencies. . ."?[2]

Not only were the pictures strangely monochrome, but their subjects, mostly beggars and other outcasts from society, were either blind (*Blind Beggar*), myopic (*Portrait of Sabartés*), one-eyed (*Celestine*) or had an inward gaze (*La Vie*) quite different from the earlier intense look in the *Self-Portrait* of 1901. Furthermore, in *La Vie*, the standing nude couple on the left, the clothed mother and infant on the right—all classically modeled—the roughly sketched crouching nude and the two figures in protective embrace visible on canvases between and behind the two groups, did not seem

to belong (as they should in classical drama) to the same place, time or action. Blue here gives the scene the veil of reverie, and perhaps symbolizes the twilight veil through which the artist's models know but do not see the world.* On this occasion, as on many others, the artist chose to remain mute. "Everyone wants to understand art. Why not try to understand the songs of a bird?" Picasso would tell Christian Zervos in 1935.[3]

The new tenant of the Bateau Lavoir who painted these blue pictures was not so forlorn as the works might suggest. In fact, not only did the Bateau Lavoir see an incessant flow of Spanish painters, sculptors, and ceramists—friends of the artist from his Barcelona days—such as the sculptor Manolo, who kept bringing visitors to one who, as he felt, was the genius of his time, but the artist's studio soon became the meeting ground of Bohemia.

Those Frenchmen whom Picasso allowed into his privacy were a complex lot and a match for his own temperament. "We always marvelled at the contrast between the gravity of his art, now brooding, now flaring up dramatically, and the genial good nature of the man himself, his effervescent sense of humor, and his love of a good joke," remarks Maurice Raynal.[4] Among the poets, there was Max Jacob, whom Picasso had met at Vollard's in 1901; he could change mask at will to entertain his friends with impersonations: "mysterious, cheerful, candid, loaded with vices, repentant, unctuous, aggressive, religious, sacrilegious, so changing that one did not know who was the real [Max Jacob]";[5] and Guillaume Apollinaire, of mysterious birth and ancestry, whose lying was proverbial and who was or was not involved in the theft of Iberian stone heads from the Louvre in March of 1907. There would soon be the old Henri Rousseau, a former customs employee, now a violin teacher, painter and composer of verse, whose credulousness was legendary, whose childishness verged on senility, yet whose soirées, paid for in complicated ways, were attended by the cream of the literary and artistic intelligentsia and whose paintings—genre and fantasy scenes rendered in infinite detail with bright colors and awkward perspective—were admired by no less than Picasso himself. Briefly there would be Alfred Jarry, buffoon and iconoclast *par excellence*, whose identity under the effect of drink merged with that of Ubu, his monstrous anti-hero. There would be Princet—who was or was not an erudite mathematician "of the fourth dimension"—and others, all multifaced jesters in a Bohemian court where Picasso soon became king.

With his friends, Picasso would leave the Bateau Lavoir in search of cheap amusement—Méliès† movies, their ridiculously over-dramatic mo-

* Identification of the artist with his subjects is not uncommon in Picasso's *oeuvre*, and Paul Gauguin's *Whence Do We Come? What Are We? Where Are We Going?* is not an unlikely influence in this allegorical work. The issue of the finished picture versus the sketch was still a burning one in French academic circles at that time.

† Georges Méliès (1861-1931), the French film pioneer.

ments highlighted by the maudlin playing of a small-time orchestra; poetry readings and popular songs at the Lapin Agile, where Frédé, the owner, was a friend; prizefights; and, as often as three times a week, the Médrano Circus. Of all these diversions, the circus inspired Picasso most, as can be seen by the peak-capped *Jester* (initially a likeness of Max Jacob) that he shaped from clay, the harlequins, acrobats, saltimbanques and other circus subjects that he painted in new subdued tonalities, including gray and drab rose, in addition to his now familiar blue. *Two Acrobats with a Dog, Acrobat and Young Harlequin, Seated Harlequin in Red Background, Young Acrobat on a Ball, Harlequin Family with Monkey, Family of Saltimbanques* were among the paintings that emerged during Picasso's first year at the Bateau Lavoir. Some were exhibited at a small gallery and gave Guillaume Apollinaire a chance to sing the merits of his new friend.

Like the blue of his earlier paintings, the choice of subjects in the new works has prompted endless discussion. Debts are equally distributed among literary, poetic (Verlaine's *Fêtes Galantes*, Baudelaire's *Le Vieux Saltimbanque*) and artistic sources, with emphasis on Cézanne's *Mardi Gras* and on Rouault, Cheret, Beardsley, Seurat and Toulouse-Lautrec, all of whom had illustrated the same theme.[6] Connections or "correspondences"—to use the Symbolist vocabulary with which Picasso was familiar —can easily be found between the artist and the saltimbanque, who, performing anywhere without a fixed fee, receives whatever money the public thinks he deserves; between the artist and the jester, whose traditional attributes combine poetry and clairvoyance; between the artist's emotion-provoking feats and those of the acrobat; between the artist and the harlequin (seen as a combination of jester and acrobat).

Picasso's cast of wandering entertainers are mostly caught offstage, conceived without their masks behind the scene rather than at the height of their prowess in the circus ring where the public usually sees them. They are static and remote, their glances averted from each other and frequently directed enviously toward some place in the viewer's world; they have only the costume, cocked hats and ruffles of harlequins and acrobats, most often only tights revealing lean, unmuscular adolescent frames. Sometimes (*Two Acrobats with a Dog, Young Acrobat on a Ball, Family of Saltimbanques*) they are depicted in a barren space under indeterminate light. Are they, as is often suggested, alter egos of the artist and his friends, outcasts and rootless members of society?* Or should they be regarded simply as inventions by a clever entertainer?

In *Harlequin Family with Monkey*, the deft handling of line and color

* Theodore Reff[7] identifies the figures in *Family of Saltimbanques* as follows: the smallest figure as Max Jacob, the taller acrobat with drum as based on André Salmon, the stout one as Apollinaire and the tall harlequin at left as an idealized self-portrait of Picasso.

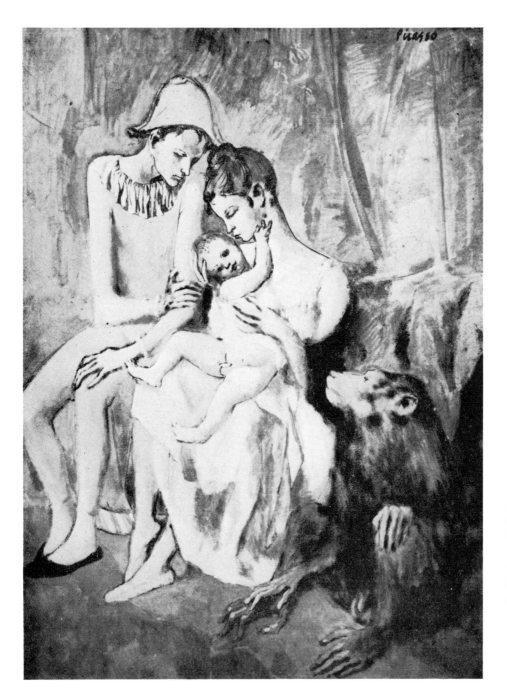

In the picture captions, the explanatory comments in italics are by the author. When comments are from other sources they are indicated by quotation marks.

. . . all virtuoso performers, including painters, can simulate emotion and transfix their public.

Picasso, *The Harlequin Family with Monkey*, 1905, watercolor, pastel and india ink on cardboard. Göteborgs Kontsmuseum. 41 x 29 1/2''.

to express pathos, meekness and defenselessness, suggests that all virtuoso performers, including painters, can simulate emotion and transfix their public. Picasso to de Zayas in 1923: "We all know that Art is not truth." And to Hélène Parmelin in 1965: "And what is truth—the thing that acts as my model or what I am painting? No, it's like in everything else. Truth does not exist."[8] Were such issues already the subjects of the exalted conversations alleged to have taken place in the Bateau Lavoir in those days? Was the tone caustic, ironic—not to say cynical—attuned to the anti-romanticism then developing within Picasso's circle? Little is known of these meetings.

In the fall of 1905, while Picasso was exploiting his sentimental "rose" vein, his supremacy as an iconoclast was suddenly challenged. At the Salon d'Automne, a painting rivaling Picasso's own creations in audacity and mystification became the talk of the town: This picture "taught me more in one instant than all the paradoxes [heard at the Bateau Lavoir]," Francis Carco would say.[9] "At last, I was able to figure out what my friends called 'a portrait.' Nothing there was physically human. One felt that the artist had cared much more about his own personality than that of the model." The picture in question was the *Woman with a Hat* and was signed Henri Matisse.

Left Bank: Schools and Salons; Matisse

Henri Matisse, unlike Picasso, had no early artistic vocation. Born in 1869, he did not take up painting seriously until he was past twenty, and this after a classical French bourgeois education intended to prepare him for the practice of law. The career he subsequently chose led him straight from the province of Picardy to Paris and the Ecole des Beaux-Arts, the official state school of art.

Indeed, remote from the Bohemian life of Montmartre, there thrived another art world, consisting of ateliers where honored artist-professors of the state school supervised a following of aspiring painters and sculptors, and of salons where these professors and their protégés regularly exhibited. Since there were still few well-known Paris galleries in 1900, the chief ambition of many young artists was to have their works seen, favorably talked about and awarded prizes at the yearly Salons, and if possible purchased or commissioned by the state. And since the heads of ateliers had a voice in the Salon selections, it seemed wise to choose one's atelier carefully.

In 1900, although grandiose themes were still the required subjects for such state competitions as the important Prix de Rome, the rigidity of academic training had somewhat relaxed. If some professors continued to admonish their pupils to idealize their figures, restrain their tonalities and aim for a polished final product, others, in deference to Impressionism, en-

couraged a more middle-of-the-road approach, "a lighter palette, a loose, quasi-Impressionist execution."[10] The former group dominated the Salon of the conservative Société des Artistes Français, the latter that of the Société Nationale des Beaux-Arts, which had been founded in 1889 by dissidents from the Société des Artistes Français. These dissidents, who would have included Gustave Moreau, Eugène Carrière among the painters, Auguste Rodin among the sculptors:

> represented to the world at large the last word in modernism and many of the younger generation idolized their work. At the same time, they gratified the public taste for modernism combined with traditionalism by modifying the disquieting features of Impressionism and rejecting the polished technique of academic painters."[11]

It was in the ateliers of Moreau, Carrière and Rodin that Henri Matisse would serve his apprenticeship.

The power of the traditional system of French art education can best be appreciated by recalling the struggles of the Impressionists, who had tried to subsist with neither sponsors nor representation in the Salons. In 1884, an independent society, Les Indèpendants, was formed by a new generation of innovating painters led by Georges Seurat and Paul Signac. Their annual exhibits were ridiculed by all but a tiny, open-minded fraction of critics and collectors. It was not until 1903 that a more respectable institution—with Frantz Jourdain, an established architect, as president and the financial backing of Jansen, a wealthy decorator—was created specifically for the encouragement of modern art. Starting in the fall of 1903, retrospective shows—all too often posthumous—of nineteenth-century innovators were held, groups of foreign artists from Scandinavia, Russia and Germany were invited. At long last the new in all its international manifestations—painting, sculpture, the decorative arts, architecture, etc.—found a forum at the Salon d'Automne, which soon became so fashionable an annual event as to overshadow the "official" Salons. The Salon d'Automne not only reduced the time lag between the creation of the new and its acceptance by the public, but also inaugurated a strange alliance between the outrageous and the fashionable.*

It was in this atmosphere that Matisse, whose work was one of the early revelations of the Salon d'Automne, of which Eugene Carrière had become honorary chairman, pursued his education in art. After a brief apprenticeship under the conservative painter Bouguereau, who told him he could not draw and ought to learn perspective, he began working in the atelier of the less academic Gustave Moreau, whom he called "a charming

* Other evidence of this new alliance will be provided by the performance of Diaghilev's ballets in Paris (see chapter 5), which though highly controversial were oversubscribed.

master."[12] "You are going to simplify painting," Moreau is reputed to have told the young man.[13]

In the meantime, Moreau sent Matisse to the Louvre: "To Moreau I owe my knowledge of the Louvre. One did not go there any more. Moreau brought us back to it by teaching us to look at, to interrogate the old masters."[14] To question them meant, of course, to copy them, to learn the *métier*. Matisse made a number of literal copies deemed worthy of purchase by the French government for its "Musée des Copies,"* as well as freer copies for himself that retained the mood of the old masters combined with a less finished execution and brighter colors.

But to question the old masters also meant to enter into a kind of communion with them, to "talk to them," as Ingres used to tell his students, or "empathize" with them. This dialogue revealed to Matisse his own affinity for the contemplative works of Chardin and Vermeer and taught him the means by which these artists achieved their particular expression. "If the relationships are expressive, the whole surface is found to be modulated, animated, light is exalted and color brought to its highest degree of purity and éclat."[15] *La Desserte*, painted according to the principles of essentially light-dark contrasts, was shown at the Société Nationale des Beaux-Arts in 1897. Though controversial, for the subject was only minimally narrative (it showed a dining-room table being set by a servant girl) and not idealized— "there is dirt at the bottom of your bottles," Matisse was told—this work, and others painted in 1896 and 1897, placed Matisse in the tradition of his favorite masters at the Louvre and were leading him toward what he himself called "a fine bureaucratic career."[16]

Soon, however, Matisse was investigating works by more recent artists, particularly Cézanne. In Gustave Moreau's class, at Ambroise Vollards's little gallery, at Durand-Ruel and especially at the Luxembourg Museum where the Caillebotte legacy† of Impressionists and Post-Impressionists had gone on view in 1897, Cézanne's works were discussed. In the most accomplished Cézannes—such as *Three Bathers* (1879-82), which Matisse acquired in 1899—the whole picture surface is constructed by parallel brushstrokes like short blunt arrows, and the illusion of volume and space is rendered by the varying consistency, orientation and tone of these blunt strokes acting like planes or facets. Furthermore, the strokes fulfill a dual purpose. Because they are part of an overall surface design, they also contribute to the constant tension between surface and depth.

To those of Matisse's generation still trained to draw first and then to fill in with color, Cézanne's inductive methods were indeed revolutionary. Matisse's *La Raie* (1900), a free transcription of a painting by Chardin,

* The "Musée des Copies," exhibited copies of masterpieces and bought some to send to provincial museums.
† Caillebotte had been a collector as well as a painter.

had, Matisse admitted, Cézanne's planar construction behind it. In *Naked Man* (1900), with its firm and ample brushwork defining almost sculpturally the musculature of the sitter area by area, Matisse put into practice the laws of architecture and the relationships of "forces" that he had found in Cézanne. *Le Serf* (1900-1903) is related to Rodin's *Walking Man* and is one of Matisse's early experiments in clay, a three-dimensional version of *Naked Man* (without the arms) realizing in a tactile way Cézanne's inductive building up of form. (Time and again Matisse would change medium for the clarification of his ideas.) In Cézanne's stroke-by-stroke construction, in his striving for order and clarity and in his meditation on nature, Matisse indeed found echoes of his own strivings. With his discovery of Cézanne, however, Matisse's bureaucratic career came to an end, and in 1901 he joined the Société des Indépendants where Cézanne, a perennial reject of the official Salons, had also been exhibited, and whose driving force was the Divisionist painter Paul Signac.

"A young painter . . . must primarily order his brain by conciliating the various points of view in the beautiful works that touch him and, simultaneously, by interrogating nature."[17] So Matisse traveled, but also when in Paris looked around for subject matter. *Rocks at Belle Ile* (1897), *Corsican Landscape: Olive Trees* (1898), *A Glimpse of Notre Dame in the Late Afternoon* (1902), *Luxe, Calme et Volupté* (1904), *Open Window, Collioure* (1905) are not only memory logs but stages in the artist's discovery of the multiple functions of color. The first works approximate the light and shade of the motif, which hums in Brittany, sings in Corsica; in *Notre Dame*, shadows tend to become color areas in their own right, color is less descriptive, more moody, the brushstrokes are attenuated and a jarring blotch of pink in an overall blue harmony already sounds a Fauve note; in *Luxe*, shadows are almost gone, color becomes spontaneous as if used right out of the tube and is applied in patches of short vibrating touches; while on the walls and windows framing the view of the harbor in *Collioure*, the touches of color, like drops of water merging into puddles, form several large flat single color areas that do not quite meet but are allowed to breathe through the blank intervals between them that serve as light sources. Moreover, the optical synthesis of loud and subdued color touches caused by the vibrating of complementaries in *Luxe* has given way in *Collioure* to the simultaneous singing of several loud dissonant colors, used not so much for conveying the colors and shadows of the motif as for their ability to express sensations, feelings and moods.

Luxe was painted along Divisionist lines after Matisse had spent the summer in Saint-Tropez in the company of Paul Signac and Henri-Edmond Cross, who with Georges Seurat had been the theoreticians of Divisionism (the juxtaposition on the canvas of spectrum colors applied in small dots); it was bought by Signac at the Indépendants exhibition in the spring of 1905.

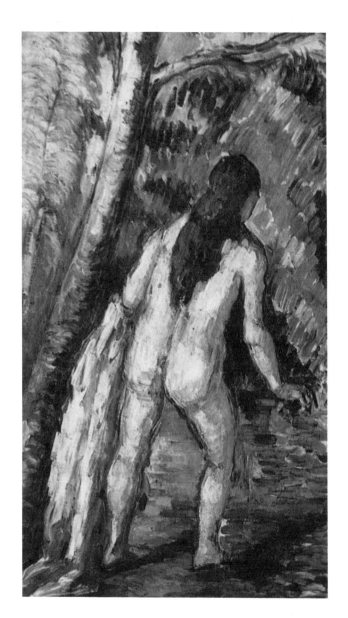
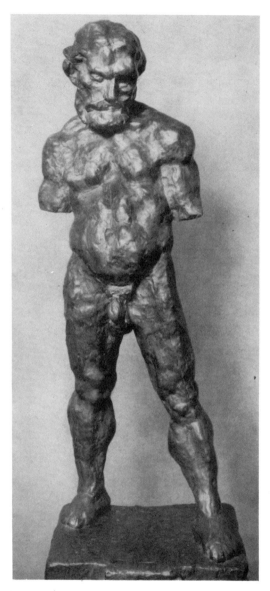

. . . one of Matisse's early experiments in clay . . . realizing in a tactile way Cézanne's inductive building up of form.

left: Cézanne, *Bathers*, (detail), 1879-1882.
Gift of Matisse to the Petit Palais, Paris.

right: Matisse, *The Slave (Le Serf)*, 1900-1903, bronze. 36 1/4″ high.

Collioure, exhibited at the 1905 Salon d'Automne a few months later, was condemned by the same Signac, who justly realized that his erstwhile proté-gé had betrayed his ideas and perhaps usurped his place as a leader of the avant-garde. Visits by Matisse to Gauguin's correspondent and spiritual heir Daniel de Monfried in the summer of 1905 may have played a part in this alleged betrayal, and surely confirmed Matisse in his belief in the emotional power of color. "In order to be called a Fauve, Gauguin would have had to construct space through color which he utilized only as an expression of sentiment."[18]

By interrogating nature, first as the Impressionists had done in order to reproduce its ever-changing atmosphere, then as the Divisionists had done in order to render natural light and shade quasi-scientifically through studies on light structure and optics derived from Chevreul, Matisse discovered that he could dispense with shadows, for light could be made to originate from the canvas itself. He could then use colors as composers use sounds and through them communicate the profound and almost religious reverence he held toward all aspects of nature.

Although *Collioure* does not convey an accurate likeness of the view (walls are blue-green on the left of the window, violet-red on the right), it does render the sensation of calm and coolness within the room by means of ample flat strokes, and of rustling and swaying outside by brisker touches. Furthermore, through the use of a high-pitched color key over the entire surface of the canvas to designate both faraway and nearby objects, Matisse was able to capture the deeply resonant emotional quality he was seeking.

Matisse was not alone in this new use of color. In the *cage aux fauves* (wild beast cage), the name given to the central room at the 1905 Salon d'Automne, similarly inclined painters, shared wall space. In close touch with each other in their development were Charles Camoin and Henri-Charles Manguin, former co-students of Matisse at Moreau's atelier; Albert Marquet, with whom Matisse would go across the Seine from Notre Dame to sketch; André Derain, whom Matisse met at Eugène Carrière's atelier; and Maurice Vlaminck, Derain's friend and neighbor in the Paris suburb of Chatou. Together they had gone to curio shops, first for Japanese prints, then for African objects. Together they had visited exhibitions of Persian art and of Van Gogh, in their search for color. Together they had made copies of masterpieces in the Louvre; from 1903 on some of them had begun exhibiting together at the Salon d'Automne. Like late nineteenth-century music, which had explored new ranges of sound and levels of volume, their paintings explored new, jarring, clashing color harmonies. Like the African art they admired, their works were meant to convey a direct and powerful impulse.

Few of the artists, however, did more than change their color keys, heighten their palettes and adopt an unfinished look. What seems to have

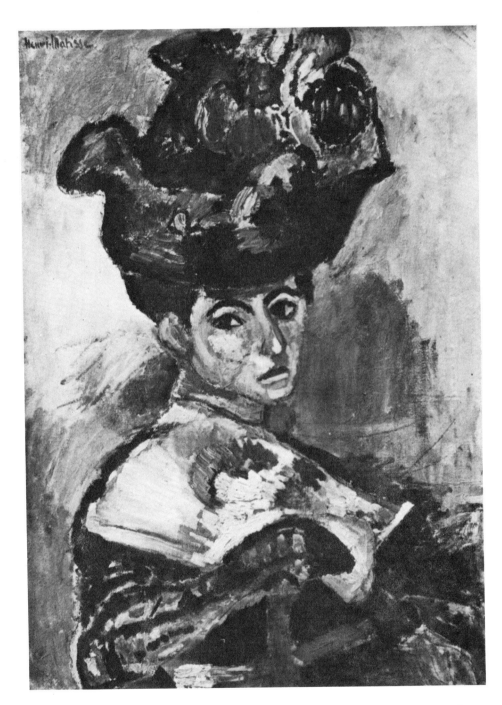

Matisse, *Woman with a Hat*, autumn 1905, oil on canvas.
Private collection. 32 x 23 1/2″.

separated Matisse from his friends was his keener sense of tension between an event in space and the overall color design, and his intuition of a new space based on precariously balancing, within a flat surface of given dimensions, proper quantities of two, three or more high-pitched colors to fulfill the dual functions of Cézanne's brushstrokes.

The problematic aspect of this ambition was immediately apparent in the other contested work that Matisse presented at the Salon d'Automne—the *Woman with a Hat*, which he had painted in a few weeks after returning from his summer at Collioure in 1905.

Traces of the artist's anxiety are what gives the *Woman with a Hat* an unfinished, discordant and unpalatable look, the Fauve look. Constructing a painting inductively like Cézanne, yet with a dissonant color palette, meant that each decision, each new color, must continue to function in the overall design imposed by the dimensions of the frame and still produce a recognizable image of the model, Mme Matisse. The green, blue, and other unlikely colors on her face are not so much willful distortions as necessities for the painting's overall harmony, just as the schematic rendering and unfinished portions of the work reflect the artist's fear of continuing lest he destroy the hard-won balance of color, light and space.

Matisse and Picasso Compete for Wall Space at the Steins

The *Woman with a Hat*, reviled and spat upon at the Salon d'Automne, was soon hanging next to Renoirs, Gauguins and Cézannes in the Paris home of two young Americans, Gertrude and Leo Stein. They, with an older brother Michael and his wife Sarah, also living in Paris, had recently begun to collect art, buying mostly near-contemporary French paintings rather than the time-tested pieces generally favored by American collectors. With the purchase of *Woman*, the Steins began their championship of the new. Their homes, in the rue de Fleurus and rue Madame respectively, were filled with contemporary paintings and sculpture. For a while, the only place where the development of Matisse and Picasso could be seen unfolding, side by side and year by year, was on the Stein walls.

Of these four Californians, Leo was probably the best prepared for the role of *mécène* or art patron. Having been a philosophy student at Harvard and for a time an amateur painter, he approached all art with a critical mind. "Keep your eye on the object and let your ideas play about it," was his motto.[19] Not unlike Matisse himself at the time, Leo questioned genre and illustration, looked for "plasticity" in pictures ("Sufficient art is where construction and composition coincide"[20]), particularly admired the great colorists of the past (in his case Mantegna), collected Japanese prints, and went on what he called "a Cézanne debauch"[21] soon after discovering that artist's work at Ambroise Vollard's gallery in 1903. His judgment of the

Woman with a Hat, "a thing brilliant and powerful yet the nastiest smear of paint I have ever seen,"[22] reveals both his insight and his contradictions, as well as an inability to adjust to a radically new point of view. His later rejection of Cubist painting and his eventual disaffection from modern art make him a complex figure in the Stein foursome. Yet it was he, it seems, who discovered both Matisse and Picasso, established personal contacts with them and, in the early days, picked the works of these artists with faultless discrimination.

Gertrude Stein had been one of William James's favorite students at Radcliffe, and while there had written articles on motor automatism that were published in the *Psychological Review*, in September 1896 and May 1898. ("Normal Motor Automatism" had a co-author, but "A Study of Character in Its Relation to Attention" seems to have been written by Gertrude Stein alone.) She then attended medical school in Baltimore, although by her own admission she was more interested in psychology and literature. When she settled in Paris near her brother Leo, she began a translation of Flaubert's *Trois Contes*. She often accompanied Leo to the Salons and to Montmartre galleries. In a 1946 interview[23] she spoke of Cézanne as having shown her the way toward decentralized composition: "It was not solely the realism of the characters but the realism of the composition which was the important thing [in Cézanne]," she said. "Flaubert . . . too had a little of the feeling about this thing," she added, alluding to Flaubert's de-emphasis of all-knowing, single-point-of-view characterization and to his reliance on contextual evidence to describe characters and events. Like her brother Leo, she was interested in the arrangement of forms—in her case, syntax, punctuation and the organization of the written word. She was soon to begin dismantling all the traditions of narrative, and particularly enjoyed visual representations that seemed to her to parallel her own experimental writings.

Michael Stein, described as "a gentle and reticent man ever helpful to his friends,"[24] watched over the family finances after the death of their father and his own early retirement from the streetcar business. Of Sarah Stein, Matisse reputedly said, "She knows more about my paintings than I do!"[25] She had apparently studied painting in California before her marriage. Carried away by the sight of the *Woman with a Hat*, which among other things reminded her of her mother, she enthusiastically backed its acquisition by the family.

Shortly after the purchase of the *Woman with a Hat* in the fall of 1905, the Steins looked up the Matisses through a mutual friend, the painter Manguin, and soon the Matisses were "constantly with them," as Gertrude reports in *The Autobiography of Alice B. Toklas*[26]* Shortly thereafter, in

* A great deal of controversy surrounds Gertrude Stein's 1933 *Autobiography of Alice B. Toklas*, a lively account of her life in Paris written from the point of view of her companion Alice B. Toklas, ever since the publication in a 1935 supplement to *Transition* magazine of

one of his rounds of Montmartre galleries, Leo discovered pictures by an unknown Spaniard named Pablo Picasso, who, he decided, was a genius and "one of the most notable draughtsmen living."[27] The *Harlequin Family with Monkey* and *Young Girl with a Basket of Flowers* were soon on view in the rue de Fleurus. The first work belonged to the *Harlequin* series, the other was more of a transitional work. A tall, narrow painting, *Young Girl with a Basket of Flowers* depicts a thin, coarse adolescent girl staring defiantly toward the viewer and barely concealing her distaste at being asked to pose. Her "clothing," reminiscent of an acrobat's tights, is curiously ambiguous, for as the eye travels from the bejeweled neck toward the hands and the ugly flat feet, tights and skin stop being separable. By the artful manipulation of paint, Picasso suggests simultaneous aspects of his model (for unlike his harlequins and circus figures, which were mostly painted from memory, there was a model for this work). Gertrude apparently did not like it, especially the "drawing of the legs and feet."[28] As had been the case with Matisse, a meeting with the artist was nevertheless arranged, this time through the novelist Pierre-Henri Roché, and, according to Gertrude Stein, "Gertrude and Picasso immediately understood each other."[29]

So Matisses and Picassos began to flow into the Stein households. *Woman with a Fan, Boy on a Ball* and a number of older blue-period Picassos were among their early purchases, which also included *Boy Leading a Horse* (1905-6).

This last was an enormous work, so tall that the Cone sisters, who were friends of the Steins and themselves collectors, allegedly had to give up the idea of buying it from Gertrude, for it would not have fitted on any of their walls in Baltimore. The two figures in the painting, a horse and a young boy, are delineated in heavy outline as in Cézanne's *Bather* (1895). They are rendered in a subdued off-white palette, the gray of the sky being repeated in the horse, the ocher of the earth in the boy, and are set in a bleak empty space of oddly shifting depths, as in the same Cézanne. Boy and horse look as if they were moving straight toward the viewer, and the horse's head, slightly askew, seems to knock against an imaginary glass pane, in fact the unassailable picture plane. The boy is nude, and reins are conspicuously absent from his right hand, which is held in a leading gesture, possibly symbolizing the artist's control of his means at least within the limits of the canvas surface.

Among Michael and Sarah Stein's purchases of 1906 were several Matisses. *Green Line*, another portrait of Mme Matisse, more "finished" than

"Testimony Against Gertrude Stein": "There is unanimity of opinion that she had no understanding of what was happening around her, that the mutations of ideas beneath the surface of the more obvious contacts and clashes of personalities during that period escaped her entirely," wrote Eugene Jolas in the introduction.

the *Woman with a Hat*, is done in bright flat colors, with a pea-green line of paint running from the dark-blue hair down the middle of the face, half pink, half ocher. *Self-Portrait* is in the unfinished technique of *Woman*, and in *Pink Onions*, shadowless forms are artlessly and naively lined up in a row in the way that children might represent such a subject. Their acquisitions were displayed at the rue Madame address, and several of them shown to collector-friends in the United States that same year, when the couple brief-ly returned home following the San Francisco earthquake.

Joie de Vivre, a work much discussed when Matisse showed it at the Salon des Indépendants of 1906, was soon hanging in the rue de Fleurus, where Leo was able to study it. He had not liked the work at first, but kept going back to the Salon to look at it, and would soon declare it the most important painting done in our time.[30] If the *Woman with a Hat* had evinced the struggle of constructing solely with strong colors in sufficient contrast to suggest modeling, *Joie de Vivre* was by comparison a serene, graceful work. At the center and in the distance, a round of pale pink dancers circling clockwise; in the foreground more boys and girls in purple, pink, red and yellow are reclining, stretching, playing the flute and embrac-ing in a paradisiacal setting of pink skies, yellow beaches, blue grass and red trees. Sinuous interrupted lines and flat color patches, arranged in rhythmic alternation, confer a sweeping counter-clockwise movement to the surface composition and give it a musical tempo. No work of Matisse at that time better succeeded in illustrating his definition of expression:

> For me expression does not lie in the passions that break out in a face or are stated in a violent movement. It lies in the entire arrangement of my paint-ing.[31]

And in no other painting before then did the placement of colors and va-grant lines so intricately sustain, like a musical accompaniment, the narra-tive features of the Arcadian scene.

The contrast with Picasso's *Boy Leading a Horse* was startling. Ma-tisse's colors are arbitrary, emotional, vibrant; in the Picasso the tonalities are marblelike. Matisse's color patches and autonomous lines are repeated rhythmically over the whole picture plane; in the Picasso color is still en-closed by lines. In the Matisse the figures are schematically rendered and respect no logical scale; the Picasso gives us a close-up view of roundly modeled figures. In the Matisse there is a tension between surface and depth; such tension is alluded to but not yet realized in the Picasso.

Less than a year after they had started buying Matisses and Picassos, the Steins (except for Leo) had begun to define their respective allegiances. The Michael Steins stood staunchly by Matisse, and bought almost all of his pictures until 1908, when the Russian collector Shchukin became in turn Matisse's chief patron. Gertrude was increasingly suspicious of Matisse:

"There is nothing within you that fights itself and hitherto you have had the instinct to produce antagonism in others which stimulated you to attack. But now they follow!" "Mademoiselle Gertrude likes local color and theatrical values!" retorted Matisse.[32] Picasso, not Matisse, was painting Gertrude Stein's portrait.

Some eighty times in the winter and spring of 1905-6, Gertrude went up to the Bateau Lavoir to pose, but Picasso then obliterated the face. Early in the fall, soon after his return from a summer at Gosol in Spain, he finished the portrait without the model and presented it to Gertrude Stein, who, perhaps not without malice, placed it right above the *Woman with a Hat* in her studio in the rue de Fleurus.

In sharp contrast with Matisse's rainbow colors in *Woman*, the *Portrait of Gertrude Stein* is a somber work in academic tonalities of dark muddy browns and deep wine-reds with white accents. A single sweeping upward curve delimits the seated figure's ample contours. The Cézanne-like folds of the clothing, the slight forward inclination of the body, the natural placement of the hands and the strong contrast between light and dark convey a self-assured, massive and assertive presence. But of Gertrude's youthful and vivacious expression there is no trace. Instead one sees an aging dried-up face in which the nose and mouth alone retain a human look, an ageless mask with stylized eyelids and brows placed asymmetrically and suggesting an Iberian or Egyptian influence.

In Matisse's portrait of his wife, facial expression tends to be secondary to the overall image, thanks to the arbitrary coloring given to the model. In Picasso's portrait of Gertrude Stein, the face is the focus of interest due to the synthesis of several aspects of the model's head: what the sitter might look like years hence, how she might have been rendered in a civilization using different conventions for representing facial features, combined with the artist's memories of her. Although it was not a likeness in the traditional sense, Gertrude Stein apparently liked her portrait. "When she saw it, he and she were content."[33]

At least she thought he was. Several works of Picasso from the summer and fall of 1906, among them the *Standing Female Nude* bought by Leo, reveal that, far from being content, Picasso was torn between two modes, one emphasizing the sculptural, the other the overall surface pattern. Picasso's portrait of Gertrude, although more sculptural than Matisse's portrait of his wife, still had a clearly focused center of interest, while Matisse's work spread interest throughout. In order to decentralize his composition, Picasso reduced his palette to light tones of pink and ocher, eliminated strong light and shadow contrasts, did away with heavy outlines and, to compensate for the loss of sculptural qualities, gave his figure squatter, less classical proportions from the waist down. Yet *Standing Female Nude* remains a wispy, insubstantial image.

In 1906 there were many pictures on the Stein walls and many visitors asking to look at them—Americans, Hungarians, Germans, Russians, collectors, critics, artists and their friends. The Steins were at home on Saturday evenings. There, according to Gertrude Stein, Matisse and Picasso finally met in the fall of 1906, that is—if she is correct—at a critical time for both artists. Within a few months of their first meeting—they apparently later frequently exchanged visits, paintings and undoubtedly ideas*—Matisse reverted to sculpture, the medium to which he turned when he was losing the sense of the three-dimensional, and made a reclining nude in clay (later accidentally destroyed). It was followed by a painted version, *Blue Nude, Souvenir from Biskra*, which Matisse exhibited at the 1907 Salon des Indépendants.

That same year, Matisse presented *Music (Sketch)* at the Salon d'Automne. Here decorative color was banned in favor of the earth colors that Picasso was then also employing. *Blue Nude* and *Music* were Leo Stein's last purchases from Matisse. For his part, in the fall of 1907, Picasso quit work on a large painting that neither Leo nor Gertrude had the courage to buy, a picture so "Fauve," in the sense of primitively barbaric, that Matisse decided it was Picasso's way of ridiculing him and the other Fauves.

* Matisse gave Picasso a portrait of his daughter Marguerite, done in the naive style he occasionally favored (*Pink Onions*). There is little reason to doubt that when Picasso visited Matisse he saw Cézanne's *Three Bathers*, as well as samples of African art even if, as he mentioned, it was not through Matisse but on his own at the museum of the Trocadéro that he "discovered" African tribal art.

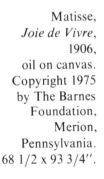

Matisse,
Joie de Vivre,
1906,
oil on canvas.
Copyright 1975
by The Barnes
Foundation,
Merion,
Pennsylvania.
68 1/2 x 93 3/4″.

Summing Up

In the Paris of 1900 two art worlds thrived side by side: one in the Bohemian milieu of Montmartre with its reputation for avant-gardism, the other around the Ecole des Beaux-Arts with its conservatism and its promise of security. One was to produce Picasso, the other Matisse.

When these two men began their artistic careers, Symbolism prevailed, ideas were presented as allegories (primitive, romantic or mythological), mood was conveyed by color and graceful arabesques embellished the contours of form.

Picasso's blue-period and *Harlequin* paintings carried on the Symbolist tradition, although ambiguities and intimations of new concerns were already apparent in his 1904-6 paintings. Whereas nineteenth-century Symbolism was generally concerned with universal themes, Picasso, in his paintings, speaks of *the artist*'s situation, his freedom and his nomadism, his kinship with virtuoso performers, his ability to arouse emotion, his control over pictorial space limited by the canvas surface.

Matisse's development from 1896 to 1906 took a different path. At first he deliberately eschewed symbolic narrative subjects and the idealization of form. Copying the old masters, he discovered the expressivity of light controlled through value contrasts; studying Cézanne, he mastered the use of brushstrokes to structure both surface and depth; and through his exploration of nature, he realized the possibilities of color. Having thus investigated separate pictorial elements, he synthesized them in his Fauve works, in which colors were used for light, for surface and depth structure and for the expression of feelings. Unlike Symbolist colors, which were intended to match specific states of mind, Matisse's colors became conveyors of emotions by their interaction on the canvas surface. One might suggest that it was Matisse who introduced the "relativity" of colors.

The clashing of large surfaces in bright unmodulated hues roughly applied (the equivalent of the new musical harmonies of such young composers as Igor Stravinsky), became Matisse's means of endowing the whole space of his paintings with a primitive dynamic rhythm. At first landscapes, portraits and still lifes were the subjects that served as pretexts for his color studies. But in *Joie de Vivre* an idea becomes the subject of a painting in which abstract and figurative symbols reinforce each other.

When Picasso and Matisse finally met, they were both aware that the expressive means of painting had to be rejuvenated, and were looking to other civilizations to enrich the expressiveness of their art, although Matisse was relying on raw color and Picasso on new graphic signs. Both questioned the Renaissance tradition and its use of figurative rather than abstract signs as metaphors of expression.

chapter 2 MOMENTS OF THE NEW IN PARIS,
c. 1907-1912

Les Demoiselles d'Avignon;
Picasso's and Braque's Cubist Adventure
The Académie Matisse; *Dinner Table, Harmony in Red;*
La Danse
Summing Up

Whether in psychology with Freud, in physics with Einstein, Planck, Ruth-erford, Minkovsky, Moseley, Bohr, in philosophy with Husserl, Bergson, Cassirer, Poincaré, the theoretical representation of nature dramatically changes in the first decade of the new century.

In December 1908, the American, Wilbur Wright, flies one hundred miles, and the following July the Frenchman Blériot crosses the Channel by air.

In the arts, with the birth of the Salon d'Automne in Paris, late nine-teenth-century innovators are finally consecrated. Gauguin in 1906 and Cé-zanne in 1907 are given posthumous retrospectives. Thanks to the premier of France, Georges Clemenceau, Manet's Olympia *is hung in the Louvre in 1907.*

Meanwhile the American expatriate Isadora Duncan revolutionizes the dance by freeing dancers from corsets. Barefoot and dressed in a free flow-ing Greek tunic, she improvises on music by Glück, Schumann and Wagner at the Paris Châtelet theater (January 1911). Beginning in 1908, Diaghilev brings his Russian musicians and singers to Paris—Boris Godunov is per-formed in 1908, and his ballets Prince Igor *(1909),* Firebird and Scheherazade *(1910),* Petrushka *(1911),* Rites of Spring *(1913) display to the Paris public the natural vitality of their dancers, the dynamic rhythm of their music and the lavishness of their sets.*

30

Les Demoiselles d'Avignon; Picasso's and Braque's Cubist Adventure

The painting that made Picasso "the one to follow," eclipsed the Fauves and forced Matisse into temporary retreat is now known as *Les Demoiselles d'Avignon*. No twentieth-century painting has been reproduced and analyzed so often as *Les Demoiselles*, for it is generally acknowledged as a seminal work for Picasso and a landmark in the history of painting.

Originally conceived as an allegory, it became in its final yet "unfinished" version a large mysterious composition representing five women, in various states of undress, and with fruit on a table and drapery. The colors, except for a few striated markings of green, yellow and orange, are essentially from Picasso's former palette, but, unlike the blue and rose paintings, the effect is grating rather than soothing, and no one color prevails (even the drapery is ocher on the left, blue and gray on the right side of the composition). In other respects as well, the painting harks back to earlier concerns of the artist while announcing new ambitions.

The two central figures, as insubstantial as the *Standing Female Nude* of 1906, are defined by their contrast of color against the background and by a few undulating lines. In the figure on the far left, lines become straight and angular, while in the two right-hand figures, noses and breasts are modeled vigorously if primitively by striated hatchings. The colors used around most of the figures serve simply to fill in the space, but, in the right-of-center interval, the blue crumpled drapery, looking rather like ice blocks faceted into angular planes simultaneously concave and convex and foreshadowing Cubism, makes it impossible to judge whether figure or drapery is closer to the picture surface. To combine tactility and overall effect, Picasso is now using Cézanne's solution of treating mass and void as a continuum of unstable, faceted volumes, at least in the right side of the painting.

As in the *Portrait of Gertrude Stein*, signs for indicating facial features are borrowed from outside the post-Renaissance Western tradition. But, in *Les Demoiselles*, the sources are multiple and ambiguous. An almond shape (Egyptian?) for the eyes, a scroll (archaic Iberian) for the ears, and other fanciful conventions (some possibly from African art)* such as the hatchings, a continuous ridge from brow to nose, a black hole for an eye, masklike simplification of facial features, are alternately used. Not unlike artists then referred to, willy-nilly, as "naive" (through a confusion that assimilated the creations of a partially trained artist like Picasso's friend Rousseau with those of tradition-bound African wood-carvers), Picasso conceptualizes appearances. He also invents or borrows pictorial signs to

* In the continuing controversy over the part African art and masks played in *Les Demoiselles*, the most radical ideas concerning the absence of African influences are contained in an article by Pierre Daix in *La Gazette des Beaux-Arts*.[1]

exaggerate the ferocious yet tragic expressions of otherwise similar figures.

The simultaneity already suggested in *Young Girl with a Basket of Flowers* and in the *Portrait of Gertrude Stein* is here developed far more boldly. The squatting figure on the lower right shows simultaneously her back, her front and a three-quarter view while the head is abnormally twisted; the profiled woman on the left appears almost to be walking, and the viewer must decide whether he is seeing her right or her left leg. Likewise, other distortions, including one eye higher than the other, a profiled nose on a full-face, a frontal eye on a profile, a downward view of a table and a side view of the melon slice upon it can be seen as discontinuities through which the artist, by multiplying the points of view from which the forms are depicted, can supply information beyond that given in traditional fixed perspective.

Finally, as in *Boy Leading a Horse*, the painting exposes the limits of its means, the unassailable barrier, the imaginary glass pane that prevents the scene from continuing in the spectator's space and separates even the most tangibly rendered presences from life, while at the same time revealing the painter's freedom, no longer metaphorically as in *Boy Leading a Horse* but through formal innovations.

Les Demoiselles is thus a summation of the issue of the limits and freedom of the artist, a testing ground for formal and expressive innovations, and a battleground on which formal innovations and questions of meaning compete for attention.

Visitors allowed to see *Les Demoiselles* in Picasso's studio—the only place where it could be seen since Picasso never exhibited it—were both mystified and repelled. The figures looked ugly and the subject matter was ambiguous. Playing on the meaning of *bordel*, a house of ill-repute but also with overtones of disarray and confusion, Picasso's friends were calling it "The Philosophical Brothel." The execution had none of Picasso's habitual virtuosity and prompted the Russian collector Shchukin—who had begun collecting Picasso's blue and rose paintings—to exclaim, "What a loss to French art!" Even Apollinaire, according to Roland Penrose,[2] "watched the revolution that was going on not only in the great painting but also in Picasso himself with consternation." Indeed the means of rendering the subject were themselves highly controversial. New all-round vision attempted to render more completely various aspects of the model; faceted volumes conferred equal weight on solids and voids; esoteric figurative signs were used inconsistently; a metamorphosis of style was taking place right on the canvas, echoing (or not) an allegory on the subject of transmutation.*

Yet Matisse's anger (see chapter 1, page 28) with *Les Demoiselles*

* The presence of a man holding a skull in the initial drawings suggests that the idea of death was not absent from the original intention of the work, and that the observable metamorphosis of the figures perhaps involves passing from life to death.

seems only partially justified. In a sense, *Les Demoiselles* paid tribute to the *Woman with a Hat*, which like Picasso's painting distinguished the impact of a picture from the beauty of the subject and the virtuosity of the artist. It acknowledged Matisse's success in distributing interest throughout his paintings and in finding emotional rather than mimetic uses for color. On the other hand, Matisse's joyful color, decorative arabesques and paroxysms of euphoria in *Joie de Vivre* seemed to be challenged in Picasso's haunting inferno.

While his puzzled visitors tried to regain their wits, Picasso was exploring his findings. He focused now on the graphic innovations, the brittle angles and striated hatchings in *Les Demoiselles* and made of a simple vase of flowers (*Vase of Flowers*, 1907, Museum of Modern Art, Ralph F. Colin Collection, New York) a frightening brutal image, and in *Nude with Drapery* (1907, Hermitage, Leningrad) used the transparency of the hatchings to keep the volumes and surrounding space ambiguous. Or, using Cézanne's angular brushstrokes rather than parallel lines, he investigated the close-up tactile quality of form already attempted in the top-right figure of *Les Demoiselles*. Since Picasso was by then familiar with African wood carvings —he himself occasionally carved at that time—a resemblance has often been noted between wooden African statuary and the mostly ocher "ax-hewn" figures in *Three Women* and *Nude in the Forest* of 1908 (both in the Hermitage, Leningrad), in which abrupt color changes play like light and dark on faceted "blocks," although the unusual proportions of the figures might also be attributed to deformations produced by a spherical mirror (the spherical space of the Orient that so influenced the late works of Cézanne).

Discarding his "African crutches," Picasso had also begun in the summer of 1908 a series of still lifes and landscapes. In *Landscape La Rue Haut Bois* (formerly, Museum of Western Art, Moscow[3]), the whole canvas space was treated as an arrangement of arbitrarily lit solids, cubes, cylinders and other abstract, three-dimensional shapes in chaotic perspective. A year later, in *The Reservoir, Horta* nearly everything except straight-edged faceted solids had been eliminated.

"What attracted me so much [to Cubism] . . . was the materialization of this new space I felt," the painter Georges Braque was to say in a 1954 interview.[4] Braque, a young Fauve and protégé of Matisse, was among the first of Picasso's contemporaries to make use of the contorted squatting figure in *Les Demoiselles* for his own "simultaneous" front-and-back view of a nude (*Le Grand Nu*, first exhibited at the 1908 Indépendants). He had found Fauve painting novel, physical, enthusiastic, he told his interviewer, but had come to understand that the paroxysms in such painting could not last. So when he had gone back to the South of France, the sunny region favored by the Fauves, for the third time in the summer of 1908, "the exal-

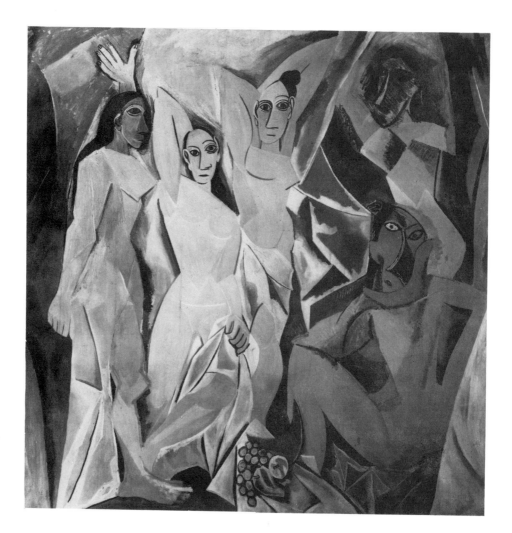

The painting that made Picasso "the one to follow. . . ."

Picasso, *Les Demoiselles d'Avignon*, 1907, oil on canvas. The Museum of Modern Art, New York (Lillie P. Bliss Bequest). 96 x 92".

"What attracted me so much [to Cubism] . . . was the materialization of this new space I felt. . . ." (Braque)

Braque, *Nude (Le Grand Nu)*, 1907-08, oil on canvas. Private collection, Paris. 55 3/4 x 40".

tation . . . had not been the same." He had seen that "there was something else."[5] (He did not need the sun any longer, for he had light within himself, as he told Jean Paulhan.[6]) This "something else" was revealed in Braque's 1908 *L'Estaque* landscapes—a conception of space in terms of pale bulky solids (cubes), arranged close to the canvas surface, seen as if from a high viewpoint, and conveying the essential idea if not the perspective view of an old sunbathed village.

Picasso's 1908 landscapes, painted outside Paris (*Haut Bois*), and Braque's, painted in southern France, were far from indistinguishable. Braque's *Maisons à l'Estaque*[7] (Kunstmuseum, Bern) was calm, almost scientific, in its horizontal-vertical rhythms; Picasso's *Landscape La Rue Haut Bois* more tortured in the now ascending, now descending diagonals of walls and slanted roofs. Furthermore, while Braque delicately modulated light and shadow on the walls of his houses, Picasso exaggerated the light-dark contrasts by abrupt color changes that rendered his volumes alternately readable as hollow or as projecting, concave or convex.

But there were enough similarities of style to startle both artists when they saw each other's work in the fall of 1908. Both left no "flat" areas on the canvas, both ignored spatial recesses as they affect size, so that their paintings gave the wholly new illusion that, by running a hand over the canvas surface, a viewer would feel as if he were rubbing like an old stone wall; and both showed a debt to Cézanne's late landscapes: high viewpoint and the synthesis of several perspective aspects, transposition of varied natural forms into primary structural volumes, passage from near to far, from solid to air, by blurring and elision of the linear "hinge" that usually marked the intersection of two planes.

A year later, in 1909, when the two again compared their works, Picasso's painted at Horta de Ebro in Spain and Braque's at La Roche Guyon near Paris, they saw that they had moved along similar lines. Although the materialization of space around the pyramid of houses in Picasso's *Reservoir, Horta* was more discreet than in Braque's *Château La Roche Guyon* (Pushkin Museum, Moscow), and made the latter painting appear more unified and abstract, more like the *Still Life with Liquor Bottle* (now at the Museum of Modern Art, New York), which Picasso painted later that same year, both artists aimed for a new transparency, a crystalline quality in the sides of their cubes that permitted the viewer not only to look at the exterior but also to penetrate into the cubic blocks (the gray roof right of the top center in *Reservoir, Horta* is also readable as an inside wall); and both were multiplying points of view, combining upward and downward views, side and frontal aspects of the landscape, thus imparting additional information on their subjects.

Picasso and Braque were apparently seeing each other a great deal in those days. Dizzy and solitary, they became, in Braque's words, "roped like

mountaineers." After the *Demoiselles* episode, Picasso had lost the allegiance of Vollard, Stein and Shchukin; while Braque, whose Fauve contribution to the 1907 Indépendants had sold out, had nevertheless been excluded from the Salon d'Automne of 1908 because of all his "little cubes." Almost alone the German collector Uhde, and the young dealer Kahnweiler, recently arrived on the scene, were tying their own uncertain destinies to those of the two artists; it was not until the fall of 1909 that Gertrude Stein, followed by the Russian Shchukin, rallied wholeheartedly to Picasso's new art. Gertrude Stein would later refer to the Horta landscapes as the real beginning of Cubism.[8]

So began what Braque called "the cubist adventure."[9] Figures, still-life subjects and their neighboring space were now fragmented, chiseled as if out of ice, reduced to their structural geometric cores, subjected to a complex scrutiny and analysis from multiple viewpoints. With paint, accumulations of transparent cubes were laboriously rendered concave and convex (*Head of a Woman*, Braque, 1909, Musée du Petit Palais, Paris); the reversal of solid and void, of concavity and convexity made tangible in sculptural form (*Woman's Head*, Picasso, 1909, Museum of Modern Art, New York); shattered little glass panes and fragments were given a reflecting look (*Still Life with Violin and Pitcher*, Braque, 1910, Kunstmuseum, Basel).

Then a new shorthand or telegraphic method of suggesting depth on a canvas surface replaced the closed transparent cubes or panes. Markings like open facets in the form of capital letters (C, V, L, T, I, O, etc.), aided by a counterpoint of light-dark contrasts from a multiplicity of sources, were used to indicate planes in space and gave the directional thrust of the former cubes, now deprived of material appearance. In the new space, no longer tactile, neither stable nor bounded, simultaneous effects became more varied and complex—is Ambroise Vollard reading, dozing or coveting a new work of art in the portrait Picasso made of him in 1909-10?

But the new open facets and the arbitrary, increasingly monochromatic color-light code used throughout rendered the works difficult to decipher (*The Accordionist*, Picasso, 1911, Guggenheim Museum, New York; *Le Portugais*, Braque, 1911, Kunstmuseum, Basel). An elusive, shallow, insubstantial and unstable space hid the subject and its surroundings in a way that Picasso would later compare to camouflage. In their desire to decentralize composition and keep the viewer's eye moving from one area of the canvas to the next, Picasso and Braque were forcing postponement of a solution to the content of their images by making signs and space ambiguous, now encouraging and then discouraging any final reading of their works. To say it was something like throwing a dart at a target and having it come back would be an appropriate metaphor. A side effect of their method was the concentration of attention on the painting as an object to be admired for its internal plastic qualities, the rhythmic flow of its lines and its use of light.

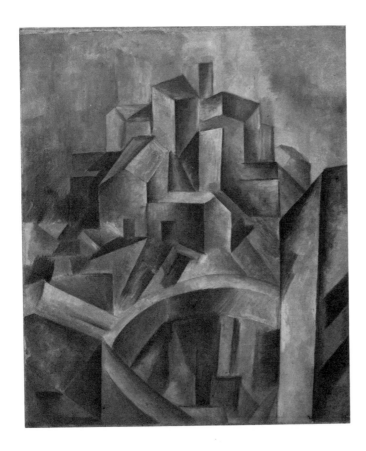

. . . both artists were multiplying points of view, combining upward and downward views, side and frontal aspects of the landscape. . . .

Picasso, *The Reservoir, Horta*, 1909,
 oil on canvas.
Private collection, New York.
23 3/4 x 19 3/4".

Braque, *Le Château à La Roche-Guyon*,
1909, oil on canvas.
The Pushkin Museum, Moscow.
36 1/4 x 28 3/4".

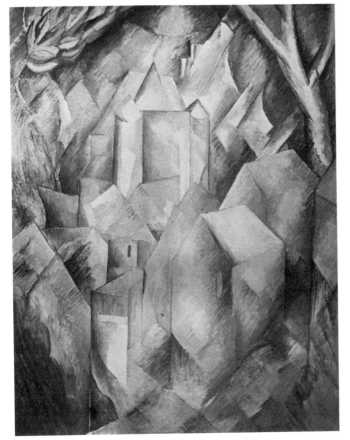

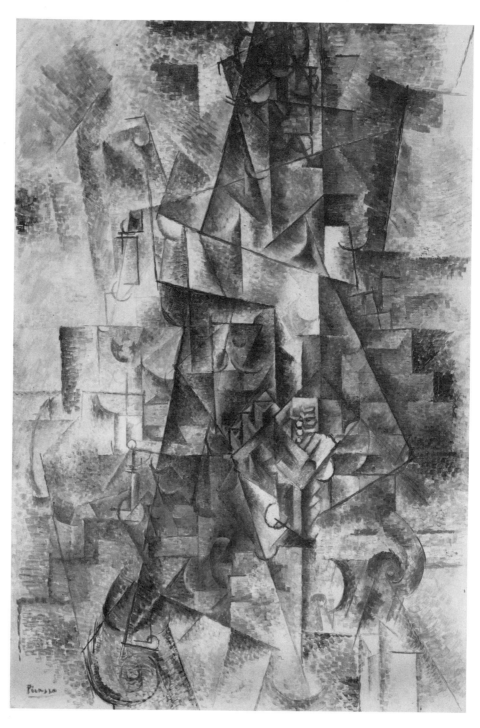

Deciphering their paintings was like . . . picking up conversations in a crowded room. . . .

Picasso, *Accordionist, (Pierrot),* 1911, oil on canvas.
The Solomon R. Guggenheim Museum, New York. 51 1/4 x 35 1/4".

In order to relate title to image in the works of 1911-12, it was now essential to follow the structural guidelines, the activity indicators—"the geometric forms that supply us with the solid armature on which we fix the products of our imagination," to use Kahnweiler's words[10]—and to attempt to interpret the strategically placed indices: a few parallel lines for the strings of a violin or a guitar, two joined half circles for the bulge of a violin, a spiral for the forward edge of an armchair, a circle for the rim of a glass, four short stubs for fingers, a half circle for an eyelid, occasional details in *trompe-l'oeil* such as a nail, or recognizable fragments of the depicted objects. These indices helped to suggest meaning while also contributing to the overall interest of the work.

Deciphering their paintings was like trying to understand a foreign language through a few disconnected words, like picking up conversations in a crowded room, like letting the sounds in a Mallarmé poem yield their own meanings, or like singling out folkloric details in a Stravinsky melody. Sometimes an oval or a round frame helped to recall the edge of the table, tray or mirror around the depicted subject—but an oval, unlike a circle, has no defined single position in space, so that the last anchor, the picture surface itself, also becomes ambiguous.* Musical keys and lines, parts of printed words, bits of sentences, surfaces imitating the color and substance of which the depicted objects were made† nevertheless guaranteed that the painting would not be construed as meaningless design, and in fact conveyed something of the atmosphere.‡

What Picasso and Braque talked about in those days "are things that no two people will ever tell each other again, or would know how to, that nobody would understand any more," Braque told Dora Vallier,[12] omitting any real clues to the content of these conversations. In Picasso's later exchanges with his dealer and friend Kahnweiler, the word "describe" often comes up:

> *Kahnweiler:* I've been to the Rubens Exhibition. . . .
> *Picasso:* He's gifted but what is the use of gifts that are merely used to produce bad stuff? Nothing is *described* in Rubens. . . . Look at Poussin, when he paints Orpheus, well, it's described. Everything, even the tiniest leaf, tells the story. . . .[13]

* No oval shape can ever be rendered as a circle whereas an oval may signify itself or a circle seen in perspective.

† Braque's initial training was in decorative arts. Among the tricks of his trade were ways of imitating wood grain with a special comb. Picasso used a comb for imitating wood grain and also to represent wavy hair.

‡ By now iconographical studies have solved a great many enigmas in these so-called hermetic works. See in particular William Rubin's analysis of the *Architect's Table* in his *Picasso in the Collection of the Museum of Modern Art*.[11]

Apollinaire had no sooner spoken of "an entirely new art . . . art that will be to painting . . . what music is to literature. . . ." than Picasso and Braque were reintroducing recognizable elements into their pictures.

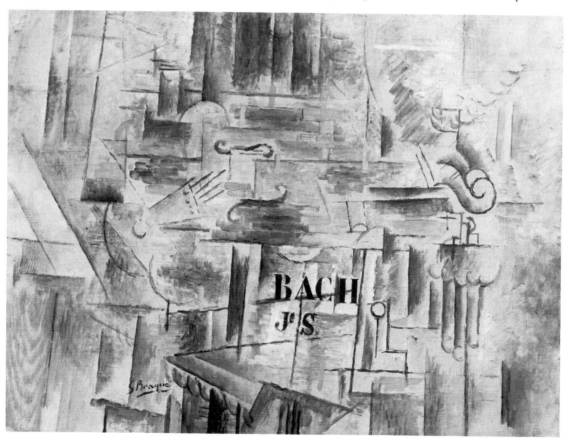

Braque, *Homage to J.S. Bach*, 1912, oil on canvas. Sidney Janis Collection, New York.
21 1/4 x 28 3/4''.

Or, Picasso to Sabartès:

> When he's [Cézanne] before a tree he looks attentively at what he has before his eyes; he looks at it fixedly, like a hunter lining up the animal he wants to kill. If he has a leaf, he doesn't let go. Having the leaf, he has the branch. And the tree won't escape him."[14]

As recounted by Gelett Burgess, who interviewed the wild men of Paris, probably in 1908,[15] a frequent topic of conversation must have been "woman": how, according to Braque, "to portray every physical aspect of such a subject required three figures much as the representation of a house requires a plan, an elevation and a section"; how a "harmony of volume . . . is a step further than any mere flat decorative effect," to render the violent emotion she arouses; and how it was necessary to "create a new sort of beauty, the beauty that appears to me [the artist] in terms of volume, of line, of mass, of weight, and through that beauty interpret [my] subjective impression," since it was impossible to render woman's loveliness completely.

Those who had seen *Les Demoiselles d'Avignon* had not been reassured by subsequent events. Picasso had indeed laid down the principle of the "picture-as-equation," to quote André Salmon,[16] but the terms of the equation were constantly changing. Matisse had called Braque's 1908 landscapes "cubist" and, by 1911, the cubes had disappeared from Cubist canvases. Guillaume Apollinaire had no sooner spoken of "an entirely new art . . . art that will be to painting . . . what music is to literature,"[17] than Picasso and Braque were already reintroducing recognizable elements into their pictures. In August of 1912, Picasso's friend, the critic Maurice Raynal, wrote, "If art is required to be not merely a means of flattering the mind and senses but more the means of augmenting knowlege, its function will only be served by painting forms as they are conceived in the mind."[18] Yet even Raynal would have to rephrase his analysis, for a new invention by Picasso and Braque was to render obsolete the word painting in "painting forms as they are conceived in the mind."

The Académie Matisse; *Dinner Table, Harmony in Red; La Danse*

Meanwhile, in 1908, after Braque's desertion from the Matisse camp, other former Fauves began hesitantly looking over Picasso's shoulder and searching for a path through Cézanne, whose *oeuvre* had finally been gathered at the Salon d'Automne of 1907. Even Matisse's frequent companion in Collioure, André Derain, had gone over to the other side. In 1908, he stopped painting shadowless harbor scenes in vibrant hues and animated strokes and, now taking his color cues from the African wood carvings he owned, aimed (in *Bathers*) for a new tactility.

"What I dream of is an art of balance, purity and tranquility. . . ." (Matisse)

Matisse, *Dinner Table, Harmony in Red* (*La Desserte Rouge*),
begun 1908 as *Harmony in Blue*, repainted 1909, oil on canvas.
The Hermitage Museum, Leningrad. 69 3/4 x 85 7/8".

Matisse, wavering and isolated despite personal successes that included his first showings in Moscow, New York and Berlin and the new patronage of the rich Russian collector Shchukin, consented, at Sarah Stein's suggestion, to take on a few students, mostly foreigners. The group, small at first, included, besides Sarah Stein, the German Hans Purrmann, the American Patrick Bruce and some Norwegian painters. They met in a small atelier at the former Couvent des Oiseaux. Matisse came by occasionally to give a few words of wisdom, which Sarah Stein devotedly preserved and Matisse himself published as "Notes d'un peintre" in the December 1908 issue of *La Grande Revue.*

Matisse's classes began shortly after Picasso had stopped work on *Les Demoiselles*, and undoubtedly in a spirit of rivalry. His thoughts reflect now and again views that could clearly distinguish him from his rival: "What I dream of," he said in "Notes d'un peintre," "is an art of balance, purity and tranquility, without preoccupying or worrisome subject, which will . . . be relaxing, mentally soothing, something analogous to a good armchair,"[19] and not intellectually demanding like the contemporaneous works of Picasso and Braque. "A work of art must carry its entire meaning within itself and impose it on the spectator even before he knows the subject," Matisse said in the same text,[20] and not require, as in Cubist paintings, that the viewer solve enigmas or the equation of signs to subject.

According to Sarah Stein, Matisse often referred his students to a model: "Take yourself the pose of the model; the place where tension is felt is the key to movement. . . ."[21] Or, "You need only consider the equivalence of color relationships in your picture and those in the model."[22] Or, "Choose two points, say the darkest and lightest in the model. . . . Consider each new stroke as it relates to them."[23] Observation of the motif, not its mental reconstruction, was his advice.

This counsel must have borne fruit, for in no time the atelier became too small and new quarters had to be found to house the "Académie Matisse." Reassured by the success of his school and reinforced in his beliefs, Matisse completed in the late fall of 1908 a decorative panel for Shchukin's dining room, now known as *Dinner Table, Harmony in Red*, which may be considered a visual statement of his position vis-à-vis the Cubists as well as a revolutionary work in its own right.

Fulfilling Matisse's wish that his art be as soothing and relaxing as a good armchair, *Harmony in Red* invites the viewer to enter a hot pink and blue interior, to sit imaginatively on a bright orange wicker seat, to select fruit or a decanter half-filled with wine from the dining-room table, to observe the soberly dressed servant girl setting the table, and, turning about, to look at the sunlit orchard in bloom as seen through a window, or "painted," for Matisse—using a Cubist device—has made the lower right-hand corner of the window ledge also readable as a picture frame.

Indeed the stated simplicity of goals and the picture's pleasant though not unusual subject—one that Matisse himself had already used in *La Desserte* of 1897—conceals its boldest features. The blank breathing spaces that had given *Collioure* and *Joie de Vivre* an unfinished look and were in fact sources of light were now gone. Tuned to an immense expanse of hot pink, the colors enhanced each other and illuminated the picture by the artist's control of saturation, brightness and his shaping of clearly defined areas of flat paint. In 1908, Picasso's and Braque's paintings were becoming increasingly monochrome, and the two artists were four years away from solving, by means of collage, the problem of rendering light without having recourse to chiaroscuro.

Although both Matisse and the Cubists were replacing the objective space of the Renaissance tradition with a more subjective one, Matisse in *Harmony in Red* suggested his alternative to Cubist space. Unlike Braque, who in his 1908 Cubist landscapes had made volume tangible by drawing a line at the intersection of two planes as well as by light-dark color changes, Matisse in *Harmony in Red* elided the intersection of horizontal to vertical planes, continued the same flowery design from wall to tablecloth, and, with a minimum of visual aids, let the viewer's imagination transform a two-dimensional surface into a three-dimensional illusion.

Not having to rely on line to separate one plane from another, Matisse was using line in *Harmony in Red* like color, to give order and clarity to his overall surface composition. The horizontals and verticals of the work emphasized calm and immobility, while the servant girl's systematic movements were metaphorically suggested through the repetitive, animated, flowery design. Although it seemed a short step to total abstraction, and although Matisse had frequent recourse to a geometric surface design (*Blue Window*, 1911; *Zorah on the Terrace*, 1912; *Piano Lesson*, 1916), rarely did he empty his canvases as starkly as he did in *Porte-Fenêtre, Collioure*, 1914. "A world without objects" was not for Henri Matisse.*

Whether Leo Stein's remark, sometime in 1908, that Matisse's paintings had become "rhythmically insufficient," induced Matisse to paint *The Dance* is conjecture. What is known is that in early 1909, perhaps feeling the first pangs of the fatigue that would lead him to close his academy two years later, Matisse moved to the Paris suburb of Issy-les-Moulineaux, where the collector Shchukin visited him while he was working on a large composition on the subject of *The Dance*. Shchukin subsequently wrote him that he had found *The Dance* so ennobling that he had resolved to brave bourgeois opinion and place on the stairwell of his home such a subject with a nude.[24] Twice again he changed his mind, and a year later, in 1910, such a

* Kasimir Malevich (see chapter 5) may have seen *Harmony in Red* at Shchukin's home, and *Zorah on the Terrace* in Ivan Morozov's collection, and been impressed by their underlying geometry. Removing objects from the works seemed a logical step.

With The Dance, *Matisse had achieved the economy he sought when he wrote, "everything that has no use in the picture is . . . harmful."*

Matisse, *La Danse* (first version), 1909, oil on canvas.
The Museum of Modern Art, New York (Gift of Nelson A. Rockefeller).
8′6 1/2″ x 12′9 1/2″.

painting, with another called *Music*, left Issy for Shchukin's home in Moscow.

With *The Dance*, Matisse had achieved the economy he sought when he wrote in "Notes d'un peintre," "Everything that has no use in the picture is thereby harmful."[25] He had also painted one of the most celebrated works of his career. Far from being libidinous as Shchukin feared, *The Dance*, with its participants minimally individualized and placed between blue sky and green earth, hovers at the edge of abstraction.* Far from being "rhythmically insufficient," *The Dance* is pure rhythmic movement. The schematic nude figures stretching, crouching, jumping (which leg does the far-right figure have up in the air?), stamping the earth; the compression of the figures within the picture's edges; the heavily saturated blue, green and ocher; the arrowlike intervals between the shapes that contribute to the circular movement; the few strategic lines marking body tensions; the underlying

* Although *The Dance* was a recurring motif in Matisse's *oeuvre*, beginning with the round of dancers in *Joie de Vivre*, it is worth noting that *The Dance* was begun about the time the Futurist Manifesto was printed in the French paper *Figaro*, February 9, 1909. It ended: "Erect on the pinnacle of the world, we hurl forth once more our defiance to the stars."

Matisse, *Porte-Fenêtre, Collioure*, 1914, oil on canvas. Private collection, Paris. 45 5/8 x 34 5/8".

structure that repeats the ratio of width to height of the framing edges—all these elements are directed toward the same expression of dynamic rhythm.

Matisse in his long life (1869-1954) was to weave not only painting and sculpture (contemporaneous with *The Dance* is *La Serpentine*, with one of its dancers at rest) but drawing, murals (at the Barnes Foundation, Merion, Pennsylvania), stained glass and vestments (for the Vence Chapel in southern France), ceramics, tapestry and illustrated books into his work. When he could no longer paint, he made cutouts of colored paper. Outwardly detached from social and political events, he was to write to his old friend, the painter Charles Camoin (April 10, 1918):

> One must struggle all day and every day to accept the irresponsibility of the artist.[26]

Of the color black, which entered his palette during the First World War, Matisse later told Alfred Barr that he was using black as a "color of light," not "darkness."[27]

Summing Up

To depict any visual experience on a two-dimensional surface had meant for Renaissance artists and their followers to render as in a mirror a static instant of that experience. In the second half of the nineteenth-century, the Impressionists, and particularly Cézanne, became conscious of the arbitrariness of a method that freezes time on the assumption that the eye cannot perceive the changes in spatial relations that in fact occur even during the briefest, most fleeting intervals.

How to render fleeting time and changing spatial relations was thus the problematic challenge for Cézanne and the Impressionists. This new challenge put the burden of representation no longer on the objective eye of a mirror, but on the artist's ability to invent pictorial equivalents for his experience of the physical world.

Now, in the twentieth century, man's knowledge of this physical world was radically altered, and this brought about a new awareness of how much was unseeable and still unknown. New theories and systems sought, fragmentarily and tentatively, to convey now the human (with Freud), now the spatial (with Einstein) aspects of nature, and what had been thought to be the old relationship between cause and effect was seriously called into question.

It is possible to appreciate the beginnings of the Cubist adventure as an attempt to capture in visual language these intimations of things as yet only dimly perceived about man and the space he lives in. The sense of security and certainty provided by the conventions of Renaissance art was diminishing, as was the effectiveness of the language that had served to convey this

sense of security. A total revision of the relationship of signs to meaning was called for.

Lines enclosing the forms of a static object had now to be dispensed with as the static image proved illusory and spatial relationships were known to be in constant flux. New signs from civilizations untouched by Renaissance conventions offered useful borrowings but in themselves proved insufficient. Cézanne's small discontinuous planes asserting the picture surface, schematic geometric graphic signs, surfaces alluding to texture, as well as word fragments and bits of *trompe-l'oeil*, were all brought together on a two-dimensional surface to describe in new terms—terms that involved thinking as much as seeing—the artist's experience of nature and space.

Less given to intellectualization than Picasso or Braque, Matisse nevertheless understood the predicament of his time. He too sought new pictorial signs by which to render his more sensual experience of nature.

In the work of all three artists at this time, there is a tendency to abstract from a given subject through a reduction to essentials of color or form, yet a residual reference to the physical world remains. The eye is led forward to the most frontal plane, the canvas surface, and no longer far into depth as in Renaissance painting. In Picasso and Braque the eye is kept from settling on that surface by contrasts of light and shade, and in Matisse by the spatial positioning of colors in relation to one another on the canvas surface. And in all three there appears a new consciousness of autonomous beauty to be found in the rhythmic arrangement of forms and colors. Many looking at their works were able to foresee that the future of art would reside in a totally abstract expression.

MOMENTS OF THE NEW IN PARIS,
c. 1912-1920 chapter 3

The Section d'Or and Postwar Purism
The Invention of *Papier Collé* and Collage
by Picasso, Braque and Gris
Foreigners and the French Avant-Garde
Summing Up

When, in 1914, the English critic Clive Bell defines the idea of "significant form," whereby forms in art contain their own meaning, he is echoing a point of view that has become increasingly accepted, as art, abandoning the realm of story-telling (realistic or symbolic), acquires a greater self-consciousness of its medium.

To find new and ambiguous relationships of signs to meaning is the endeavor of the French group of poets meeting at the Closerie des Lilas (of which Picasso is a member) around 1912. The sound of words, their rhythm, their disposition on the blank page, open a new field of investigation. By 1914 Apollinaire has published Calligrammes *(poems arranged like images on the page space); Max Jacob and Blaise Cendrars in France, the American Ezra Pound (soon to be joined by T.S.Eliot), the Italian Marinetti, the German Morgenstern and the Russian Kandinsky, and the Russian Futurists as well are all at work rejuvenating poetry. The significance of Gertrude Stein and of Raymond Roussel, who, as of 1910, introduced new genres and new formal techniques in writing, has still not been fully assessed even in our own day.*

Often using colloquial language, breaking up time, substituting psychological time for historical time, novelists from Proust to Kafka, Joyce and Virginia Woolf will enter the literary scene before 1920. Unlike many of the painters whose work the war interrupted, the writers who survive will indeed come out of it with major literary contributions, and even some of its victims (Alan Fournier, Rupert Brooke, etc.,) will leave valid traces of their brief careers.

49

The Section d'Or and Postwar Purism

Describing the twenty-eighth Salon des Indépendants in 1912, Guillaume Apollinaire noted that Picasso's influence was the most profound, while Matisse's seemed to have disappeared almost completely.[1] Lapidary as this statement was, and like most of Apollinaire's pronouncements only partially accurate, it did reflect the upsurge on the Paris art scene of a new avant-garde whose spectacular creations seemed far more indebted to Picasso than to Matisse. The alleged followers of Picasso were variously known as Cubists, Orphists, Tubists, etc.*

In the Paris suburb of Puteaux, the Cubists had begun meeting in 1911 at the studios of the three Duchamp brothers—Jacques Villon, Marcel Duchamp and Raymond Duchamp-Villon—sons of a Norman notary all of whose progeny became artists. Most of the Cubists had been formed under the influence of Divisionism or Fauvism, and Cubist theory with its frequent reference to color revealed such an ascendency. They compared, for example, the functioning of forms and color: "Form," one would read in *Du Cubisme*, published in December of 1912 and co-authored by the Puteaux painters Albert Gleizes (1881-1953) and Jean Metzinger (1883-1957), "appears endowed with properties identical with those of color. It can be tempered or augmented by contact with another form; it can be destroyed or emphasized; it is multiplied or it disappears."[2] For color equivalents of daylight they substituted form equivalents of bodies:

> The least intelligent will quickly recognize that the pretense of representing the weight of bodies and the time spent in enumerating their various aspects are as legitimate as imitating daylight by the collision of an orange and a blue.[3]

They agreed with Matisse that all plastic qualities guarantee a preliminary emotion, and admired the subtle way in which Cézanne handled unstable volume: Cézanne, they said, "prophesies that the study of primordial volume will open unknown horizons to us."[4] By calling their group exhibitions the Section d'Or (Golden Intersection), a reference to ideal proportions in the classical tradition, they signified their belief that through the scientific if not mathematical (rather than Matisse's intuitive) organization of pictorial means, they could arrive at absolute beauty in a work of art.

Not only were discussions at Puteaux often philosophical attempts to rationalize art, but also one of the participants, Marcel Duchamp, whose critical faculties would often manifest themselves through his art, pointed out in his own controversial *Nude Descending a Staircase* (1912) the weak-

* Also Synchromists, a group of expatriate American painters, including Morgan Russell, Stanton MacDonald-Wright and Patrick Bruce, between 1914 and 1919; Vorticists in England between 1914 and 1916, with Wyndham Lewis among others; Futurists in Italy.

nesses in some of his friends' contemporaneous creations. For unlike Picasso and Braque—or for that matter Cézanne, who had been careful to select mostly static subjects such as still lifes, landscapes and seated figures— several of the Puteaux Cubists quite frequently adapted the 1908-11 methods of Picasso and Braque to paintings of moving subjects, as did Gleizes in his *Harvest Threshing* (1912), Metzinger in his *Dancer in a Café* (1912) and Picabia in his *Procession at Seville* (1912). While Duchamp, however, included a kinetic element by showing successive aspects of figures moving in space, the fragmentation employed in the Metzinger and the Gleizes works hardly conveyed in a convincing manner the events described in the titles.

Furthermore, these artists did not make changes of subject matter commensurate with their changed forms, as Duchamp was somewhat facetiously doing by painting a nude descending a staircase as an articulated love machine. Duchamp's criticism went unheeded and was in fact most unwelcome. Some of the Puteaux group eventually reverted to traditional styles matching equally conservative subject matter; some continued to render traditional subjects in increasingly stylized and abstracted ways; some, like Jacques Villon and the Czech Frantisek Kupka, became known for their sensitive handling of abstract colored forms.

Nevertheless, within the Puteaux group there were artists who, like Duchamp, sensed the dangers and exploited the possibilities that the Cubist experiment had opened.

Fernand Léger (1881-1955), who had tested the possibilities of color and texture, now substituted "tubes" for "cubes" in *Nudes in a Landscape* (1909-11) and created a world of mechanically animated tree forms and robots in shades of cold grays and greens, images prophetic of astronauts working on the moon. In *Contrasts of Forms* (1913), he was to pack into his canvas tubular, cubical and conical metallic-looking parts in red, blue and yellow, highlighted in white, that seemed to clang and bang like industrial machinery, or like certain musical passages of Mussorgsky's *Boris Godunov*. Apollinaire, recognizing the rhythmic musical beat of Léger's abstract forms, would label him "Orphist" at that stage. More often than not, Léger was to put these forms at the service of representation. In *Houses among the Trees* (1914) they signified houses, trees and roofs. In his postwar production inspired by modern life, its machinery, technical prowess and "advertising panels . . . abruptly interfering with the landscape,"[5] Léger affirmed his belief that the expanded pictorial means must be used with the greatest possible logic to pay tribute to the realities of modern life, and relied on thick stylized lines often independent of color, and on simple, brightly colored forms either flat or shaded, compressed and held close to the picture surface, to achieve his aims.

Another participant in the Puteaux meetings was Robert Delaunay (1885-1941). Delaunay, whose 1912 creations were to be singled out by the

German avant-garde and the Italian Futurists, had begun as a Divisionist. He first applied Cubist multiple viewpoints to an immense object taken from the Paris landscape, the Eiffel Tower. In *Eiffel Tower* (1911), as one looks down to the distant roofs in the lower part of the painting, then up at the soaring spire, so tall that it is not contained whole within the canvas but seems to be tottering forward, one senses alternately dizziness, oppression, menace and awe. Neither the interaction of color nor of form alone permanently held Delaunay's attention, for his interest was in the refraction of light and eventually the movement of color.

Blaise Cendrars, a poet-friend of Delaunay's, explains[6] how Robert Delaunay's experiments with light began when, through a small hole drilled in a shutter, he let in a few rays of sunlight that he would study, decompose and analyze in terms of form and color; how he enlarged the hole and began painting the colors as they played on a transparent and fragile material such as glass; how he began introducing pulverized lapis lazuli and other precious stones into his palette; and how the hole in the shutter became so large that Delaunay finally opened it wide and allowed daylight to penetrate inside. Romantic as this description is, it does reflect the methodical investigation that Delaunay was then pursuing on a phenomenon hitherto reserved for scientists. In *Windows on the City* (1912), one of the resulting compositions, the image is seen as if through glass and a gauze curtain, flattened into a delicate color grid; the sense of nearness and distance is practically lost as if swiftly rotating blades had interposed themselves between the observer and the view. Very soon, Delaunay would study the movement of light alone, declaring that color was form and subject, would begin to "play with colors [simultaneously perceived] as one would express oneself in music through the fugue of colored fugued phrases."[7] He, too, was called an "Orphist" by the poet Guillaume Apollinaire. Images of colored disks and circular forms were to become constants of his *oeuvre*, their decorative possibilities being utilized in his murals of the 1930s for architectural projects, and in the textiles designed by his wife, Sonia Terk Delaunay.

Of the hosts at Puteaux, Marcel Duchamp (1887-1968) was to become the most notorious for his ever alert mind, and for his objects, so difficult to classify as either painting or sculpture.* Duchamp's early work had a Symbolist aura not to be found in that of his Puteaux friends. However, like Léger, Duchamp invented and painted new forms, such as those of *The Bride* (1912), which render their subject through strange allusions to human organs and to alchemists' vials. Like Delaunay, Duchamp was intrigued by

* *Etant Donnés*, his last work (1946-66), is a mixed-media assemblage comprising old wooden doors, bricks, velvet, wood, leather stretched over an armature of metal and other material, twigs, aluminum, iron, glass, Plexiglas, linoleum, cotton, electric lights, gas lamp, motor. At first only the wooden doors are seen, until a hole in the doors enables the viewer to peep inside and discover the nude figure lying in a landscape.

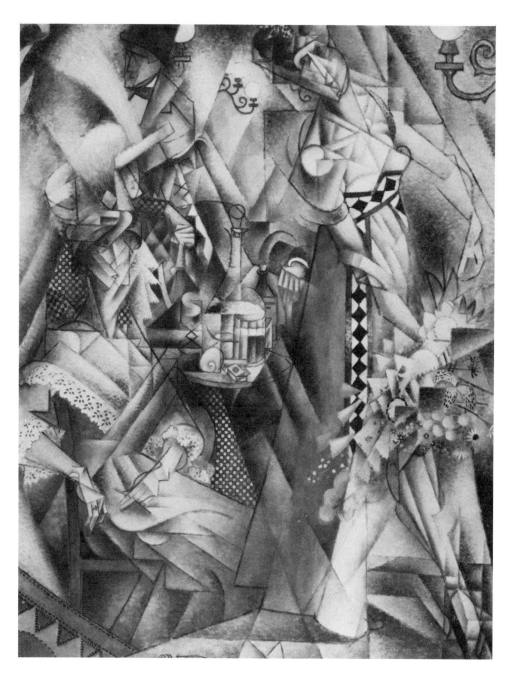

*"Form appears endowed with properties identical
with those of color." (Du Cubisme)*

Jean Metzinger, *Dancer in a Café*, 1912, oil on canvas.
Albright-Knox Art Gallery, Buffalo, New York. General Purchase Funds. 57 1/2 x 45″.

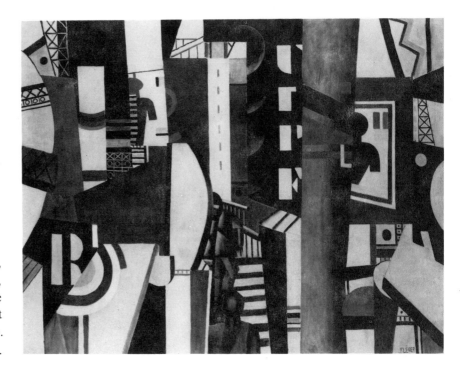

Léger affirmed his belief that the expanded pictorial means must be used with the greatest possible logic to pay tribute to the realities of modern life. . . .

Fernand Léger,
The City (*La Ville*),
1919, oil on canvas. The
Philadelphia Museum of Art
(A.E. Gallatin Collection).
90 3/4 x 117 1/4".

Delaunay would study the movement of light alone, declaring that color was form and subject. . . .

bottom left: Robert Delaunay, *Circular Forms*, 1930, oil on canvas. The Solomon R. Guggenheim Museum, New York. 50 3/4 x 76 3/4".

With this assisted Ready-made, Duchamp was, so to speak, cured of art as it was regarded in the formalist and rarefied atmosphere of Puteaux

bottom right: Marcel Duchamp, *Bicycle Wheel*, 1951 (third version after lost original of 1913), metal wheel, diameter 25 1/2", mounted on painted stool, 23 3/4" high. The Museum of Modern Art, New York (Gift of Sidney and Harriet Janis).

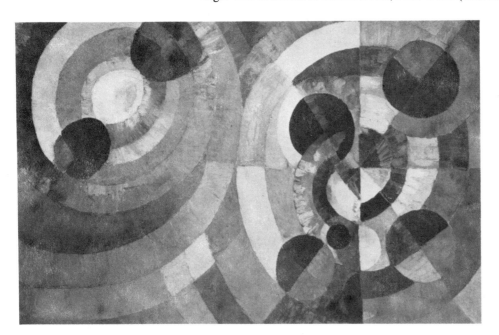
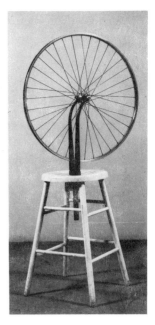

motion. Two versions of the *Nude Descending a Staircase* were painted in 1912, showing the influence of chronophotography; in 1913, he fastened a bicycle wheel to a stool for the idle purpose of watching something rotate. But with this "assisted Ready-made" Duchamp was, so to speak, cured of art as it was regarded in the formalist and rarefied atmosphere of Puteaux, and he would continue to use his art as a subversive tool, in turn to expose and to blur the boundaries between art and life (see chapter 6). His Ready-mades would include a bottle rack (1914) and a shovel (1915), which he humorously entitled *In Advance of the Broken Arm.*

The Spanish painter Juan Gris (1887-1927), a neighbor and close friend of Picasso since his arrival in Paris in 1906, also attended the meetings at Puteaux. He had not started as a colorist and owed his knowledge of painting to his compatriot, whom he watched closely and with whom he exchanged ideas while earning a living as an illustrator. In one of his early paintings, *Portrait of Picasso* (1911), he represented the artist as if parallel beams of light were falling diagonally on the crumpled cardboard effigy of his subject. In *The Clock* (1912), he conveyed the spatial disorientation and synthesis of aspects in a room by bringing together on the picture surface fragments of floor, ceiling, walls, drapery and other objects. But his most singular contribution would take place later as he joined Picasso and Braque in their last common adventure, the invention of collage and *papier collé.*

The Russian Alexander Archipenko (1887-1964) also participated in the Puteaux discussions and exhibited with the Section d'Or. Out of various materials, he invented sculptural equivalents for the new forms then being created in paintings and was to contribute open "sculpto-paintings," a new concept of wall reliefs. Another promising sculptor, Marcel Duchamp's brother Raymond Duchamp-Villon (1876-1918), did not survive the First World War.

The variety of images going under the name of Cubist, and the lack of agreement on what Cubism was, soon proved a strain on the cohesion of the Puteaux group. Marcel Duchamp was persuaded by his own brothers to withdraw *Nude Descending a Staircase No. II* from the group's showing at the 1912 Salon des Indépendants. Robert Delaunay participated in the first Section d'Or exhibition but abstained thereafter. Picasso and Braque never exhibited with the Puteaux group. The group's activities were to dwindle after 1913, and the First World War scattered its members far and wide, some to their deaths at the front.

In 1920, Albert Gleizes attempted to resuscitate the Section d'Or by organizing a Salon, but the mood of the times had changed and the effort was not repeated. *After Cubism*, published in 1918 (co-authored by Amédée Ozenfant and the budding architect-painter Le Corbusier, then known as E. Jeanneret), "The Cube is Falling Apart," a noted article written by Blaise Cendrars, *L'Esprit Nouveau* (The New Spirit), a periodical founded in

1920, all announced a new era. Commenting on the future of Cubism, Ozenfant and Le Corbusier were to write in 1925:

> [The Cubists] will end by achieving a real virtuosity in the play of forms and colors as well as a highly developed science of composition. On the whole, and in spite of personal co-efficients, one can detect a tendency which might be described metaphorically as a *tendency toward the crystal.*[8]

Purist theory, which now superseded the Cubist theories of the Section d'Or, while endorsing the search for ultimate beauty, was to attempt to carry the search beyond art to all of life through beautiful design, functional architecture and triumphant technology. Purist ideas found favor in France with several Section d'Or members, including Fernand Léger, and were echoed by the activities of a group of artists and architects in Holland, including the painter Mondrian, who called themselves de Stijl (the Style), as well as by the Constructivists in Russia and by the Bauhaus in Germany. However, no practical encouragement was given to these idealists anywhere except at the Bauhaus, and that only for a limited time. In Paris, the activities of the Cercle et Carré (Circle and Square), 1930, and of Abstraction-Création, 1931-36, would rally geometric abstract tendencies on an international scale with frequent exhibitions and a yearly publication, *Abstraction-Création* (1932-36).

The Invention of *Papier Collé* and Collage by Picasso, Braque and Gris

Just as Cubism was threatening to become a method of painting, a manner as slick and pervasive as Fauvism had been a few years earlier, in 1912, at the height of the Cubist epoch in Paris, Picasso, Braque and Gris broke new ground. Picasso completed *Still Life with Chair Caning*, in oil and overprinted oilcloth framed with rope; Braque inserted a piece of wallpaper into his drawing *Fruit Bowl and Glass*; while Juan Gris included a piece of mirror and paper in his painting *Washbasin.*

"I was looking for relief without *trompe-l'oeil*," said Braque to Jean Paulhan.[9] "People would say: 'You need only put in shadows!' but when I place a white paper on this blotter, I see it BEFORE the blotter." In his searching, he made paper sculpture (Picasso called him "*mon cher Vilbure*" because this reminded him of Wright and airplanes). Picasso too was searching. In early 1912—according to William Rubin[10]—Picasso fashioned a relief, *Guitar*, of sheet metal and wire, which did not offer a play of light and shade either on its face, consisting essentially of a few flat parallel sheets of cut and folded metal and parallel strings of wire, or on its sides when seen in strict profile. It was then just a matter of making "the sculpture enter the canvas"—to use Braque's words.[11] This the three artists did in close succession with scissors and paper.

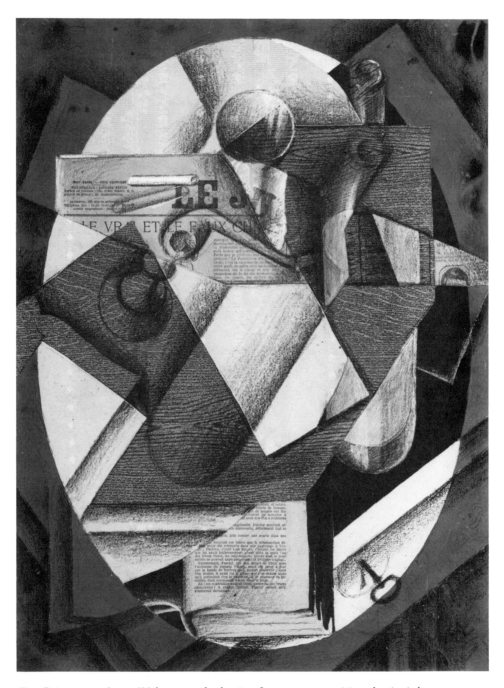

For Gris . . . papier collé *became the basis of a new compositional principle. . . .*

Juan Gris, *Still Life* (*The Table*), 1914, colored paper, printed matter, charcoal, gouache on canvas. The Philadelphia Museum of Art (A.E. Gallatin Collection). 23 1/2 x 17 1/2″.

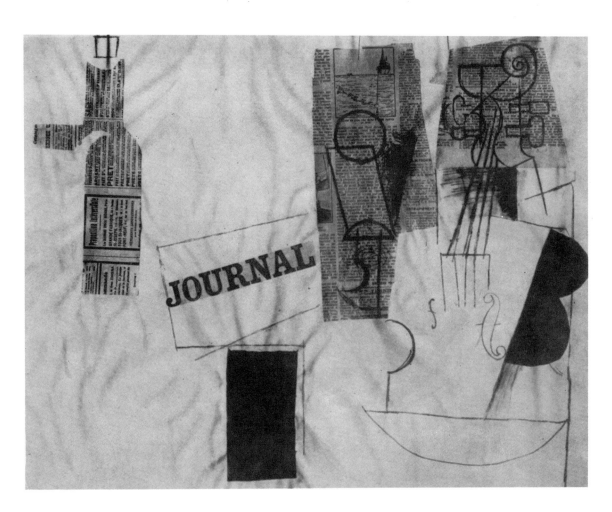

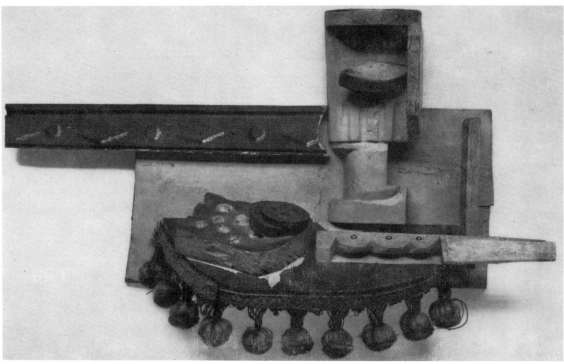

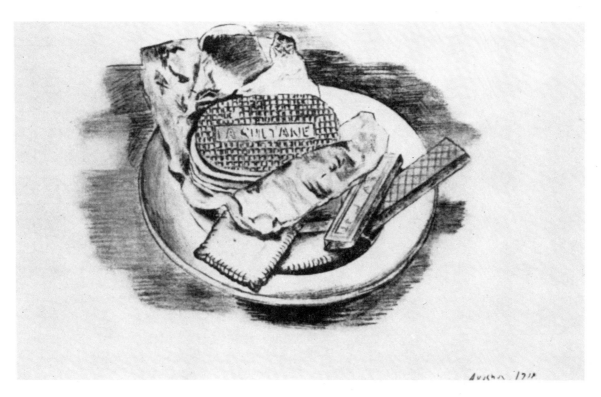

Picasso pointed out in visual riddles witty and unexpected connections between things. . . .

facing page, top: Picasso, *Bottle, Glass and Violin*, 1912-1913, *papier collé* and charcoal on paper. Moderna Museet, Stockholm. 18 1/2 x 24 5/8".

. . . the technique of assembling and construction was as new as the utilization in sculpture of humble subject matter. . . .

facing page, bottom: Picasso, *Still Life*, 1914, painted wood with upholstery fringe. Private collection, London. 18 7/8" wide.

Parts looked as if they had been copied from an advertisement for biscuits. . . .

top: Picasso, *Plate with Wafers*, 1914, pencil. Present owner unknown. 11 13/16 x 16".

The head looked as though it had been copied from a studio photograph. . . .

bottom: Picasso, *Max Jacob*, 1915, pencil. Private collection, Paris. 13 x 9 7/8".

Papiers collés were far more revolutionary than even Braque suspected. The position of planes in space could now be rendered by flat paper cutouts pasted next to or on top of one another on a flat surface, rather than by the former method of shading imaginary tilted planes. Also, with paper affixed over the canvas, the canvas itself was no longer the restricting, foremost plane of the picture. Color as well as tactility came back through the use of paper, as Braque could not help but note when he used brownish wallpaper imitating wood grain in his first mixed-media effort. Furthermore, paper and collage had more than formal properties. They could recall an object through a fragment of itself (the mirror), or allude to it by imitating its surface (oil cloth for chair caning, wallpaper for a wooden table).

Picasso, Braque and Gris used their discoveries in many ingenious ways. For Gris, who often covered most of the picture surface with pasted paper of different colors and texture, *papier collé* became the basis of a new compositional principle whereby the still-life motif was suggested by the juggling of pieces of flat materials until their arrangement evoked the desired effect. These materials would then be immobilized by glue, additional information would be supplied by drawing and by paint in such a way that it was extremely difficult to tell what was paint and what was collage (*The Table*, 1914). Braque, by juxtaposing only a few large flat shapes on a white paper ground, greatly simplified the structure of his works, aiming at a new formal ideal empirically realized by trial and error. Furthermore, in *Clarinet* of 1913 (private collection, New York), one of the collage elements, the long strip of wood-grained paper, combines allusions to the wooden surface of the table and to the elongated shape of the clarinet (also indicated in pencil).

But it was Picasso who apparently made the most versatile use of the new medium. In *Bottle, Glass and Violin* of 1912-13 (Moderna Museet, Stockholm), while newsprint is used compositionally—various forms being spaced out over the picture surface—it also serves to outline such shapes as the bottle shown in profile with a corkscrew-tip incision, but tells nothing of the color or texture of this object. In the same picture, a fragment of the front page of a newspaper serves to name another object, a newspaper, through the word JOURNAL, while indicating nothing of its content, and part of an inset illustration from a newspaper is found to have descriptive qualities (it can be read as a profiled section of a glass half-filled with liquid) different from those originally intended (the sea). In other words, Picasso first identified the various qualities and definitions of objects, their shape, color, texture, appearance from the top, the side, etc. He also investigated the evocative powers and resources of newsprint, or other collage materials.* These mental exercises resulted in new sets of metaphors: indeed,

* The Bauhaus teachers, especially Moholy-Nagy and Albers, were to make the analysis of materials the basis of their teaching (see chapter 8).

by discovering certain characteristics common to the objects and the collage elements, he pointed out in visual riddles witty and unexpected connections among things, some visually, some conceptually logical.

The use of collage was controversial, for it broke the accepted rule that each art had its own separate and inherent means (painting being done with paint on canvas). Yet its possibilities were to reverberate in many directions and have not been exhausted yet.

Picasso soon extended the working method involved in collage to three-dimensional creations and made "constructions" out of various materials—such as *Still Life* of 1914, in painted wood with upholstery fringe, and *Glass of Absinthe*, also of 1914, of painted bronze with a silver spoon—in which the technique of assembling and construction was as new as the utilization in sculpture of humble subject matter—food, glass on a table in one case, food, glass and utensil in the other. These "painted" sculptures represented yet another assault on tradition, given their disregard of the separate qualities of sculpture and painting.

Once they had begun using *papier collé*, Picasso, Braque and Gris combined it with its imitation in paint, sometimes mixed with sand and sawdust for texture. By so doing, they were causing the viewer to question the reliability of his perception, the ability of the eye to distinguish among several levels of illusion or by extension between illusion and reality.

But mixing collage and its imitation in paint had regressive aspects, for it reintroduced "imitation," although now restricted to two-dimensional images such as wallpaper but conceivably including posters or photographs. Picasso, in his *Plate of Wafers* (1914), parts of which look as if they had been copied from an advertisement for biscuits, and *Portrait of Max Jacob* (1915), in which the head looks as though it had been copied from a studio photograph, was perhaps alluding to this logical outcome of the Cubist adventure.

The deception involved in combining collage and its convincing imitation in paint had opened a Pandora's box and pointed to the artist's dilemma: whether to reach his audience through his virtuoso craftsmanship (like Picasso's acrobats) or despite his lack of it (like Picasso's wise if awkward jesters). No wonder the hybrid jester-acrobat, the harlequin, reappears time and again in Picasso's *oeuvre*.

The gradual deterioration of the Picasso-Braque partnership, which apparently began with the invention of *papier collé*, the ties that are said to have developed between Matisse and Juan Gris when they spent the summer together in southern France in 1914, as well as a comparison between Picasso's, Braque's and Gris's later works, reflect their diverging viewpoints. Braque and Gris show an unwillingness to abandon the realm of art for that of intellectual speculation, a reluctance to overstep the boundaries of art for

its own sake, and reveal a narcissistic fascination for process. Picasso's stylistic inconsistencies in the many productive years that were to follow his Cubist achievement perhaps answered his awareness of the multiplicity of styles (none being more "advanced" than another, from his point of view) from which he was now able to draw in order to express eternal verities.

Foreigners and the French Avant-Garde

The reputation of Paris as an art center was nothing new, and the interest stirred by the leaders of the French avant-garde overstepped national boundaries. Fauves and Cubists (at first lumped together under various epithets) were often exhibited abroad or at least talked about. They inspired, or confirmed in their convictions, artists in Russia, Germany and elsewhere. In New York, a mammoth display of contemporary European painting and sculpture was gathered at the Armory Show in 1913 and belatedly alerted American artists to conceptions far different from Impressionism or the realism of the Ashcan School, then still considered avant-garde in the United States. England would slowly awaken from its artistic somnolence, thanks to exhibitions of avant-garde art beginning in 1912.

In Italy, artists with varied talents such as Boccioni, both a painter and a sculptor, Russolo, a painter and composer (with noise machines) and several painter-poets who had gathered around the tumultuous Filippo Marinetti were in search of styles appropriate to their program, to translate the dynamism they sensed in an era of fast transport, moving pictures, mass production and new media. "We declare that the splendor of the world has been enriched by a new form of beauty, the beauty of speed," Marinetti said in the Futurist Manifesto, a text in which words and images spouted as from a machine gun.[12] (The manifesto appeared on the front page of the French newspaper *Figaro*, February 9, 1909—Marinetti spoke fluent French, had spent part of his youth in Paris and wrote poetry in French as well as in Italian—and did not fail to produce an impact on the French avant-garde).

We declare "that all subjects previously used must be swept aside in order to express our whirling life of steel or pride, of fever and of speed . . . that universal dynamism must be rendered in painting as a dynamic sensation . . . that movement and light destroy the materiality of bodies,"[13] one read in the Technical Manifesto of Futurism signed by five painters, Umberto Boccioni (1882-1916), Carlo Carrà (1881-1966), Luigi Russolo (1885-1947), Giacomo Balla (1871-1958) and Gino Severini (1883-1966). There were to be equally sweeping manifestoes on sculpture (Boccioni), music

(Pratella), architecture (Sant'Elia), poetry, photography, film and so on.

The Futurists arrived in Paris in the fall of 1911 and, guided by Gino Severini who had lived there from 1906 on, visited the Salon d'Automne, the ateliers of Picasso, Braque, Delaunay and probably others. Between their visit to Paris and their first Paris exhibition the following spring, several of them apparently made changes in their works, having found that there was more to indicating different times of day than simply juxtaposing on one canvas three descriptive vignettes (Balla's *Worker's Day*, 1904), that it was not enough to use a dragging brushstroke to suggest fleeting time, nor to agitate a picture surface by means of several diagonal guidelines to indicate disorderly motion (Boccioni, *Riot in the Gallery*, 1910). The confusion caused by fast-moving events, by partially apprehended images, by past, present and anticipatory sensations, could also be rendered by spatial disorientation and multiple viewpoints (Severini, *Dynamic Hieroglyphics of the Bal Tabarin*, 1912), by the repetition of forms as in chronophotography (Balla, *Dog on a Leash*, 1912), by the counterpoint of dry lines and sweeping undulating color masses (Boccioni, *States of Mind I: The Farewells*, 1911-12), by collage of newsprint with incomplete words and evocative sound messages (Carrà, *Patriotic Celebration*, 1914) or by new sculptural forms such as the bronze "wings" of Boccioni's powerful and singularly frightening demonic symbol of relentless motion and devouring power (*Unique Forms of Continuity in Space*, 1913).

In 1914, these glorifiers of danger and lovers of battle were to find in the spectacle of war their most appropriate imagery, but the war would soon take its toll among them. After the war, Marinetti was to make Futurism serve Fascist propaganda.

Nevertheless, the Futurists, committed in their art and in their daily life to breaking accepted codes—they traveled noisily through Europe, behaving like agents provocateurs—attracted so much attention that the pacifistic Dadaists and the political revolutionaries in Russia would seize on Futurist self-serving publicizing methods to attain very different goals.

In Holland, exhibitions of Cézanne, Picasso and Braque led one of that country's most promising artists, Piet Mondrian (1872-1944), to leave for Paris in the winter of 1911-12. Allegedly unable to choose between a religious and an artistic vocation (he came from a strict Calvinist background), Mondrian, from his earliest days as a painter, seems to have looked for means to express a religious state of being, an inner harmony. Painting damp moonlit landscapes with no particular movement had at first answered his needs. Theosophy, inspired by Far Eastern thought, had also influenced such works as *Red Tree* (1908?) with its strange flaming branches, and a triptych called *Evolution* (1911), showing three figures in various states of spiritual contemplation.

Picasso's Cubist works, which were to inspire some of Mondrian's

most intuitive works, such as *Trees in Bloom* (1912) and other paintings of trees and facades, were still materialistic visions of objects. Through the Cubist experience, Mondrian saw that if painting was to fulfill its spiritual purpose, he must deprive it of all sensual references, of objects, curves, diagonals, painterly brushwork, and eventually of the colors of nature (green in particular). The horizontal-vertical cross motif that was to structure his later works began to appear in his *Pier and Ocean Series* (1914), the image of pier and ocean reduced to an overall grid of plus and minus signs, in compositions with little rectangles and in "checkerboard" paintings. Eventually all the picture's elements participated separately, while being coordinated to give maximum tension to his surfaces—the square or diamond shape of the canvas left without a frame, the crisscrossing of the horizontal and vertical black lines that often repeated this shape, the juxtaposition of rectangles in blue, red, yellow, gray or black and their whitish intervals. In other words, the painting's structure (which in all paintings until then had been concealed for the sake of depicting objects) was now the painting's very subject.

Beginning around 1921, Mondrian's *Compositions* seemed to isolate a privileged moment of pure beauty and tenuous equilibrium, which any alteration in the relationship of colors, placement of line or change of scale would threaten and destroy. Seen with the advantage of time these so-called abstract paintings also allude to aerial views of modern cities, their streets crossing at right angles. But whether looked upon as "landscapes" or as complete abstractions, they convey the rhythm of twentieth-century life up to the point where all sense of order—even of a syncopated order—ceases to exist. Thus Mondrian's mature *oeuvre* appears as a pivotal moment in the history of twentieth-century painting, and of twentieth-century attitudes toward the meaning of "modern."

Caught in Holland during the war and isolated from his foreign contacts, Mondrian had nevertheless evolved toward ideals (in his country called Neoplasticism) comparable to those of the Purists in Paris, the Suprematist-Constructivists in Russia. In the review *De Stijl*, started in 1917, the theories of Neoplasticism were formulated by Mondrian and his friend Theo van Doesburg. In tune with Neoplastic ideas, several architects, including van Doesburg, J. J. P. Oud and Rietveld, conceived of a new type of building consisting of interlocking cubes with brightly colored outside walls for happy functional living, and of new type of angular furniture often painted in primary colors (the Rietveld armchair). Mondrian returned to Paris after the First World War, moved to New York in 1940 and died there in 1944.

A more earthy personality was the young sculptor from Rumania, Constantin Brancusi (1876-1957), who packed his clothes in a bundle and reached Paris in 1904 on the eve of the artistic revolutions in that city. Al-

though he held a diploma from the Bucharest School of Fine Arts, he prolonged his apprenticeship by enrolling in the Ecole des Beaux Arts, supporting himself by washing dishes in a restaurant. Brancusi's *Torment* (1907), a sculpture that revealed an affinity with Picasso's blue period, was selected for display at the Salon de la Société Nationale of 1907. The pathos of the suffering child was rendered not so much in the distant gaze of the adolescent as in the sensitive treatment of neck and shoulders. Friendships with such diverse personalities as the Douanier Rousseau, Matisse, Duchamp and Léger brought Brancusi into the orbit of the French avant-garde, beginning in 1908. By 1910-11, with a series of heads each called *Sleeping Muse*, Brancusi had left the nineteenth century and Romanticism, and was considered a full-fledged member of the avant-garde. Brancusi's *Sleeping Muse* in marble (1909-10), like the figures in Matisse's *Dance*, hovers at the edge of abstraction, an abstraction here reached by a formal simplification, a smoothing-out of the stone until the unitary egg form appears pure and whole, identified as human by a slight ridge for brow and nose, a depression for the eyes and the mouth, a rougher texture for the hair. Change the light that falls on the head, vary the material from marble to bronze, heighten or reduce the polish of the surfaces, place the cheek rather than the temples down on the base, and a new image emerges—a spiritual "icon," a sleeping head, an object of either reverence or humor.* Alternately idolized and forgotten, Brancusi spent the rest of his life in Paris, where he died in 1957.

Artists from Italy, Holland, Central Europe, Russia and the United States all made a pilgrimage to Paris. Some like the Russian Vladimir Tatlin stayed only a few days, others like the Americans Arthur Dove, Joseph Stella, John Marin and the German-American Lyonel Feininger stayed several months. The Italian de Chirico remained for many years, and some like Brancusi adopted France as their homeland.

In this last category was the Russian Marc Chagall (b. 1887), who arrived in Paris in 1910, returned home in 1914, and eventually settled in France. Although the themes of Chagall's *oeuvre* were apparently fixed before the artist arrived in Paris—themes connected with synthesized memories of his Jewish peasant youth, particularly those connected with the rituals of birth, death and marriage—once in Paris, Chagall's palette lightened and brightened and the expository tone of *Candles in the Street* (1908) with its fiddler on a roof, a woman wailing and a corpse lying in the street, gave way to a more complex plastic expression. In *I and the Village* (1911), memories of life in the village were now rendered through a composite multilayered image showing illogical scaling, floating figurative elements (a

* These variations on a given form anticipate Claes Oldenburg's works of the 1960s, works in which the change of materials from hard to soft, from black to white, also changes the mood suggested by the form.

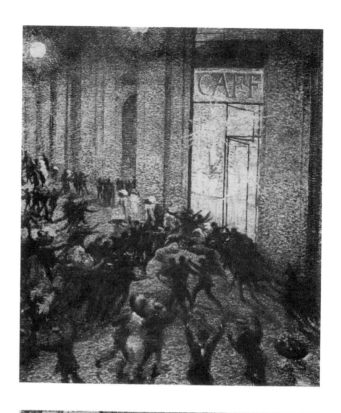

It was not enough to use a dragging brushstroke to suggest fleeting time nor to agitate a picture surface by means of several diagonal guidelines to indicate disorderly motion. . . .

Umberto Boccioni, *Riot in the Gallery*, 1910, oil on canvas. Private collection, Milan. 30 1/8 x 25 1/4″.

The confusion caused by fast moving events . . . could also be rendered by collage of newsprint with incomplete words and evocative sound messages. . . .

Carlo Carrà, *Manifesto for Intervention*, 1914, tempera and pasted papers. Private collection, Milan. 15 x 12″.

*The painting's structure . . .
was now the painting's
subject.*

Piet Mondrian,
*Composition with Red,
Yellow and Blue*,
1921, oil on canvas.
Gemeentemuseum, The Hague.
40 5/8 x 39 3 /8".

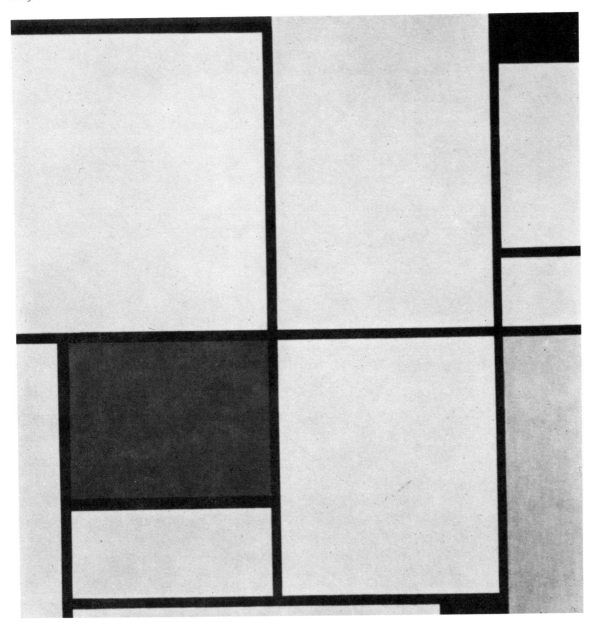

peasant woman is depicted upside down) and a disorienting, fragmented and transparent space.

Another permanent Russian expatriate, Chaim Soutine (1894-1943), who arrived in Paris in 1913, would also lighten his palette and borrow from current idioms—in his case, rather timidly from Cézanne—to imbue his still lifes and portraits in heavy impasto with the chaotic emotional impact that was to be his lifelong trademark. In Paris since 1908 was the Spaniard Julio González (1876-1942), then struggling to become a painter, who would explore iron welding and open-form sculpture with Picasso in the 1930s. Amedeo Modigliani (1884-1920) and Jules Pascin (1885-1930) were also among the foreigners who had moved to Paris permanently, and at the outbreak of the war were waiting for a consecration that would come but rarely in their lifetimes.

In 1920, Picasso (1881-1973) could no longer be seen in his blue working overalls taking a breath of fresh air with his friends in Montmartre's Place Ravignan. He had moved out of the Bateau Lavoir in 1912 and had since become rich and world-renowned. The Bateau Lavoir had ceased to be the meeting place of poets, and many of Picasso's poet-friends, no longer young nor poets, had settled for journalistic art criticism and apartments near Montparnasse. Apollinaire had died in 1918. A new generation of young poets and painters was noisily making its presence felt in Paris. They would come to be known as the Surrealists.

Summing Up

In 1912—five years after Picasso painted *Les Demoiselles d'Avignon*, five years after Cézanne had been granted a posthumous retrospective at the Paris Salon d'Automne, seven after Matisse first exhibited his *Woman with a Hat* and launched the Fauves—the forces of these events had reached a culmination, in the light of which, in Paris and abroad, avant-garde artists were re-evaluating their past accomplishments. Art seemed on the brink of redefinition as well as revolution.

In the work of some artists, only style changed while their subjects remained in the old tradition. In others, the change of style was linked to new subjects, the sensations of a modern industrial age, the bustle of city life (rather than the rustling of trees in a placid landscape), the confusion of states of mind, the poetic yearning of the spirit.

Others, basing their ideas on Kantian esthetics, on art-for-art's-sake theories and on their appreciation of the increasingly abstract appearance of painting from Cézanne to Matisse, Braque and Picasso, decided that the function of art was not to represent the physical world but to create a beauty of its own. Form and color were now believed to have their own

expressive power, like sounds, musical harmonies, words. By entitling works "compositions," these artists were to frustrate the viewer's tendency to associate by means of a descriptive title an image in the physical world with what appeared on the picture surface.

When Picasso and Braque, joined by Gris, invented collage, they broke through another convention of Renaissance space (chiaroscuro), while reinstating the representational function of art by new equivalents.

Marcel Duchamp in his Ready-mades (which can be thought of as collage without a support) possibly came closest to understanding the meaning of the Cubist adventure from beginning to end by pointing out that there are other connections besides visual ones between signifiers and the signified (to use the linguistic terminology of de Saussure), and by showing that style was not something that evolved historically through art forms but rather marks a society at any given time even in its most banal productions. He, too, was giving art a new function, one that he called art in the service of the mind.

THE NEW ART OF GERMANY,
c. 1896-1914

Kandinsky and Klee in Munich: Artistic Beginnings
Groping Toward a New Expression
Die Brücke and *Der Blaue Reiter*
Summing Up

At the turn of the century, the German empire is a young state dominated by a conservative aristocracy. The artist, frequently at the service of a local princeling hostile to foreign influences, is asked to decorate public places with murals and sculpture acceptable to public taste, and therefore tends to work within a narrow academic tradition. Timidly defying academic art are artists' associations called "Secessions" that spring up in the 1890s, led by progressive elements within academic circles. Munich, Weimar, Dresden and Berlin are the rival capitals of art, music and literature. But it is the Bavarian city of Munich, with its quaint houses and Baroque churches, that seems to have a particularly romantic appeal. The survival of medieval pageantry, Oktoberfest, Faschings, *masked balls and street-reveling contribute to an atmosphere of unreality that causes Wassily Kandinsky to exclaim, "[I] felt that I was in a city of art, which was the same to me as a city of fairies."*[1]

Kandinsky and Klee in Munich: Artistic Beginnings

Wassily Kandinsky (1866-1944) was thirty when, abandoning his native land, Russia, and declining the offer of a professorship in law and economics at Dorpat University, he descended on Munich in 1896 with the firm intention of becoming a painter. Multilingual, well-to-do, a worldly eclectic with a social consciousness evinced by his sympathy for the Russian peasantry, he was to impress those he met with his quiet self-confidence and single-mindedness.

For Paul Klee (1879-1940), only nineteen, and barely graduated from high school in 1898, going to Munich from his native Bern (Switzerland) meant "I had first of all to become a man"—as he tells in his diaries. "Art would then follow inevitably. . . ." (66)* Young Klee, who seems to have attracted more attention in school by his clever doodling than by his scholarly achievements (although his sister insists that he was always fascinated by the natural sciences), became an avid explorer of Munich. Sights, theater, concerts and girls at first claimed his attention as much as art.

The ambition of young artists in Munich would seem to have been to become pupils of Franz von Stuck, whose famous students were later to include de Chirico between 1909 and 1910, and Albers in 1919. "Franz Stuck was the foremost draughtsman in Germany," Kandinsky relates in *Reminiscences*.[3] In a more desultory manner, Klee admits that "to be a student of Stuck sounded good" (122).

Franz von Stuck, the co-founder of a powerful artists' society, the Munich Secession, and a teacher at the Munich Academy, thus unintentionally became an early critic of two of the most prophetic artists of the twentieth century. He called some of Klee's illustrations "original" (122). "Expressive," he told Kandinsky at their second meeting. (Kandinsky had been sent home for further study the first time because "everything [was] rather distorted."[4] In their writings, both Kandinsky and Klee speak of the limitations of Stuck's teaching.† According to Stuck, nature was something to be embellished, transformed into figurative allegories. A graceful arabesque style, derived from Jugendstil (as Art Nouveau was called in Germany), was to render this heavily charged imagery.

Stuck warned his students against the excesses of color, advised them to paint in black and white in order to study form alone. For Klee, who had a talent for caricature (*Two Men Bowing to Each Other, Each Presuming the Other to Be of Higher Rank*, 1903) but who was unsure of himself in the handling of color, not much could be gleaned. Kandinsky learned not to work "too nervously," to avoid "plucking out" at the start the most interesting part of the picture, ‡ but received no help in going further with color, for which he had an innate sense based, as he tells us, on his love for the richly painted folk artifacts (icons, popular cartoons) of his native Russia.

Disaffection with Stuck was followed for Klee by a period of confusion, a time when his many talents (he was an accomplished violinist, wrote poet-

* The numbers in parenthesis refer to entries in Paul Klee's *Diaries* (University of California Press, 1968).[2]

† Knirr, under whom Klee studied before going to Stuck, may have been a more inspiring teacher. "At Knirr's they rightly spoke about the presentation of a picture, by which they meant . . . the expressive motions of the brush, the genesis of the effect." (640)

‡ Kandinsky claims to have enjoyed perfect recall, something he fought against in his search for nonfigurative expression.

ry and dabbled in sculpture) occupied him in turn. The systematic exploration of the past, first at the famous Pinakothek and in other Munich museums, then for almost a year in Italy (1901-2), helped him to decant the serviceable from the unusable past. He discovered, for example, his preference for "sculptures in a naive style" over the more elaborate Baroque (290). He also began to understand by the intermediary of Italian architecture the structural elements common to all the plastic arts (429). (His *Diaries* contain a number of sketches; entry 309 shows the plan of a basilica.) When, upon his return from Italy, Klee definitely opted for a career in painting, he began a series of etchings (of which only seventeen were completed between 1901 and 1906), then did a number of paintings on glass (such as *Street with a Carriage*, 1907, emphasizing the cold light and silence of a clear snowy day), and little by little taught himself the specifics of various materials. *A Portrait of the Artist at the Window* (1909) is done in ink wash and colored chalk.

Kandinsky, after a year under Stuck, founded his own school and art association, "The Phalanx" (1901-4), which apparently attracted little attention although Kandinsky daringly exhibited pictures by the French and Belgian Divisionists. He too traveled (between 1901 and 1908) to Holland, Italy and France, looking for new ways of handling color, and stopping a few months during the fall of 1906 in Paris, where he found that his paintings were attuned to the Fauve sensibility prevailing in Paris art circles and at the Salon d'Automne. Kandinsky had already sent pictures to the Salon d'Automne in 1904 and 1905; in 1905 he was elected a member of the jury and in 1906 won the Grand Prix. (At the 1906 Salon he showed *Sunday, A Small Park, Stormy Evening, Friends, Italian Port, Sadness, Caravan, A Feast, Autumn, Parc de Saint-Cloud, Lion Tamer.*[5])

Kandinsky also spent many holidays in Murnau, a village near Munich, which he painted under various aspects, shadowless, with increasing simplification, in naive perspective, eventually dividing his canvas surface into painterly areas, in bright colors arbitrarily used to give rhythm, depth and light to the works rather than to fulfill descriptive functions (*Street in Murnau*, 1908).

By 1909, while Kandinsky had achieved renown as a "pseudo Fauve" in Paris, Germany and Russia,* Paul Klee was still struggling for a one-man show. The museum of his native Bern finally gave him an exhibition in 1910, consisting of fifty-six works, mostly sight notations in watercolor, pen, pencil and charcoal. Although tentative, they revealed his curiosity about medium, his willful naiveté and his ability to transform the banal into a secretive, intimate experience. Klee's *Diaries* include (880) a list of the

* He was regularly exhibited in Moscow, Saint Petersburg and Odessa beginning in 1902, and also sent pictures to various German exhibitions.

works in this show, with their selling prices and the artist's parenthetical comments.

German conservatism in the visual arts at the turn of the century is counter-balanced in other cultural realms: the Munich Opera House offers Wagner, Richard Strauss, Berlioz, César Franck. In 1913, "even Schönberg is being performed" (Klee, 916). The plays of Strindberg (". . . the characters are not so much real individuals as symbols for the self or the various selves of the author"—Klee, 557) are read if not often produced. Books are cheap. Nietzsche's essays glorifying the self, Freud's investigations, Steiner's anthroposophical writings, Dostoevsky's novels, are beginning to be dis-cussed by the intellectual élite. Professors at the university lecture on the music of colors (Herman Bahr), on the psychic effect of organized lines (Theodor Lipps). In 1908, a university student, Wilhelm Worringer, pub-lishes his thesis, Abstraction and Empathy, *a reformulation of art history in terms of the artists' "will to form," distinguishing periods of empathy when man and nature are in tune and art is imitative from periods of abstraction when man and nature are in disharmony. Theories of artistic form, empha-sizing the autonomy of the picture plane, by the German painter Ferdinand Hodler and the French painter Maurice Denis, as well as Signac's Division-ist theories of color, become well known. The Expressionist distortions found in the work of Grünewald (1470-1528) of El Greco (1540-1614), of Edvard Munch (1863-1944) and of Van Gogh (1853-1890), become positive qualities, and these artists are re-evaluated.*

Groping Toward a New Expression

Between 1910 and 1911 Kandinsky's work began to show turmoil and upheaval; the earth seemed to shake under the wildly listing trees, houses and church towers depicted in his landscapes. Probably in 1911 (the date is disputed among scholars), Kandinsky painted a strange little watercolor consisting of a loosely structured but dynamic arrangement of soft multi-colored patches and wiggly black lines. "Very curious paintings," Paul Klee noted in his *Diaries*, referring to such "nonobjective pictures without subject by this Russian" (903; Autumn 1911). Iconographic studies based on Kandinsky's drawings and glass paintings have gradually revealed the sources of these nonobjective works, and Kandinsky himself later distin-guished between nonobjective and purely abstract paintings. There are sug-gestions of amoebas and other microscopic water creatures in his earliest so-called abstract watercolor (Collection Mme. Nina Kandinsky).

Between 1910 and 1911, Kandinsky's work began to show turmoil and upheaval, the earth seemed to shake under the wildly listing trees, houses and church towers depicted in his landscapes.

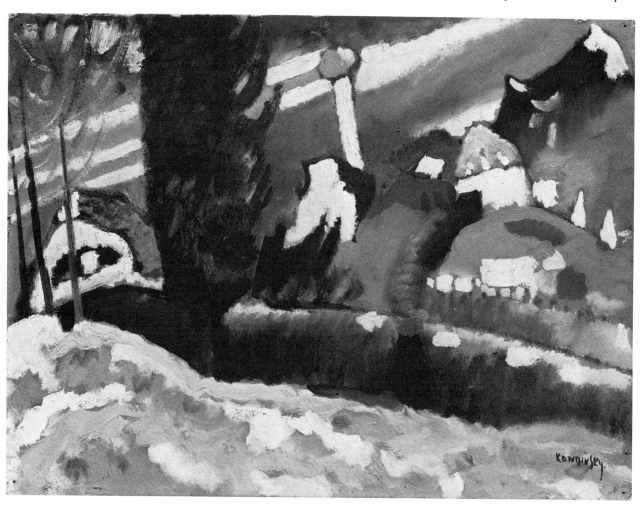

Kandinsky, *Winter Study with Church*, 1911, oil on board. The Solomon R. Guggenheim Museum, New York. 13 x 17 1/2".

In 1914, Klee brought back from a visit to Tunisia a number of delicate watercolors, in which the white village of Hammamet was transposed into a loose rectangular grid, a flat patchwork counterpoint of color and light. In the interval, Klee had met Kandinsky, surmounted his initial distrust of him, and like the older artist stepped into the twentieth century with a cryptic and controversial art.

Although Klee and Kandinsky had once studied under Stuck during the same period and had lived at times only a few doors from each other in Munich, they were not to meet formally until the fall of 1911. Thus at first they separately sorted out for themselves the ideas of their contemporaries and near-contemporaries as they groped toward a revolutionary new expression. Yet, to read the two contemporaneous documents already alluded to, Kandinsky's *Reminiscences* and Klee's *Diaries* between 1900 and 1911, is not only to unearth the keys to their artistic development but also to observe in men of different temperaments a closeness of thought and awareness that the following excerpts can only hint at:

On the beautiful subject: Kandinsky (*Reminiscences*, p. 37): "I soon found [while drawing from a model] that every head, no matter how ugly it seems in the beginning, is a perfected beauty." Klee (733): "As if only the beautiful subject were acceptable in art! The beautiful, which is perhaps inseparable from art, is not after all tied to the subject, but to the pictorial representation."

On the relationship of painting to nature: Kandinsky (p. 35): "Ten looks at the canvas, one at the palette, a half at nature, thus I learned to battle with the canvas, to come to know it as a being resisting my wish (= dream), and to bend it forcibly to this wish." Klee (873): "To adapt oneself to the content of the paint box is more important than nature and its study. I must some day be able to improvise freely on the chromatic keyboard of the rows of watercolor cups."

On taking liberties with traditional exigencies: Kandinsky (p. 41): "Gradually I became conscious of my earlier feeling of freedom, and the secondary demands that I made of art eventually disappeared." Klee (294): "I have now reached the point where I can look over the great art of antiquity and its Renaissance. But, for myself, I cannot find any artistic connection with our own times. And to want to create something outside of one's own age strikes me as suspect."

The one exigency left: Kandinsky (p. 41): ". . . a single demand: the demand of *inner* life in the painting." Klee (136): "Some will not recognize the truthfulness of my mirror. Let them remember that I am not here to reflect the surface (that can be done by the photographic plate), but must penetrate inside. My mirror probes down to the heart."

Their experiences also followed parallel lines, as revealed by the following:

Having felt inside the picture: Kandinsky (p. 31): "When I finally entered the room [he is recalling a visit to a farmhouse in a remote part of Russia when he was overcome by the unexpected picture of the table, benches, large oven, wardrobes and every article brightly decorated] I felt myself surrounded on all sides by painting into which I had thus penetrated." Klee (425): "I force the third dimension into the flat plane. Disposition of the arms, paired legs, absence of foreshortening. I even dream about it. I dream of myself. I dream that I become my model. Projected self. Upon awakening, I realize the truth of it. I lie in a complicated position, but flat, attached to the linen surface. I am my style."

Having found a relationship between visual art and music: Kandinsky (p. 26): "I saw all my colors in my mind's eye. [He recalls an evening at the opera watching Wagner's Lohengrin.] . . . Wild almost mad lines drew themselves before me. I did not dare use the expression that Wagner had painted 'my hour' musically." Klee (640): "More and more parallels between music and graphic art force themselves upon my consciousness. Yet no analysis is successful."

Discovering that form can lead instantaneously to feeling: Kandinsky (p. 32): "I suddenly saw an indescribably beautiful picture drenched with an inner glowing [he has returned home at dusk]. At first I hesitated, then I rushed toward this mysterious picture, of which I saw nothing but forms and colors, and whose content was incomprehensible. . . . It was a picture I had painted, leaning against the wall, standing on its side." Klee (822): "Genesis of a work: 1. Draw strictly from nature, possibly using a telescope. 2. Turn no. 1 upside down and emphasize the main lines according to your feeling. 3. Return the drawing paper to its initial position and bring 1 = nature and 2 = picture into harmony."*

Defining the role of an artist: Kandinsky (p. 35): "The creation of works of art is the creation of the world.

"Thus these sensations of colors on the palette (and also inside the tubes, which resemble humans spiritually powerful but unassuming in appearance, who suddenly in time of need reveal and bring to bear their hitherto concealed powers) became experiences of the soul."† Klee (895): "All the things an artist must be: poet, explorer of nature, philosopher!"

Reminiscences was published in 1913. Very concise, messianic in tone, it sifts out of the artist's experience only the elements that can help the reader share his gradual discovery of an art capable of expressing directly

* By taking this last step Klee, of course, distinguishes himself from Kandinsky at that stage.

† A posthumous showing of Kandinsky's paintings in 1945 at the (Guggenheim) Museum of Non-objective Painting, and the accompanying catalogue with the English translation of *Reminiscences*, are said to have given a boost to the development of Action Painting in America.

without recourse to naturalistic images "the revelation of the spirit." Prior to this text, another essay by Kandinsky, *Concerning the Spiritual in Art*,[6] had appeared in conjunction with the artist's first exhibition of paintings with such musical titles as *Improvisations* and *Compositions*, at the Thannhauser Gallery in Munich, in December of 1911.

Klee's *Diaries* continue until 1918. Published by his son Felix in 1957 long after the artist's death, they are a day-to-day record of discoveries and retractions, of steps forward and back, of hope and discouragement. They deal with his search for a new expression (his *Creative Credo*,[7] which begins, "Art does not copy the visible, but renders visible," appeared later in 1920), with his entire cultural assimilation—which by any standard looks gargantuan—and with various aspects of his personal life.

Thus we learn of his first meeting with Kandinsky in the fall of 1911, in a Munich café, and how, prior to their meeting, a mutual collector-friend used to take along works by one to show the other. We sense Klee's misgivings toward these "nonobjective pictures without subject," along with his empathy for the man with "an exceptionally fine, clear mind." We perceive Klee's reluctance to embark on Kandinsky's daring course: "Personal acquaintance has given me a somewhat deeper confidence in him." We guess the meeting of minds that must have taken place as the two agreed to meet more often, and are told that Kandinsky broached to Klee the subject of organizing a new society of artists, the future Blue Rider (*Blaue Reiter*). (903).

Awareness of artistic developments abroad increases over the years, to the extent that in 1911 a German painter named Vinnen can accuse German museums of being partial to modern French art. Responsible for this change are such museum heads as Von Tschudi (Berlin, Munich), Von Kessler (Weimar), Osthaus (Folkwang Museum), who introduce Van Gogh, Cézanne, Gauguin, Rodin, etc., to the German public around 1903. Also responsible are critics such as Meier-Graefe, an editor of the satirical review Pan *and author of studies on Manet and Impressionism (1902) and of an anthology of modern art (1903), as well as Wilhelm Uhde and Daniel-Henry Kahnweiler, who write on the Fauves and the Cubists from Paris. Then there are the art dealers, such as—in Berlin—Cassirer (who shows Cézanne in 1904, Matisse in 1907, the Futurists in 1912), Walden's* Der Sturm *(which shows Delaunay in 1913), and—in Munich—Goltz (who shows Cézanne and Matisse in 1909 and whose gallery is open to a succession of art groups). The ground is also broken by traveling artists; Kandinsky's friend Von Jawlensky attends Matisse's art school in 1908. Delaunay visits Germany with Apollinaire in 1913.*

Die Brücke and *Der Blaue Reiter*

Because of the refusal of the salons to exhibit works that showed deviations from strict academic styles, many artists in Germany and Austria, starting in the 1890s, grouped themselves into artists' societies or "Secessions." Sometimes they had their own rooms in the halls of the official salons, and occasionally foreign artists were included. Munich, Berlin, Vienna and other cities had their own "Secessions," each characterized by the tastes of its founders*—a linear arabesque style in Munich and Vienna, a colorist and Impressionist one in Berlin. Powerful as they became, these societies tended in their turn to be stultified and rejected artists who were considered too individualistic. Klee was often refused; Kandinsky was welcomed into the Berlin Secession more easily than into the Munich group. As a result, dissident groups were also formed.

In Dresden, Ernst Ludwig Kirchner (1880-1938), Karl Schmidt-Rottluff (b. 1884) and Erich Heckel (1883-1970), who had become friends while attending the same technical institute, founded the Bridge (*Die Brücke*) in 1905 and later were joined by Emil Nolde (1867-1956) and Max Pechstein (1881-1955). Acquainted with tribal art of Africa and Oceania through the collections of the Dresden Ethnological Museum, familiar with anonymous and neglected woodcuts of the sixteenth century, they sought in their life as well as in their art to regain the freshness and spontaneity of these spiritual forebears. They revived handicraft techniques and experimented freely with woodcuts, etchings and lithographs. In 1910, they moved from Dresden to Berlin, but found that their paintings, combining a Fauve brutality of color and a harshness of line bordering on caricature, were highly controversial. Rejected by the Berlin Secession, which continued to endorse Impressionistic styles and accused them of being "Expressionists," the Bridge members founded their own group, calling it the New Berlin Secession.

This new group functioned for only two years, but was the rockbed of so-called Expressionism in painting and sculpture. In Berlin, all avant-garde artists, including Fauves and Cubists, became known as "Expressionists" at first. (Stylistically heterogeneous, "Expressionism" was eventually the label applied indiscriminately to pictures with social commentary, particularly in pre-Nazi Germany, in Mexico, and the United States during the Depression, as well as to the sensuous painterly surfaces of Soutine's works, which have little narrative content and, later, to the "Cobra" group.)

Meanwhile, in Munich in 1909, Kandinsky and his protégée Gabriele Münter created the New Artists Association, along with another Russian painter, Alexei von Jawlensky (1864-1941). Their first exhibition, in De-

* Gustav Klimt in Vienna, Max Liebermann in Berlin and Fritz von Stuck in Munich.

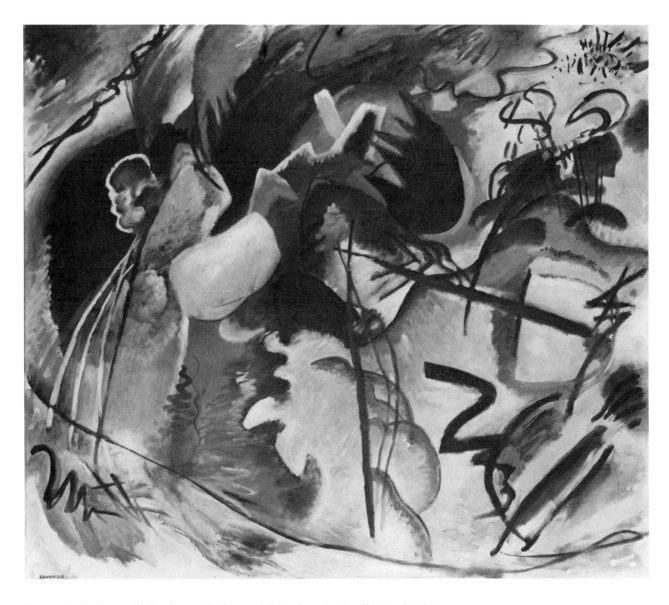

". . . a single demand, the demand of inner life in the painting." (Kandinsky)

Kandinsky, *Painting with White Form, No. 166*, 1913, oil on canvas. The Solomon
R. Guggenheim Museum, New York. 47 3/8 x 55 1/8".

cember of that year, comprised mostly young German artists of Expressionist tendencies, but their second show was notable because for the first time several young French (and Russian) contemporaries—among them Picasso (a 1909 *Head of a Woman*) and Braque (several Cubist landscapes) —were being exhibited in a German city.

As the group enlarged, Kandinsky, under pressure, gave up the chairmanship, and then was eased out of the Association. The reason given was that Kandinsky's work for the third exhibition had "the wrong dimensions." In fact, his work and ideas were becoming too controversial, his sympathy for foreign artists too obvious. A painter who had joined the group in 1910, Franz Marc (1880-1916), appalled by the narrow-minded attacks to which Kandinsky was subjected, resigned, and with Kandinsky started yet another artists' association, the *Blaue Reiter* (Blue Rider), in the late fall of 1911. Unlike the previous groups in which Kandinsky had participated, the Blue Rider grew in strength and scope, and only the advent of the First World War was to disperse its members.

The name "Blue Rider," which Kandinsky and Marc had chosen in a seemingly offhand manner, because Marc had just completed a picture called *Blue Horses*, was in fact replete with meanings for Kandinsky. Riders, as knights, crusaders, mythological heroes, had appeared in his pictures from the time he had begun to paint, and lingered on consciously or not in some of his so-called abstract works. The troika or horse-drawn sled is an integral part of the Russian scenery, while Romanticism associates the armored knight with the ideal savior. Furthermore, Marinetti's Futurist Manifesto was then firing artists all over Europe with ideas of a new art that would translate the modern world of movement and speed. In *Reminiscences*, Kandinsky had likened the process of creation to the relationship between horse and rider in these terms: "The horse bears the rider with strength and rapidity but the rider guides the horse. . . ."[8] As for the color blue, Kandinsky in his 1912 text, *Concerning the Spiritual in Art*, would try to demonstrate that blue was the color of spirituality. Today such symbolism is regarded with skepticism; Kandinsky was apparently going through a mystic phase at the time.

Forty-three works were presented under the banner of the Blue Rider at Thannhauser's Munich gallery in December of 1911. Kandinsky, introducing the show, insisted on the nonprogrammatic aims of his group when he said in the catalogue:

> In this show we are not trying to propagate one precise and specific form, but we do hope to illustrate, by the variety of forms represented, how the artist's inner wish may be variously embodied.

Kandinsky was represented by three groups of works ranging from impulsive notations or *Improvisations*, to *Impressions*, to the more elaborate *Com-*

"... I am not here to reflect the surface. . . .
My mirror probes down to the heart." (Klee)

Paul Klee, *Young Girl with Jugs*, 1910,
oil on cardboard. Felix Klee Collection,
Bern. 13 1/2 x 10 5/8".

positions. Improvisation 22 was characterized by the concentration of pain-terly activity in the top right. *Impression Moscow* had houses seen as in a flash of recall through the mind's eye. *Composition V*, dominated by a rib-bony whiplike line of unfathomable scale, brooding over a chaotic array of color patches and broken graphic design, gave the viewer the feeling of no longer looking through a window but into an indefinite and disorienting space simultaneously microscopic and celestial. (Disorientation will be total in Kandinsky's 1913 paintings such as *Painting with White Form, No. 166.*) Marc's *Blue Horses*, a rhythmic pattern of massive blue horses' heads and rumps silhouetted against an arc of green and red hills, and abstract-looking works by August Macke (1887-1914) and other founders of the Blue Rider, were also on view.

But the Blue Rider's first exhibition was more than a bringing together of some of the most advanced German artists on a large scale in a reputable gallery, and a confrontation with foreign artists (the Frenchman Robert De-launay, who sent an *Eiffel Tower* (1911) and possibly a *Window*, and the Douanier Rousseau were particularly noted). It was massive evidence of the spirit of artistic change that was sweeping the Western world.

The new spirit that breathed through the exhibition did not escape Paul Klee, who had at first been reluctant to participate in Kandinsky's Blue Rider and was not included in its first exhibition. Now he hailed "those who are working toward the impending reformation" (905), a reformation that he read as the return to primitive beginnings, to an uncorrupted vision akin to that of children and the insane, the very expression that can be found in his own work at that time, such as *Young Girl with Jugs* (1910), naively drawn and with a strange side glance, and the sticklike elongated human shapes of his *Candide* etchings of 1911. In early 1912, Klee went on a whirl-wind tour of the Paris art scene in the course of which he met Robert Delaunay and saw works by Picasso, Braque, Matisse and other Paris in-novators. Before the end of the winter of 1912, Klee had joined Kandinsky's Blue Rider.

Blue Rider shows traveled through German cities, inaugurated the Sturm Gallery in Berlin, which was to become an international center of avant-garde activity, and acquired new participants. It was Kandinsky's am-bition for the Blue Rider to be not only an association for the exhibition of painting and sculpture but also a forum of avant-garde thinking. To that ef-fect, Marc and Kandinsky were planning a yearly almanac with essays by artists on art, poets on poetry, composers on music, through which the unifying forces among the various aspects of contemporary painting, among all art forms and, eventually, between art and science would become appar-ent. Only the first number of the Blue Rider Almanac appeared. It con-tained Kandinsky's first work for the stage, *Yellow Sound*, a kind of total spectacle that incorporated sound, color and movement, and it also con-

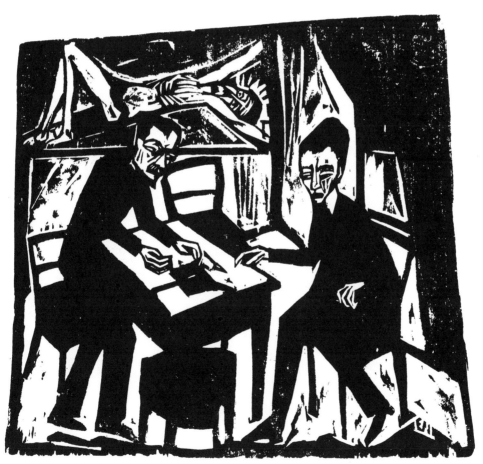

Erich Heckel, *Scene from Dostoevsky*, 1912. Woodcut.

tained musical lines by the three composers of the New Viennese School, Arnold Schönberg, Alban Berg and Anton Webern. (Kandinsky had apparently met Schönberg in 1911 at a time when the composer was beginning to emerge as the theoretician of twelve-tone music, a music that dispensed with key notations altogether, as radical a step as Kandinsky's own abandonment of naturalistic references in painting.) Thanks to the Blue Rider's multifold activities, Germany was becoming an international center of creative thought. Beginning in 1913, Berlin even had its own Salon d'Automne.

In 1914 the war broke out. Kandinsky left Munich for Switzerland and then returned to Russia by way of Norway, barely completing four panels for Edwin Campbell, a New York collector. Klee went from the ecstasy of having finally mastered color during a revelatory trip to Tunisia—"Color and I are one. I am a painter" (926-o)—to the somber realization of what war meant: "The whole business had as much sense to it as a wad of dung on a shoe heel" (956). In 1916 he was called up by the German army. Two Blue Rider founders, Marc and Macke, fell at the front. Kandinsky and

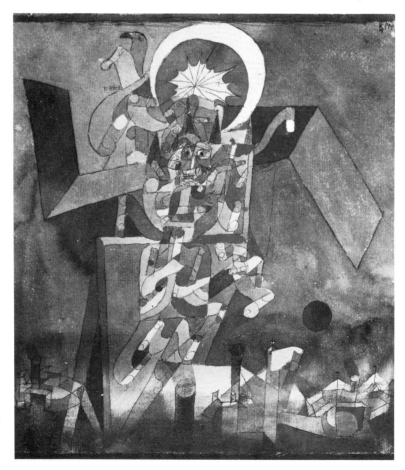

Klee's poetic fantasies were frequently hailed as preludes to Surrealism.

Paul Klee, *Demon above the Ships*, 1916, watercolor, pen and ink. The Museum of Modern Art, New York (Lillie P. Bliss Bequest). 9 x 7 7/8".

Klee were not to see each other again until the early 1920s, at the experimental Bauhaus in Weimar, where both had been invited to teach. As their pictures circulated in Europe during the 1920's, Kandinsky's floating forms, now combining organic and geometric elements, and Paul Klee's poetic fantasies were hailed as preludes to Surrealism.

Summing Up

The new art of Germany developed within a rich intellectual and cultural milieu. It was embodied in a series of Secessionist groups that became more audacious as they grew more international in outlook, with two solitary figures in the vanguard: Wassily Kandinsky and Paul Klee.

As a gifted colorist, Kandinsky saw the perils of an art of bright decorative color rhythms and sought to mitigate them by giving the artist a messianic role. He likened the process of artistic creation to that of Creation itself: "To create a work is to create a world." Although he was a religious man concerned over the rise of materialism, the works he produced achieved the very disorientation suggested by the new sciences and philosophy, with man no longer in the center of the universe but passing through. His *Compositions*, extensions of real space, convey this sense of relativity, inconclusiveness and floating. His *Impressions*, like flashes of memory, also carry the burden of their irresolution. His *Improvisations*, the most hermetic of his works, catch the painting process "as it happens." Perhaps the one contribution of his least often noted was contained in the goal of his *Blaue Reiter* group to establish an open forum for creation in all its manifestations, a pool of material through which the creative instinct might be clarified, the mystery of "inner necessity" unveiled.

For Klee, younger by thirteen years, the same period was a time of solitary gestation. He too saw the danger of the merely decorative, in his case the graceful line. A bent for caricature led him to analyze in his drawing the external manifestations of human character. "My mirror probes down to the heart." An interest in architecture enabled him to explore the main forces interacting in the structure of buildings, and by extension in nature. Thus, for him, line ceased to be a boundary between color areas and assumed an independent and expressive pictorial value. He came to use line to "render visible" the structural forces that he felt were inherent in all things, independent of external form. In 1914, under the spell of Mediterranean light, Klee, like Van Gogh, Cézanne and Matisse before him, learned to render the potency of color independently of its local effects.

What distinguished Kandinsky and Klee from their German contemporaries, and particularly from the *Brücke* group, was their belief in the

ability of painting to translate directly the emotional and spiritual powers of the creative instinct. For the *Brücke* group, art remained tied to recognizable images, illustrating rather than expressing emotions. The issue of whether "abstract" painting can continue to function as a carrier of emotion beyond the moment of its historic situation is an important one, which was to be raised again by the Abstract Expressionists of the 1950s and has still not been resolved.

ART REVOLUTIONS IN RUSSIA,
c. 1895-1923 chapter 5

Serge Diaghilev and the World of Art
Mikhail Larionov and Natalia Goncharova:
Catching Up With Europe
Vladimir Tatlin and Kasimir Malevich
Epilogue: Art and the Russian Revolution
Summing Up

As of 1861 Russia's fifty million serfs become free men. In the 1880s Russia belatedly begins its industrialization. A new class of merchants and industrialists gains economic strength. Intellectuals (among them nihilists, social revolutionaries and Marxists) emerge from the various strata of a new industrial hierarchy. The last czar, Nicholas II, does not pursue his father's liberal policies. He rules autocratically, through a complex network of functionaries, sends dissidents into exile or forced labor, summarily executes those accused of terrorism and personally organizes the country's artistic life in the capital of Saint Petersburg. Yet the vigilance of the censors does not prevent the publication in Russian of Das Kapital *(1872), nor the proliferation of realistic novels sympathetic to the oppressed, nor the production of anti-bourgeois plays. The socially conscious Wanderers use Russian epic folklore to expose in their paintings the cruelty of the czar, the fanaticism of the church and the bravery of the common man.*

Serge Diaghilev and the World of Art

In the mid-1890s a number of former classmates at an exclusive private school in Saint Petersburg, while desultorily pursuing their university studies, began meeting at each other's elegant homes to discuss painting, music and poetry. Well traveled and well read, they were more in tune with the ultra-refined English Pre-Raphaelite painters, their Munich Jungendstil counterparts and the French Symbolists than with either Russian official art circles or with the socially conscious Wanderers. Alexander Benois, a

painter-writer who was a founding member of the group, later reflected that the world of art could be considered as a kind of community "which tried in a number of ways to influence society and inspire in it a desirable attitude to art—art understood in its broadest sense, that is to say including literature and music."*[1] Such vague and grandiose ideals might never have materialized had not these lackadaisical gentlemen had in their midst at least one forceful personality. Serge Diaghilev (1872-1929), the country cousin of one of them, proved to be just that. Lacking the effete manners of his friends, Serge Diaghilev possessed an uncanny flair for publicity. Although short on creative ability—he had been found wanting by his music teacher, the renowned Rimsky-Korsakov—he could recognize talent in others, and unlike his dilettante friends he proved to be a real achiever.

Beginning around 1897, the group became known for its sponsorship of the unusual exhibitions that Diaghilev arranged: watercolors from England and Germany, paintings from Scandinavia, pottery made at the Abramtsevo colony, Tiffany and Lalique glassware, Russian portraiture of the eighteenth and nineteenth centuries, religious icons, and even more important, yearly exhibitions by young Russian artists as well as late nineteenth-century Western Europeans. In 1898, Diaghilev also began publishing a monthly review (said to have sold at a sixth of cost), which he called *World of Art*, thus coining the name by which the group came to be known. In *World of Art*, one could read either learned articles by Diaghilev's philosopher-esthete friends or the lively art chronicle that Diaghilev himself sent from his foreign travels, or one could look at many pages of arresting photographic material ranging from typically Russian handcrafted artifacts, sleds, balalaikas, peasant furniture, etc., to reproductions of paintings by French artists, including Ingres, Daumier, Degas, Bonnard, Vuillard and Renoir, as well as by contemporary Russian and German artists, some now familiar, others forgotten.

For two years, Diaghilev also held an administrative post with the Imperial Theaters, a short tenure but an important step in his career as impresario. He called on his painter friends from the World of Art to create sumptuous stage designs; he commandeered ballet scores from World of Art composers—such as Igor Stravinsky—who performed their latest works at musical evenings of modern chamber music sponsored by two members (Koussevitzky and Ziloti) of the World of Art; he sought out the most promising ballet dancers and choreographers and, with the support of wealthy friends, was able to coordinate all these talents in spectacular ballet productions.

Not only was he fulfilling in a concrete way the synthesis of the arts

* Kandinsky's Blue Rider later also embodied these ideas (see chapter 4).

implied in the World of Art philosophy, but in so doing he revolutionized the ballet world. For example, in his creation of the Stravinsky ballets *Petrushka* (1911), *Firebird* (1910) and *Rites of Spring* (1913), the dancers were no longer clad in old-fashioned tutus but appeared in glittering costumes against colorful and imaginative sets painted by Alexander Benois, Leon Bakst, Alexander Golovin and Nicholas Roerich; instead of moving in stereotyped patterns to the Romantic music of Tchaikovsky, his dancers, Vaslav Nijinsky, Anna Pavlova, Karsavina, jumped, bent, recoiled to the syncopated rhythms of a Stravinsky score, using their whole bodies, especially their hands, in new expressive ways. In short, the balletomane was simultaneously offered new steps, new music, fresh décors and new folklore-oriented themes. Since Serge Diaghilev was shortly denied the Imperial Theaters, beginning in 1909 he brought his ballets to Paris, where they were greeted with much initial controversy and final acclaim. Until his death in 1929, Diaghilev continued to bring together contemporary painters and composers in ballets that were to "astound" (his own word) the world.

The World of Art was short-lived as a cohesive unit. In late 1904, the magazine of that name stopped publication; Diaghilev, following his dismissal from the Imperial Theaters, spent more and more time abroad, and after the 1906 art exhibition in which an "old guard," comprising the original group of painters and stage designers interested in refined *fin-de-siècle* stylization and erudite allegorical subject matter, confronted a younger generation of down-to-earth pseudo-Impressionist painters, a split occurred and World of Art exhibitions changed character, consecrating established talents rather than discovering new ones. Be that as it may, the World of Art played a primary role in awakening European society to Russian art and in alerting Russian society to recent developments in Western European painting as well as in young Russian art. Great collections of French art were begun in the heyday of the World of Art. Furthermore, Alexander Benois, who had coedited the magazine *World of Art* with Diaghilev, remained for many years an influential if rarely positive art critic, mostly through his writings in the magazine *Apollon* (1908-17). As late as 1916, the painter Kasimir Malevich was complaining "Your system is triumphing. . . . You [Benois] have all the tools to erase everything that is not in your likeness!"[2]

In early 1905, striking factory workers march toward the czar's winter palace in Saint Petersburg but are stopped by gunfire. Following this "bloody Sunday," uprisings, mutinies and strikes spread throughout the country, and for several months menace the survival of the czarist regime. Constitutional measures temporarily appease the people and the revolution aborts. Soon the czar changes course. Severe repressions occur, giving the country a sem-

blance of calm for several years. Meanwhile, in various parts of Europe, leftist exiles train followers and plot the next revolution.

Mikhail Larionov and Natalia Goncharova: Catching up with Europe

In the fall of 1906, the Salon d'Automne in Paris included an important Russian section. This section, arranged by Serge Diaghilev, consisted in the main of works shown earlier that year in Saint Petersburg at the World of Art exhibition. A sumptuous setting had been created by Leon Bakst (c. 1867-1924) of the "old guard." On view also were a number of pseudo-Impressionistic works considered avant-garde in Russia. None of the Russian works, it seems, looked new or particularly interesting when juxtaposed with Gauguin, Cézanne, the Douanier Rousseau, Matisse, and many other violently colored works by the Fauves. That year the Salon d'Automne honored Paul Gauguin with a retrospective, presented eleven Cézannes (*Maison en Provence, Pins dans les rochers, Assiette de pommes, Pot vert et sucrier, Buffet, Paysage, Jeune Homme au foulard blanc, Maison dans les arbres, Le Chemin tournant, Marine, Portrait de femme*), showed Henri Rousseau's *Le Joyeux Farceur*, and offered colorful works by Kandinsky and by the French Fauves, then at the height of their powers (by Matisse, *La Liseuse, Nature morte au tapis rouge, Nature morte et statuette, Fleurs, Paysage*).[3]

That Impressionism was no longer avant-garde in Paris and that much needed to be accomplished before Russian painting could hope to attract attention was painfully apparent not only to Serge Diaghilev, but also to two young painters, Mikhail Larionov (1881-1964) and Natalia Goncharova (1881-1962), who had accompanied Diaghilev to Paris. While Diaghilev succeeded in the following years in presenting World of Art painters through ballet productions, it fell to Goncharova and Larionov, as informed leaders of the new generation of Russian artists, to work toward an expression in painting that would no longer look provincial or outdated in an international context. As organizers of exhibitions and as experimenters in their own work, these two artists helped to create in Moscow a vital and energetic artistic climate.

Mikhail Larionov came from a provincial background and had met the woman who was to become his lifelong companion, the aristocrat Natalia Goncharova, in Moscow where both were pursuing their artistic studies. In his student days in 1901, Larionov had demonstrated his arrogant albeit humorous temperament by monopolizing the walls of his art school with some 150 sketches of his own making, an act for which he had been temporarily expelled. Following his 1906 visit to Paris and a stint in the military, Larionov settled in Moscow. The catalogue of one of his first enterprises,

the Golden Fleece exhibition of 1908, set forth his goals as follows: "On the one side, by juxtaposing Russian and Western experiments, to show more clearly the peculiarities in the development of young Russian painting and its problems; on the other, to emphasize the characteristics which are common to both Russian and Western painting, for in spite of the different national psychology . . . the new experiments of young painters have a certain common psychological foundation. Here it is a question of getting over aestheticism and historicism, there it is a reaction to the neo-academic art which gave birth to impressionism."[4] Such a program contained indeed a number of portentous signs: it assumed that native Russian and French paintings could be compared when juxtaposed on a "psychological" basis. As it turned out, the most powerful Russian collectors, Sergei Shchukin and Ivan Morosov, continually favored the French. And it assumed that the peculiarities of Russian painting were sufficiently original to give Russian art a place in the world avant-garde. This hope was shattered time and time again as Russian artists found themselves having to decipher and assimilate into their art the rapidly changing artistic conceptions of the West.*

Larionov's ambition to show the most advanced art from abroad and to develop a truly nationalistic art contained a number of incompatible elements that make it possible to observe in Moscow a situation parallel to that found in Munich at the same time. This was the conflict between an open-minded attitude vis-à-vis the foreigner and a distrust leading to his exclusion from exhibitions in favor of truly national artists. Thus the exhibitions organized by Larionov between 1908 and 1913 wavered between showing the new from Europe and shaking off the foreigners. For example, in 1908 the first exhibition of the Golden Fleece was dominated by the French —Henri Matisse, André Derain, Albert Marquet, Georges Braque, Paul Cézanne—with 280 French works. In March 1909 the second exhibition of the Golden Fleece was equally divided between the Russians and the French (among them Georges Braque's 1908 *Grand Nu*). In December 1909 the third Golden Fleece exhibition showed only the two Russians Larionov and Natalia Goncharova. In 1910 the first Jack of Diamonds exhibition, another show inspired by Larionov, included several French Cubists of the Puteaux group along with works of the Munich New Artists Association (with four of Kandinsky's *Improvisations*), as well as Russian artists. In March 1912 the so-called Donkey's Tail exhibition showed only Russians, Larionov and Goncharova having left the Jack of Diamonds because David Burliuk, an associate of Larionov's, planned to show the French Fernand Léger and the Munich Blue Rider group.

Such ambivalence reached a head in Larionov's attitude toward the

* The role played by avant-garde European art for many Russian artists—although controversial in its importance—seems difficult to ignore on the basis of available information.

Italian Futurist Filippo Marinetti. When the Futurist Manifesto was pub-
lished in the Russian press, first in French in 1909 and later in translation, it
met with extraordinary enthusiasm. The idea that the new dynamic environ-
ment and the corollary new consciousness of man required an entirely new
expression fortified the Hylaean group of Russian painter-poets* in their
own experimental work with words and sounds. Larionov could not remain
insensitive to Marinetti's appeal and was soon involved with the Hylaean
group. One finds in Hylaean collections of poetry many illustrations signed
by Larionov. However, when Marinetti himself came to Moscow in 1914,
Larionov's enthusiasm was markedly less.† In the article that appeared in
the Russian press at that time he told his friends to "hurl rotten eggs at
Marinetti for his betrayal of Russian Futurist ideals."[6]

If Mikhail Larionov and Natalia Goncharova revealed their national-
istic bias in the shows they organized and in their hostility to Filippo Marin-
etti,‡ as experimenters in their own work they demonstrated a furious desire
to offer their countrymen an original alternative to avant-garde Western
European art. For example, while artists in Paris were discovering African
sculpture and feasting the naive Douanier Rousseau, while the Germans
were resurrecting the Gothic tradition of anonymous woodcuts, Mikhail
Larionov and especially Natalia Goncharova sought inspiration in Russian
popular imagery, the *Lubok* or popular cartoon, sign paintings by peasant
artists and religious icons, and between 1908 and 1912 produced a number
of "neo-primitive" paintings. Larionov's rendering of relaxing soldiers, of
prostitutes at the hairdresser, and Goncharova's peasant scenes share a
childlike simplification of form and modeling, awkward perspective and a
pervasive earthy humor. Then, while Paris artists were exploring the frag-
mentation of form, while Kandinsky was confounding his viewers in Ger-
many with seemingly abstract compositions, while the Italian Futurists were
destroying the "materiality of bodies" through simulated movement and
light,[7] Mikhail Larionov and Natalia Goncharova brought out their own
Rayonnist pictures, which Mikhail Larionov defended in the following terms:
"Rayonnism creates forms in space. These forms are born from the intersec-
tion of the luminous rays emitted by different objects. . . . Non-figurative

* Hylaea was an association of painters turned poets whose center of activity was Hylaea on
 the Black Sea. They experimented with new word associations, grammar-free sentences
 and other ways of liberating the word from traditional meanings to release a new transra-
 tional mystical and esthetic content. Vladimir Mayakovsky, David Burliuk, Victor Khleb-
 nikov, Alexei Kruchenykh and Benedict Livshits were some of the Hylaean members. In
 1913 they become known as Futurists.

† "Poets saw humiliating overtones in Marinetti's visit. He seemed to them to affect the pose
 of a general who had come to inspect one of his remote garrisons."[5]

‡ Marinetti did not reciprocate this enmity and warmly welcomed Larionov when the latter
 visited Italy, giving him a Futurist membership card.

art is not an abstract art. It is a vision of the world which reproduces not the objects themselves but their fulguration."[8] Larionov's *Red Rayonnism* (1911) with its red, purple and orange "beams" crisscrossing the canvas exemplifies this theory; in *Cats* (1913) Natalia Goncharova uses the Rayonnist theory while retaining depicted objects within the frame. Finally, when Marinetti's Futurist message came to be interpreted as a sweeping gesture against any art with ties to the past, Larionov acquiesced by hanging his hat in the space allocated to him at a Russian Futurist manifestation.

Curiously, however, it was neither Natalia Goncharova nor Mikhail Larionov who was to produce the most radical work of the period—they left Russia in 1915 and spent the rest of their lives in Paris, working largely on stage designs—but two of their recruits and erstwhile friends, Kasimir Malevich (1878-1935) and Vladimir Tatlin (1885-1956). Furthermore, these artists were not to be granted any sort of confrontation with French art but were to reach their extreme artistic conceptions isolated from Europe—the First World War having effectively sealed Russia off from the West. The radical steps taken by Malevich and Tatlin were not to be purely artistic gestures for long, but gestures forced into productive lines according to the new revolutionary ideology.

In 1913, parts of Wassily Kandinsky's Concerning the Spiritual in Art, *a major theoretical text, appear in Russia in conjunction with a Kandinsky exhibition. Albert Gleizes and Jean Metzinger's* Du Cubisme *receives two Russian printings in 1913. By 1913 also, the collections of Sergei Shchukin and Ivan Morozov, with a version of Cézanne's* Cardplayers *and a large number of Picasso's Cubist paintings, are open to the public on a limited basis. After 1909, Marinetti's Futurist Manifesto is known in Russia, but a Russian translation appears for the first time in June 1912 in the second issue of the* Union of Youth, *an avant-garde periodical. In 1913, the young poet Vladimir Mayakovsky has five poems in the review* Croaked Moon, *in which one also finds an essay by Benedict Livshits on the liberation of the word. In 1913, Vladimir Mayakovsky, David Burliuk and Wassily Kamensky carry the Futurist banner throughout Russia with lectures on the latest movements, invective against the public and audacious predictions of the end of bourgeois art and the beginning of a new era. In 1915, Mayakovsky reads aloud at the Stray Dog Café some of his revolutionary poems, such as "This is For You"* (Eto vam).

Vladimir Tatlin and Kasimir Malevich

Much of the life and work of Kasimir Malevich and Vladimir Tatlin are still shrouded in mystery. This is illustrated by an incident in London in

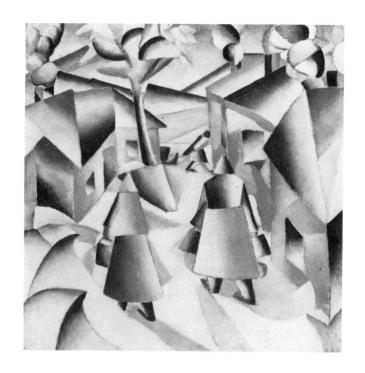

*"These forms are born from the intersection
of the luminous rays emitted by different
objects. . . ." (Rayonnist Manifesto)*

Natalia Goncharova, *Cats*, 1913, oil on can-
vas. The Solomon R. Guggenheim Museum,
New York. 33 1/4 x 33".

*. . . mechanical animation was now optically
suggested through the contradictory shading
given to the tubular or conical sections that
could be read as either concave or convex.*

Kasimir Malevich, *Morning in the Country
after the Snowstorm*, c. 1911-1912 oil on
canvas. The Solomon R. Guggenheim
Museum, New York. 31 3/4 x 31 7/8".

1971 that for a few moments jeopardized the opening of a show entitled "Art in Revolution," to which the Soviets had contributed. A number of paintings by Malevich and the replicas of two corner constructions by Tatlin were among works that had to be removed from the exhibition since they were considered decadent from the Soviet point of view, mistakes by otherwise talented "servants of the Revolution," as witness their architectural projects, scenic designs, furniture and other concrete manifestations of socially inspired goals that were allowed to remain in the show. While a number of paintings by Kasimir Malevich filtered to the West, Tatlin's "free art" is essentially known only through photographs or reconstitutions. While manuscripts and notes by Kasimir Malevich have been found, Vladimir Tatlin's ideas are primarily known through their influence on other artists.

Be that as it may, a collection of essays by Kasimir Malevich published in English translation in 1968 reveals in an appendix the beginnings of an autobiography. In this text, Malevich tells of his birth in the southern Ukraine, in an environment where the words "art" and "artist" did not exist, of "negatives" that he stored in his memory of certain forms and states of nature, cloud formations passing across the disk of the sun, the horizon stretching all around him as he stood on a hill.* He also tells of his early attempts to study painting while earning a living as a civil servant.[10] Abruptly the memoir stops. The rest is in a private archive in Moscow, unfinished and untyped. Malevich apparently succeeded in going to art school in Moscow and, most likely in 1909 or 1910, met Larionov at the opening of an exhibition in which Malevich was a participant. The two left the opening together, Larionov recalled many years later, and talked all night while sitting on a bench. If one is to trust Larionov's memory, they talked about form, how the object on the canvas played no role whatsoever, and agreed that a picture must be invented, that what counts is the manner of execution, that the problem is color, a problem that Larionov claims to have already solved while Malevich was still struggling with it. "From then on, we were friends," Larionov writes.[11] Indeed, Malevich exhibited several times with Larionov, first at the Jack of Diamonds in 1910, then at the Donkey's Tail of 1912 and finally at the Target (March-April 1913).

In *Flower Girl* (1904-5), exhibited at the Jack of Diamonds of 1910, Malevich revealed himself a pseudo Impressionist, but by the time of the Donkey's Tail exhibition in 1912 he had changed considerably. A new primitivizing mood appeared in the apelike *Bather* (1910), in *On The Boule-*

* With the image of clouds and sun suspended in an indefinite space yet moving, Malevich supplies a clue to his future Suprematist paintings, dynamically slanted geometric forms, unanchored, floating. In another section of *Essays on Art*, Malevich writes: "I have destroyed the ring of the horizon and escaped from the circle of things, from the horizon ring which confines artists to the forms of nature."[9]

vard (1910), in *Floor Polishers* (1911) and other gouaches painted in 1910-11. His figures now had powerful feet and hands, large haunting eyes, and were brightly if roughly painted. But an even more advanced technique was seen to develop in another series of paintings related to country life. In *Taking in the Rye* (1912), for example, Malevich harnessed all of his forms in brightly highlighted cylindrical sections, including the tall grasses running all the way to the top of the canvas. Several of Malevich's pictures dated 1911 and 1912 refined this compositional principle, and mechanical animation was now optically suggested through the contradictory shading given to the tubular or conical sections that could be read as either concave or convex. *Woman with Buckets, Morning in the Country after the Snowfall* and *Haymaking*, painted in the manner just described, were shown at the Target in 1913 with an even more radical work, the *Knife Grinder*, in which the subject was integrated with the ground by means of a unifying network of small conical sections and rectangles suggesting a complex shallow space.

Immediately after the Target exhibition, however, Malevich publicly broke with Larionov, allegedly because of Larionov's disparaging remarks about the Italian Futurist Marinetti. Kasimir Malevich sent the following notice to the press: "Those who dissociate themselves from Larionov. . . . I request that you bring to your readers' attention that the group of Russian Futurist artists has nothing in common with the Rayonnist Larionov and is on guard against such a head. Signed Artist Kasimir Malevich."[12] (Note the careful use of the word artist, which Malevich denies Larionov.) It seems that by mid-1913 at least two groups were identifying themselves as Futurists, one, the Rayonnists headed by Mikhail Larionov, the other, the Cubo-Futurists headed by Larionov's ex-friend David Burliuk, and by the poet Vladimir Mayakovsky. Malevich apparently sided with the Cubo-Futurists. He illustrated their poems, made settings and costumes for a Futurist opera and exhibited at the Cubo-Futurist league, the Union of Youth, some new paintings that he called "Nonsense-Realist" pictures. In *An Englishman in Moscow*, for example, the "Englishman" was shown in the midst of an incongruous array of words, parts of words and floating artifacts, a sword, a fish, a candle, a ladder, etc., which, as in Cubo-Futurist poems or "Zaums," lacked a syntactical link yet could produce the direct response that sounds sometimes induce as well.

Exactly when the spirit of camaraderie within the Larionov circle had begun to disintegrate is hard to ascertain. Describing the acute competition reigning in the Moscow art world in 1915, a witness wrote:

> These scandal-making gentlemen are so on guard against each other that each tries to put his work on exhibition last, to prevent competitors from borrowing his caprices. . . . They . . . knock together their exhibition pieces at the last conceivable moment. They order space on the wall and let it stand empty until the exhibition is to open. If their "picture" is ready, they go around with

it under their arms. If they are suddenly struck by a bright idea, they work directly on the walls—and if there is no space . . . on the window panes.[13]

No wonder that alliances were short-lived and art associations no sooner formed than disbanded.

It was in such an atmosphere, fueled further by police interference, public derision, poverty and political frustration that in 1915 Kasimir Malevich confronted a new and dangerous rival, the painter-turned-sculptor Vladimir Tatlin.

Even more than Malevich, Tatlin is a legendary figure in modern Russian art. His early years as a sailor (he was born into a bourgeois family that seems to have rejected him); his near adoption by the Larionovs, at whose country place he spent a summer in 1907 or 1908; the rapidity of his rise as a painter (just a few years after starting art school he was exhibiting with Larionov, Goncharova and Malevich at the Donkey's Tail); his break with Larionov shortly thereafter; his narrow culture (Futurist poems were his favorite reading) and varied talents (he could wrestle and play the accordion); his meteoric visit to Paris in 1913-14 to offer his services to Picasso, who refused them—such are the generally known facts about this shy, naive, and reputedly self-doubting man.

After his return from Paris—although dates are difficult to ascertain—it seems that Tatlin abandoned painting and devoted himself to three-dimensional work, what he called at first "synthetic-static" compositions.* These were painted reliefs on plaster, with the salient parts, scraps of wood, bent and spliced metal, glass, jutting out at various angles toward the spectator. A few, such as *The Bottle*, alluded to real objects; others were simply combinations of various found materials unified by paint, and by Vladimir Tatlin's continuing affinity for curved forms (arcs and ellipses), an interest already apparent in such paintings as *The Fishmonger* (1911) and *Composition from a Nude* (1913). In the highly competitive atmosphere of Moscow nobody, it seems, looked forward to showing his work next to these unwieldy creations—nobody except for Kasimir Malevich, his friend Olga Rozanova, and some of the Russian women painters like Liubov Popova, Nadezhda Udaltsova and Alexandra Exter, who had studied Cubism in Paris and come back to Russia at the outset of the war.

Twice in 1915, Vladimir Tatlin matched wits with Kasimir Malevich, first at an exhibition called Tramway V, where Malevich showed more of his "Nonsense-Realist" paintings, some incorporating real objects, works that despite their Cubo-Futurist content, probably looked *déja vu* next to Tatlin's constructions, and second at the so-called 010 exhibition (De-

* In Paris, Picasso, Braque and Gris had just invented collage and *papiers collés*, and it is generally assumed that Tatlin saw not only their latest paintings but also Picasso's *Guitar* and other constructions.

cember 1915). With this latter show, the most radical art of Malevich and
Tatlin was unveiled, albeit not without considerable tension just before the
opening, for Tatlin apparently refused to exhibit in the same room with
Malevich, claiming that the latter's very latest work did not deserve the
name of art. A compromise was found by partitioning the exhibition hall.
The works featured in Tatlin's section were a number of suspended corner
reliefs, no longer on a plaster ground but open constructions in mixed media
that, from a distance, must have looked as if some yet unnamed organic
beings were hanging in air.* Malevich's new work consisted of one or more
diagonally oriented geometric forms painted flat on a white ground and
floating. It may also have included a black square hypnotically centered in a
larger white square field.

Manifestos were written, debates held to discuss this new manifestation
of art and to ascertain the dates of its origin. Malevich traced his own
beginnings as a Suprematist, the title he adopted to define himself, to 1913
when for a back cloth for the Futurist opera *Victory over the Sun,* written
by Alexei Kruchenikh, music by Matyushin, he had first drawn a square
within a square.† He defended Suprematist painting as the expression of
feelings inspired by the modern world, feelings offered by sensations of
flight, by wireless telegraphy, by metallic sounds, by movement and resis-
tance, by a sense of universal space, etc. He also suggested in his later writ-
ings that the black square on the white field had been the first form in which
the "nonobjective" feeling came to be expressed: the square equals the feel-
ing and the white field equals the void beyond this feeling.[14]

Tatlin announced that sculpture had now a new foundation based on
materials, volume and construction—in other words, that sculptural form
was no longer a carved or shaped mass but open construction playing void
against mass, suspension against gravity, one material against another. Al-
though the public remained unconvinced, Tatlin and Malevich soon ac-
quired a large following among young artists. When in 1916 Malevich and
Tatlin, forgetting their previous quarrels, exhibited together in a rented
store in Moscow, a new recruit named Alexander Rodchenko joined them,
later incorporating some of the concepts of both artists into his own work in
two and three dimensions. In 1918 Rodchenko painted black mat ovals in a
black glossy circle. In 1920 he made a hanging construction of intersecting
loops, and another construction of stacked wooden blocks. Young artists

* Tatlin's fascination with the phenomenon of suspension is further shown in an experimental
 glider that he constructed in the late 1920s, a winged insect form in wood that he called *Let*
 [fly] *Tatlin,* "Letatlin," and a moving moon to serve as a theater prop on which he worked
 in the 1930s.

† The three-dimensional concave-convex illusion readable in this alleged first Suprematist
 work seems to look back to the paintings with cylinders as well as forward to the flat ge-
 ometry of his Suprematist works.

 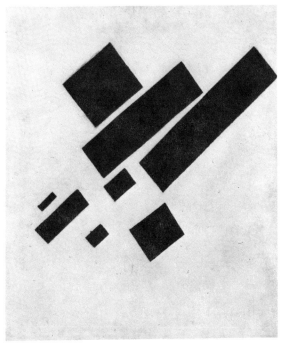

Vladimir Tatlin matched wits with Kasimir Malevich

left: Vladimir Tatlin, *Complex Corner Relief*, 1915, iron, aluminum, zinc, etc. (presumably destroyed).

right: Kasimir Malevich, *Suprematist Painting, Eight Red Rectangles*, 1915, oil on canvas. Stedelijk Museum, Amsterdam. 22 5/8 x 19″.

found an enormously rich field of research both in Malevich's investigation of the perceptual and emotional properties of colored geometry and in Tatlin's search for the optimal relationships among materials used together in space. The movement that emerged has come to be known as Constructivism.

The October Revolution of 1917 further isolated Russian art from the West, and it was not until 1922 that a traveling exhibition of modern Russian art organized by a former student of Kasimir Malevich, the painter-architect El Lissitsky (1890-1941), revealed to the West the existence of a Russian avant-garde, working very much in the same direction as several Western artists in the de Stijl group and in particular the Dadaists, a direction in which, it seems, the Russians might have been pioneers had they been able to confront Western audiences in 1915, the time when these works first appeared in Russia.*

Up to November 1917, and in spite of war, there are few changes in the artistic life of Russia: exhibitions continue—for the benefit of the wounded; the Futurists shift their propaganda activities to the front lines; Vladimir Tatlin with some friends redecorates the Café Pittoresque in Moscow between February and October 1917. Then the Bolsheviks take over. Many intellectuals flock back home in the wake of returning political exiles. Civil war rages, food is scarce. A period of idealism and chaos follows. After a brief resurgence of private enterprise during the New Economic Policy of 1921, political, economic and cultural activities lose their autonomy.

Epilogue: Art and the Russian Revolution

At an early session of the Council of People's Commissars, one of the members rushed out of the room crying, "I cannot stand it, I cannot bear the monstrous destruction of beauty and tradition. . . ." (False reports had been circulating that the Kremlin had been sacked.[15]) The voice was that of Anatoly Lunacharsky, recently named head of the People's Commissariat for Education (Narkompros). Between 1917 and 1929 Lunacharsky, a Marxist literary critic and former lecturer at the Louvre in Paris, and whom the writer Maxim Gorky had once called lyrically minded and muddle-headed, attempted to guide the cultural destinies of Russia.

At first, Lunacharsky surrounded himself with an esoteric group of assistants, old friends from his days of exile in Paris, members of the avant-

* The prophetic quality of Russian art extends far beyond the 1920s, and into the 1970s with Hard-edge Painting, Minimal sculpture, Assemblages and even Conceptual Art.

garde, wives of high officials (including Lenin's and Trotsky's), and World of Art conservatives such as Alexander Benois. To the wives he chiefly assigned literacy programs. He sought Benois's advice on the reorganization of museums, and asked him to help inventory Russian artistic treasures. From artists he asked cooperation. Some worked on propaganda. "Agit-trains" and "agit-ships," their sides covered with cheerful designs and revolutionary slogans, transported writers, poets and actors all over the land and often became improvised stages from which the masses were harangued.* ROSTA (Russian Telegraph Agency) posters (many by the poet Vladimir Mayakovsky) serializing current events in popular cartoonlike fashion appeared on store fronts in lieu of newspapers, later to be replaced by photomontages grouping several photographic shots into a single narrative image (El Lissitsky and Alexander Rodchenko became experts in this new medium). When the czarist art academies were abolished and replaced by free studios, many artists became teachers. Thus the gentle Marc Chagall, who had made a success in Paris with his dreamlike fantasy paintings and had come back to Russia in 1914, found himself approved as director of an art school in his native town of Vitebsk. Malevich also went to Vitebsk to teach while Tatlin opened a free studio in Moscow. At the new art schools, students were welcome without entrance examinations and could freely select their courses. Other artists became functionaries in the art section of Lunacharsky's department, apportioning meager funds for purchases of the new art and opening museums and new schools (Kandinsky was among them).

A spirit of laissez-faire prevailed in the early days of the Revolution. Chagall tells in *My Life*[16] how he gathered the local house painters and had them copy his designs of flying cows and horses on the walls of the town and on large banners for the celebration of the anniversary of the Revolution. In Petrograd, for the same occasion, the central obelisk of the square in front of the Winter Palace was adorned with huge abstract sculptures,[17] "the buildings around the square camouflaged with Cubist and Futurist designs." Even the trees were painted! Such erratic activities led Kasimir Malevich to exclaim, "all that the revolution did was to give everyone the right to have his own studio, his own church and congregation and to teach there anything he liked. . . ."[18] Malevich hoped for the adoption of his own teaching—of which a few of his writings plus a number of charts and color studies are the only available evidence—in all of the new schools, and felt that the prerevolutionary avant-garde whose art had anticipated the political revolution ought to be the only artistic voice of the country.

However, not only Chagall's banners of flying horses and cows, but

* Trotsky's famous train, which carried him back and forth throughout Russia, also reveals the role of the railroad in spreading new ideas in that enormous land.

also Malevich's abstract compositions alluding to a world purified by the absence of objects and by the primacy of feeling, and even Tatlin's visionary project for a building celebrating the Third International—a dynamically slanted structure spiraling upward, to be constructed of glass and steel with rotating parts within—all these allegedly patriotic manifestations were highly controversial. Did they, the Cubistically distorted renderings of revolutionary heroes and other strange modern works encountered in the streets or in museums of artistic culture sprouting all over the country, truly get across to the proletariat?

Much soul searching went on at all levels. Defending the production of Mayakovsky's play *Mystery Bouffe* with a setting by Malevich (of which unfortunately no designs have survived), Lunacharsky was forced, in his evaluation of it in the newspaper *Pravda*, to distinguish between the form or staging, which might well contain "all kinds of eccentricities," and the text, which "can be understood by anyone; it goes straight to the heart of the worker, the Red soldier, the typical impoverished peasant."[19] Lenin admitted: "I cannot value the works of Expressionism, Futurism, Cubism and any other ism as the highest expression of artistic genius. I don't understand them. They give me no pleasure."[20] Speaking for the proletariat, Alexander Bogdanov, head of the Organization for Proletarian Culture (Proletkult), which he had founded several years before the 1917 Revolution, insisted that art should not have to submit to either approval or disapproval by any party organ but should develop autonomously out of the immense pool of proletarian talent, and that eventually artists would themselves find the best level of communication and efficacy. Bogdanov was supported by a number of avant-gardists, Tatlin, Rodchenko and his wife Stepanova among others, and through its multiple activities—a proletkult journal, a proletkult theater and cinema—exerted its influence over many spheres of creative life until 1920 when Lenin ordered Lunacharsky to put the Proletkult under the commissariat for education (Narkompros).

Artists were also questioning their role under the new regime. Many left Russia. Wassily Kandinsky, who had returned home and had been asked by Lunacharsky to devise a unified art-teaching method, never saw any part of his program (related to Malevich's and Tatlin's theories) implemented. He went to Germany in 1922 where he soon became a teacher at the Bauhaus. Chagall returned to Paris in 1922. Two brothers, the sculptors Naum Gabo and Antoine Pevsner, who, inspired by Vladimir Tatlin's constructions, had published in 1920 a "Realist" manifesto in defense of engineer-oriented sculpture utilizing the workers' new industrial materials, also decided to emigrate in 1922. David Burliuk and Alexander Benois had left in 1918.

Among the artists who remained in Russia, one group calling itself "Productivists" abandoned free art and began to work directly with the

workers in the factories, saying that the artist's business was not to decorate life but to organize it. Tatlin eventually designed a stove capable of heating with a minimum amount of fuel and a cantilever chair with a molded rubber seat. Rodchenko designed a worker's outfit. His wife Stepanova and other women painters worked in textile mills making print designs. This group came to the attention of the theater director Vsevolod Meyerhold, who asked them to work on props and sets for his revolutionary "buffoon" theater. For Meyerhold's productions they made simple multifunctional "acting instruments," some with moving mechanical parts, constructed so as to reveal their structure. Often the wings of the theater were dispensed with so that stage crews and actors could be seen at all times, and the proscenium was covered to induce an interaction between actors and spectators.

Some young creators veered from painting and theater into film making, pioneering through lack of funds what today would be called *cinéma vérité*. Sergei Eisenstein, who had been Meyerhold's assistant, integrated in his films the latest techniques in acting (biomechanics) and in film (photomontage). Others went into architecture.

As for Kasimir Malevich, he did not join the workers in the factory but planned their future habitat at his school (renamed Unovis) in Vitebsk. There he apparently taught universal principles of color and composition, made architectural models and called these white plaster geometric sculptures "planits." One of his students, El Lissitsky, created large numbers of *proun* drawings, red and black on white geometric designs, which, although non-functional per se, could be turned into maquettes for buildings, book covers, textbook illustrations, etc.

The crisis of art under the new regime, suggested by the need to disguise free art as architecture or design, was further attested by Malevich's series of *White on White* paintings (some with a cruciform design), which he painted during the years immediately following the Revolution. In these paintings, the form and the field are almost indistinguishable, or—in Malevich's terminology—feeling and void have almost merged. Malevich, as far as is known, stopped painting in the 1920s, resuming it with a modified naturalism and portraiture toward the end of his life. (The self-made, planit-shaped coffin in which he was buried in 1935 is said to have been adorned with Suprematist designs.)

The departure from Russia of a number of artists; the spontaneous realignment of the avant-garde in new activities in propaganda, consumer goods, theater and film, compounded by the tremendous pressures in Lunacharsky's department for quick progress in literacy at the expense of art education; Lenin's increasing impatience with the intellectual avant-garde, with the exception of filmmakers whose photographic art he judged entirely legible by the masses; the temporary resurgence of a bourgeois class with a taste for photographic types of portraiture and landscape during the 1921

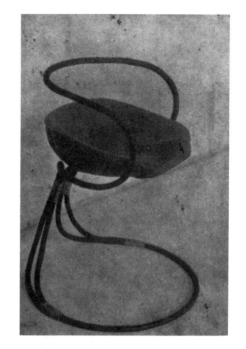

*". . . the artist's business is not to de-
corate life but to organize it." (The
Productivist Manifesto)*

Tatlin, bent-tube chair with molded seat,
c. 1920.

*He called these white plaster geometric
sculptures "planits".*

Kasimir Malevich, *Gota-2a*, n.d.,
whereabouts unknown.

New Economic Policy; the cutting off of state subsidies for free studios and museums of artistic culture—such in brief were the complex factors that led to the increasing monopoly of the fine arts by the Union of Soviet Artists, whose concept of Socialist Realism eventually became the official art of the Soviet Union.

Summing Up

The successive waves of artistic rebellion in Russia from the late 1890s to the early 1920s suggest questions that are still relevant today:

On the purpose of the visual arts. Is picture-making, like music, a means to delight, shock and amaze its public as Diaghilev's World of Art group sought to demonstrate? Is it simply part of an urge to enter and make one's mark on the history of art, or rather the history of forms (Larionov and Goncharova)? Or does creative originality mean finding a new vocabulary for the expression of new ideas with social implications (Malevich and Tatlin both claimed that their revolutionary art prophesied the political revolution, and suggested its role as a banner, a symbol for new social goals behind which to rally the masses)? Or is art justifiable only as propaganda (as implicit in the attitude of Communist regimes toward creative artists)?

On the relationship of form to content in art. Can abstract signs on a picture surface work as the direct symbolic translation of feelings in all their complexity and contradiction?

On communication by means of art. For example, who decides the meaning of Malevich's *White on White:* Malevich through his theories, or the viewer in Malevich's time, or a present viewer contemplating the work for the first time?

DADA, OR THE HUMOR OF DESPAIR,
c. 1915-1923

Beginnings of Dada in Zurich and New York
Dada Spreads through Germany
Dada Ends in Paris
Summing Up

The First World War rages in Europe. Young intellectuals and artists must accept the draft or flee their native land. The choice is clear for a number of them. Abhorrence of war, indifference to nationalist motivations, awareness of the absurdity of the carnage give many no alternative but to find a haven in a neutral country.

Beginnings of Dada in Zurich and New York

In 1915, Hugo Ball (1886-1927) and his mistress Emmy Hennings arrived in Switzerland. Poet, playwright, philosopher, Ball had established contacts with young avant-garde poets in his native Germany, written several dramatic works and directed others. Drafted in 1914, he was wounded, lost several of his friends at the front, and became totally antimilitarist. Tall, thin and emaciated, often dressed in black like a churchman, he and his fluty-voiced girl friend with her faraway look and youthful manner must have made an extraordinary pair. With Ball at the piano and Emmy singing, they became entertainers at the Cabaret Voltaire* when it opened in 1916 in the respectable city of Zurich. "I went to Herr Ephraim . . ." Ball explained, "and said . . . : 'Please let me have your room. I want to start a night-club. Herr Ephraim agreed and gave me a room. And I went to some people I knew and said, 'Please give me a picture, or a drawing, an engraving. I should like to put on an exhibition in my night-club. I went to the

* Voltaire had also found exile in Switzerland, having been banished from France for subversive ideas.

friendly Zurich press and said, 'Put in some announcements. There is going to be an international cabaret. We shall do great things.' "[1]

As soon as the Cabaret Voltaire opened, other young exiles joined in. Among them was Tristan Tzara (1896-1963), a Rumanian poet—dynamic, aggressive, vivacious. Constantly on the move, Tzara could sing and recite in French, German, Rumanian and Russian. There was his friend Marcel Janco (b. 1895), a Rumanian architect who constructed strange masks painted white and adorned with mirrors. There was also Richard Huelsenbeck (b. 1892) the doctor-poet from Germany, acid and impertinent, obsessed by African drum rhythms. There was Hans Richter (b. 1888), a German painter, who arrived in Zurich to fulfill his promise to meet his friends at a certain café on a certain date, who was introduced to Ball and decided to join him. And there was the Alsatian Hans Arp (1887-1966), a friend of Klee's, acquaintance of Kandinsky's and a Blue Rider participant, who had come to Switzerland in the confusion of his twin allegiance to enemy countries, France and Germany. Since all these men had participated in the avant-gardes of their respective lands, whatever they were about to do as a group would hardly be conventional.

In their café, adorned with aggressive posters, masks, modern paintings and props of all sorts, the group performed nightly, alternating ribald songs with Russian dances, noise concerts* with simultaneous recitations. *L'Amiral cherche une maison* (The Admiral is Looking for a House),[2] one of these mixed-media events, had Huelsenbeck reciting in German, Janco in English, Tzara in French. Between recitations were "rhythmic interludes" of voices, drums, whistles and noisemakers. A note to the bourgeois members of the audience, included in the program, pointed out the analogy between such recitations and simultaneous principles in Cubist paintings, traced the history of such poetry to Mallarmé, Marinetti and Apollinaire, and distinguished between previous poetry and this kind: here each listener had the possibility of making his own associations, for he could retain, mix and fragment whatever word elements suited his personality (something that might also be said of Cubo-Futurist poetry by the Russian Mayakovsky).†

The satire in the songs, the cacophony of the simultaneous voices, the tempo of the dancing, the deafening effect of the noise and the odd works of art on the walls, shocked, jarred, stimulated or simply exasperated the audience. But the more the public reacted—jostling, whistling, throwing things at the performers—the happier the actors were. For this was no ordinary

* Probably inspired by the Italian Futurist Russolo's compositions for noise machines. In many ways, the Zurich group would emulate its Futurist forerunners, mixing the Russian and the Italian versions of Futurism.

† Linguists throughout Europe, including de Saussure, Trubetzkoy and Jakobson, would later delve into the problem of how signifiers—signs, symbols and signals—relate to what is signified or meant.

group of nightclub entertainers. Behind each of the acts lay an ultimate goal, to change the consciousness of an apathetic, usually passive crowd. Provoked to the limits of his proper behavior, the Cabaret Voltaire spectator might see himself as he really was: belligerent or intolerant or base. In short, the small group of idealists gathered at the Cabaret Voltaire saw in the use of irony, parody and new forms of entertainment a means to translate antiwar and antibourgeois attitudes into action.

Hugo Ball, having successfully launched his café, also decided that a review was needed, a small sheet "intended to present to the Public the activities and interests of the Cabaret Voltaire, which has as its sole purpose to draw attention, across the barriers of war and nationalism, to the few independent spirits who live for other ideals. . . . *La revue* paraitra à Zurich et portera le nom 'Dada' ('Dada'). Dada, Dada, Dada, Dada."[3] Why Dada? The word *dada* seems to have been accidentally found in a French dictionary while Huelsenbeck and Ball were searching for an amusing name for one of their female performers. It is the child's name for a hobby-horse in French. "*A dada, à dada* (let's go, let's go)," says the child as he bounces on his father's back. Was *à dada* meant to spur the group to action, or was *dada* chosen for its Russian meaning of "yes yes"? Perhaps they simply liked an amusing word that was vague enough to prevent any definite association with the past, and empty enough to take on meaning in time.

Chance, which gave Dada its name, would also give it something more. It would enable the group to produce art while rejecting its traditional attributes, preconceptions, carefully thought-out composition and craftsmanship. The painter Hans Arp would demonstrate the viability of chance for art in his epoch-making *According to the Laws of Chance* (1920), a collage based on the chance fall of a drawing he had just torn up and on his decision to immobilize the parts on paper exactly as they had fallen. Other Dadaists would likewise integrate materials and processes that they "chanced" upon into their art.

Just as the Cabaret Voltaire was breaking with the tradition of entertainment by mixing, fusing and destroying art forms, *Dada* the review was also breaking rules. In its typography, presentation and juxtaposition of new art and literature, *Dada* was innovating, presenting material in live if chaotic ways that defied reading and seeing habits. Tzara, who from the start directed the review, not only included his own poems, sometimes chance assemblages of newspaper words drawn from a hat, and his virulent Dada manifestos, but also solicited articles from abroad, especially from young French intellectuals who seemed to share his suspicion toward logic and rationality. Richter, Janco, Arp and others contributed woodcuts and linotypes.

Not content with a café and a propagandist sheet, the Dadaists, as they soon came to be called, spread their activities. They started a gallery where

the most controversial art of the time (including that of Kandinsky, Klee and de Chirico) was seen together with their own works. Arp, for example, showed his collages, and reliefs consisting of pieces of free-form plywood layered and then nailed together. In their gallery, they organized tempestuous meetings in the course of which Dada manifestos were delivered in incoherent language, and poems free of syntax (some of them by Arp) were read.

In June 1917 Ball announced an evening of abstract poetry at the new gallery. In a costume by Janco, consisting of a cylinder that immobilized his legs, a stiff cardboard cape and a shaman mask, Ball started to incant slowly and solemnly sequences of syllables: "Gadji beri, bimba glandridi laula lonni cadori. . . ." Facing a public that was becoming increasingly aggressive, Ball was saved by being carried away, still majestic and still serious, through a nearby trapdoor. While the provocative effect of the reading went beyond his expectations, Ball's efforts to create a new language in which the sound of words would, like the colors and shapes of abstract painting, evoke ambiguous personal feelings were stalled. Following this event, Ball gradually retired from Dada. He eventually moved to the canton of Ticino to live the rest of his life as a mystic among the poor. Tzara took charge of the Zurich group until 1919, when he moved permanently to Paris. Janco followed him briefly there, returned to Rumania and eventually settled in Israel. Huelsenbeck returned to Germany and later moved to New York where, under a new name, he became a psychoanalyst. Richter wandered for a while in Germany and also came to live in the United States. Arp, after returning to Germany, settled in Paris until the Second World War.

While the Dadaists in Zurich were attempting by irony and provocation to shake the public out of its complacency, a group of nonconformist intellectuals was creating scandal in New York.

> During the years 1914-17 [writes Gabrielle Buffet Picabia], before the United States came into the conflict, New York was invaded by a large number of refugees of all nationalities, escapees by who knows what maneuvers from the European conflict. . . . Their presence [in New York] created an atmosphere of intrigue and license that was especially favorable to the first manifestation of the revolutionary spirit that came to be crystallized under the name Dada.
>
> This spirit, the symptoms of which could have been detected long before the war, seemed at first a natural reaction of one generation against another. . . . Later, under the pressure of events, it was to transcend questions of art and literature and attack in humorous and scandalous ways (the only ways not subjected to censorship) the laws of a cruel society that refused the right to exist to everything which did not participate in its war-prone exigencies."[4]

Who then were the Balls, Arps and Tzaras of New York? Whereas the Zurich group might be called Central European, the New York group of exiles was French-speaking.

Arthur Cravan (pen name for Fabian Lloyd) was by turns a poet and a boxer. His physique assured him impunity when he punched anyone he did not like, either with his fists or in *Maintenant*, a small pamphlet that he edited in Paris. Penniless, he agreed while in New York to give a talk on modern art. But once on stage and very drunk, he took off his coat, lowered his suspenders and probably would have given a boxing demonstration if the police had not immediately intervened. His exploit, in the purest Dadaist vein, did not help his personal situation. He set sail on a small boat and is thought to have drowned somewhere off the Mexican coast in 1918.

In New York during the First World War was Marcel Duchamp (1887-1968). Unlike Cravan, Duchamp outlived the Dada epoch. Although he pretended that he stopped producing art in the 1920s in order to play chess full time, and although he lived in semiretirement for many years, his sharp intelligence and troubling ideas, embodied in a varied and elusive *oeuvre*, made him the respected father figure for several succeeding artistic generations.

As noted in chapter 3, he participated in the animated debates about Cubism and produced several pseudo-Cubist paintings, but he did not share the Puteaux Cubists' formalist concerns. In 1914 he inscribed his signature on a bottle rack chosen for its visual ordinariness and indifferent taste, an object he called a "Ready-made." (Whether the idea was suggested by Picasso's mixed-media constructions is not known.) By the time of his New York exile, Duchamp was already famous in the United States, thanks to *Nude Descending a Staircase*, a painting that had aroused passionate controversy during its display at the 1913 Armory Show in New York.

Showered with commissions, he preferred giving French lessons to socialite ladies, playing chess and indulging in wordplays.* Invited to select works for a group show in 1917, he proposed *Fountain*, a white ceramic urinal, signed "R. Mutt," plainly another of his Ready-mades to which he had added one of the many pseudonyms he invented for himself in the course of his life. The object was not included in the show and Duchamp promptly resigned from the selection committee, but the urinal became a *cause célèbre* and is a subject of discussion to this day, as is every other object produced by Duchamp until his death in 1968.

Also in New York during the First World War was Francis Picabia (1879-1953). If *Nude Descending a Staircase* had been the most controversial work at the Armory Show, Picabia's contributions to the same event had made him almost as famous as Duchamp. A darling of the New York press, to whom he would rattle off in French the merits of post-Cubist art,†

* A reproduction of the *Mona Lisa*, with an added mustache, was captioned "L H O O Q," a coarse allusion. Picabia became "πqu'habilla," etc.

† Picabia had also participated in discussions with the Puteaux group on Cubism, and had painted pseudo-Cubist pictures in 1912.

Picabia parodies the engineer or draftsman by applying their methods to a fantasy mechanism that is possibly sexual.

Francis Picabia, *A Little Solitude in the Midst of Suns*, c. 1915-1920, ink and gouache. Private collection, Milan. 18 7/8 x 13 1/2''.

he happened on the New York scene in 1915 while supposedly on a diplomatic mission to Cuba. He forgot about Cuba in order to stay in New York for a while.

Unlike the Zurich Dadaists, the New York group had no wish to become organized. What brought Duchamp and Picabia together was not a moralistic desire to remake the world—far from it. All they shared was the hope for a "free existence" where nothing would be taken seriously, as well as a violently destructive sense of humor. What had attracted Duchamp to Picabia when they had first met in Paris was the latter's mode of living, his women, his cars, his drinking and opium smoking, and his endless questioning. "With him, it was always yes but, no but. . . ." said Duchamp.[5] The French composer Edgard Varèse,* Duchamp, Cravan, Picabia, the young American painter Man Ray (b. 1890) and his French wife spent many evenings at the Walter Arensbergs, whose role it was to support, bail out and entertain the unruly coterie. At their home, the group met the photographer and gallery owner Alfred Stieglitz, who exhibited their work and published in the review *291* the varied products of their active minds. While in New York, Picabia showed his first anti-art art, paintings of machinery parts represented with the objectivity of an engineer and the seeming accuracy of an industrial draftsman. In *A Little Solitude in the Midst of Suns* (c. 1915-20) Picabia describes a mysterious car engine seen in sectional profile but parodies the engineer or draftsman by applying their methods to a fantasy mechanism that is possibly sexual. The assimilation of motor to female anatomy recurs in Picabia's *oeuvre* at this time, as it does in Duchamp's various renderings of his "brides."

Picabia fell ill while in New York, and in 1917 or 1918 went for a cure to Switzerland. While under treatment, he wrote and illustrated a group of poems on the theme of the "motherless daughter" (the machine?), which came to the attention of Tzara in Zurich. In his enthusiasm, Tzara invited Picabia to join the Dada group, and a famous meeting took place. Tzara relates how he found Picabia, in his hotel room in Zurich, busy with clock mechanisms that he would dip in ink and then delicately apply to a sheet of paper. The New York-Zurich junction had been accomplished and Picabia formally became a Dadaist.

The antimilitarist attitudes of young intellectuals has caused their exile to neutral countries. But after three years of fighting, an antiwar movement is growing in Germany itself, making the Kaiser's position increasingly un-

* "That he [Varèse] fathered forth noise . . . into twentieth-century music . . . makes him more relative to present musical necessity than even the Viennese masters," John Cage, himself a composer with sound, wrote in a 1958 article reprinted in *Silence*.[6]

tenable. Under great pressure, the Kaiser resigns a few days before the Armistice of November 11, 1918, leaving Germany in the throes of a revolution and in the hands of a weak and divided new democratic government. Judging the situation opportune, the German Dadaists return home to help the revolutionaries.

Dada spreads through Germany

When Huelsenbeck, the doctor-poet, left Zurich for Berlin late in 1917, he carried with him a version of Dada tinged with leftist propaganda (Lenin, after all, lived only a few doors away from the Cabaret Voltaire). While using the same methods as those that had been used in Zurich, he also made Dada into a political club for intellectuals and artists with a revolutionary program: "*Dadaism demands:* 1) the international revolutionary union of all creative and intellectual men and women on the basis of radical Communism; 2) the introduction of progressive unemployment through comprehensive mechanization of every field of activity. . . . 3) the immediate expropriation of property . . . further, the erection of cities of light, and gardens which will belong to society as a whole and prepare man for a state of freedom."[7] Membership in the Club poured in and there ensued an unhealthy exclusiveness.

Founding members included political anarchists such as the painters Raoul Hausmann (b. 1886), George Grosz (1893-1959) and a strange madman named Johannes Baader. All of them contributed to *Der Dada*, which, unlike the Zurich review, became a subversive political tool, looked upon with considerable suspicion by the German authorities. In their pages could be found devastating cartoons by Grosz, such as *Fit for Active Service* (1916-17?) showing a doctor listening to the heart of a standing cadaver while an officer takes notes and others chat. One could also see photomontages by Hausmann and his girl friend Hannah Hoech (b. 1889), collages of newsprint through which things could be said that might otherwise have been censored. Huelsenbeck was trying meanwhile to transform churches into halls of propaganda where "optophonetic" poems (similar to Ball's abstract poems) would be read, and Baader succeeded once in interrupting the service in the Berlin cathedral by shouting blasphemies from the choir. Ambitious but disorganized, and confused between their idealism and their need for individual freedom, the Berlin group also suffered from internal rivalry, especially between Hausmann and Huelsenbeck. After a triumphant celebration in 1920, called *Dada Messe*, where all tendencies of Dada "art" were exhibited (including the stuffed effigy of a German officer with a pig's head), the whole Dadaist structure began to collapse in Berlin, just as the German revolution had collapsed. "By the beginning of 1923 . . . painters

Hannah Hoech, *Cut with the Kitchen Knife*, 1919, collage of pasted papers. Nationalgalerie Staatliche Museen, Berlin. 44 7/8 x 35 1/2".

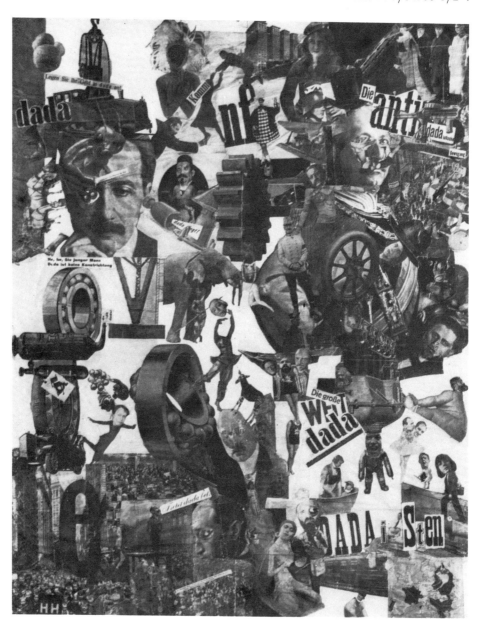

had reverted to being painters, the poets to being poets, the doctors to being doctors."[8]

Meanwhile in Hanover, another young painter, Kurt Schwitters (1887-1948), described by Hausmann at the time of their first encounter as having "brown hair, blue eyes, a straight nose, a rather weak mouth and an unforceful chin,"[9] having been rejected by the Berlin Dada club because of his "petit bourgeois" physiognomy, had created his own Dada club and review. Much less politically inclined than the Berlin group, Schwitters sensed the ambiguity of Dada and the confusion of the Dadaists between political and artistic revolution. "As a matter of principle, Merz [his form of Dada] aims only at art, because no man can serve two masters,"[10] he wrote in 1920. Schwitters shared with the Zurich Dadaists a total rejection of past art and poetry. He was a collector of odd things—tram tickets, ribbons, feathers, rags—all sorts of discards that he would reassemble on a flat surface in a humorous and skillful way (*Merzbild*): "The medium is as unimportant as I myself. Essential is only the forming. . . . When I adjust materials of different kinds to one another, I have taken a step in advance of mere oil painting, for in addition to playing off color against color, line against line, form against form, etc., I play off material against material. . . ." Schwitters wrote.[11] "He would also make poems from disconnected memories of conversations overheard in public places.* His particular "Dada" was the construction of a column on which he worked daily, changing parts and adding new elements. It was first a structure of concave and convex forms. Each form had its own meaning. The cavities contained details from the lives of their namesakes. This column was supposed to grow as long as the artist was alive; soon it was bulging out almost to the walls of the room and eventually went through the ceiling and was continued on the next floor! Unfortunately, Schwitters was forced to flee Nazi Germany and his unfinished column was bombed out of existence during the Second World War. Schwitters moved to Norway and then to England, where he died in 1948.

Also, the voice of Dada became heard in Cologne, but not until the German empire had in fact collapsed. A review, *Der Ventilator,* created by a rich bourgeois, Johannes Baargeld and his friend Max Ernst (b. 1891), then an unknown painter, attacked in its pages the stagnating atmosphere of postwar Germany. In *Die Schammade,†* more literary than political, thanks to the former Zurich Dadaist Arp, were published the writings of such young French intellectuals as André Breton, Louis Aragon, Paul Eluard and Apollinaire who had just died. A Dada exhibition held in a Cologne beer hall

* The method of writing that consists in part in the verbatim transcription of real-life conversations has become common in today's literature, especially in modern theater (Edward Albee, Samuel Beckett, Marguerite Duras).

† For *Schalmeu*, high and low sounds, *Charade*, and *Chaman* (Shaman).

"The medium is as unimportant as I my-self. Essential is only the forming. . . ."
(Schwitters)

Kurt Schwitters, *Disjointed Forces*, 1920, mixed media on board, Kunst-museum, Bern. 42 x 34 1/4".

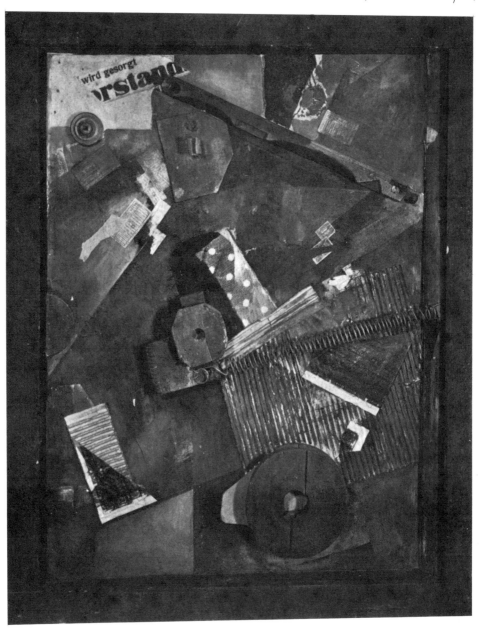

in April 1920 revealed the mysterious collages of Max Ernst (*The Hat Makes the Man*), and joint efforts by Ernst and Arp called *Fatagagas* (*fabrication de tableaux garantis gazométriques* or fabrication of pictures guaranteed to be gazometric). Collaborating on the creation of collages, they could explore the chance development of pictorial ideas and draw inspiration from each other. Using this method, they produced works that had none of the logic of a preconceived painting but a free poetic logic. Ernst, during his sporadic studies in psychiatry, had visited insane asylums and seen art made by inmates in which the poetic content was also tied to the unlikely juxtaposition of pictorial elements.

But Paris was beckoning, and neither Arp nor Ernst was to stay in Cologne long.

The war that had caused so much devastation finally ends. Almost overnight the French begin to live again, unaware of the precariousness of peace. An era of madness ensues that attracts the Dadaists, ready to inject their cries into the prevailing atmosphere.

Dada ends in Paris

The word Dada, after two years of use, was really no more than a state of mind among intellectuals and artists who were dissatisfied with the establishment of the time. What the Dadaists agreed upon was the need for a change in art as well as in life. How this change was to occur was an individual matter. In Zurich, the emphasis had been on using new art to change public consciousness. In New York, Dada was a new way of life, and art was put at the service of the mind (Duchamp, Picabia). In Berlin, Dada flirted with Communism as an alternative to other social systems and art was a political instrument (Grosz, Hausmann), while in Cologne and Hanover, Dada opened the door to expressions utilizing chance, found materials, breaches of logic (Arp, Schwitters, Ernst). In Paris itself, Dada was represented by a group of young writers who had been through the war and personally experienced its absurdity. Neither their eventual leader, André Breton, nor any of them, really knew as yet what Dada meant. No wonder that, when the termination of the First World War enabled the Dadaists to regroup in Paris, a mutually acceptable program was to be hard to find. A sense of total despair caused by the absurdity of war had been the common bond of men with varying experiences and backgrounds and different ways of coping with life. As long as they had been physically far from one another, their awareness of each other had existed on the high plane of mutual admiration. Face to face, the total personality of each hero emerged

and it became evident that harmony would not last long. The "foreigner" Tzara, who in 1919 had established his headquarters at the Paris home of Picabia's mistress, Germaine Everling, made a poor impression on André Breton, who had been the chief Paris-based contact for the Dadaists. Breton saw in the short, aggressive, passionate and despotic young Tzara a rival to his own ambition as intellectual leader. And Tzara watched "his" Dada being Gallicized and the whole spirit of Dada harnessed into dogmatic formulas by Breton. As for Picabia, for whom the whole epoch of Dada was in some ways a distraction for his neurasthenia, and whose ample wealth enabled him to keep above the mêlée, he gradually phased himself out of the group while adding fuel to the feuds by spreading rumors and false news in the press.

Even so true a Dadaist as Duchamp remained aloof from Dadaist activities in Paris and, when asked by Tzara in 1921 to participate in a Dada salon, sent a telegram from New York which simply read "PODE BAL," possibly a spoonerism for *pas de bol,* "no such luck." Until his semipermanent return to Paris in 1923—he would emigrate to the United States during the Second World War—he worked intermittently on a project that he had first conceived around 1912, and done much work on since 1915, *The Large Glass* or *La Mariée mise à nu par ses célibataires même.* (The English translation, *The Bride Stripped Bare by Her Bachelors, Even,* does not reflect the wordplay on *même* or "even" which to a French ear sounds the same as *m'aime* or "loves me.")

An extremely puzzling work, it has been subjected to innumerable iconographical analyses, including one by the English Pop painter Richard Hamilton. His analysis is based on an investigation of *The Green Box,* a compilation of notes and documents that Duchamp kept on the progress and development of the ideas and forms in *The Large Glass.*[12] The "bride" section is the upper half of the work, the "bachelors" section the lower half; several of the forms, reflecting the New York Dadaists' assimilation of organic to machine parts, recall forms in former paintings by Duchamp, and the work as a whole is particularly notable for the inventiveness of its media and its processes: glass instead of stretched canvas, dust mixed with varnish, lead wire, matches dipped into paint and shot from a toy cannon, photographic impressions of a square of gauze—anything is used. In this work Duchamp appears to belie the idea that the painter's craft involves creating illusionary space on a two-dimensional surface since glass is by nature transparent; he also seems to refute the idea that painting needs to be done with paint and brushes on *canvas* (a sly one-upmanship on Picasso's use of collage). Duchamp, in *The Large Glass,* had also broadened the definition of painting just as he had by means of his Ready-mades previously broadened the definition of sculpture. Throughout his life, Duchamp never ceased looking for unconventional ways of giving form to ideas that contradicted a stereotyped way of thinking.

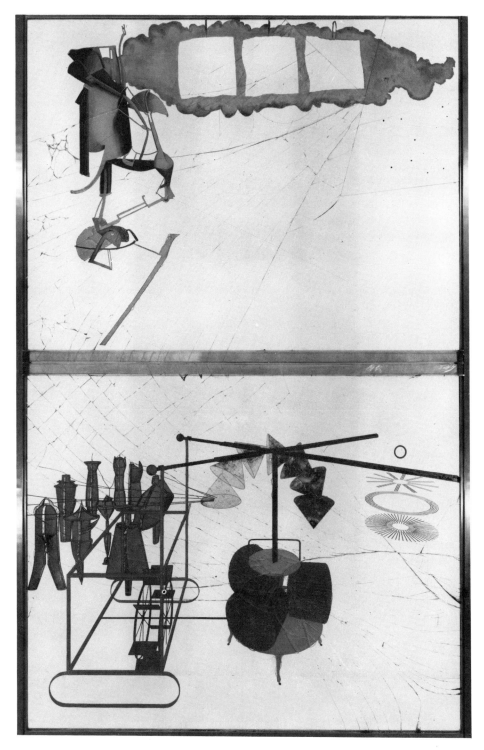

. . . [Duchamp] also seems to refute the idea that painting needs to be done . . . on canvas.

Marcel Duchamp, *The Large Glass* or *The Bride Stripped Bare by Her Bachelors, Even*, 1915-1923, oil varnish, lead foil, lead wire and dust on two glass panels (cracked). The Philadelphia Museum of Art (Bequest of Katherine S. Dreier). 109 1/4 x 69 1/8''.

Several Dada reviews—*Proverbe, Littérature,* etc.—and well-publicized evenings of mixed events in Paris theaters spread Dada's reputation in Paris. A number of exhibitions brought a new generation of artists, such as Arp, Ernst and Man Ray, to the attention of the Paris public. But deprived of any cohesion, and content to scandalize by ever more outrageous and propagandist acts, the "movement" that Dada seemed to have become in Paris quickly disintegrated into warring factions. One of these outrageous acts was the stealing of a wallet from a waiter at the Café Certa, the Dadaists' hangout. It seems that eventually the wallet was returned but not without endless reflections on what might constitute true Dadaist behavior. An evening in a Paris theater on July 6, 1923, ended in bloodshed as actors and Dada leaders of the Tzara group suffered blows from Breton and his cohorts. Bitterness, brutality and violence presided over the last manifestations of Dada in Paris.

The end of Dada in Paris did not kill the Dada spirit. Just as Dada had taken some of its ideas from Marinetti's Futurist Manifesto, some Dadaist ideas were in turn picked up by the Bauhaus and by the Surrealists. Tzara's memoirs further attest to the vitality of the Dada spirit in such remote places as Tiflis and Istanbul, which he visited in the 1920s. The Dada spirit, and particularly Duchamp's influence, is present in so much contemporary art from Pop Art to Conceptual Art that one must conclude with Richard Huelsenbeck: "What Dada was in the beginning, and what developed later, is totally insignificant in comparison with what it means today." And Hans Richter adds: "One or two generations later, Dada may 'mean' something else again!"[13]

Summing Up

Dada was not an art movement in the sense that Cubism was—it did not confine itself to producing new art. Nor was it a system of ideas like Marinetti's Futurism by which to change the appearance of painting. Yet Dada is surely one of the critical phenomena in twentieth-century art and its influence has not yet been exhausted. Why has it been so important? Because its aim was to free the mind and establish a constant questioning of the conventions of life as well as of art. Dadaist activities led to the ideas that:

Paintings did not have to be done on canvas. Duchamp found glass a challenging support (he could use both sides of it), while Arp abandoned the limitations of the rectangular format by nailing one thickness of shaped plywood on top of another.

Sculpture need not be a handcrafted object. For Duchamp, sculpture meant any object existing in actual three-dimensional space.

Chance could replace preconceived planning. Ernst, Arp and Schwitters seized on the found object and on found images to guide their work step by step.

Art could be made collectively and anonymously. Arp's and Ernst's *fatagagas*, the mixed theatrical events, were collective enterprises in which the idea of individual style as an essential ingredient of art was repudiated. (Braque and Picasso had already suggested this possibility when for a while they left their paintings unsigned.)

The sources of art were unlimited. Discards from nature, from the urban environment, manufactured objects or their maplike traceries, newsprint, etc., could equally serve the artist's purpose. (Collages by Picasso, Braque and Gris had paved the way for this idea.)

The raw material of music was sound. Any sort of aural impression, children's noise-makers, voices, words out of context could be incorporated into a "musical composition." (Cubist and Futurist poetry and Russolo's noise machines were undeniable precedents.)

Quality in art was irrelevant. Duchamp plucked items for exhibition from the everyday world that would resist esthetic evaluation (bicycle wheels, bottle racks, typewriter covers, etc.), giving the observer the choice of either foolishly dismissing them for not being "quality" art or, better, of asking himself when an object ceases or begins to be a work of art.

Durability was an unnecessary attribute of the arts. Few of the original Dadaists' creations are still in existence. Duchamp destroyed most of his Ready-mades, assuming that their interest lay in their idea content, not in the pleasure they might give to those looking at them.

Painting and sculpture were old-fashioned categories. Duchamp's rotating disks had features of both painting and sculpture, but were neither. (Picasso's painted constructions had also alluded to this idea.)

There was no sharp distinction between actor and spectator. In a loosely conceived Dada spectacle, designed to provoke reactions in the audience, the roles might be reversed.

There was no sharp line between art and life. This fundamental Dadaist idea was the most subversive of all because it forever prevented limits from being set on what constituted art. Excerpts *of* life (Dada behavior) were as much art as excerpts *from* life (Ready-mades).

By questioning artistic means in painting, sculpture, music, writing and the performing arts, by rejecting style, quality and durability as goals, the Dadaists were depriving art of all of its traditional attractions and attributes. By abolishing boundaries and categories, they were further confusing their critics. In interpreting Dadaism, the old-fashioned methods of criticism failed. The Dadaists meant in their art and lives to express ideas and not to satisfy the esthetic tastes of society. Ironically, when many of their principles were rediscovered in the late 1950s and 1960s, the artists who

applied them (Jasper Johns, Robert Rauschenberg, Arman, Claes Olden-
burg, Roy Lichtenstein, etc.) found almost instant recognition in the art
world. More recently, the original Dada message has been retrieved by Con-
ceptual artists whose work does not easily fall into a sociopolitical frame-
work.

BRETON AND THE SURREALISTS,
c. 1924-1940 chapter 7

Who Was André Breton?
Breton's First Manifesto of Surrealism
Breton's Artists: First Wave
Realignment and Second Wave
Consecration and Dispersal
Summing Up

The signing of the armistice, November 11, 1918, opens the door to a new era. Oblivious of past sorrows and ignoring ominous signs ahead, Parisians are seized with an unbridled gaiety. A young singer in a straw hat, Maurice Chevalier, sets the tone of the day with his carefree songs. While movie fans applaud on the big screen a funny little man named Chaplin, the public discovers the rhythms of jazz and the Charleston. At the Casino de Paris, Mistinguette shows off her perfect legs, and at Bouffes Parisiennes, Gallic humor pervades a new musical comedy, Phi Phi.

For the bourgeois, the antics of the Dadaists in Paris may have looked like just another sparkle of regained effervescence. But for a new generation of intellectuals, Dada had a deeper meaning. André Breton (1896-1966), who saw himself as the intellectual heir of the poet Guillaume Apollinaire, discoverer of the most advanced art of his day, had embraced Dada as one of the manifestations of the "new spirit." Breton observed the Dada adventure from the inside while trying to shape its destiny. Eventually he stopped being a participant. He went into temporary retreat and, after a pause, launched the First Manifesto of Surrealism.

Who was André Breton?

Breton came from Brittany. In Vannes, he attended the *lycée* (the French high school system ends with the choice between a major in the sciences or philosophy). He took few philosophy courses, he told Tristan

Tzara in their correspondence, but familiarized himself with psychiatry, then a new branch of study. ("Freud and Kräpelin have affected me very deeply."[1]) When the First World War began, he was in medical school in Paris, meanwhile having acquired a certain fame for his poetry. (He refers to the poet Paul Valéry as "my old friend."[2]) He served as an orderly in a psychiatric military hospital, where he met Jacques Vaché, with whom he developed an intense friendship, of the sort that sometimes grows between two opposite types of youths, one naive, passionate and idealistic, the other blasé and demoralizing. In 1919, Vaché died of an overdose of opium, and his death dealt a shocking blow to Breton. At that time, Tzara's vituperative language was just beginning to be known to the small circle of friends around Breton. Breton took the initiative in writing to Tzara, and immediately sought with him the same bond he had had with Vaché. In his very first letter, he communicated to Tzara the names of his intellectual heroes ("I believe in the genius of Rimbaud, Lautréamont and Jarry"*) and of his favorite painters ("My favorite painters are Ingres, Derain, I am in tune with the art of de Chirico"†[3]). He also told Tzara that he had loved Apollinaire intensely. Indeed Apollinaire, who had died of pneumonia two days after the Armistice, left a gap, both intellectual and personal, in the artistic life of postwar Paris.

The deaths of Apollinaire and Jacques Vaché surely had something to do with Breton's search for a new soul mate, and no doubt Tzara, with his scandalmongering, his position in favor of all contradictions, his hatred of conventional thinking, was a likely candidate. Perhaps Tzara had opened the door to "this disappointing God, somewhat snickering, and terrible in any case," and Dada was the new spirit prophesied by Jacques Vaché in his letter of December 19, 1918 to André Breton.[4] Whatever his motivations, in 1919 Breton, cast so far as a romantic hero with long brown hair tossed back like a lion's mane, put on his nose a pair of green-tinted glasses, which

* All three were late nineteenth-century writers with a small following that Breton did much to enlarge.

Arthur Rimbaud (1854-1891) had completed his *oeuvre* at twenty. His poetry was rich in dream images.

Lautréamont (1846-1870), pseudonym of Isidore Ducasse, created in *Chants de Maldoror* a new genre in which he attempted to render the hopping and skipping about of uncontrolled thoughts.

Alfred Jarry (1873-1907) was an adolescent when he wrote his most famous play, *Ubu Roi.* Ubu, portrayed as a cynical, heartless, power-seeking and ridiculous fat-bellied little man, is still today the prototype of the anti-hero.

† *J.-B. Ingres,* nineteenth-century academic French painter who never wavered from classicism in an era of Romanticism.

André Derain, a Fauve painter who was one of the first to become interested in African sculpture with Picasso, Braque and Matisse.

Giorgio de Chirico, see p. 129.

gave him a serious, somewhat *recherché* appearance, and thereupon became a Dadaist. Tzara's writings were included in *Littérature*, while Breton's entered the pages of *Dada*. For the next few years, Breton asserted himself as the voice of the avant-garde in Paris. It was he who analyzed the works of Cubist painters as they filed by during the first Dadaist theatrical evening after Tzara's arrival in Paris. It was at his suggestion that the bookstore Au Sans Pareil began exhibiting the creations of the Dadaists. He wrote the catalogue of Max Ernst's first Paris exhibition. He presented Dada in the pages of the French literary review *NRF* (Nouvelle Revue Française). And it was his idea to gather a congress of writers, painters and musicians thanks to whom the "modern spirit" would be defined. Although the congress never took place—forces against Breton's growing influence with Dada were gathering momentum, and the whole plan of an organized assemblage of artists was against the Dada idea of sabotage—its preparation served Breton well. He acquired a precious documentation on current happenings. In his appreciation of this event, first written for a speech that he delivered in Barcelona on November 17, 1922, Breton admitted: "Out of a large number of productions . . . I had thought I could extricate a minimum of common affirmations, I was burning to draw out of them for myself a trend (*une loi de tendance*),"*⁵ which he did, and reported as follows: "I believe that Cubism, Futurism and Dada are not finally three distinct movements, that all three participate in a more general movement, the meaning and scope of which we do not yet know precisely."⁶ The new Apollinaire thus revealed his ambitions and, in 1924, announced that this general trend was toward "Surrealism"—a term he did not even have to invent, as Apollinaire had already used it in describing his play *Les Mamelles de Tirésias* as a Surrealist drama.

The shaky foundations of rationality were not solely contained in the absurdity of wars—or for that matter in the collective amnesia that follows wars. From many directions, new evidences had been collected pointing to the frailty of logical thinking. Since Freud's publication of The Interpretation of Dreams *in 1900, the mechanisms of the unconscious had been investigated. Occult phenomena were also under renewed study. Meanwhile such playwrights as Artaud in France and Pirandello in Italy deal with the separation of the self, while Joyce's* Ulysses *and Eliot's* The Waste Land *explore the multiple levels of consciousness.*

* Breton also said that although artists are not created by art movements, it was quite rare for the most remarkable artists to remain immune to them.

Breton's First Manifesto of Surrealism

Parallel with his Dadaist activities, and in some ways secretively, Breton carried out experiments to ascertain the sources for the breakdown of logic in Dadaist productions. For example, in 1919, Breton, having become aware that certain sentences completely out of context come to mind at the edge of sleep, decided to jot them down. He and a friend, the writer Philippe Soupault, began to transcribe the flow of unpremeditated prose stimulated by one of these sentences, staying with the project sometimes ten hours at a stretch, never reading over the material, never erasing a word, stopping arbitrarily at the end of the day. To their amazement such "automatic" writing revealed the existence of extraordinary creative powers below the conscious level of thought. Also during the early 1920s, Breton would often gather his friends for seances of table-turning and hypnosis. Two men appeared to respond readily. René Crevel dreamt aloud disconnected scenes of rape, violence and murder; Robert Desnos talked with distant persons (including Marcel Duchamp) and reported their answers. In the course of these meetings, they recounted and discussed each other's dreams, and revealed to each other their true feelings ("truth game") just to see what would happen. Then, the poet Aragon relates in *Paysan de Paris*,[7] exhausted, bored and quite drunk, they would set out on aimless walks through the dark empty streets of Paris, awaiting "the unbelievable incident," what Duchamp called the geometric focus of coincidences, and ready for the magic encounter.

By escaping from the constraints of watchful thinking and purposeful behavior, or, to quote Breton, from servitude to immediately perceived sensations—from what one hears, sees, etc.—Breton and his friends were able to reach a state of total openness, to become liberated. When this happened, dreams and consciousness were no longer two separate contradictory states, but a continuing manifestation of absolute reality, or "surreality."

Out of these experiments and shared experiences, fortified by Freud's writings on the nature of the unconscious, Breton announced his conclusions in a long essay that he called the "First Manifesto of Surrealism." In this text, Breton first indicts society, which stifles the richest qualities of man, innocence, spontaneity and imagination, in the name of realism, progress and civilization.* He then attacks the products of conscious thought, from the organization of society to the writing of novels, as enslaving constructions of man. He claims that in dreams and in other products of the imagination—which occupy such a large part in life—can be found the keys to true progress, that is, improved knowledge of the processes of the mind. He admonishes poets to explore these subterranean levels, which Freud calls the

* R. D. Laing: "The perfectly adjusted bomber pilot may be a greater threat to species survival than the hospitalized schizophrenic deluded that the Bomb is inside him."[8]

unconscious. He goes on to define Surrealism as "pure psychic automatism by which an attempt is made to express verbally or in any other manner the true functioning of thought,"[9] and names poets who according to this definition have on occasion been Surrealists. Finally he enumerates the criteria of success by which to measure Surrealist achievement. "For me, the most successful Surrealist image," he writes, "is that which presents the highest degree of arbitrariness . . . that which it takes the longest to translate into practical language either because it contains an enormous dose of apparent contradiction, or one of its terms is hidden, or the image, declaring itself to be sensational, is resolved in feeble terms . . . or [the image] possesses the character of hallucination, or it lends to the abstract the mask of the concrete or vice-versa, or it implies the negation of some elementary physical property, or it releases laughter."[10]

Shortly after the publication of the Surrealist Manifesto, a Surrealist bureau manned by the playwright Antonin Artaud* opened in Paris. All those were welcome who had encountered the marvelous in dreams, in hallucinations, in coincidental meetings, in abnormal behavior, etc. These extraordinary tales were for a while to feed the pages of the new Surrealist publication *La Révolution Surréaliste*. The bureau was open to the public for only a year.

The Surrealist Manifesto was soon to be interpreted as a bill of rights —for total freedom and nonconformism and against the tyranny of reason. Its ideas concerning creation, its emphasis on an interior vision, paved the way for the release of innumerable sources of inspiration for Breton's contemporaries among poets and artists.

The First Manifesto of Surrealism was addressed primarily to poets. However, there were in its pages hints as to which artists in 1924 would be welcome in the castle of the marvelous: "Picabia comes to visit," Breton writes, "and just last week a certain Marcel Duchamp was received in the great hall of mirrors. As for Picasso, he hunts on neighboring grounds."[11] Such tipping of the hat to three men who were his seniors and in no need of his support is much less significant than a footnote listing several new names on the Paris art scene of the early 1920s. They are Chirico, Klee, Man Ray, Max Ernst and Masson, a remarkably prescient list.[12]

Breton's Artists: First Wave

Guillaume Apollinaire's comment in an issue of *Soirée de Paris* that Chirico was the most astonishing painter of the young generation had not

* Brilliant but deeply troubled playwright who inaugurated the Theater of Cruelty. He was enthusiastically welcomed by Breton in 1925 and expelled from Surrealist ranks a year later—allegedly for seeking financial help for his productions from Swedish diplomats but also for his involvement in drugs.

"For me, the most successful Sur-realist image is that which presents the highest degree of arbitrariness. . . ."
(André Breton)

Giorgio de Chirico, *The Regret*, 1916, oil on canvas. Munson-Williams-Proctor Institute, Utica, New York. 23 3/8 x 13".

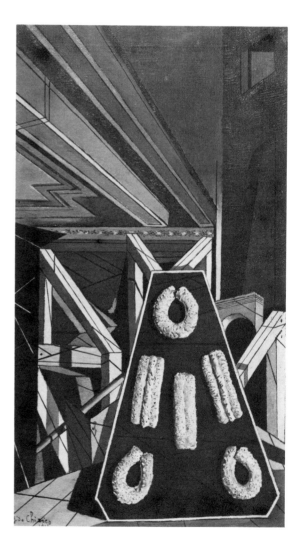

fallen on deaf ears. Breton was one of the first to acquire one of his works, *The Enigma of a Day* (1913). Giorgio de Chirico (b. 1882), an Italian national, had lived in Paris in 1913 and had become a close friend of Apollinaire. While in Paris, he had produced paintings that showed with naive precision empty piazzas with arcades and other architectural elements as static and unreal as settings frozen for eternity. Although not naive in a cultural sense (he was to write in the 1920s a philosophical novel called *Hebdomeros*), Chirico, like the Cubists he frequented, knew the Douanier Rousseau and his meticulously painted pictures such as *Sleeping Gypsy.*

Back in Italy during the First World War, Chirico pursued such themes, occasionally peopling his urban scenes with mannequin figures or stone effigies with long black shadows. He also started to include paraphernalia partly inspired by the goods of bakery shops and fruit stands, and partly by geometers' tools, which when brought together in a mysterious interior had no more affinity with one another than the strange perspective views in which they were depicted. These composite memory paintings Chirico called "metaphysical." Shortly after the war Chirico had an exhibition in Rome that was far from well received. Breton and his friend, the poet Paul Eluard, were among his rare supporters. Breton even asked Chirico to send him a drawing to accompany a book of poetry he was about to publish. But, by 1919, Chirico was beginning to abandon his "metaphysical phase" in favor of a "great master" imitative style. The drawing he sent was clearly unacceptable to Breton. In one of many turnabouts, Breton started to attack Chirico, calling him a coward and a cheat and accusing him of amorality and greed.* Moreover, Breton gave him credit only for a temporary "rare faculty of discrimination exerted on the most troubling external appearances," and for having known for a while "how to bathe his images in the propitious light of an eclipse, of early dawn and lightning."[13] Chirico returned to Paris in 1925 and moved outside the Surrealist orbit. Nevertheless, the influence of his early work looms large in the creations of several Surrealist painters.

Another early interest of Breton was the Dadaist Max Ernst (b. 1891), whose collages, which apparently arrived in Picabia's Paris home in the presence of Breton sometime in 1921, were greeted as a revelation. Bringing together on canvas several incompatible realities on a plane that appeared to suit them not at all was exactly like writing such a sentence as Breton's "On the bridge the dew with the face of a kitten is swinging," or the poet Soupault's, "The church stood erect and glowing like a bell" or Roger Vitrac's, "In the burnt out forest, the lions were cool."[14] As soon as Ernst was able to move to Paris, he entered the Surrealist circle. His relationship with Breton was often tense. He did not obey the rules set up by Breton. The

* Chirico has been known to plagiarize his own work on occasion.

Dadaist revolution, with its antisocial and anarchic attitudes, was for him a thing of the past, especially since he felt the stigma of being a foreigner, and a German one at that. He settled for a revolution limited to art. Receptive to new sources of inspiration, he tells how one day, confined by pouring rain to a hotel room, he became obsessed by the lines on the wooden floor. After spreading pieces of paper at random on the floor, he obtained a series of drawings by rubbing a lead pencil on them over the floor (*frottages*). Looking attentively at the drawings, he narrates, he was shocked by the intensification of his visionary powers and by the succession of contradictory images that kept appearing on top of one another. So was born his now famous *Histoire Naturelle*. He then applied the method to oil painting by placing wood under a canvas and "grating" away paint with a mason's trowel (*grattages*). Ernst's ceaseless inventions were exhibited in all Surrealist shows of the 1920s and 1930s. When the Second World War broke out, Ernst, after being interned in France twice, was able to join Breton and other Surrealists and intellectuals in Marseilles, and with them finally landed in the United States. He spent the war years mostly in Arizona, with the painter Dorothea Tanning,* and returned to France after the war.

Man Ray (b. 1890) arrived in Paris in 1921 and, met by his New York friend Marcel Duchamp, was immediately catapulted into the Breton group. In his autobiography,[15] he recalls the meeting in a Paris café and the evening of frolicking with his new friends in the gayest, wildest and most dizzying way imaginable. Thanks to them, he soon had a show of his work in a Paris gallery, but nothing was sold. A trained photographer, he supported himself at first by photographing other artists' works, and eventually by fulfilling commissions for portraits of fashionable Parisians, meanwhile venting his Dadaist humor by the confection of "useless objects," such as the *Gift*, an iron with tacks glued on its smooth surface, the *Catherine Barometer*, etc. He also used photography in experimental ways, obtaining enigmatic images by exposing to light objects placed on sensitive paper (rayograms). Breton immediately recognized the Surrealist quality of his work, spoke of Man Ray's ability to corner "appearance or nonappearance,"[16] and frequently included his imagery in the pages of *La Révolution Surréaliste*. Man Ray moved not only in Surrealist circles, but also among the Paris expatriates—Joyce, Hemingway, Pound, Gertrude Stein, etc.—whom he photographed. His autobiography is a *Who's Who* of the Paris intelligentsia during the era between the wars. At the outbreak of the Second World War, Man Ray left France, spent several years in Hollywood (where his former friend and patron Walter Arensberg had moved) and returned to

* Max Ernst's interesting love life included an affair with the poet Eluard's wife Gala, who later married Dali, another with the Surrealist painter Leonora Carrington, and a brief marriage to Peggy Guggenheim. He married Dorothea Tanning in 1947 in a double ceremony—each man acting as best man for the other—with Man and Juliet Ray.

Paris in the early 1950s. Some of his "useless" objects—*Board Walk, Object to Be Destroyed*—reappeared in a Paris Dada exhibition in 1957, and had a decided impact on a young group of artists whom the critic Pierre Restany has called the New Realists.

Breton first encountered the work of André Masson (b. 1896) in the context of a Cubist exhibition. Unlike Man Ray and Ernst, Masson had remained aloof from Dada. A native of Ile de France, he had studied painting in Belgium and felt the pull of the Belgian Expressionist James Ensor, before discovering the Cubist movement in Paris. *The Four Elements*, which Breton acquired in the early 1920s, shows this conflicting influence. As usual with Breton, interest in an artist's work led to a meeting with the artist, who, it seems, fell under the persuasive influence and magnetic personality of the poet. For shortly after Masson encountered Surrealism, he began to adapt automatic writing to drawing, fulfilling what he called later "a dreamlike inclination, a longing to be infinite, a taste for the secret within the visible, the aim to be at the same time perceptible and concealed."[17] Until his break with Breton on political grounds, his doodlelike drawings—in which the hand seems to be following orders from a strange region of the mind—appeared regularly in the pages of *La Révolution Surréaliste*, and illustrated a number of collections of Surrealist poems. Even after the break, Breton maintained an enduring esteem for Masson and his work. In 1941 Breton was to write that "the essential discovery of Surrealism had been that without any preconceived idea, the pen rushing to write, or the pencil running on paper, weaves an infinitely precious substance replete with all the repressed emotions of the poet and artist."[18] Masson and Breton met again in the United States during the Second World War. There Masson exhibited his automatic drawings and some paintings, incorporating traces of sand. He has often been given credit for suggesting new paths to the then arising generation of American Action Painters.

That Klee should be mentioned in a footnote of the First Surrealist Manifesto with Masson, Ernst, Man Ray and Chirico indicates the tenuous thread that in Breton's mind tied together Surrealist artistic production. Breton had heard of Paul Klee through the Zurich Dadaists (Arp was a friend of Klee's and Kandinsky's) and had bought *Der Blick des Ahriman*, one of five works exhibited by Klee in a Paris gallery in 1920. Klee's little pictures could rightly be called "a complete museum of dreams" (as René Crevel said in 1929). As realizations of the artist's idea that a picture is not to be a copy of the visible but must render visible, they fitted Breton's declaration in *La Revolution Surréaliste* that pictures must come from an interior model. In conjugating various textures, in offering contradictory perspectives, in occasional references to naive art, they paralleled other Surrealist creations by Ernst and Chirico and justified Breton's endorsement of Klee as an occasional Surrealist. But Breton had not the hold on Klee that

he had on his Parisian friends. Klee had begun teaching at the Bauhaus in 1920 and lived first in Weimar and then Dessau in Germany. Furthermore, his pictures had a refined and calculated appearance that showed little if any trace of automatism. And, most important, the process that had led Klee to his particular expression, and which he was then expounding to his students, had little to do with Surrealism. In particular, the musical correspondences present in so much of Klee's work could not possibly appeal to the Surrealists, who seem to have shared, at least in their public pronouncements, a deaf ear for music. Still, the first monograph on Klee in 1929 contained testimonies by several Surrealist poets, and his first one-man show in Paris was held under Surrealist patronage.

All these artists were gathered for the first show of Surrealist painting at Galerie Pierre from November 14 to 26, 1925. The show also included two important new recruits, Miró and Arp, as well as the artist who, according to Breton, had done more than anyone else to break away from the customary appearance of things—Pablo Picasso. Picasso's participation undoubtedly raised the show to an exceedingly high level of quality but did not serve to clarify what Surrealist painting was about. Breton must have sensed the difficulty when he wrote at about this time that it would be impudent to subject Picasso's methods to the rigorous system of criticism that he, Breton, proposed.*

Of Miró's production in 1925, the same thing could not be said. "In 1925," Miró has told an interviewer, "I was drawing almost entirely from hallucinations. . . . Hunger was a great source of these hallucinations. I would sit for long periods looking at the bare walls of my studio trying to capture these shapes on paper or burlap."[19] Miró, (b. 1893) had come to Paris from Spain in 1919. Through Masson, whose neighbor he became on the rue Blomet, he met the Surrealists. (*The Hunter* entered Breton's collection in 1924.) Carried away by the new ideas they brought and the poetry they discussed, he began to move away from naive realism, enclosing transparent shapes within thin wavy lines and floating them on an indeterminate painterly ground. "An important state in the development of Surrealist art,"[20] Breton was to say of these new works. Far from dogmatic, Miró was soon to find Surrealism too rigid for his temperament. Over the years, he developed a repertory of symbolic forms, disks, crescents, stars, etc., outside of the Surrealist milieu. In 1975 he was still very active and living in Majorca.

Arp (1887-1966) was not in Paris for the first Surrealist show. However, his participation in Dada had given him a familiar aura in Surrealist circles. By 1925 he had refined his early wood reliefs; painted in clean enamel colors, they contained disparate elements, lips, navels, mountains, clouds,

* Whether Picasso's *oeuvre* up to that time could be called Surrealist or not is less important than the fact that the artist had broken through traditional representation.

André Masson, *Combat de Poissons*, 1928, ink. Photograph courtesy Lerner-Heller, Blue Moon Gallery. 12 1/2 x 16 1/4″.

coexisting on the background like incomplete sentences. In 1926, Arp and his wife, Sophie Taeuber-Arp, settled in the Paris suburb of Meudon. Arp began to make sculpture. Out of plaster, or in marble, he fashioned smooth rounded shapes, evoking the roundness of a breast, the slope of a shoulder, the curve of a back, which he called concretions, in their allusion to a continuous process of growth and transformation. Although one of the most faithful members of Breton's group (he also wrote automatic poetry), Arp likewise took part in exhibitions of abstract art sponsored by Abstraction-Création (see chapter 3). Fleeing France from the Nazis, he moved to Switzerland, where his wife died in 1943. He later remarried and remained in Switzerland until his own death in 1966.

The year 1925 also marked the appearance of Yves Tanguy. Stranded in Paris with his friend, the poet Jacques Prévert, after a stint in the military, Tanguy (1900-1955), destitute, accepted odd jobs, read voraciously and spent his free time—he was unemployed more often than not—looking into gallery windows (the sight of a Chirico is said to have determined his career), and doodling on the paper tablecloths of Montparnasse cafés. Thanks to a rich protector, he found an atelier and taught himself to paint. The Surrealists soon welcomed him in their ranks, and it was in his atelier that they began to play the game of "exquisite corpse."* In the game, each participant added a word, or a bit of a drawing to one started by his neighbor, and so a poem or a drawing was born, with a disorienting collusion of words or images. In 1927 Tanguy had his first exhibition, for which Breton wrote an introduction in which he described Tanguy's paintings as filled with "the desert's dazzling furniture." Tanguy's favorite themes over the years were to be of more or less dense groupings of meticulously painted organic shapes (biomorphic) that touch but do not seem to bear weight, on flat, calm expanses of gray beach and sea (the setting of his youth in coastal Brittany). Tanguy, in the 1930s, met the American artist Kay Sage, and in 1940 came to live in America, where he remained until his death in 1955.

In 1928 Breton published a collection of his critical writings on the artists mentioned so far. This text, the numerous prefaces for his friends' exhibitions, the opening of a Surrealist gallery, other shows of Surrealist art, his ceaseless efforts to introduce artists to collectors† and dealers, and his acquisition of their work—all these activities bore fruit. Surrealism spread. His artists, although not rich, acquired a following. If Breton's ambition was to become the new Apollinaire, one could say that by 1928 he had

* Translation of "*cadavre exquis*," the most famous example of the game. In full it read "*Le cadavre—exquis—boira—le vin—nouveau.*"

† Breton was the advisor of the collector Jacques Doucet, first owner of *Les Demoiselles d'Avignon* and custodian—until his death—of an extensive documentation on Dada and Surrealism. This documentation is now known as the Bibliothèque Littéraire Jacques Doucet, Paris.

Miró, cartoon for *Dutch Interior I*,
summer 1928, charcoal and graphite
pencil. The Museum of Modern Art,
New York (Gift of the artist).
24 5/8 x 18 5/8".

achieved his goal. He was the chief of a new movement. Yet as Duchamp once said, "movements always begin by the formation of a group and end with the dispersion of individuals."

An anticolonialist war in Morocco (1926), the trials of anarchists in the United States (1921-28), the summary dismissal of Trotsky after Lenin's death (1922), these and many other causes célèbres *stir the conscience of leftist intellectuals. Was Surrealism to be a revolution of the mind or that of the world of fact? What is the function of creation?*

Realignment and Second Wave

Willy-nilly, Breton was forced after 1926 to give thought to issues far removed from an abstract concept of man's freedom. The First Manifesto of Surrealism did suggest that ideally there was no contradiction between the inner and the outer world, but it was not explicit enough to offer a code of behavior. On Breton's left, there were writers who would have liked to use Surrealist publications to show their sympathy for causes of justice and self-determination all over the world. They accused Breton of being a "revolutionary phrase-maker." On his right, artists whose popularity was growing with the help of the moneyed classes were wary of expressing themselves in public on matters that did not concern their art. Breton's excommunication of friends who refused political commitment, his dictatorial way of deciding the drink of the day as well as the "line" of the day, also began to arouse serious strife in the ranks. Thus, in early 1929, still heady with success from a major Surrealist show, Breton, the leader of a flock now some thirty strong, was forced to re-count his followers and redefine his positions. The Second Manifesto of Surrealism appeared in 1929. Many Surrealist painters deserted him. According to Maurice Nadeau, some, like Miró and Masson, were "opposed to common action." Ernst was among those who "advocated the pure and simple pursuit of Surrealist activity."[21] Taking advantage of the confusion, new men, some recently arrived on the Parisian scene, were about to turn Surrealism in new directions, and thanks to them, the movement remained in the limelight. Among these new exponents were the painters Magritte and Dali, and the sculptors Calder and Giacometti.

René Magritte (1898-1967), a Belgian, arrived in Paris in 1927 after a stint as a designer of wallpaper. Thanks to a rich poet-friend, Mesens, he had been kept informed of Surrealist activities in Paris and read their periodicals. During his stay in Paris he created over sixty paintings which, in spite of their near-photographic approach, Breton embraced as Surrealist. "The nonautomatic procedure," he writes, "the totally deliberate approach

buoys up Surrealism at this time. Alone in this tendency, he has approached painting in the spirit of the natural sciences [*leçons de choses*]. . . . He questions the visual image whose deficiencies he likes to underscore and whose character—dependent upon figures of speech and thought—he likes to point out."[22] Breton wrote an introduction to Magritte's first show in Paris. However, Magritte did not stay. The collapse of the gallery and alleged difficulties between Breton and Mme Magritte (she appeared at Surrealist meetings wearing a crucifix around her neck) decided his return home. In Brussels he pursued his work until his death in 1967.

"The surrealist group," Dali wrote, "appeared to me the sole one offering me an adequate outlet for my activity. Its chief André Breton seemed irreplaceable. . . . I was to make a bid for power."[23] Dali (b. 1904), "the Divine," as he has often been called, had had a notorious if brief artistic past when he descended on Paris in 1929. The star pupil at the Academy of Barcelona, the hero of the local avant-garde, which included the poet Federico García Lorca and the film director Luis Buñuel, he had already had a one-man show in his country and made a movie with Buñuel called *Un Chien Andalou*, before moving permanently to Paris. He tested Breton's squeamishness by showing him a painting that included a figure seen from behind whose drawers were bespattered with excrement. "Yet," said Dali with the false naiveté that was to become his trademark, "this painting was done . . . following as a criterion and norm of their arrangement only the most automatic feelings which their sentimental proximity and linking would dictate."[24]* He further put Breton to the test by using paradox not only in his utterances—favoring academicism over experimentation, Gaudi's architecture over functionalism, decadent *fin-de-siècle* art over primitive art from Oceania—but also in his paintings. To look at a Dali of that period is to confront a strange phenomenon: nowhere on the picture surface can the viewer be satisfied that he is looking at a stable image. Interpretations are multiple, images melt and reappear as something else. The air of unreality was further refined by Dali's awareness of the instability of images *per se*. (Possibly, the films he made with Buñuel were revelatory; the movie medium which is perceived in time permits such transformations through manipulation of the sequence of successive frames or images.) Breton and his friends now had in their midst a lively but subversive element. For some years, they rejoiced in his "paranoia-criticism." In 1934, Breton considered him the master impulse in the renewal of Surrealist experiments. However, when either in a spirit of irony (Breton was after all something of a dictator) or in earnest, Dali began to extol autocratic regimes and Nazism, his rela-

* A temperamental affinity between Dali and the Pop artist Andy Warhol has often been noted. Both have carried out visually to the most radical consequences the ideas of the movements in which they have participated.

tionship with the Surrealists soured, and eventually Breton's praise was replaced by venom.

Still, not only was Dali's participation good for public relations (his influence was felt in fashion, advertising and design), but one of his suggestions—the manufacture of articles only found in dreams—spurred among the Surrealists a renewed interest in the confection of nameless "things," variations on the idea of the Ready-made. Man Ray, Tanguy, Arp, Miró, Breton himself, and even Picasso indulged in making these witty objects— poem objects (Breton), hybrid objects (Picasso)—in which found parts often played a catalytic role. In May 1936 at the Galerie Charles Ratton, the public was invited to view these creations, which also included minerals, carnivorous plants, fetishes from Africa and Oceania and works by two sculptors, Alberto Giacometti and Alexander Calder.

Calder (b. 1898), a Philadelphian, had studied engineering before turning to sculpture. His motorized circus was shown at the Humorist salon in Paris in 1927. In the early 1930s, he created his first moving sculpture, "the motorized mobile that Duchamp liked," noisy, grinding, repetitious in its movement. With Miró and Arp, he next exhibited wind-activated sculpture made of thin sheets of metal cut into organic shapes and suspended from wires. The creation of mobiles and stabiles, in color and in black, small and large, figurative and abstract, has kept Calder active to this day.

Giacometti (1901-1966), a Swiss national, had lived and worked in Paris for several years, alternating painting, drawing and sculptural activities of an academic nature, when the strange experience of becoming gradually unable to capture a likeness from nature led him to work from memory. Freed from a model, Giacometti temporarily lost interest in the appearance of things and now gave form only to those images that he claimed offered themselves complete to his imagination. One of these early works was a suspended ball hung inside an open cube that by oscillating gently stroked the inside of a crescent form (*The Hour of Traces*, 1929). Enigmatic, erotic and humorous, this impeccable example of Surrealist creation reconciled interior and exterior space (or reality) and materialized the continuum between the two by means of a penetrable enclosure, the cube-cage. During a scant five or six years of Surrealist work, Giacometti created a number of "inscapes," landscapes of the mind that he often set on miniature stagelike platforms and framed within open cages or houses as in *Palace at Four A.M.* (1933), although in other instances his objects were either without frame or base or both. But the vagueness of his memory and the increasing abstractness of his forms led Giacometti back to working from a model—a decision considered anathema by the Surrealists. During the Second World War, he began to resolve the fluidity of his vision, first by producing minuscule figures again from memory, then by drawing. Having captured the substance of his figures, he then increased their scale while

top: André Breton, Jacques Hérold, Yves Tanguy, Victor Brauner, *Cadavre Exquis*, 1934. Private collection, Paris.

bottom: René Magritte, "Words and Images," from a page in *La Révolution Sur-réaliste*, no. 12, December 1929. (Magritte's text is given in translation to the right of the reproduction.)

Une image peut prendre la place d'un mot dans une proposition :

An image can take the place of a word in a statement:

"The is hidden by the clouds"

Un objet fait supposer qu'il y en a d'autres derrière lui :

An object can suggest that there are others behind it.

Tout tend à faire penser qu'il y a peu de relation entre un objet et ce qui le représente :

l'objet réel *l'objet représenté*

Everything tends to make one think that there is little relationship between an object and its representation:

"the real object" "the represented object"

retaining their elongated filiform proportions and their appearance as if seen indistinctly from far away. Monumental as they became in the 1950s and 1960s, Giacometti's bronze figures of walking men, women demurely standing on their rectangular platforms, and crowds, and even his starving cats and dogs maintain their psychological distances from the onlooker particularly when seen close-up.

The 1930s see the slow recovery from the Great Depression and the "gathering of the storm" that will culminate in the 1939 "phony war." Society helplessly watches the rise of Nazism in Germany, the triumph of Fascism in Spain, of Stalinism in Russia. The warnings of a few intellectuals, Breton, Malraux, Sartre, etc., are drowned in confusion. Picasso's Guernica (1937), seen at the Paris International Fair, may have touched its viewers but spurred few to action.

Consecration and Dispersal

Breton's inability to dictate a moral line of conduct to his friends left him alone to choose a path of action for himself. In the 1930s, more often than not, he deserted the Paris cafés to assume a new role—that of speaker on Surrealism. Fired by Breton's ideas, groups formed in various capitals. He was invited to lecture, to read Surrealist poetry and to help arrange Surrealist exhibitions. In Zurich (1934), Prague (1935), in the Canaries (1935), in Copenhagen (1935), in Mexico (1940), in Brussels (1934, 1935), in London (1936), he gave impetus to Surrealist activity and discovered new recruits, new poets, new artists for the movement.

The results of Breton's proselytizing were reaped in the United States. One of the most important consecrations of Surrealism took place in New York in 1936. There the first director of the recently founded Museum of Modern Art, Alfred Barr, put together a mammoth show—it included some seven hundred works by a hundred artists—entitled *Fantastic Art, Dada and Surrealism.* The opening, according to Man Ray who attended it, was a great social as well as artistic event. Streams of people in evening dress poured into the museum. The press was delighted with the controversial aspect of the exhibition, although snide in its comments: "Many persons attending the preview found some of the conceptions hard to follow," said the *New York Herald-Tribune.*[25] Entitled "The Fur-lined Cup School of Art Gets the Spotlight," and illustrated by a photograph of a cup and saucer lined with fur by a young Swiss girl named Meret Oppenheim, the article conceded that experts in modern art were unanimous in saying that the show was among the most important to be held in the United States. Sin-

top left: Hans Arp, *Head of an Imp*, 1930, original plaster destroyed. Photo Etienne Bertrand-Weill.

top right: Alberto Giacometti, *Flower in Danger*, 1933, wood, plaster and metal. Alberto Giacometti Foundation.
21 7/8 x 30 3/4 x 7 1/8″.

bottom: Man Ray, *Rayogram (Rayograph)*, 1922. Photograph courtesy of Timothy Baum.

gled out besides Meret Oppenheim's Surrealist object were the works of Chirico, Miró and Picasso, and in particular, Miró's *Personage Throwing a Stone at a Bird.*

The detailed catalogue revealed the geographical extension of Surrealism at that time. European artists, in addition to the now familiar names, included Hans Bellmer, who added celluloid dolls to the repertory of Surrealist objects; Oscar Dominguez, who contributed decalcomania; and Wolfgang Paalen, who contributed "fumage" (smoke deposits of candle flame) to Surrealist techniques. England was represented by the sculptor Henry Moore, who since 1934 had grouped roundish perforated stones in complementary pairs or threesomes; and the United States, by Joseph Cornell and Noguchi in the early phases of their careers.

In introductions by Barr and the Surrealist poet Georges Hugnet, Surrealism was given genealogical respectability as the heir to fantastic art (Arcimboldo, Goya, Blake, etc.), with Dada as its direct ancestor and collateral relationships to the art of the insane and the very young.

Finally, and perhaps in illustration of the idea that Dadaism and Surrealism belong to a charming interlude of irrationality before our world went completely mad, Breton chose Paul Eluard and Marcel Duchamp to help him organize an International Surrealist Exhibition in Paris in 1938. The Galerie des Beaux-Arts was transformed into a Surrealist microcosm: in the courtyard, *Rainy Taxi* by Dali, containing a skeleton driver, a half-nude passenger and a sewing machine companion; along Surrealist Street, more department-store mannequins altered by Man Ray, Ernst, Duchamp, by a newcomer from Chile called Matta, etc.; the Central Hall, a dark grotto in which Surrealist works could be seen only by aiming a light at them; and assaulting the nonvisual senses, the recorded sounds of insane laughter, the odor of freshly roasted coffee. Visitors, and they came in droves, found themselves not only literally disoriented but, according to accounts of the time, did not know whether to laugh or be frightened. A year later, Breton was to bring out his *Anthologie de l'humour noir*, synthesizing even further the fundamental ambiguity of Surrealist thought concerning the tragicomic, the serious-lighthearted, the pessimistic-optimistic, the real-illusory aspects of life. The anthology's suppression by the pro-German Vichy government, the blacklisting and persecution of Surrealists by European officialdom were proof that Breton had been right in thinking that artists could not remain indifferent to the moral issues of their time.

Many of the early Surrealists met again in 1940 as they sought to flee from occupied France. Thanks to Varian Fry, some of them found temporary haven in the Chateau Bel Air near Marseilles and eventually reached the Western hemisphere. Breton, Ernst, Masson, Tanguy, Seligmann and others were reunited in New York where, thanks to friends in the art world, they were able to resume their activity. The galleries of Pierre Matisse,

Julien Levy and Peggy Guggenheim exhibited their work. The reviews *VVV* and *View* published their writings. However, the status of these artists was that of exiles and their sense of cohesion was waning. Those who benefited most from their presence were young American artists who had so long felt cut off from Europe and now had a sample of its art within reach. After the war Breton returned to Paris, where he resumed his quest for Surrealist talent and his leadership of Surrealist publications, exhibitions and related social and cultural activities. He never wavered from this course and remained active (though less than during the prewar and war years) until his death in 1966.*

Summing Up

In *La Clef des Champs*, Breton says that Surrealism was born from the affirmation of an unlimited faith in youth. The heroes of the past extolled by the Surrealists had all done their best work before they were thirty.

—The young Surrealists, having grown up in an atmosphere of hatred and revenge, were intent on remaking the world.

—The *tabula rasa* of the Dadaists was to be the basis on which to build the new world. This new world was to be free, its freedom to be achieved within and without—no complexes, no more false gods.

—To these ideas, artists of different backgrounds and nationalities rallied: ex-Dadaists like Arp, Ernst, Man Ray, Breton; antiromantics like Dali and Buñuel; as well as those like Masson, Tanguy, Brauner, Magritte, Seligmann and Delvaux, who had had nothing to do with Dada.

—The application of the dicta of Surrealism to artistic creation was difficult. Automatism yielded few results since concrete technical problems arose for the artist the minute he began to express himself, and what is now called Surrealist painting is an image that, loosely speaking, would seem to represent a nonrational state.

—To the extent that a painting represents something it remains narrative, even if it is the narrative of dreams, and as such falls into a long tradition of visionary or fantastic art—as the exhibition organized by Alfred Barr in 1936 at the Museum of Modern Art in New York set out to prove.

—However, Surrealism inaugurated a wealth of new processes—frottage, grattage, decalcomania, rayograms, the use of found objects in sculpture, to name a few. Many of these constituted shortcuts, and in this sense were Duchampian in their negation of the artist's need for form.

* Of Breton's private life little is known. His personal papers will not become available until fifty years after his death. He married three times and had a daughter named Aube ("Dawn").

—The content of Surrealist art has been generally the expression of man's suppressed desires and fears, and thus eroticism, scatology, death, birth and magic are frequent themes.

—Although pursuing a course in some ways distinct from Dada, which had eliminated categories, Surrealism provided painting with a new function, that of emptying the self. An understanding of this new function was destined to guide American artists in the 1940s and 1950s.

—Further, the illogical linking of parts in Surrealist paintings and drawings may have affected the way they were looked at. The viewer, scanning them for meaning, went on an imaginary trip over the whole canvas surface—as he would in all-over painting of the 1950s.

THE BAUHAUS: UTOPIA FOR A BEAUTIFUL LIFE, c. 1919-1932 chapter 8

The Birth of a School
First Stage of a Bauhaus Education
Second Stage of a Bauhaus Education: Workshop Training
The Final Stage of a Bauhaus Education: Architecture
Summing Up

The Treaty of Versailles, which terminates the First World War, imposes an enormous debt on Germany. Galloping inflation leads to a complete economic breakdown in 1923. Uprisings, revolts, putsches (including one by Hitler in Munich the night of November 8, 1923) rack its political life. Friedrich Ebert, a socialist, becomes the first president of the new Weimar Republic, February 19, 1919.

Around April 1, 1919, there circulated in the art schools of Germany an illustrated leaflet announcing the opening in Weimar of a new educational institution. Addressed to future architects, sculptors and painters, the proclamation contained in its two pages echoed the visual message of its cover, which showed a crystallike cathedral shape topped by three stars. "Let us create," one read, "a new guild of craftsmen without the class distinctions that raise an arrogant barrier between craftsman and artist. . . . Together let us desire, conceive and create the new structure of the future which will embrace architecture and sculpture and painting in one unity and which will one day rise toward heaven from the hands of a million workers like the crystal symbol of a new faith."[1] The signature below the proclamation was that of a young German architect, Walter Gropius, and the name of the new institution was the Bauhaus or House of Building.

An outline of the program followed, stressing the mastery of a craft, for "in itself [art] cannot be taught but the crafts certainly can be"; offering a workshop system with "constant contact with the leaders in the crafts and industries of the country"; promising a plan that would avoid rigidity and

145

replace the teacher-pupil relationship with a looser concept of masters, journeymen and apprentices; encouraging friendly relations among all outside of working hours by plays, lectures, poetry, music, costume parties with "a cheerful ceremonial"; opening the school to "any person of good repute without regard to age or sex whose previous education is deemed adequate by the Council of Masters . . . as far as space permitted."[2]

"This challenging call to action," recalls an applicant, "had a great appeal to idealistic youth, and young people came to the school from all over the country. They wanted to sample the new freedom in educational methods, learn a trade in one of the Bauhaus workshops and engage in communal activities."[3]

Overnight, the yet nonexistent school acquired a particular mystique.

The Bauhaus theoretically was the answer to an anomalous situation shared by all industrialized nations at the time. In Germany, for example, in the face of new architecture (Frank Lloyd Wright's work appeared in a German architectural review in 1910), there was no school where contemporary architectural problems were discussed. In the face of new products and new designs (the work of the Werkbund, a league of craftsmen, industrialists and architects, was exhibited in Cologne in 1913), few institutions existed to train other than craftsmen. In the face of new art (the 1914 Salon d'Automne in Berlin revealed a completely new world of forms), there was no place to unravel the meaning of those new creations.

Design, fine arts and architecture were taught helter-skelter in arts and crafts schools (Dresden since 1898, Weimar since 1902), in art academies and in technical institutes. The future architect usually started out in an architect's office where old ideas and old forms were endlessly repeated. Only in Peter Behrens's office in Berlin was there a different atmosphere. As artistic director of the German General Electric since 1907, Behrens was engaged in overhauling the appearance of the company by offering his firm's own designs, not only for a new factory (the Turbine factory of steel and glass), but for all the accessories that go into the total building—lamps, furniture, etc. It was such a conception of building that seemed especially new, and impressed Walter Gropius, Le Corbusier and Mies van der Rohe, who were briefly Behrens's assistants in the years immediately prior to the First World War.

The Birth of a School

The birth of the Bauhaus and nomination of Walter Gropius as its director were the conclusion of complicated negotiations that seem to have begun in 1914 or 1915 when Henri van de Velde, director of the Arts and Crafts School in Weimar approached Gropius to succeed him and Fritz

Mackensen, director of the Weimar Art Academy, suggested that Gropius accept a chair in architecture at his institution. Walter Gropius (1883-1969) had attracted nationwide attention with the realization of two glass-and-steel buildings in which new materials and form not only seemed happily married but were structurally interdependent (Fagus Factory, 1911; Cologne Office Building, 1914). Gropius was also known as an advocate of multiple-family housing using standardized, and therefore cheaper, building parts, which could be assembled in various ways to take into account a variety of individual needs.

The war shattered both van de Velde's and Mackensen's scheme, but, while in the army, Gropius formulated a plan for a school designed to train creative people in all aspects of building—from construction proper and even city planning to doorknobs, lighting fixtures and other furnishings, besides giving them an art education. The young architect found that his plan was very much in tune with the general reform in education being discussed at various levels of the German government. Eventual absorption by the crafts and industry of a large percentage of the 10,000 painters and sculptors who were expected to populate German cities of the future was a deciding argument. "At best," the argument went, "there would be 1/10th or 1/20th of that number who, moreover, being enlisted as teachers for preparatory instruction would have a more promising future than at present."[4]

The governing authorities of Weimar offered Gropius the directorship of the Academy of Art, including the former Arts and Crafts School, in March 1919.

Except for buildings themselves, and a few women weaving-teachers who had stayed in Weimar during the war years, there were few resources on which to draw—van de Velde's workshops had been dismantled, and the staff of the Art Academy was resigning. As for Gropius's conceptions, they were so broad and visionary, not to say Utopian, that much seemed to depend for the success of the school on their implementation and interpretation by a creative staff. The immediate appointment of Lyonel Feininger (1871-1956) gave one clue: an innovative painter and fine printmaker, Feininger had exhibited with the Blue Rider. The opening of weaving and pottery workshops emphasized the fact that crafts as well as art would be in the curriculum of the new school. But it was Johannes Itten (1888-1967), recruited by Gropius in the summer of 1919 in Vienna where he had been teaching art by methods unheard of in art academies, who gave the Bauhaus a definite and original image, at least in its early stages. A former pupil of Hoelzel, from whom he had learned the psychology of design, Itten believed that the creativity latent in all human beings could be released by expanded perceptions leading to new experiences. Gropius directed new students to Itten for an introductory six-month course, after which they would be allowed to

specialize in one of the workshops being set up as fast as masters were found to lead them and facilities obtained.

First Stage of a Bauhaus Education

In his introduction to *Design and Form: The Basic Course at the Bauhaus*,[5] Itten describes the situation he found when he first arrived in Weimar. He speaks of the poverty of the students, many barely out of the army; he tells how difficult it was to form a judgment about the students' talent and character, since their previous art training had been so traditional and narrow. He speaks of the spiritual emptiness of people confused by the terrible events and shattering losses of the war, of endless discussions, "eager searching for a mental attitude," and he admits that slogans such as "Back to Handicraft" or the "Unity of Art and Technology" did not seem to him to solve the problem. He tells of his encounter with the work of Spengler,* with Oriental philosophy and Persian Mazdaznan,† and how he felt that outward-directed scientific research and technology must be balanced by inward-directed mental and spiritual forces. Thus the basic course he devised with Gropius's approval answered what he felt were the very special needs of the first generation of Bauhaus students.

Paul Klee's son, Felix, who took Itten's course in 1921 thus describes Johannes Itten: "He looked like a priest to me, with his red-violet, high-buttoned uniform, his bold shaved crown and his gold-rimmed glasses." He adds that he was fascinated by Itten's personality, teaching ability and overwhelming imagination.[6] Itten at the time gave lectures three times a week. "Once a week," Felix Klee writes, "there were those marvelous exercises which especially relaxed the cramped tense students." He is referring to Mazdaznan, or what might be called yoga practice today. "Here, we also presented the work we had done during the week both on assignment and on our own."[7] This work, the core of Itten's teaching, consisted of studies of combinations and contrasts. Mixing found objects, humble scraps of all sorts, students were encouraged to make free constructions, which Itten would evaluate in terms of resourcefulness and originality and the understanding shown of the materials used. Texture, form, color,[8] rhythm, light and shadow—all the fundamentals of design were likewise the source of innumerable exercises. Optical and tactile as well as psychological effects, of which the students may have had no prior awareness, would thus become apparent to them and part of their experience. Gradually perception became

* Oswald Spengler, German historian and philosopher, author of *The Decline of the West.*

† Mazdaznan, a form of religion based on the teachings of Zoroaster, sought a new humanism, while implying practice in concentration, meditation and relaxation, and a vegetarian diet.

Student work in rhythmic motion done under Johannes Itten.
Drawing by W. Graeff, Weimar, 1920. Courtesy Otto Maier Verlag, Ravensburg.

keener, and affinity for a particular material, wood, metal, glass, stone, paper, ink or paint, would develop. Student work reflected no coherent style, since Itten had a great respect for individual temperament. Dadaist construction and hard-edge color studies, gestural brushwork and modular compositions—in short the whole vocabulary of contemporary art—seem to have been contained in his teaching.

Itten devoted his second course to the analysis of form in the old masters (mostly from slide projections), and a third to life drawing. "What a revelation," Felix Klee remarks, "the encounter with and analysis of the nude body. I never saw my studies as academic exercises imitating nature but rather as analogous to analyses of old masters."[9]

Nevertheless, Itten was a controversial personality at the Bauhaus. Mazdaznan, a faith he shared with an increasing number of converts, tended to divert students from the practical goals that Gropius had in mind. The competing appeal of a visitor from Holland, Theo van Doesburg, who set up a course in de Stijl architecture next to the Bauhaus; an exhibition of Russian art at the Van Diemen Gallery in Berlin, featuring hard-edge geometric paintings by Malevich and mixed-media constructions by Tatlin; the success of a Constructivist congress in Weimar in 1922, in the course of which Gropius met the painter Lazlo Moholy-Nagy (1895-1946); and a lessening of cordial relations between Gropius and Itten led to the latter's resignation in the spring of 1923.

One of Itten's more gifted students, Josef Albers (b. 1888), who had risen to technical master in a newly created stained-glass workshop, unofficially assumed the role of teacher in the preliminary course after Itten's departure. Albers, thirty-two when he came to the Bauhaus, had a background in arts and crafts (he had studied at the Essen Arts and Crafts School from 1916 to 1919) and in art itself (as a student of Franz Stuck in Munich in 1919). In his course the often whimsical, mind-expanding studies of Itten acquired a new focus, confined as they now were to one material only—paper—and limited further by restrictions on tools.* As Albers said: "Instead of pasting [paper] we will put paper together by sewing, buttoning, rivetting, typing and pinning it; in other words, we fasten it in a multitude of ways. We will test the possibilities of its tensile and compression-resistant strength."[10]

One of the most vivid demonstrations of his ideas was apparently provided by a young Hungarian architect who, given a newspaper, made a screen by folding the paper lengthwise and standing it on end.[11] The student had made a pliable material so stiff it could stand up. He had utilized the paper so that there would be no waste, and so that there would be no "negative" side, as the construction had neither front nor back. Both sides were

* Early evidence of Minimal Art (See chapter 10).

equally active. Simplicity, new application of a given material, understanding of the material and economy—of labor (maximum effect with minimum effort), and of material (nothing left over)—were the criteria of success in Albers's class. A continuous ribbon sculpture by Max Bill and a cantilever chair by Marcel Breuer fulfilled these criteria.

One of the side aspects of Albers's emphasis on thrift was his investigation of optical illusions whereby a single arrangement of black lines on white paper, for example, by shifting positions in the beholder's perception, offers a variety of visual experiences. Or, as Albers was to demonstrate in his more recent series of paintings called *Homage to the Square*, two colors yield three, three colors yield more or fewer to the beholder's eye.

Until 1928, Albers shared the teaching of the preliminary course with Lazlo Moholy-Nagy, recruited by Gropius in 1923. A Hungarian, Moholy-Nagy (1895-1946) had turned from law to painting while recovering from his war wounds. While living in Berlin, he had met El Lissitsky and become an enthusiastic Constructivist. Moholy-Nagy believed in the obliteration of individual workmanship in painting and was to become known for rigidly geometric spray paintings left unsigned, for many experiments in photography (photograms, rayograms and shadowgraphs), and for a threesome of so-called "telephone pictures" (1922) ordered from a sign factory by telephone according to the artist's specifications.*

Like Itten's and Albers's preliminary course, his course also covered an analysis of materials, in his case with emphasis on such then new and synthetic materials as plastics. In this part of the course, Moholy-Nagy illustrated his discussions of texture, structure, surface treatment and mass arrangement with his own photographs and microphotographs. However, his course, which came after Albers's, had as its main purpose to give students a new awareness of space—in painting, sculpture and architecture. To make this new space apprehensible, as he explains in *The New Vision*,[12] he showed them how sculpture had evolved from pure mass to perforated mass, to mass in tenuous equilibrium, to mass in movement, and how the visual grasp of space was thus replacing the tactile grasp. Similarly, in architecture, space was more than an awareness of scale and outward form, but involved sensing space flowing in and out of masses, around masses and through transparent areas. As for painting, which for so long had been involved with the illusion of the third dimension, it must now accept its existence as surface,† on which moving lights and shadows can create a new spa-

* In 1972 Moholy-Nagy's first wife, Lucy, published *Marginal Notes* (Bauhaus Books) offering new information on the artist.

† Several of the issues raised by Moholy-Nagy became important again in the 1960s: obliteration of individual workmanship, absence of tactile qualities, opposition to illusionistic space, and integrity of the picture surface in painting (see chapter 10).

Studies in the plastic uses of paper done in Josef Albers' course in Fundamental Design. Transformation of a cylinder through cutting and bending, 1925-1926. Photograph courtesy The Museum of Modern Art, New York.

tial feeling. Between 1921 and 1930, Moholy-Nagy worked on a light machine, a moving chrome and glass construction reflected in the surrounding atmosphere through the light projected on it.

A versatile personality—he could teach photography, theater, film, and typography as well—highly valued by Gropius, Moholy-Nagy nevertheless left the Bauhaus at the same time as Gropius in 1928, whereupon Albers became the sole master of the preliminary course for the remaining few years of the Bauhaus's existence in Germany.

Germany, deprived by a blockade from the sources of its raw materials during the First World War, has become a leader in chemical research and the production of synthetics. A wide range of synthetic substances with original properties—heat- and shock-resistant, insulating, transparent, light-weight, fast-drying, etc.—have found applications in a multitude of new objects required by budding industries: electrical, photography, optics, automotive construction and building parts, furniture, mechanics, printing and advertising. Light alloys, plastics, plywood, acrylic paints, synthetic fibers, are just a few of the challenging materials available after the war.

Second Stage of a Bauhaus Education: Workshop Training

Walter Gropius, in the Bauhaus Manifesto, had promised to transform unproductive artists into excellent craftsmen. To achieve his goal, he felt it necessary at first to supplement technical training from a craftmaster with design training from a form master. Interfertilization of ideas and exchange of knowledge, he thought, would accomplish the "unity of art and technique" of which he dreamed, breed a new type of professional, a designer, and lead to the creation of visually new objects by these new designers.

By 1924, students had seven workshops to choose from, the stained-glass workshop (with Paul Klee as form master and Albers as craftmaster) having been recently absorbed into the mural workshop and Albers transferred to the preliminary course. They were: carpentry, printing, wall painting, metal, stone and wood sculpture, weaving, pottery. Of the nine form masters at the Bauhaus in 1924, four, Walter Gropius, Adolf Meyer, Lyonel Feininger (1871-1956) and Gerhard Marcks, (b. 1889) had been at the Bauhaus since it opened; three, Georg Muche, (b. 1895), Oskar Schlemmer (1888-1943) and Paul Klee were hired between 1920 and 1921; Wassily Kandinsky was invited in 1922 and Lazlo Moholy-Nagy in 1923. Except for

Gropius and Meyer, his partner, the form masters who ran the workshops were thus either painters or sculptors or both. But these painters and sculptors were a far cry from the art teachers in the academies: two, Kandinsky and Klee, had already published their controversial artistic beliefs, *Concerning the Spiritual in Art* (1912) and *Creative Credo* (1920) respectively. Moholy-Nagy, as noted before, was acquainted with the Russian avantgarde. The founder of an artists' association called "Today" (*Ma*), he had become in Hungary the editor of a Constructivist review, *Horizon*. Oskar Schlemmer had organized, in Stuttgart with former students of his art teacher Hoelzel, an avant-garde group known as "Dawn" (*Uecht*). Several form masters, including Gropius, had been members from 1918 to 1919 of an artists' association with progressive political leanings called the Berlin Novembergruppe. Kandinsky, Klee and Feininger, but also the younger Schlemmer, Moholy-Nagy and Muche had already exhibited at Der Sturm, Berlin's famous gallery of modern art.

The role of form master was loosely defined and the approach to form varied from master to master. Form masters were essentially guides helping students to discover for themselves the terms of a new expression.

Paul Klee's course was based on a new approach to nature. "Art does not reproduce the visible but makes visible," Klee wrote in his *Creative Credo* (1920).[13] An intuitive feeling for the contradictory forces at play in the world of phenomena led him to infinitely varied compositions. The unfolding of a melody, the growth of a plant, the distribution of crystals in a stone, would, under his pen and brush, reveal laws concerning their underlying structure, their rhythm, their spatial arrangement. Folders, containing innumerable sheets of demonstrations, represent with his writings now gathered in *The Thinking Eye* and *The Nature of Nature*[14] the sum of his Bauhaus teaching. A new world inspired by fresh perceptions would, he hoped, open itself to students. He would explain how constructions may deviate completely from the optical image of objects without contradicting it from an overall point of view.

The discovery of structure and stresses was also the aim of Kandinsky's course in analytical drawing. "Drawing instruction," he wrote in the Bauhaus Journal (1928), "is a training towards perception, exact observation and exact presentation not of the outward appearance of an object but of its constructive elements, its lawful forces. . . ."[15] In his course, a still life would be set up and drawn, so that objects eventually receded into a dry arrangement of lines, squares, triangles and circles made with ruler or compass. Kandinsky also conducted a color seminar: there, cold, neutral and warm colors contained in a variety of geometric shapes were analyzed for their range of active qualities. (Kandinsky, who had been back in Russia

Products of the Bauhaus workshops. Photograph by Herbert Matter.

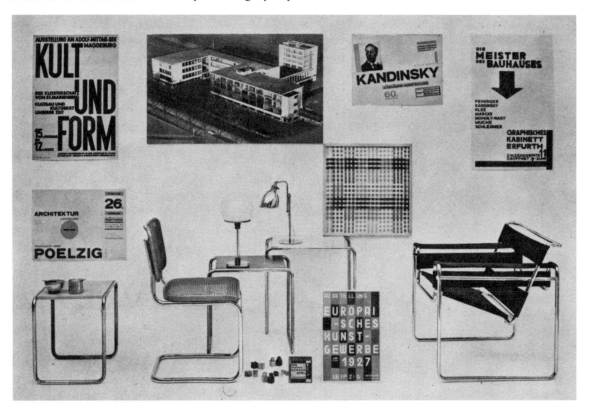

from 1914 to 1922, had participated in the Russian cultural revolution and begun to formulate a unified art teaching method attuned to the ideas of the Suprematist Malevich and the Constructivist Tatlin. This in turn may have influenced his teaching at the Bauhaus and led him to publish *Point and Line to Surface*[16] in the 1920s at the Bauhaus Press.)

The mural workshop in which Kandinsky, and on occasion Klee, taught form until 1925 received few commissions. Even after a large Bauhaus exhibition in 1923 had given the mural workshop a chance to demonstrate its potential for monumental wall design,* and singled out several talented students who later became masters,† the workshop chiefly did interior wall painting for Bauhaus projects. In this humble function, the workshop sought to create suitable atmosphere through color or texture, hoping to endow walls with sufficient "life" to preclude further decoration with pictures. Black, a color particularly significant in Kandinsky's work, appeared in many wall painting projects and covered ceilings in the masters' houses built in 1926.

Oskar Schlemmer's form course was an especially popular one at the Bauhaus. Although Schlemmer had been hired to conduct the form course in the stone and wood sculpture workshop, thanks to his experience in choreography (he had been working for several years on a "triadic" ballet), he transformed what might have been an academic life-class into a laboratory in modern dance. His course, eventually entitled *Man*, dealt with the structure of the human body, static sculptural form as in Greek statuary, but also active as movement in space. The student-models who illustrated for the class natural movement in free space, movement confined to ordered space and body gesture such as pantomine, tended to become dance apprentices, and the sculpture workshop which was impractical anyway‡ was turned with Gropius's endorsement into a stage workshop. An unexpected development at the Bauhaus, the stage workshop stimulated research in architectural stage design—theater-in-the-round—gave all the workshops a chance to work on various aspects of production (costumes, sets, lighting, etc.) and stimulated the masters to design for the stage. In 1923, Schlem-

* The workshop created a mural and a fresco. Both had free irregular edges, both incorporated windows, radiators and whatever elements were functionally needed in the room into the design. The designs themselves were exercises in stucco techniques, in the use of spray for creating effects of light and shade on illusionistic volumes, and in transparency effects by precise color control.

† Hinnerk Scheper, Alfred Arndt, Herbert Bayer.

‡ Its chief achievement was the redecoration of the workshop building for the 1923 Bauhaus exhibition. Schlemmer filled the walls of van de Velde's building with stucco murals and bronze reliefs of monumental sexless figures, here idealized as static symbols, there articulating movement.

mer's *Triadic Ballet* was performed during Bauhaus Week:* dancers whose stiff costumes made them look like wooden figurines moved to the beat of music by Hindemith. In 1928, Kandinsky staged Mussorgsky's *Pictures at an Exhibition*. Here the musical phrases were rendered visual by moving colored forms and light projections. Between 1929 and 1931, Moholy-Nagy did a number of sets for the Berlin State Opera using slide projections instead of props as backdrops.

Whereas the mural and stone (stage) workshops were stimulating if not exactly remunerative sections of the Bauhaus at Weimar, the other five worked in a financially more rewarding direction. The pottery, weaving and printing workshops turned out saleable articles noted for their high quality and original designs.† The carpentry workshop, which for a while benefited from the presence of Gropius as form master, was never short of commissions. Furniture and toys designed by Gropius and by such students as Marcel Breuer, Josef Albers and Alma Buscher, revealed a nascent Bauhaus style when they were first displayed in the experimental house of the 1923 exhibition. Simple angular cubic shapes, cheerfully painted lacquered wood and mixed materials were typical features.

The carpentry workshop and the metal workshop, conducted by Moholy-Nagy in addition to his preliminary course, set the future direction of the Bauhaus. Working away from "spiritual samovars and intellectual doorknobs"‡ toward prototypes for wholesale manufacture, Moholy began

* Bauhaus Week was held in August 1923. It included exhibitions of the Bauhaus workshops, an international exhibition of modern architecture, a show of free art by masters and students, and an experimental house.

During that week, Gropius lectured on "Art and Technics, a New Unity"; Kandinsky spoke on "Synthetic Art"; and J. J. P. Oud, the Dutch architect, on "New Building in Holland." Besides the performance of Schlemmer's ballet, there were several concerts under the direction of Herman Scherchen. The program included works by Hindemith, Busoni and the premiere of Stravinsky's *Ballade du Soldat*.

A paper lantern and kite festival, fireworks, a dance featuring the Bauhaus jazz band, reflected-light composition by Hirschfeld-Mack, completed the entertainment. Bauhaus Week was important as it revealed to the 15,000 visitors and the public at large through the press, the vitality, ambition and achievements of the young institution.

† The print workshop, under the supervision of Feininger as form master and Carl Zaubitzer as craft master, did particularly memorable work. Printed on the Bauhaus presses were: a portfolio of European graphics which included, in addition to Bauhaus masters, prints by Russian and Italian artists as well as German artists (1921);

a masters' portfolio with prints by Feininger, Kandinsky, Klee, Marcks, Muche, Moholy-Nagy, Schlemmer, Schreyer (1922);

Small Worlds, consisting of four lithographs, four etchings and four woodcuts (1922) by Kandinsky.

‡ A remark attributed to an assistant of Oskar Schlemmer, on the subject of the early products of the metal workshop.

to design crude models with the help of students (Marianne Brandt in particular) as soon as he took over the workshop. Functional rightness and objective standards were the goals emphasized. Bauhaus lighting fixtures, simple hanging globes and tight-fitting ceiling cubes or cylinders of glazed glass, desk lamps with aluminum shades and many other articles were to be manufactured in great quantities all over the world a few years later.

In 1925 the Bauhaus closed at Weimar and moved to the town of Dessau. Between 1925 and 1926 buildings designed by Gropius went up in a suburb of Dessau, and in the fall of 1926 the school opened in its new quarters. Gone were the days of improvised workshops and idealistic goals. The new school, a model of its kind, no longer equivocated on its function and was an acknowledged "Institute of Design." Several former Bauhaus students turned masters began to assume both craft and form training in the newly organized workshops; the artists Feininger, Klee, Kandinsky and others were liberated from workshop duties. Kandinsky and Klee pursued their teaching in a painting class and Feininger remained at Dessau as artist-in-residence. Others left. The pottery workshop disappeared. Collaboration with industry increased: Bauhaus students were encouraged to spend time in factories while factory technicians were invited to the Bauhaus. Bauhaus designs, which had come to public notice first at the 1923 Bauhaus exhibition, then at the Leipzig Fair and at the Paris salon of decorative arts of 1925, were soon much sought after. The weaving workshop under Gunta Stolz experimented with mixed and synthetic fibers and designed simple unobtrusive patterns for textile firms. The mural workshop under Hinnerk Scheper experimented with new paints, new plaster techniques, spraying, etc., and eventually went to work for a large wallpaper firm that could produce at low cost the visual effects invented in the workshop.* The carpentry workshop under Marcel Breuer became a cabinet-making workshop, creating among other items, light and cheap tubular furniture, folding chairs, stool tables, theater seats, and the Breuer "cantilever"† chair, all of which went into production in the late 1920s. The cabinet workshop was eventually combined with the metal workshop, which had already been turning out prototypes before the move to Dessau. The print workshop under Herbert Bayer was changed to a photography, advertising design and typography workshop. New lettering styles, stressing clarity and economy such as Universal Type and contourless shadow script, were invented there, and the

* Four and a half million rolls of Bauhaus-designed wallpaper were sold by Rasch Brothers in 1929.

† This chair, called cantilever because the sitter's weight is supported from one side only, is made from one continous tube.

abcdefghi jklmnopqr stuvwxyz a dd

New lettering styles, stressing clarity and economy . . . were invented

Universal Type, designed by Herbert Bayer, 1925.

Bauhaus advertising design for building construction work.

BAUHÜTTE ANHALT
DESSAU G. M. B. H.
KAISERPL. 2 TELEFON 2843

Hoch-, Tief-, Beton-, Eisenbetonbau
Dachdeckerei, Zimmereibetriebe, Bau- und Möbeltischlerei, Töpferei, Glaserei, Zementwaren - Fabrikation
Kleinwohnungsbau

ZWEIGSTELLEN:

BERNBURG
CÖTHEN
COSWIG
ZERBST

dropping of capital letters became a feature of Bauhaus printing. The workshop continued to publish the Bauhaus books, treatises by leading contemporary theoreticians in art and architecture in and outside the Bauhaus.*

After the departure of Gropius in 1928, several workshop heads besides Moholy-Nagy left, among them Herbert Bayer (b. 1900), Marcel Breuer (b. 1902) and Oskar Schlemmer. Under the new regime, four departments were created: architecture, commercial art, interior design and textile. Later architecture and interior design were combined.

By 1900 the United States has mastered the skyscraper, but few buildings yet show the streamlined simplicity that will increasingly dominate twentieth-century architecture all over the world. Premonitory of things to come are several instances of the rejection of ornament and other Art Nouveau features during the years 1900-1914. Homes designed by the American Frank Lloyd Wright in this period feature harmonization with the site, horizontal lines and overhanging roofs. Mies van der Rohe wrote: "At this moment [1910], so critical for us, the exhibition of the work of Frank Lloyd Wright came to Berlin. This comprehensive display and the exhaustive publication of his works enabled us to become really acquainted with the achievements of this architect. The encounter was destined to prove of great significance to the European development . . . The dynamic impulse emanating from his work invigorated a whole generation."

The Final Stage of a Bauhaus Education: Architecture

Although the word "building" was contained in the name Bauhaus and although the 1919 manifesto stated that "the complete building was the final aim of the visual arts," architecture as a branch of study developed slowly at the Bauhaus. At first, architectural experience was limited to participation in commissions assigned to Gropius privately—Summerfield House with a window by Albers (1922), redecoration of the interior of a theater in Jena (1922) painted by the wall painting workshop, and to lectures by Gropius on statics and the history of architecture. When in 1922 the public authorities in charge of Bauhaus finances demanded an exhibition to review Bauhaus work, the construction of an experimental house was included in the projected show. It was to be designed by a master, Georg Muche of the weaving workshop, under the technical supervision of Gropius's partner Adolf Meyer and entirely outfitted by the Bauhaus workshops.

*See page 235.

"For this first house," writes Georg Muche, "we intentionally chose the simplest and most clearly defined floor plan arrangement (high-ceilinged large central living room surrounded by low-ceilinged smaller auxiliary rooms)."[17] Stressing economy in the mode of construction (it took only four months to build), in the choice of materials (the walls were made of jurko plates and stuccoed) and size (the overall surface was 12.70 meters by 12.70), the house reflected in its clean starkness the hardship of the times. By its unusual floor plan, a healthy family life was sought. Its two levels of flat roofs emphasizing the horizontal and its structure, a cube within a section of a cube, evoked to the informed person a synthesis of Frank Lloyd Wright and de Stijl architecture. The plain white house, called "Am Horn" (by the river Horn), was an eyesore in the context of other Weimar residences and the focal point of much controversy in 1923, although many of its features, among them white stucco exteriors, the use of plate glass for windows, built-in closets, doors and windows flush with the walls, have since become standard features of many modern homes in the Western world. Even after the exhibition of 1923 had brought the architectural experiments of the Bauhaus to public attention, still no architectural training was envisaged—only a research department started for a few particularly gifted students who, investigating the problem of housing, indeed produced several interesting models of slab-shaped, high-rise apartment houses (Herbert Bayer and Marcel Breuer in particular). Lack of commissions prevented this research center from ever doing practical work.

The expulsion of the Bauhaus from Weimar—the Weimar public authorities did not renew their contract with the school—which in 1925 menaced its very survival, gave Gropius a unique opportunity when the mayor of Dessau offered the Bauhaus not only temporary quarters but also money to build a new Bauhaus, including student and master housing and a technical school.* Better than theoretical instruction, a large-scale building complex was about to be erected to demonstrate Gropius's conceptions.

"A modern building," said Gropius, "should derive its architectural significance solely from the vigor and consequence of its own organic proportions. It must be true to itself, logically transparent and virginal of lies or trivialities, as befits a direct affirmation of our contemporary world of mechanization and rapid transit . . . the old obsession for the hollow sham of axial symmetry is giving place to the vital rhythmic equilibrium of free asymmetrical grouping."[18] Thus was defined what came to be called the International Style.

The Bauhaus buildings completed in October 1926 had a floor plan in the shape of a partial swastika. Asymmetric arrangement of interpenetrat-

* The unusual generosity of the citizens of Dessau is attributable in part to the German industrial revival after 1923, thanks to the Dawes Plan and to the prosperity of the Junkers aircraft factory nearby.

ing cubes made for separation yet connection of the various functional wings, workshops, student studio housing, technical school, administration. The administration wing, accessible to all the other sections, was literally a bridge over a street. The workshop had glass walls which wrapped around corners as in the Fagus Factory. Merely screens, these glass walls were suspended from cantilevers that projected from the internal structural piers made of concrete and steel. All the roofs were flat and, except in the workshop and in the terraced studio wings, the windows were continuous plate-glass segments reiterating for each of the two or three stories the horizontal pull of the roofs. Lavish use of glass and resulting transparency, internal structural core and connecting bridge gave the feeling of buildings "floating over the ground," says the architectural historian S. Giedion.[19] Giedion also suggests that the glass surfaces of Gropius's buildings, which combined transparency and reflection, were architectural equivalents of Cubist paintings. An experimental stage opening to an auditorium on one side and to a dining hall on the other occupied part of the raised ground floor. As for the masters' duplexes built on a neighboring woody site, they had identical floor plans rotated ninety degrees from one floor to the next, thus respecting individualism while achieving standardization. In the new Bauhaus, room was reserved for an architectural department and building office on the second floor of the bridge near Gropius's office. In 1927 this architectural section came to be occupied by Hannes Meyer, a Swiss architect known for his collaboration on important housing projects in Germany and for an unusual design for the SDN building in Geneva. In 1928 Gropius resigned, naming Hannes Meyer his successor.

During his three years at the Bauhaus Hannes Meyer sought to change the institution's image as he saw it. He had felt when he arrived that

> inbred theories closed every approach to a form for right living. The cube was king and its sides were yellow, red, blue, white, gray, black. One gave this Bauhaus cube to children to play with and to the Bauhaus snob for idle sport. The Square was red. The circle was blue. The triangle was yellow. One sat and slept on the colored geometry that was the furniture. One lived in the colored plastic forms which were the houses. On their floors lay, like carpets, the psychological complexes of young girls. Art stifled life everywhere.[20]

He taught that building should be a biological process and not an esthetic one, that it should answer the needs of the people rather than the requirements of luxury. He instituted courses in city planning (taught by Ludwig Hilberseimer), in Gestalt psychology (taught by Durkheim) and would have liked to invite sociologists and economists to lecture. During his time the new architectural department was able to fulfill a number of commissions, among them a boarding school for trade union members in Bernau near Berlin. Plain and austere, the boxlike brick buildings dotted with identical windows owed their singularity to an implied concern for well-be-

ing: good light, and grounds designed for active sports. (Meyer introduced physical exercise at the Bauhaus.) However, Meyer was held responsible for the students' political unrest and the severe disturbances of class work that ensued, and was fired in 1930.

He was succeeded as head of the Bauhaus by a Berlin architect, an old friend of Gropius, Ludwig Mies van der Rohe (1886-1969). When he was appointed to the Bauhaus, Mies had just completed the German pavilion at the 1929 Barcelona Fair, a small but jewellike structure of travertine marble, onyx, stainless steel and tinted glass, which was sparsely furnished with Mies-designed steel and leather chairs (since known as "Barcelona chairs") and glass-topped tables.

Poles apart from Hannes Meyer, Mies imparted to students his love of quality materials and his search for perfection and simplicity of design ("less is more," he always said). Because furnishings were to him inseparable from the character of the buildings themselves, he combined the department of interior design with that of architecture. Under his guidance, students were confined to simple projects—one bedroom house with courtyard, for example—on which they were kept working for months until a clear and simple solution had evolved.

With the rise of Nazism, everything connected with the word Bauhaus fell under suspicion, from the reputed Communist leanings of a small minority of students to the "degenerate" creations of the masters.* The Dessau Bauhaus was forced to close down in 1932 and the buildings were later used as a center for Nazi indoctrination. Mies reopened the Bauhaus as a private institution in Berlin.

On July 21, 1933, by means of a letter to Professor Mies van der Rohe, the German State Secret Police demanded that Ludwig Hilberseimer and Wassily Kandinsky no longer be permitted to teach; that a new modified curriculum be submitted to the Prussian Ministry of Culture; that the teaching staff answer a questionnaire "satisfying the requirements of the civil service law."[21] On August 10, 1933, Mies van der Rohe distributed a leaflet to the Bauhaus student body announcing the dissolution of the Bauhaus on the grounds of "the difficult economic situation of the institute. . . ."[22]

A number of the Bauhaus personalities seem to have temporarily flocked to Berlin immediately after leaving the school, in order to pursue careers in experimental film (Moholy-Nagy); private architectural practice (Gropius, Mies, Breuer); commercial art (Bayer); teaching (Itten, Muche, Schlemmer). Only Oskar Schlemmer, Gerhard Marcks, Georg Muche and Marianne Brandt were never to leave Germany, although they suffered persecution and were prevented from showing their work during the Nazi regime. In 1933, Kandinsky left for Paris and Klee for Bern. From 1930 to

* An exhibition of "degenerate art" was held in 1937 in Munich. Thousands of works were destroyed, while others mysteriously disappeared during the Nazi regime.

A creation by a Bauhaus master which the Nazis called "degenerate."

Lazlo Moholy-Nagy, *A II*, 1924, oil on canvas. The Solomon R. Guggenheim Museum, New York. 45 1/2 x 53 1/2".

1936, Hannes Meyer was teaching architecture in Moscow before returning to his native Switzerland. Johannes Itten, after teaching in various places in Germany, retreated to Switzerland in 1938 where he assumed, until his death, various teaching and curatorial positions. In 1934 Walter Gropius and Lazlo Moholy-Nagy moved to London, followed by Marcel Breuer.

Josef Albers was the first to cross the Atlantic, in 1933; he taught at Black Mountain College, North Carolina, from 1933 to 1949, then at Yale University. In 1937, Walter Gropius and Marcel Breuer went from London to teaching posts at Harvard University, while Herbert Bayer and Lyonel Feininger moved to New York, and Lazlo Moholy-Nagy to Chicago to head a New Bauhaus and later teach at the Chicago Institute of Design. In 1938 Ludwig Mies van der Rohe also accepted a teaching post in Chicago at the Armour Technical Institute. Few of the original Bauhaus teachers are still alive, but due to the forced exile to the United States of many of its progenitors, the Bauhaus seed was widely sown in America.

Summing Up

The Bauhaus experiment raised more issues than it solved.

Gropius's idealism involved him in contradictions from the start: between respect for the individual and social usefulness, artistic freedom and integration into society, an avant-garde outlook and a necessary reliance on conservative benefactors.

Such conflicts, which have confronted all artistic experimenters, were particularly dramatic at the Bauhaus, where they were institutionalized and exacerbated by the dependency of the school upon the voters, first in Thuringia, then in the Dessau province.

Under these circumstances, Gropius may have especially welcomed as collaborators artists interested in such noncontroversial topics as the autonomy of art, structural analysis, material studies, economy and spatial awareness. These included Klee, Kandinsky, Schlemmer, Albers, Moholy-Nagy and Itten. Furthermore, the teaching methods he envisaged had the advantage of applying equally to design, architecture and—as Gropius assumed—the fine arts.

Gropius did not satisfy his benefactors in Thuringia, nor was he able to maintain an equilibrium between free and applied art: the Bauhaus was banished from Weimar and, when it reopened in Dessau, was simply a model institute of design. In Dessau, artists were more or less relegated to the background, as a new generation of masters (the "designers") took over.

Whether the Bauhaus teaching method offers a fruitful approach to other than designers and architects is a critical issue for today's art students, many of whom have imbibed Bauhaus principles imported into the

United States by former masters and propagated in American universities and schools of design and technology.

At the German Bauhaus, the method gave impetus to a number of imaginative designs and generated a characteristic appearance particularly in buildings, which became light and pared down, hard-edged, eye-catching through color, texture and the unusual combination of materials.

Its contribution to free art is more debatable. Is it possible to teach the art one practices? Is it necessary to practice what one teaches? Does teaching consist of imparting techniques or inspiring the student to find his own way? Could such painters as Klee and Kandinsky, for example, verbalize for their students the instinctive choices, the bypassing of rules that one senses in their best paintings?

NEW YORK AND
ABSTRACT EXPRESSIONISM,
c. 1930-1960 chapter 9

Prehistory, 1930-1940
In the 1940s
What Abstract Expressionism Was About
Summing Up

America in 1900 is preoccupied with itself. By 1916 Wilson's idealism is put to the test. In the 1920s artists and writers expatriate themselves, but after 1929, as the world of The Great Gatsby *comes crashing to an end, the exiles return home. Drought is the physical symbol of the 1930s but not of its intellectual life. William Faulkner, Ernest Hemingway, John Steinbeck and John Dos Passos, among others, will write some of their best works during these years and, thanks to Edmund Wilson, Malcolm Cowley and other critic-essayists, their novels and some of the best writing from Europe (Thomas Mann, Virginia Woolf, André Malraux) are reviewed in magazines. Marxism is examined in all of its deviations, social realism is evident in fiction. In the new moving pictures, comics such as W.C. Fields, the Marx Brothers and Charlie Chaplin provide those who can afford a ticket to the movies with a few moments of laughter. Various New Deal programs utilize writers and artists, while New York galleries and museums slowly open their doors to European art since Impressionism.*

Prehistory, 1930-1940

Jackson Pollock (1912-1956) arrived in New York in the fall of 1930 from Los Angeles to join two older brothers. He entered the Art Students League* and began to attend the class in life drawing, painting and com-

* The Art Students League was founded in 1880. Although many of the teachers were American artists, they also included such foreigners as Hans Hofmann, who taught there in 1932-33. League students chose their instructors freely. The school still exists at its original location on West Fifty-seventh Street in New York.

The New York art world . . . was far from monolithic in the 1930s. The Regionalist painter, Thomas Benton, [was] a forceful influence at the League. . . .

(Iowa born) William Palmer, *Dust, Drought and Destruction,* 1934, tempera. The Whitney Museum, New York. Photograph courtesy Midtown Galleries. 24 x 30".

position taught by Thomas Hart Benton. The Dutch-born Willem de Kooning (b. 1904), in the United States since 1926, had taken a studio in Manhattan in 1927, and in 1930 was earning his living from commercial art, carpentry, window display, sign-making and the like, while painting in his spare time. Up in the Bronx, Barnett Newman (1905-1970), with a degree from the City College of New York and several years of experience at the Art Students League, was teaching in a high school and helping in the family business. His friend Adolph Gottlieb (1903-1974), also a native New Yorker and former League student, won a painting prize in 1930 and had his first one-man show at Dudensing Gallery that year. Mark Rothko (1903-1970)—son of a Russian émigré pharmacist living in Oregon—following two years at Yale between 1921 and 1923 and some bumming around, had come to New York in 1925 and attended a few classes at the League. By 1930 he had already been shown once at the small Opportunity Gallery. Arshile Gorky (1904-1948), born and raised in Turkish Armenia, moved to New York in 1925 after five years in schools of design and technical institutes in the Boston-Providence area and until 1931 taught at the Grand Central School of Art. In 1930 he was among the "Forty-six Painters and Sculptors under Thirty-five" whose work was shown at the newly founded Museum of Modern Art. David Smith (1906-1965), a midwesterner and once a welder in an automobile factory, was in and out of New York in 1930 and studying painting at the League. Ad Reinhardt (1913-1967) was finishing high school in Queens and applying to Columbia University, which he entered in 1931.

Thus, in various stages of maturity, a multicultural, national, regional nucleus of the future Abstract Expressionist group was already living in New York in 1930. Barely out of their teens, these men faced the worst economic disaster America had ever suffered—the Great Depression. Artists, who had often to supplement their meager sales by a variety of odd jobs, and whose productions were of marginal value to the public, were especially hard hit. According to Francis O'Connor, "When Franklin D. Roosevelt became president on March 4, 1933, ten thousand artists were unemployed in the United States."[1]

With Federal Arts Project I, which began operating in the fall of 1935, all artists irrespective of age or experience at last had options open to them. Prior to this project, a branch of the Works Progress (later called Project) Administration, another relief program called the Public Works of Art Project functioned during the winter of 1933-34. Criticized for élitism, it was broadened into Federal Arts Project I, in turn subdivided into Music, Drama, Literature and Art. Under the Treasury Department, there existed another art program—not specifically a relief program—designed to commission artists on the basis of competitions for the decoration of new public buildings. Philip Guston's mural for the Social Security Building in Wash-

ington, installed in 1943, was one such commission. There was a distinct dif-
ference between the mural division of the Federal Arts Project, through
which artists were given mural commissions in pre-existing buildings, and
the Treasury Department's Art Program, which carried far more prestige.*

In return for producing one picture every four to eight weeks (depend-
ing on size and pace of work) for the easel division of the FAP or in
exchange for ninety-six hours of work per month on a mural project, for ex-
ample, the artist received an average of ninety-five dollars a month. Easel
pictures were allocated to various Federally supported institutions, which
could then accept or turn them down. Federal patronage thus became pri-
marily responsible for the artists' survival during the Depression years and,
in the best of circumstances, enabled artists to experiment freely without
having to worry about sales.

It is quite likely that indirect pressures exerted by Project officials or
eventual recipients of the art tended to influence the style and subject matter
of a number of artists. If, as alleged in *Art Front,*† the artists' union review,
Project officials frowned upon social criticism, depressing subjects and ab-
stract art, it is no wonder that many artists on relief who felt that allocation
of their work was important to their self-respect took refuge in a banal and
conventional execution. In New York, however, the Project official in
charge of the easel division was Burgoyne Diller, an abstract painter him-
self, who did his best to help and protect young experimental artists like
Pollock and de Kooning.

In any event, the Federal government's new interest in the arts gave art-
ists a sense of professional identity that few had ever experienced before.
Hitherto, "the choice was always to be a dutiful artisan, a polite courtier or
a pariah," says Dore Ashton in *The New York School.*[2] The uneasiness of
the artist's position in society was not, however, radically changed by the
Project, and this issue was to be thrashed over time and again.

Apart from Barnett Newman, all the artists mentioned above worked
on the Federal Arts Project at some point during the 1930s, as did the paint-
er Philip Guston (b. 1913), who came to New York in 1936. Jackson Pol-
lock was in and out of the easel section of the Project until its termination
in 1943; other artists competed for mural or sculpture assignments. Both

* According to Lee Krasner, a painter on the mural division of the FAP in New York, in a
conversation with the author, the "big boys" working for the Treasury in the 1930s
tended to lord it over their less fortunate comrades, a situation that left traces of bitterness
and was reversed in the 1940s.

† A monthly sheet covering the arts, sponsored by the Artists Union and the Artists Com-
mittee for Action, with Stuart Davis on the editorial board—was started in November
1934 and came out regularly until the end of 1937. A number of young American intellec-
tuals, such as Meyer Schapiro and Harold Rosenberg, were frequent contributors, as well
as the painter Fernand Léger, who lived in New York during part of the 1930s and painted
murals for the French Line piers under WPA auspices.

Adolph Gottlieb and Philip Guston participated in the 48-States Competition in 1939-40 for the decoration of post offices, Adolph Gottlieb winning with a landscape, *Homestead on The Plain,* for the Yerington, Nevada, post office; Philip Guston with a genre scene, *Early Mail Service and Construction of Railroads* for a post office in Commerce, Georgia.* Arshile Gorky's mural at the Newark Airport, *Aviation: Evolution of Forms under Aerodynamic Limitations* (1935-36), now hidden under several layers of paint, was among the earliest and most ambitious of the Federally subsidized murals. It consisted of ten panels combining collage and flatly painted, semiabstract forms.

The New York headquarters of the Federal Project was in downtown Manhattan on King Street. In the 1930s, many artists found lofts in and around Greenwich Village. When not working, they would leave their uncomfortable quarters and browse around on Eighth Street, ending their walk in Washington Square Park in the summer, in nearby cafeterias in the winter. They met haphazardly, on park benches (Gorky, de Kooning), through mutual friends at the League (Newman, Gottlieb, Rothko), at political rallies, at openings of the various exhibitions sponsored by the Project or by the Municipal Art Committee,† on mural assignments, at the Project headquarters and elsewhere. They showed each other their works, formed tentative groupings such as The Ten,‡ and exchanged ideas. Thus, to quote Thomas Hess in his monograph on Willem de Kooning's paintings, a community was born, marked by "a sense of colleaguality and mutual respect."[4]

Scant evidence remains of paintings and sculptures produced by this community in the 1930s either for the Project or for strictly experimental purposes. A New York restorer-dealer, Herbert Benevy, retrieved some two hundred canvases out of a lot of several thousand that had been auctioned off by the defunct Project in 1944 and bought by a plumber for insulation, when the plumber, finding them unsuitable, turned them over to a junk dealer. Most of the pictures have since disappeared from the restorer's shop, apparently stolen.[5]

Few of the future leaders of Abstract Expressionism had one-man

* An art map for the 1939-40 New York World's Fair[3] lists among other art items a mural attributed to Arshile Gorky (*Aviation*) in the Aviation Building, one by William de Kooming [sic] (*Production*) in the Hall of Pharmacy, one by Philip Guston (*Maintaining America's Skills*), over the entrance to the WPA Building.

† Upon a suggestion made half in jest by Barnett Newman to the mayor of New York, and under the pressure of the Artists Union founded in 1933, a Municipal Art Committee began to arrange exhibits, first in temporary galleries, then at the Municipal Art Gallery, run essentially for artists by artists between 1936 and 1939.

‡ The Ten, who were in fact nine, included Ben Zion, Ilya Bolotowsky, Adolph Gottlieb, Louis Harris, Kufeld, Mark Rothko, Louis Schanker, Joseph Solman and Nahum Tschacbasov. They held their first exhibition at the Montross Gallery late in 1935 and were also shown as a group at the Municipal Art Gallery in 1936.

shows in the 1930s; their group shows often did not receive notice, and they apparently destroyed a great deal of their work. Even so, from an occasional review, the testimony of friends, a rare museum purchase, the inclusion of a sampling of their 1930s work in a recent major retrospective, from photographs and other sources, one can get an idea of the group's accomplishments.

Definitively figurative at that time were Mark Rothko and Adolph Gottlieb, who in 1935 founded The Ten, an association of artists described in *Art Front* as attempting "to combine a social consciousness with the abstract, expressionistic heritage [of the modern movements], thus saving art from being mere propaganda on the one hand, or mere formalism on the other."[6] Mark Rothko, the review pointed out, showed an interest in the proletariat and its problems in *Woman Sewing*; Adolph Gottlieb, his awareness of futility, abandonment and the insecurity of modern life in *Conference* and *Rendez-Vous*. Rothko also did a number of subway scenes in light pastel colors (the example shown at the 1972 Paris retrospective of the artist brings to mind Piero della Francesca, and the American Milton Avery). Gottlieb painted figures of sturdy, athletic women (a photograph at the Whitney Museum suggests a debt to the *Brücke* group of German Expressionists). Barnett Newman told Thomas Hess[7] that he too was working figuratively using a felt tip with a holder to make large flat areas of color.

Willem de Kooning oscillated between compassionate portraiture—*Two Men Standing* (1938)—and abstractions such as *Elegy* (1939). A tendency to obliterate, to leave unfinished was already apparent in de Kooning's work of the 1930s, characterized by delicate though acid color choices. De Kooning's friend Arshile Gorky also painted some naturalistic pictures, such as the *Portrait of the Artist and His Mother*, which he never finished, as well as abstract-looking works heavily indebted to the artists he admired at the time, Picasso and Fernand Léger, as in *Painting* (1938) at the Whitney Museum. Better than his "gritty" paintings of this period, the many drawings he was making reveal the personal, almost trembling and ultrasensitive touch that would appear in his later works.

David Smith, who turned to sculpture in the early part of the decade, created works—such as *Interior* (1937) and *Amusement Park* (1938)—reminiscent of the airy constructions of Picasso and Julio González, and not unlike three-dimensional Surrealist doodlings. His *Unity of Three Forms* (1937), consisting of small welded geometric sections of steel sheets, announces on a reduced scale the thin tall pieces compressed within a single planar axis that he would produce later on, some anthropomorphic like *Unity*, some not. Ad Reinhardt, who studied with abstract painters only, was from the start nonrepresentational and worked in the line of Neoplasticism and hard-edge abstraction, moving to eye-tingling collages of magazine and newspaper cuttings in 1940.

Jackson Pollock, besides borrowing from his teacher, Thomas Hart Benton, and from the American mystical painter, Albert Pinkham Ryder, already showed some unusual traits in *Landscape with Train* (1937), one of the pictures he executed for the Project. As if the artist's intention had changed course in mid-painting, the flat, open landscape—its horizon defined by a range of mountains, the distant train of the title puffing its plume of smoke into a bland sky—contains in the foreground a grayish, primordial, biomorphic shape with a "foot" barely touching a gently flowing rivulet. In Pollock's *Flame* (1937) and *Seascape* (1934), which are suggestive of El Greco and other expressionistic styles, light radiates as in glowing coals with near-mystical force. In an untitled painting of the late 1930s (at Marlborough Gallery), in which one can vaguely make out a knife pointing and figures fighting, the suggestion of Picasso's *Guernica* is obvious, but, as in a number of Pollock's so-called psychoanalytic drawings,* the figures are so interwoven with each other that it is impossible to disentangle (female?) victim from (male?) executioner.

From the large *Gallery of American Art Today* show[8] assembled by the Federal Arts Project director, Holger Cahill, in connection with the 1939-40 World's Fair, one can also note that Adolph Gottlieb, represented by *Relics of the Southwest*, had become interested in a new subject, still life, which he treated in a Cubistic manner. As it happened, in the late 1930s Gottlieb and several other young artists turned away from social concerns as a reaction to international political events. Philip Guston, who inserted in his contribution, a mural sketch entitled *City Slum*, a woman standing in an open coffin or sarcophagus, was combining social commentary and surreal elements.

The New York art world that served as a setting for these creations was far from monolithic in the 1930s. The Regionalist painter, Thomas Hart Benton, a forceful influence at the League, where Jackson Pollock, Mark Rothko, Barnett Newman, Adolph Gottlieb and others once studied, and who took particular interest in Jackson Pollock, did not conceal his distaste for modernism and intellectualism nor his conviction that great American art would come from the provinces. In answer to the question, "Do you believe that the future of American art lies in the Middle West?" he had written: "Yes . . . because there is among the young artists of the Middle West as a whole less of that dependent, cowardly and servile spirit which in a state of intellectual impotence and neurotic fear is always submitting itself to the last plausible diagnostician, "just to be on the safe side."[9] Jackson Pollock was to say to an interviewer in 1944 that his work with Benton "was important as something against which to react very strongly later on; in this it was better to have worked with him than with a less resistant personality who would have provided a much less strong opposition."[10]

* These are drawings which Jackson Pollock showed to his analyst, Dr. Joseph Henderson, who treated him in 1939.

David Smith [once a student of Jan Matulka] created works . . . reminiscent of the airy constructions of Picasso and Julio Gonzáles, and not unlike three-dimensional Surrealist doodlings.

top: David Smith, *Interior*, 1937, painted steel and bronze on wood base. Mr. and Mrs. Samuel Dorsky Collection, New York. 15 1/2″ high, 26″ wide, 6″ deep.

bottom: Julio Gonzáles, *Danseuse à la Palette*, bronze (cast from 1933 original in iron). Musée National d'Art Moderne, Paris. 32 1/2″ high.

On the other hand, three highly respected figures—the lyrical painter Milton Avery (1893-1965), close to Adolph Gottlieb and Mark Rothko; the Russian-born painter-esthete John Graham (1881-1961), who befriended Willem de Kooning, Arshile Gorky, David Smith and Jackson Pollock; the avant-gardist Stuart Davis (1894-1964), who also helped young promising artists—had all worked in the mainstream of recent European art. Not only had they been to Paris in the 1920s, but Stuart Davis had lived next door to the French émigré painters Albert Gleizes, Jacques Villon, Marcel Duchamp and Francis Picabia in New York during the First World War. Attacking the "Regionalists," and the Kansan John Steuart Curry in particular, Stuart Davis wrote in the pages of *Art Front:* "How can a man who paints as though no laboratory work had ever been done in painting . . . [who] proceeds as though painting were a jolly lark for amateurs to be exhibited in county fairs . . . be considered an asset to the development of American painting. . . ?"[11]

Concurring with Stuart Davis, a group of American artists banded together in 1936 to found the American Abstract Artists or AAA, which invited young experimental painters for yearly exhibitions. Several future Abstract Expressionists were friendly toward the AAA, although the art-for-art's-sake attitudes of the group were distasteful to the socially conscious moralists among them. Stuart Davis himself, stylistically inclined toward abstract art, painted only murals in the 1930s, which, being "public" art, had a social purpose.

Thomas Hart Benton was not the only influence at the League at this time—Jan Matulka, an abstract artist, was also a respected figure there. Hans Hofmann (1880-1966), the Munich art teacher, later a close associate of the Abstract Expressionists, had now opened his school on Eighth Street, where refreshing insights were given into contemporary art, which Hofmann had absorbed first-hand in Paris and Munich. Students and outsiders alike, whether they approved of the master's art-for-art's-sake views or not, came to attend Hans Hofmann's critiques and Friday night lectures.*

In 1936 the Mexican muralist David Alfaro Siqueiros, started an experimental workshop on Union Square, which Jackson Pollock frequented. There one heard about new materials such as nitrocellulose lacquer and silicones, new surfaces such as plywood and asbestos, new ways of applying paint with airbrushes and spray guns or by pouring, dripping, splattering and hurling it at the picture surface and about "a theory and system of 'controlled accidents,' " recalls Axel Horn.[12] The Mexican painters Siqueiros, José Clemente Orozco and Diego Rivera, whose leftist allegiances were well known—Rivera had included a head of Lenin in his mural for Rockefeller

* In 1940 Hofmann painted *Spring*, a miniature "drip painting" now at the Museum of Modern Art, but he did not exhibit it or any other work until 1944.

Center in New York—attracted around them a host of young artists on whom their large works, such as Orozco's *Gods of the Modern World* (at Dartmouth College), dramatizing social commentary by the inclusion of surreal elements, exerted great fascination.

No young artist of any ambition could help but be stimulated by the international art exhibitions presented at the newly founded Museum of Modern Art; by the shows, lectures and symposia organized under the auspices of the Société Anonyme;* by the Gallatin Collection of modern art on view at New York University; by the Kandinskys shown in the Guggenheim Museum of Non-objective Painting; by the galleries specializing in modern Europeans (Pierre Matisse, Julien Levy); by the French art magazines, *Cahiers d'Art* and *Verve*, which were eagerly consulted in these years.† Yet the new generation, deprived of the cultural shock that had come with the 1913 New York Armory Show and rarely in a position to visit Europe‡ (where the avant-garde impulse was wavering anyway in the 1930s), were forced, if interested in "catching up," to assimilate at second hand the various art revolutions that had transformed the European art scene during the first twenty years of the century, and looked in some cases as far back as the Italian Renaissance (to Piero della Francesca and Paolo Uccello, for example) for models worthy of emulation.

Uneven as they were, the creations of the future Abstract Expressionists must have looked bold and dangerously unconventional in the company of the innocuous photographic landscapes, still lifes and genre scenes that abound in the catalogue of the *Gallery of American Art Today* show, mentioned above. But this New York "underground" community suffered from a lack of revolutionary ideas and an absence of direction. Of the decade, Barnett Newman said that it had been "limbo" for him. "I was drifting away and casting about, involved in a search for myself, for my subject . . . a hunger about myself"[13] Jackson Pollock, in a 1940 letter to his brother Charles[14] speaks of violent changes in his works in the last two years, calling them "pretty negative stuff so far," and, in profound psychological conflict, he entered Jungian analysis that same year.

By 1941 the somber political situation of Europe has brought to the United States a tidal wave of refugees from the Nazis, many of them professional

* Founded in 1920 by Marcel Duchamp and Katherine Dreier, this was an international organization for the promotion of the study in America of modern artistic trends. Through gifts and purchases, works of art were collected and eventually incorporated into the permanent collection of the Yale University Art Gallery.

† The dead surfaces found in so much painting of the 1930s are often attributed to the reliance of artists on photographic material.

‡ David Smith did get to Paris in the 1930s and Adolph Gottlieb was able to make a trip through Europe in 1921.

and first-rate. They swell the ranks of art historians (Panofsky, Fried-laender), composers (Schönberg, Milhaud, Bartok), philosophers (Jacques Maritain, Paul Tillich and several members of the Vienna circle of posi-tivists, scientists (Einstein, Fermi), sociologists (Claude Lévi-Strauss) and psychoanalysts of both the Freudian and Jungian persuasions.

News-reporting by radio and other media rivals the novelists' most gruesome war stories, and from the front the poet Randall Jarrell sends his disillusioned messages: "It happens as it does because it does/ It is unneces-sary to understand if you are still/ In the year of our welfare indispensable/ In general, and in particular dispensable/ As a cartridge, a life. . . ." ("Siegfried").

Concluded by the dropping of atomic bombs over Japan, the Second World War ends in a nightmare, fed further by revelations of the extermi-nation of millions in concentration camps. In the United States blacklist-ings and witchhunts go along with the Cold War, splitting the country and leading a number of creators, particularly in film, to expatriate themselves.

In the 1940s

In November 1943 Jackson Pollock had his first one-man show in New York; *Male and Female, She Wolf, Moon Woman, Guardians of The Secret*, were some of the works displayed. In June of the same year Mark Rothko and Adolph Gottlieb exhibited, with the Federation of Modern Painters and Sculptors, paintings called *Syrian Bull* and *Rape of Per-sephone*, respectively. Having reached a dead end, the New York group had been searching for new themes and new means of expression. By 1943 some of them had escaped from the options of the 1930s—the American scene, Social Realism and derivative Modernism—by investigating poetic imagi-nary subject matter as found in ancient mythology, in the myths of the American Indians and in the writings of Carl Jung on the primitive collec-tive unconscious. Pollock was in Jungian analysis; Rothko and Gottlieb were both avid readers of Jung. "Given a subject matter that was different, perhaps some new approach to painting, a technical approach might also develop," Gottlieb would later say in a 1963 interview with David Sylves-ter.[15]

The French Surrealist review of the 1930s, aptly called *Minotaure*, often reached New York; the presence of the Mexican painters had contrib-uted to an increased interest in archaic American civilizations; a show of North American Indian art was held at the Museum of Modern Art in 1941. Both Pollock and Gottlieb had spent time in the Southwest during the 1930s and were familiar with Indian sand painting. Picasso's 1936 master-piece, *Guernica*, frequently reproduced in art magazines and on view in

New York in 1939, had transformed a horror scene, the bombing of innocents, into a universal statement against war by means of allusive and symbolic, rather than descriptive, imagery. Miró's amoebic and starlike designs, "randomly" assembled on an indefinite painterly background, and on view at his Museum of Modern Art show in 1941, offered a vocabulary of poetic forms and spaces that could lead to mythical interpretation without telling a story.

Whatever the source, an interest in ancient and primordial myths came to the fore and gained momentum in the 1940s. Like Pollock, Gottlieb, Rothko and their entourage, Hans Hofmann (better known then through his teaching than his painting) gave mythical titles to some of his works, such as the *Idolatress* of 1944. Barnett Newman wrote articles on primitive art, organized shows of pre-Columbian stone sculpture (1944) and Northwest Coast Indian painting (1946) and called one of the first works he created after a long silence *Gea* ("mother earth" in Greek). De Kooning's *Women* alluded to a universal symbol rather than to a specific female; his *Orestes* was painted around 1947; and David Smith's *Widow's Lament* of 1943 and *The Hero* (1951-52) were likewise symbols rather than portraits. The schematic figures of *Pancho Villa Dead or Alive* (1943) by Robert Motherwell* evoked a child's primitive drawings. The mythological theme even invaded the field of modern dance, as Dore Ashton reminds us[16]—ballets by Martha Graham are called *Dark Meadow, Night Journey, Clytemnestra*, etc.

The interest of artists in ancient or isolated cultures and more generally in primitivism was certainly not new in the 1940s—hardly an artist since the turn of the century had escaped this shock of discovery. But Adolph Gottlieb pointed out in a WNYC radio broadcast on October 13, 1943, that while modern art got its first impetus through discovering the forms of primtive art, he and Mark Rothko felt that "its true significance lies not merely in formal arrangement but in the spiritual meaning underlying all archaic works."[17] Genteel painting, they said, was now irrelevant. If art was to survive, it must, like archaic painting, take on a primitive and direct expression and in some way signify the elementary and unbridled instincts that were, then in the war-torn 1940s, making monsters out of some men and striking terror into the lives of others. As Rothko said in the same broadcast:

> The myth holds us, not through its romantic flavor, not through remembrance of the beauty of some bygone age, not through the possibilities of fantasy, but because it expresses to us something real and existing in ourselves as it was to those who first stumbled upon the symbols to give them life."[18]

* See page 180.

"Given a subject that was different, perhaps some new approach to painting, a technical approach might also develop." (Gottlieb)

top: Adolph Gottlieb, *Voyager's Return*, 1946, oil on canvas. The Museum of Modern Art, New York (Gift of Mr. and Mrs. Roy Neuberger). 37 7/8 x 29 7/8".

bottom: Jackson Pollock, *Stenographic Figure*, 1942, oil on canvas. Photograph courtesy Marlborough Gallery, New York. 40 x 55 3/4".

As pointed out by Irving Sandler,[19] the goals set out in 1943 did not materialize for several years. The immediate effect of the shift in subject matter was not so much toward Abstract Expressionism as such* as toward the introduction of private, symbolic language into painting, only partially related to the objectives set:

> 1. To us art is an adventure into an unknown world which can be explored only by those willing to take the risks.
>
> 2. This world of the imagination is fancy-free and violently opposed to common sense.
>
> 3. It is our function as artists to make the spectator see the world our way— not his way.
>
> 4. We favor the simple expression of the complex thought. We are for the large shape because it has the impact of the unequivocal. We wish to reassert the picture plane. We are for flat forms because they destroy illusion and reveal truth.[20]

If possibilities were opened up through the exploration of new subject matter, there was stimulation also in the changed context of the New York art scene. The group loosely formed in the 1930s was enlarged, and by 1943 Jackson Pollock, Willem de Kooning and Lee (Leonore) Krasner had been brought together in a group show organized by John Graham.† Lee Krasner, who was later to become Pollock's wife, introduced him into her circle at the Hofmann school and presented him to Hans Hofmann himself.‡ A young art reviewer at *The Nation* named Clement Greenberg who had taken an interest in Pollock would begin writing about him and his friends. By 1943 Robert Motherwell, a philosophy student from California recently turned painter, had met various artists through Meyer Schapiro, his former professor at Columbia Graduate School.

This enlarged group benefited still further from the arrival en masse of representatives of the European art world, refugees from the Nazi onslaught, including painters, sculptors, poets, writers, collectors and dealers. As early as 1939, such solitary figures as the painters Piet Mondrian, Fernand Léger and Marc Chagall, the sculptors Zadkine and Jacques Lipchitz, and a vociferous group of Surrealist painters and poets had been dis-

* See page 186-199.

† At the McMillen Gallery in 1942, John Graham had invited his friends among young artists and showed their work with that of Stuart Davis, Braque, Bonnard, Matisse and Modigliani.

‡ Hofmann then went to see Pollock's work at Lee Krasner's suggestion, and told Pollock he should enroll at the Hofmann school, to which Pollock retorted, "Your theories don't interest me, where is your art?" A visit to Hofmann's studio ensued and in 1944, thanks to Pollock's intervention, Hofmann had a one-man show at Peggy Guggenheim's gallery, *Art of This Century*, his first in many years.[21]

embarking in New York, which soon became the most avant-garde and lively art center in the world.

The Surrealist André Breton, who arrived in New York in 1941, immediately began to try to resume his moral and intellectual leadership and continued his quest for young talent. Interviewed on the present and future orientation of Surrealism, Breton answered by quoting Baudelaire: "*Plonger au fond du gouffre/Enfer ou Ciel qu'importe/Au Fond de l'inconnu pour/Trouver du nouveau. . .*"*,[22] and included Joseph Cornell, maker of boxes with a nostalgic content, and the photographer-sculptor David Hare as young American Surrealist hopefuls. Although handicapped by his refusal to learn English, Breton aired his ideas in *View* and *VVV*, founded in 1940 and 1942 respectively, which published, in French and English, theoretical and poetic writings by the exiles as well as American intellectuals.

One of Breton's discoveries, the young Chilean painter Matta, had no sooner settled near Eighth Street than he began to seek out his American counterparts. To Matta's loft came Pollock's friend from the Project, the painter William Baziotes, Pollock himself, Robert Motherwell and Arshile Gorky, among others. In turn, Matta visited his friends' studios and is said to have encouraged if not introduced among them the practice of *automatism†* and free association, whereby fluidly applied paint becomes, like the first sentence of an automatic poem, the stimulus to an intimate psychological exploration, the details (or morphologies) of which are indicated by a succession of wandering lines giving clues to the current obsessions of the artist.

Kurt Seligmann, another Surrealist of recent allegiance, began to teach engraving and to hold evenings of "black magic." Meanwhile, Stanley William Hayter reopened the print-making atelier he had run in Paris, which the French surrealist André Masson and other exiles continued to patronize, joined now and then by New York artists including Motherwell and Pollock. Throughout the decade, New York galleries held showings of the exiles' works, from Mondrian's "open-ended," Neoplastic squares, left unframed but placed forward of a white border, to the poetic meanderings in paint of André Masson, Max Ernst, Yves Tanguy, Kurt Seligmann and Matta.

In 1942 the former Dadaist Marcel Duchamp, recently arrived from France, organized with André Breton a Surrealist event, "The First Papers of Surrealism." The modern paintings and sculptures gathered for the oc-

* To plunge to the bottom of the abyss
 Heaven or Hell, no matter which,
 To the bottom of the unknown
 In search of something new.

† He, Motherwell and Pollock apparently wrote some automatic poetry in the early 1940s and, thanks to Matta, Pollock came to the attention of Peggy Guggenheim.

casion were made practically invisible by a mile of white string running throughout the interior of the gallery. This network of twine, a sculpture of sorts, suggested that one creates even as one destroys; the event as a whole revealed one more example of Duchamp's iconoclasm (an attitude shared to a certain extent by the young New York artists who had questioned art-for-art's sake attitudes in the 1930s); while essays in the accompanying catalogue spoke of Surrealism as part of a tradition among American "eccentrics" going back to naive anonymous limners of the nineteenth century, and including the mystical painter Albert Pinkham Ryder and such visionary writers as Herman Melville and Edgar Allan Poe.

But the most dynamic and catalytic personality of the time was undoubtedly an American woman, a patron of the European avant-garde of the 1920s and 1930s, Peggy Guggenheim, then married to the Surrealist painter Max Ernst. She realized in New York an ambition she had long cherished—to create a museum-gallery to display her own collection and promote young, unknown artists. In a setting designed by the Surrealist architect Frederick Kiesler, the Art of This Century Gallery opened in the fall of 1942. For the duration of the war and until 1947, Peggy Guggenheim gave several future Abstract Expressionists their first opportunity to be seen, starting with Jackson Pollock in the fall of 1943. She showed his work from 1943 to 1947, that of his friend William Baziotes in 1944, Robert Motherwell in 1944, Mark Rothko in 1945 and the Californian Clyfford Still in 1946. In 1944 she exhibited Hans Hofmann, not a beginner but new to the New York art scene as a painter; moreover, she challenged some of them with specific projects, such as a collage show—the preparation of which especially stimulated Robert Motherwell (one of the participants with Jackson Pollock and William Baziotes)—and a mural that launched Pollock on large-scale painting.

Between the cosmopolitan Surrealists and the rugged, self-made New York artists, there seems to have been little personal affinity. The closeness of Matta to Gorky was rather exceptional, while Clement Greenberg's poor opinion of the Surrealists became legendary. However, with all the activity that was going on in New York, American painters in particular could not help but change, and change was reflected in the appearance of their works, which eventually became pulsating surfaces animated by the discovery of improvisation, chance and accidental effects and of innumerable ways of applying paint to canvas.

Pollock's works exhibited at Art of This Century in 1943 evince traces of an impulsive hand scribbling in joyous colors over vaguely figurative images as if to make them less visible. In *Stenographic Figure* (1943) the artist's signature itself is partially concealed by black scratches. Rapidly traced notations contradicting an underlying image also appear in de Kooning's *Pink Lady* of 1944, and in the free and fluid black and white "land-

*. . . a new feeling of intimacy, as
if the painting had become, for
Gorky, a nonverbal diary, a record
of past visions and present
obsesssions. . . .*

top: Arshile Gorky, *Diary of a
Seducer*, 1945, oil. Collection
Mr. and Mrs. William A. M. Burden,
New York. 50 x 62''.

*"His art depends on a sense of the
vicious past. . . . To the American
mind, nothing could be more alien. . . ."
(Motherwell)*

bottom: Max Ernst, *The Blessed
Virgin Chastises the Infant Jesus
before Three Witnesses: A.B., P.E.
and the Artist* [Breton, Eluard,
Ernst], 1928, oil on canvas. Private
collection, Brussels. 77 1/4 x 51 1/4''.

scapes" that he exhibited at his first one-man show in 1948. In Hans Hofmann's small *Ambush* of 1944, now in the Museum of Modern Art, the surface has become "explosive" through the brutal encounter of a fat, loaded brush with the canvas. A loose painterliness appears in Reinhardt's works of the 1940s; accidental stains become the facial features of a human form in Motherwell's *Pancho Villa Dead or Alive* (1943), now in the Museum of Modern Art; and in Still's *The Spectre and the Parakeet*, exhibited at Art of This Century in 1946, the two shapes of the title seem accidentally born from the dark abstract field with its ragged edges.

Only allusive references to air, water and primordial life are given in Rothko's delicate watercolors and gouaches of this period, which are often divided into two pale horizontal bands traced by a wide brush, the lower band reflecting, as if the paper had been folded over, the inklike spots and blotches of the upper band, as in *Vessels of Magic*, a 1946 watercolor now in the Brooklyn Museum. Little illusionistic depth appears in Gottlieb's pictographs,* which consist of incongruously juxtaposed symbols inside rectangular grids—heads, spirals, fish and lozenge shapes—jotted down as if by a child's hand in *Voyager's Return* of 1946, more direct and supple in *Man Looking at Woman* of 1949 (both now in the Museum of Modern Art).

Gritty surfaces and heavy Picassoid outlines no longer appear in the works that Gorky showed, from 1945 to his death in 1948, at Julien Levy's gallery; instead there is a transparent quality to the paint, sometimes allowed to stain into the canvas; rather than an accord between paint and line, there is an autonomous existence for both, and a new feeling of intimacy as if the painting had become for Gorky a nonverbal diary, a record of past visions and present obsessions, particularly in his very large *Diary of a Seducer* of 1945.

One complaint often voiced about some of the works done in the 1940s was that the viewer was unable to connect an outwardly abstract or near abstract design with the mythical references in the title; and a corresponding problem for some of the artists was, indeed, to come to grips with the content of their works, less and less the product of preconceived ideas, increasingly guided by surprise happenings in the process of creation, yet invoking a name to link the resulting signs to some definite meaning. Gorky, who avoided myths, skirted the issue. Another criticism took aim at the derivative features in the Americans' works. Robert Coates wrote in *The New Yorker:*

> As I've remarked before, a new school is developing in this country. It is small as yet, no bigger than a baby's fist, but it is noticeable if you get around the

* Pictographs or petroglyphs are technical words for rock pictures, and the terms were used in the essays accompanying the 1941 Museum of Modern Art show, *Indian Art of North America.* Gottlieb's first pictograph, *Rape of Persephone*, looks like a picture drawn on a rock.

galleries. It partakes a little of surrealism, and still more of expressionism and although its main current is still muddy and its direction obscure one can make out a bit of Hans Arp and Miró floating in it, together with large chunks of Picasso and occasional recondite influences such as the ancient byzantine painters and mosaicists and the African Negro sculptors.
It is more emotional than logical in expression and you may not like it but it can't escape attention. Pollock, Gorky, Rothko represent the extreme left of the movement.[23]

Interviewed in the winter of 1947 about what he thought of young forward-looking American painters, Joan Miró, answered: "I admire very much the energy and vitality of American painters. I especially like their enthusiasm and freshness." And he added, "They would do well to free themselves from Europe's influence."[24] The closing down of Peggy Guggenheim's gallery in 1947, the demise of the Surrealist-oriented *View* and *VVV*, and the exiles' deaths or return to Europe left the New York artists on their own. From then on they no longer had the shield that the exiles had provided and which in fact had been a barrier between them and their true identity. Speaking of Max Ernst, Robert Motherwell wrote: "His art depends on a sense of a vicious past. To the American mind, nothing could be more alien. . . . For better or for worse, most Americans have no sensation of being either elevated or smothered by the past."[25] The blank canvases they now faced mirrored their own hazardous and uncertain future.

High and low culture are poles apart in the late 1940s and early 1950s. Musical comedies, big-budget movies, money games on television speak of America's prosperity and low-brow tastes.

Taking refuge in universities or in Greenwich Village, American intellectuals, writers and poets turn into critics, re-evaluating their cultural heritage rather than their society, and accepting alienation from the masses as inescapable. Moby Dick *is one of the favored subjects for the New Critics, who discover in Melville's opus new symbols, meanings, allusions and interpretations. Existential questions are often raised and existential philosophers eagerly read and discussed.*

By 1950, a new "beat" generation looking for "authenticity" actively withdraws from society. It will find in the poet Allen Ginsberg a natural ally and leader.

Among the new writers, alienation from social concerns is evident as well, with the exception of the playwright Arthur Miller. In The Adventures of Augie March, *published in 1953, Saul Bellow's hero, crisscrossing the North American continent in search of an identity, hints at a new open situation and space.*

What Abstract Expressionism Was About

When in 1960 Ad Reinhardt began to paint over and over again five-by-five-foot squares that at first seemed totally black and revealed only upon close inspection a geometric cruciform design in slightly tinted variations of black, he was pushing to the limit—a limit since challenged by the so-called Minimalists of the 1960s—the series of rejections and paroxysms through which New York artists reached their most singular and powerful statement in Abstract Expressionism. He was perhaps also alluding to the latest accomplishments of some of the painters, which by the late 1950s had become stabilized and repetitive, courting academic dullness. Reinhardt's black square paintings can be read as signifying the end of art, or the possibility of a metaphysical experience through art, or simply as an absence of content; they illustrate in their ambiguity the narrow ledge on which New York artists staked their lives and work in the late 1940s and early 1950s.

In the midst of American postwar prosperity, the New York group assumed no less than a heroic stance. Sick and defeated, Arshile Gorky committed suicide in 1948, only to become posthumously hailed as a precursor of the new American art and a key transitional figure. Jackson Pollock, brutally placed in the limelight through an article in *Life* magazine (August 8, 1949) entitled "Is He the Greatest Living Painter in the United States?", acquired a dubious celebrity in New York and around his home in Springs, Long Island. David Smith, confronting only a *succés d'estime*, retreated to Bolton's Landing in upstate New York. The increasingly monumental sculptures in reflecting or enamel-painted steel that he made there were destined to dot the field outside his window. Such New York dealers as Parsons, Egan, Willard and Kootz, now exhibiting the often impractically scaled works of the New York artists, saw few sales indeed, since the public continued to favor European art. If friends wrote favorably about the Americans in *The Nation, Partisan Review, Art News, The Magazine of Art* and other intellectual publications, *Life* magazine, torn between the tastes of its readers and the news value of the Americans' accomplishments straddled the fence and argued unintelligibility. As for the daily press, it ignored or at best summarily dismissed them. When in May of 1951 the group gave an exhibition in a loft on Ninth Street, the *New York Times* barely signaled the opening and never reviewed the show, although retrospectively this event turned out to be momentous, gathering as it did for the first time, in their mature styles, practically all the key figures of what is now called the "first generation" of Abstract Expressionists. "An unusual exhibition has opened at 60 E. 9th Street. A group of enterprising artists has joined in transforming large empty store quarters into galleries whose work by 50 abstract painters may be seen till June 10." Names of collaborating galleries followed and seventeen of the artists were listed.[26]

In the late 1940s and early 1950s many in the New York avant-garde were teaching in order to survive. Hans Hofmann, now facing a new generation of war veterans, spoke to them about "push and pull," using metaphors, analogues, diagrams and sketches and the intonations of his accented speech to make his points. "Depth," he wrote, "in a pictorial, plastic sense is not created by the arrangement of objects one after another toward a vanishing point, in the sense of Renaissance perspective, but on the contrary (and in absolute denial of this doctrine) by the creation of forces in the sense of push and pull."[27]

In the fall of 1948 Mark Rothko, Robert Motherwell, Clyfford Still, Barnett Newman, with William Baziotes and David Hare, opened a school in downtown New York, called Subjects of the Artists, "to enlighten students to what modern artists paint about as well as how to paint"—so the description of the curriculum read in part. The school lasted only a year, but its legendary Friday night discussions, open to the public, continued until 1951.

Josef Albers (b. 1888), head of the art department at Black Mountain, the experimental college in North Carolina, asked de Kooning, Motherwell and Franz Kline to teach at the school's summer institute, where visual artists could participate in a broader avant-garde of musicians, dancers, poets and writers. The summer of 1948 was a particularly good one, bringing together the painter de Kooning, the inventor Buckminster Fuller, the composer John Cage and the choreographer Merce Cunningham. "It may have been out of the Black Mountain thing," Cage remarked to Duberman, "that de Kooning started an Art Club in New York. . . ."[28] Begun in 1933, Black Mountain College closed in 1956.

The California Institute of the Arts, where Clyfford Still taught for several years, by inviting Mark Rothko for two summers, Ad Reinhardt for one, stimulated interaction between mystically inclined Easterners and such Orient-influenced Western painters as Mark Tobey (b. 1890). The California Institute of the Arts, thanks to its director Douglas McAgy, became after the war a vital art school well informed on New York developments and progressive in its thinking, as can be seen by the Table of Modern Art held there in 1949, in which the architect Frank Lloyd Wright, the composer Darius Milhaud, the former Dadaist Marcel Duchamp and many other eminent persons participated.

David Smith taught at Sarah Lawrence College, Rothko and Reinhardt at Brooklyn College, Guston had been at the University of Iowa since the early 1940s, de Kooning went to Yale for a year. Indeed several modern artists began to appear on the campuses of American colleges and universities, and this took care of their financial needs, provided them with valuable experience and, it turned out, gave them a position within a cultivated élite if not fame as creative artists.

Robert Motherwell, in addition to his other activities, became an editor of the *Documents of Modern Art* series. In this capacity, he brought out a translation of Kandinsky's *Concerning the Spiritual in Art*, which, with the memorial show of Kandinsky's work in 1945, is said to have helped turn the tide from a Surrealist-oriented to an Abstract Expressionist outlook within the New York group. Moreover, in the winter of 1947-48, Motherwell, the poet-critic Harold Rosenberg and the composer John Cage produced the one and only issue of what was intended to be an occasional review of art and literature. It was called *Possibilities*. With its statements by Pollock, Rothko, David Smith and William Baziotes, *Possibilities* gave the first inkling of what Abstract Expressionism was; but its editorial, guardedly suggesting that something might emerge even "as the political trap seems to close on him [the artist, the writer],"* reflected the general pessimism at the time among the avant-garde.

Under the circumstances it seemed unlikely that recognition would come to the American avant-garde either locally or internationally. The presence of a few works by Gorky, Pollock and de Kooning in the United States Pavilion at the Venice Biennale (the renowned international art confrontation held every other year in Venice since 1895) next to seascapes by the senior John Marin, in 1950, produced silence abroad and an enraged response here. Yet it seemed just as unlikely that the New York avant-garde would succumb to the prevailing tastes of an antagonistic public. Significant in this respect is the "joining up" (to use Clement Greenberg's phrase) in the late 1940s with the cause of Abstract Expressionism by Franz Kline and Philip Guston, both of whom had acquired over the years a respectable standing as serious if somewhat traditional painters and draftsmen.

In question was the meaning of Pollock's mural-sized, frameless paintings, covered with writhing trails of paint, controlled yet diffused linear patterns in which the eye would hopelessly seek a focus, entitled *Cathedral, Autumn Rhythm*, or simply numbered and dated: *1, 2, 3; 1948, 1949*. Even some members of the learned team gathered by *Life* magazine in 1948 to examine modern art were miffed by *Cathedral* and admitted their lack of appreciation.† "It seems to me exquisite in tone and quality, and would

* A reference to anti-Communist witch hunts.

† This team consisted of: Clement Greenberg, critic; Meyer Schapiro, professor at Columbia University; Georges Duthuit, editor of *Transition 48* from Paris; Aldous Huxley, philosopher-novelist; Francis Taylor of the Metropolitan Museum; Sir Leigh Ashton, of the Victoria and Albert Museum; R. Kirk Askew, Jr., art dealer; Raymond Mortimer, British author and critic; Alfred Frankfurter, editor and publisher of *Art News*; Theodore Greene, professor of philosophy at Yale; James Johnson Sweeney, author and teacher; Charles Sawyer, dean of Fine Arts at Yale; H. W. Janson, then professor of art and archeology, Washington University, Saint Louis; A. Hyatt Taylor, curator of prints at the Metropolitan Museum; James Thrall Soby, department of painting and sculpture, Museum of Modern Art.

make a most enchanting printed silk," someone exclaimed, while Aldous Huxley raised the question of why it stopped when it did: "The artist could go on forever," he said.[29]

Indeed, following a short heavy-impastoed "landscape" phase (*Shimmering in the Grass*, 1946, Museum of Modern Art) Pollock had begun in 1947 to work directly and from all four sides on enormous canvases laid flat on the floor of his studio. Dipping a stiffened brush, a stick or a trowel into a can of commercial paint, or letting the paint flow directly from the can, he would fling it from a distance, rapidly moving not only his hand but his wrist, arm and whole body, so that the paint spilled, dribbled, trickled and dripped on the canvas in ample arabesques. In a half-hour or more of frenzied activity and "dance," Pollock would work the entire surface in an almost continuous stream or burst of energy, then leave it to dry; later he would tack the canvas to a wall and a period of contemplation would follow. Sometimes, as in *One* (1950) or *Autumn Rhythm* (1950), nothing more happened to the work; or, as with *Blue Poles* (1952), the artist might "re-enter the painting again and again, and again," to quote Lee Krasner Pollock,[30] so that a skein or web would be built over several months by a series of abrupt starts and stops, constructive or destructive moves. "When I am *in* my painting, I am not aware of what I am doing," Pollock said. "It is only after a sort of 'get acquainted' period that I see what I have been about. I have no fears about making changes, destroying the image, because the painting has a life of its own. I try to let it come through. It is only when I lose contact with the painting that the result is a mess. Otherwise, there is pure harmony, an easy give and take and the painting comes out well."[31]

Willem de Kooning's new *Women* of the early 1950s were mystifying, appearing even larger than the canvas size would suggest, adorned with a set of grotesque and almost frightening teeth, big monstrous eyes or missing an eye, with fat breasts or none, their shapeless bodies painted in layers of thick, gesticulating brushmarks of sanguine tones, looking like torn bits of flesh stretched across the canvas. Indeed, after a bout with "landscapes"— *Night Square* (1949), *Dark Pond* (1948)—mostly in black and white enamel paint, de Kooning was again exploring the theme of woman in a new gestural style. (Whether a show of the Russian Expressionist Soutine at the Museum of Modern Art in the fall of 1950 had an effect on de Kooning's new works, or simply reflected a common museum policy—to revive artists from the past whose sensibility seems in tune with that of the current moment—is hard to ascertain.) Unlike Pollock's rapid decisions, his *Women* would take months, sometimes years, to emerge while de Kooning altered them by papering or painting over with his thick, house-painter's brushes now this, now that corner of his work, depending on his changing feelings and moods, until, as he explained, somehow the painting would leave him, and he painted himself out of the picture.[32]

Even more puzzling were Hans Hofmann's paintings, which did not contain hints of the figure, but were mostly bursts of crusty color patches, singing or despondent, melodious or jarring, rhythmically packed on fairly large canvases. Hofmann would often start from a view outside his window, or from a still-life arrangement—"an artist must look to nature for the essence of space," he told Elaine de Kooning[33]—concentrating a long time before making the first decision, the first stroke. Then, with astonishing speed, he would apply the paint with "broad lunging gestures"—according to the same witness—grabbing this brush, this piece of gauze, this tube, mixing, rubbing, deleting, working this area, then that one with uninterrupted élan. "Making a picture is almost a physical struggle. . . . You can't use your biceps on a small picture . . . at the time of making a picture, I want not to know what I am doing. A picture should be made with feeling, not with knowing. The possibilities of the medium must be sensed. Anything can serve as medium—kerosene, benzine, turpentine, linseed oil, beeswax, even beer. . . ." he also told Elaine de Kooning.*

Rothko's paintings were dismissed as lacking in content. In the late 1940s Rothko had eliminated the biomorphic elements that had previously appeared on his hazy backgrounds to limit himself to centering on his canvases parallel layers of horizontal rectangles, often rather longer than wide, with fuzzy bleeding edges and diffused watercolor texture. Vibrating and hypnotic surfaces, they resounded insistently when shown in groups sparsely placed on the walls, the way Rothko liked to display them. "I paint very large pictures. I realize that historically the function of painting large pictures is painting something very grandiose and pompous. The reason I paint them, however—I think it applies to other painters I know—is precisely because I want to be very intimate and human. To paint a small picture is to place yourself outside your experience, to look upon an experience as a stereopticon view or with a reducing glass. However, you paint the larger picture, you are in it. It is not something you command . . . ," Rothko remarked during a symposium on how to combine painting, architecture and sculpture.[34]

The modern artist's use of increasingly private symbols had been the chief complaint of the *Life* team, which felt, as did the public at large, that this abuse was the cause of a breakdown in communication. "Demands for communication are both presumptuous and irrelevant," observed Clyfford Still, whose hermetic images consisted of dry-textured "curtains" of dark paint, torn to reveal brightly lit, flamelike shapes or ragged edged expanses seeming to be eating into or eaten by the surrounding field. "The observer

* Hans Hofmann, whose production was extremely varied, held an unusual place within the group of Abstract Expressionists. Although much older, he was a participant in their discussions and, as can be seen from the above remarks, shared many of their concerns.

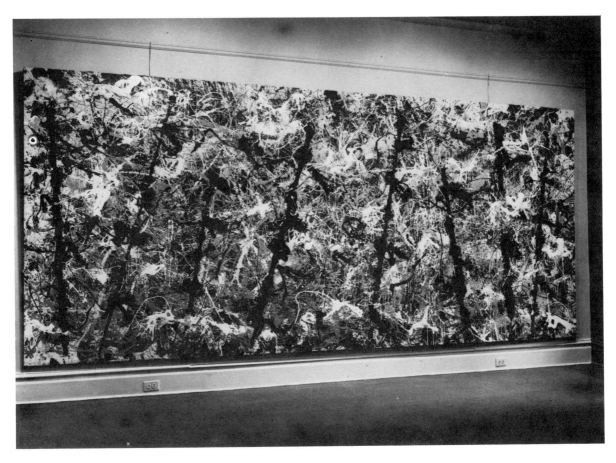

. . . the artist might "reenter the painting again and again. . . ."
(Lee Krasner Pollock)

Pollock, *Blue Poles*, 1952, oil on canvas. Photograph courtesy Sidney Janis Gallery,
New York. 6′ 11″ x 16′ 1″.

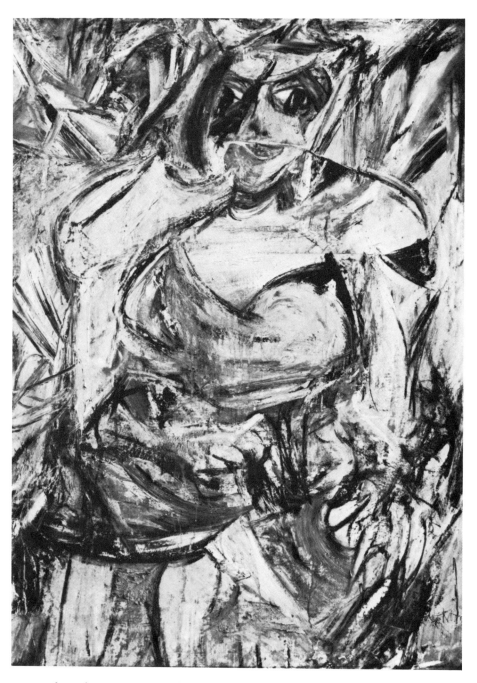

. . . somehow the painting would leave him, and he painted himself out of the picture.

Willem de Kooning, *Woman II*, 1952, oil. The Museum of Modern Art, New York.
59 x 43".

usually will see what his fears and hopes and learnings teach him to see. But if he can escape these demands that hold up a mirror to himself, then perhaps some of the implications of the work may be felt."[35]

"What I try to do is to create the painting so that the overall thing has that particular emotion, not particularly just the forms in it," Franz Kline told David Sylvester in 1963.[36] He was referring to his black and white paintings of the 1950s, such as *Chief* (1950), energetic black and white thrusts, precariously balanced, caught but not captured whole within the confines of the canvas, syntheses in paint of calligraphic sketches as spontaneous as the shorthand notes writers keep of fleeting ideas and observations.

"Force, power, ecstasy, structure, intuitive accident, statements of action dominate the object," the sculptor David Smith said of contemporary art.[37] True of some of his painter friends' creations, these words also applied to his own sculpture, the dynamic, anthropomorphic figures fashioned from industrial found parts, or his *Cubi* series, such as *Cubi I* (1963), consisting of reflecting polished steel cubes precariously stacked as though in danger of "falling," while sending the eye zigzagging upward. Smith often called his self-generating production of *Cubi*, *Totems* and *Zigs* statements of his identity. "It comes from a stream, is related to my past work, to three or four works in progress, to work yet to come. In a sense it is never finished."[38]

"The need is for felt experience—intense, immediate, direct, subtle, unified, warm, vivid, rhythmic," Robert Motherwell concluded his answer to the question "What Abstract Art Means to Me."[39] After several years of manipulating paper collage forms, Motherwell in 1949 had begun a series of large, wide, black-and-white oils—black ovals and vertical stripes set off against a luminous white ground splattered by messy black drips—which he called *Elegies to the Spanish Republic.* "Sometimes I wonder, laying a great black stripe on a canvas, what animal's bones (or horns) are making the furrows on my picture. A captain on the Yukon River painted the snow black in the paths of his ships for 29 miles; the black strip melted three weeks in advance of spring and he was able to reach clear waters. . . . For the rest there is a chapter in *Moby Dick* that evokes white's qualities as no painter could except in his medium," Motherwell explained in the catalogue of his show *Black and White*, held at the Kootz Gallery in 1950.[40]

"Painting is a tug of war between what you know and what you don't know, between the moment and the pull of memory," Guston has often said. *Painting* (1952, in the Albert H. Newman Collection), consisting of a weave of delicate vertical and horizontal brushmarks expanding from an off-center point of maximum tension, concentration and heaviness of pigment, thinning and paling toward the edges of the canvas, evoked Guston's impression of Ischia, the Italian island village of which he made several drawings during a visit in 1949, yet showed the effect on the artist of working

directly, without conscious construction, without even stepping back to look at what he was doing.

"I frequently hear the question, 'What do these images mean?' " Gottlieb wrote in the catalogue of *The New Decade*.[41] Gottlieb abandoned "pictographs" in the late 1940s and, taking a cue from a single compartment, greatly enlarged it. In his *Blasts* series of the mid 1950s, within a long canvas frame, two brusquely rendered shapes drawn in paint with a wide brush, a dark red disk above a black X, are related tensely to one another and to the canvas edge. "Visual images do not have to conform either to verbal thinking or optical fact. A better question would be: 'Do these images convey any emotional truth?' "

Of all the Abstract Expressionists, Barnett Newman was probably the most controversial. When in 1950 and 1951, in the hushed interior of the Betty Parsons Gallery, he showed "empty" paintings called *Abraham, Concord,** Onement*, and the huge red *Vir Heroicus Sublimis*, not only did the public jeer but even his own friends had doubts. Thomas B. Hess wrote in *Art News*:[42]

> Barnett Newman again wins his race with the avant-garde, literally breaking the tape. This genial theoretician filled a gallery with stripes and backgrounds —a thin white line surrounded by white, a red line surrounded by nothing at all, and a Cecil B. deMille-size number in Indian red with five verticals were some of the better ideas presented. In discussing the announcement of his exhibition—a white card printed in white ink—the artist suggested that it was a continuation of the TABULA RASA and Huck Finn's invisible ink. This may also give some idea of the exhibition. Prices unquoted.

What could possibly be the content of an immense field of one booming color evenly covering the entire surface of the canvas except for a vertical band, which the artist called a "zip" and which led the viewer's eye upward as if to question the heavens? Could Dada be lurking behind these creations? Yet it was Newman, the most articulate member of the group, who had spoken, perhaps for all of them, of the new concerns of painting in the review *Tiger's Eye*:[43]

> We are completely denying that art has any concern with the problem of beauty and where to find it. . . . We are reasserting man's natural desire for the exalted, for a concern with our relationship to the absolute emotions [which he called "the sublime"]. Instead of making cathedrals out of Christ, man or "life," we are making it out of ourselves, out of our own feelings.

Listed in the same passage were the impediments of European painting that

* In *Concord*, now in the Metropolitan Museum, Newman left the brown paper tape running down the length of the painting.

"We are completely denying that art has any concern with the problem of beauty. . . . We are reasserting man's natural desire for the exalted. . . . Instead of making cathedrals out of Christ, man or 'life', we are making it out of ourselves. . . ."
(Newman)

Barnett Newman, *Cathedra*, 1951, oil and magna on cotton. Mrs. Annalee Newman Collection, New York. 96 x 213".

had lately obscured the sublime and must now be rejected—memory, nostalgia, association, legend and myth—dismissals leaving the exalted moments of creation as painting's exclusive concern.

If the members of the New York group, constantly subjected to questioning, attempted in their many statements over the years to clarify the motives and processes by which their works came about, discussions among themselves were also necessary to deal with the public's accusations that they were crackpots and crooks. In Greenwich Village, at the Cedar Bar, on Friday nights at Studio 35, the locale of the short-lived Subjects of the Artists School, and at the Club, their meeting place nearby, a continuous dialogue was going on. Pouring out their self-doubts and insecurity—"We have no position in the world, absolutely no position, except that we just insist on being around" (de Kooning)—they revealed to each other their existential anxiety as well as their artistic views. When is a work is finished? "A decision of moral considerations" (Newman). "When all parts involved communicate themselves, so that they don't need me" (Hofmann), "When I have a deadline" (Reinhardt). "I usually ask my wife" (Gottlieb). Concerning titles: "If a title does not mean anything and creates a misunderstanding why put a title on a painting?" (Reinhardt). "Positive means of identification" (David Smith). "The question is how to name what as yet has been unnamed" (Motherwell). "The question of title is a purely social phenomenon," "So that the audience could be helped" (Newman). "The only people who have ever objected [to any work of art because of title] were critics because they did not like the work" (Smith). On a name for what they were doing: "Abstract expressionist? abstract symbolist? abstract objectionist?" (Motherwell). "Direct art" (the painter James Brooks). "Concrete" (the painter Bradley Walker Tomlin. "Self-evident" (Newman). "It is disastrous to name ourselves" (de Kooning).[44]

Yet named they were, by one of de Kooning's closest friends, Harold Rosenberg, who in a controversial article in *Art News*[45] measured the danger of definition and took the plunge in a typically existentialist mode: "The attempt to define is like a game in which you cannot possibly reach the goal from the starting point but can only close in on it by picking up each time from where the last play landed."

Rosenberg called them Action Painters, each painter an actor, the canvas an arena, painting an event, the painting a drama of self-discovery.

What distinguished the new American artists from previous abstractionists was, in Rosenberg's view, the entirely new relationship between the artist and his work. The artist was no longer representing nature (real or imagined) or making an art object. He was engaging his total being in the act of painting so that the event on the canvas and the artist's identity in constant flux were each reflections of the other. Or, to use Rosenberg's own

words, "a painting is inseparable from the biography of the artist, it is a moment in the artist's life."

To arrive at this point, "when it was decided to paint, just to paint," the American artists had discarded "politics" and "art"—not as a condemnation or defiance of society (as Dada had done) but in a mood of diffidence, he said. Since they could not change the world they would in a sense escape by making the canvas their world. The adventure of Melville's Ishmael going to sea was theirs as well. They would attempt to realize their selves, reach greater consciousness or greater reality, affirm their uniqueness and individuality through action. "The gesture on the canvas was a gesture of liberation from value—political, aesthetic, moral," as Rosenberg saw it.

Inherent in their actions was a dialectic of tension, checks against learned gestures and visual memories, surrender to gestures never performed before, acceptance of risks and dares never previously taken. For a number of these artists, the exhilaration of such an adventure resulted in a spiritual transformation, which each artist experienced privately in the course of creating, some after getting inside the canvas, some from meditating in front of a blank canvas, others by other means. In any case, the quality of the art depended on the quality of the actor: "The test of any of the new paintings is its seriousness and the test of its seriousness is the degree to which the act on the canvas is an extension of the artist's total effort to make over his experience." Or, one might say, the guarantees attached to Action Paintings were based on the authenticity of the act, the honesty of the actor and the depth of his search for inner reality.

Without mentioning any specific artists, and defining not a school but a way of thinking and feeling, Rosenberg had thus hypothesized the content of Abstract Expressionism, and it seems, suggested that it consisted in an expression of the creative process at its earliest, most inchoate stage: "The painter does not approach his easel with an image in his mind, he goes up to it with material in hand to do something to that other piece of material in front of him." It was a definition that only a poet could supply, someone who could empathize with the process of his artist friends by likening it to his own way of creating. It was a definition and a critical view that was to subject Rosenberg to many attacks, attacks which he himself forestalled in the same article.

He anticipated his detractors among formalist critics by stating that to apply the criteria usually applied to art objects when criticism of actions was called for meant to distort the intentions of the Action Painters: "[What counts] is the way the artist organizes his emotional and intellectual energy as if he were in a living situation." He sensed that the tensions and difficult choices involved in making each stroke an act of risk and will could

be turned into easy gratuitous gestures resulting in "apocalyptic wallpaper," and he predicted that what was now a statement of identity might soon become a stylistic device of recognition, a signature, once the public took cognizance of these artists' works and began to buy Rothkos, Pollocks or Motherwells, as indeed happened in the course of the 1950s.

Rosenberg's diagnosis in turn became a subject of discussion among the artists who, by inviting existentialist philosophers, psychiatrists, political historians and artists from other fields to talk to them at the Club sought further confirmation that what they were doing was not parenthetical or gratuitous but was part of the worldwide thinking of their age, the age of existentialist anxiety.

Summing Up

It is small wonder that the group broadly labeled Abstract Expressionist had difficulty settling on a name. There was outwardly little to connect the hard edges and dry surfaces of Ad Reinhardt with the sensuous painterliness of de Kooning, Newman's vertical zips in a field of one color with Pollock's writhing paint trails, Guston's delicate Impressionist brushstrokes with Franz Kline's arm-length gestures. Nor were they all even "abstract." (There are remnants of landscapes and human presences, for example, in the work of de Kooning, Pollock, Hofmann, Guston and Kline.) If some of them seemed to lunge at the canvas without preconceptions, others did not. Not all revealed through gestures of the brush the successive decisions that had produced the works. Although social issues had affected the work of some of them in the 1930s, that influence had not been visible in the whole group. And while the majority of them had evolved when the European avant-garde had appeared in New York, others had had little or no contact with the Europeans.

According to Harold Rosenberg, it was the content of their paintings and sculpture that provided the key to their statement as a group, and it was by giving art a new content that their works became unique and historically important. Never before, Rosenberg claimed, had art reached so far into individual consciousness, never before had the dynamics of the creative process been the subject of art. It followed that the absence of a common style was an assertion of individuality and a reflection of the various ways in which poetic images came about, ways as unlimited as other possibilities of self-definition.

Of course the individual's historical situation limits his possibilities. It is not surprising that the French philosopher Jean-Paul Sartre, posing the questions "Why write?" and "What does it mean to write?" in *Situation II* (which appeared in translation in the *Partisan Review* in 1947 and 1948),

should have found sympathetic readers among this group of artists. (Curiosity, Sartre exonerates artists from the responsibility for "content" that he ascribes to writers.) Having lived through recurring crises, first the Depression, then the Second World War, then the Cold War and its restrictions on individual freedom, these artists were indeed themselves wondering "Why paint at all?" and finally finding solace in sublimated actions on the canvas and in mystical experiences in the course of painting that spoke of doubt and anxiety.

Varied as their images were, is it possible to detect in them evidence not only of an historical but also of an artistic situation? Did their images correspond to a shared awareness of the exhaustion of expressive content in the formal language previously used by artists? Assuming that their statement was against style, is there such a style as the negation of style? (Could gauche be right?)

Here one treads on slippery ground. Yet for Abstract Expressionism to have put American art "on the map" as it did in the late 1950s implies that a new language had been found to match the new subject matter.

When they first appeared, these paintings were surely offensive in terms of what had been accepted as art until then, offensive either by their apparent chaos or the strict intellectual rigor of their parts, or by the fact that the viewer's eye looked in vain for a form to which to cling as a clue to meaning. Whether the eye traveled unhampered by forms across large surfaces painted in a single overpowering color, or was hypnotically held to dead center or guided upward; whether it attempted to follow the weaving of brushstrokes that made figure and ground interchangeable or discovered, from a surface first seen as monochrome, a geometric design slowly emerging whereby figure and ground again became ambiguous—however the eye was asked to function amidst these sensations, visual exploration became a quest, a search, a plea.

ROOTS AND ROUTES OF TODAY'S ART

In the 1950s
Toward the Present
Summing Up

In the United States, a fragile bridge from high to low culture is built in the 1950s by the rising paperback industry for literature, followed by the development of lithography and other multiplying processes for art and paralleled by the proliferation of art galleries in New York. With a growing sense of the arts as investment opportunities, the establishment fraternizes with painters, writers and sculptors at cocktail parties and on the Hampton beaches.

But high, low, or, eventually, "camp," culture is threatened by a new medium, television. Television undergoes a boom in the late 1950s when 85 percent of American homes have sets turned on as much as five hours a day. Television is a double-edged new tool, one that extends perception but is also perceived and therefore can manipulate as it informs. In 1959 revelations of subliminal advertising and rigged quiz programs blemish the medium's image in America.

Also in 1959, an unusual piece of general news in the New York Times, *the mass murder of a farm family in Kansas, prompts Truman Capote to begin writing* In Cold Blood, *a report based on imagination and in-depth interviews with the murderers and other persons in the case. In France, small-budget films by a new wave of French directors (Godard,* Breathless, *1959) tend to drive the viewer's sympathies toward the "bad guys" as victims of society. In 1959 Alain Robbe-Gillet's anti-novel* Jalousie *is translated into English.*

In the 1950s

What destroyed Abstract Expressionism, like what destroyed Pollock racing his car on a deserted familiar road at night, remains highly ambiguous. One possibility is that Abstract Expressionism died of success. During the 1950s many young artists flocked to downtown New York, trying to establish personal ties with the "giants," becoming "acolytes and lieutenants" (to quote one of them, Mario Yrissary[1]). Some went to the Hofmann School—until it closed in 1957—where they mistakenly assumed that Abstract Expressionism would divulge its methods and the mysteries of its creation. There, each was told to aim at "the perfect painting," offered insights into basic formal matters, but left alone to choose from any number of stylistic possibilities. At the popular Cedar Bar, expressions such as "tough painter," "privileged moment," "decision," "existentialism," "to be direct," "tension," "no fussing," "guts," "decisive stroke," "struggle," "suffering," "painting your way in and out of chaos," "push-and-pull" were bandied about. Many younger New York artists, with the exception of a few really "tough" painters,* were overcome by a gestural affectation, while others, sensing the difficulty of assuming the philosophical positions of their elders, were prompted to try something totally different.

To Harold Rosenberg, Action Painting was doomed when it became distorted by being looked upon as a style by certain critics, collectors and dealers. "The net effect of deleting from interpretation of the work the signs pointing to the artist's situation and his emotional conclusions about it is to substitute for an appreciation of the crisis dynamics of contemporary painting an arid professionalism," Rosenberg writes in *The Anxious Object.*[2] He adds: "The radical experience of confrontation, of impasse, of purging is soaked up in expertise about technical variations on earlier styles and masters." Action Painting has been denounced as "historically inconsequential and as gratuitously subversive of esthetic and human values."[3]

The internal contradictions implicit in Abstract Expressionism as a style killed it, says Barbara Rose in *American Art Since 1900.*[4] She names as such contradictions the conflict of figuration versus abstraction, the irresolution of an ambiguous pictorial space, and the lack of structure of the gestural abstraction practiced by de Kooning's followers. She adds that the rejection by younger artists of the notion of the artist as existential matador alone in the arena of his canvas was another factor in the death of Abstract Expressionism.

It was the fear of ending like Pollock, says Allan Kaprow, a young painter at the time of Pollock's death. "His heroic stand had been futile. Rather than releasing a freedom, which it at first promised, it caused him

* Including several women, such as Lee Krasner, Joan Mitchell, Grace Hartigan.

not only a loss of power and possible disillusionment but a widespread admission that the jig was up. And those of us still resistant to this truth would end the same way, hardly at the top." (At least this had been his initial reaction. He was to change his mind, as he explains further in "The Legacy of Jackson Pollock"[5])

It was a new mentality within the art world, according to Thomas Hess, who defines it in terms of "G.I.ism":

> It embraces a belief in short aims, day to day cures for changing symptoms. . . . No attempt that seems bound to fail . . . is made. Manners are deliberately cultivated, irony and parody are the permitted vents for explosions of exasperation. G.I.ism is the perfect expression of American culture in 1955. It is as safe and sound as the currency that floods the nation and it will fight for its integrity only at the point of "you can't push me around"—as do all self-respecting capitalists.[6]

Be that as it may, in the course of the 1950s, a number of New York artists veered away from Abstract Expressionism, signaling a new attitude in ways that for the moment were hardly noticed. As for Europe, somnolent in the aftermath of the Second World War, which had drained it of many of its creative talents, it attempted to re-enter the international art scene in the 1950s with an elegant calligraphic abstraction (in paintings by the Frenchmen Soulages and Mathieu, and the German Hartung), but was swept aside by the more radical gestures of the American Abstract Expressionists. The case of Giacometti's sculpture has been dealt with in chapter 7. His figure paintings, and those of the Englishman Francis Bacon, mark European art in the aftermath of the war with their shared sense of man's solitary predicament.

In New York, Roy Lichtenstein (b. 1923), a future "Pop" painter, exhibited regularly in the 1950s. *To Battle* (1951?), *Weatherford's Surrender to Jackson* (1953?), the titles of his whimsical, semiabstract images were, it is true, takeoffs on historical paintings but, in the context of the times, they may also be seen as the comments of a young artist trying to assert himself against the running tide, and a foreshadowing of the kind of "in" or very private joke that Pop artists would frequently indulge in later. In 1952, an unknown named Andy Warhol (b. 1931) showed in a New York gallery fifteen drawings based on the writings of Truman Capote. According to the reviewer in *Art Digest*[7] they had an air of "preciosity, of carefully studied perversity" that reminded him of Beardsley, Lautrec, Demuth, Balthus and Jean Cocteau. That same summer at Black Mountain College, the composer John Cage (b. 1912) gave a single representation of simultaneous and unrelated events not unlike the Dadaist evenings of earlier days.*

* Various performances took place in and around the audience. "Cage read a lecture from a
 lectern on one side. M. C. Richards recited from a ladder . . . Charles Olson and other

Meanwhile, Helen Frankenthaler (b. 1928), following Pollock's lead in his black and white paintings of 1951, began in 1952 to spill thinned paint on unsized canvas that lay on the floor and guide its spread accordingly. Frankenthaler's early "stained" paintings suggested an intimate experience by their loose, soft, passive forms and subtle hues like watercolors. They also called attention to the canvas as an absorbent surface with a will of its own, as though the artist, working on a much larger scale than in watercolor, had become narcissistically involved with her materials and processes.

In Washington, D.C., Morris Louis (1912-1962)—like Helen Frankenthaler, whom he knew through Clement Greenberg—began making "stained" paintings in 1954. In his "veils" Louis carefully guided the paint by tilting the canvas this way and that so as to achieve his goal of symmetry vis-à-vis the picture edges. In his later work he was to keep bands of clear color separate and flowing parallel to each other, often leaving wide empty spaces in the middle of his large canvases. Louis's sinuous trails imparted to the viewer a sense of slow, deliberate, controlled motion rather than spontaneity. They evinced attention to process and structural discipline and lacking in illusionistic depth and tension, intimated the single "holistic" frontal image typical of the 1960s.

It was in 1956 that the former American expatriate Ellsworth Kelly (b. 1923), after several years in Paris, first showed in New York paintings in which, as one reviewer wrote,[9] ". . . one form, either biomorphic or geometric, is placed on a canvas just large enough to hold it; the form of black or pure color brought to its highest intensity is sharply profiled against a bright white ground, producing an image of extreme directness—with an impact which reverberates long after the eye has left the painting." Although the means in Kelly's works were not those of Action Painting, the impact through forms and color could, it was implied, rival that in a painting by Adolph Gottlieb or Franz Kline; Kelly appeared to be substituting intense color contrasts and calculated clean-edged flat forms for the energy of the brushstroke, while using impacted colors, forms and stretcher shapes instead of spontaneous gestures to convey a sense of vigor. Kelly, however, who was not part of the Abstract Expressionist movement, may have had no such intention, since his total *oeuvre*, including his 1956 works, seems involved with chance effects, threshholds of form recognition (or camouflage) and later the phenomenology of color.

Yet the possibility of disconnecting the directness of the impact from the spontaneity of the attack—perhaps as a way of prolonging the life of Abstract Expressionism—was also to appear in paintings of the 1960s by

performers planted in the audience each stood up when their time came up and said a line or two. David Tudor played the piano. Movies were projected on the ceiling. . . . Merce Cunningham improvised a dance . . . Robert Rauschenberg operated old records on a hand-wound phonograph."[8]

former Abstract Expressionists turned Hard-Edge painters—for example, Al Held (b. 1928) in *Big A*, 1961, Ken Noland (b. 1924) in *Cadmium Radiance*, 1963, Agnes Martin (b. 1912) in *The Tree*, 1966, and a number of others.

Far more provocative, and not without a tinge of the devil were the methods by which Robert Rauschenberg (b. 1925) achieved notoriety in the 1950s. To the reproach that his work was no good and ought to be thrown into the Arno River, Rauschenberg answered by doing just that with the assemblages of found materials that he had exhibited in a gallery in Florence, Italy, in 1953. That a work of art was dispensable or should survive only if deemed worthy by contemporary criticism was surely indicative of a new attitude. Back in New York, Rauschenberg met de Kooning and asked him for a drawing that he might erase, a request de Kooning satisfied by choosing a particularly good drawing and one difficult to erase. By an "act" ironically accomplished with an eraser (negative tool) rather than a paintbrush, he did erase the de Kooning drawing, later exhibiting it as *Erased de Kooning Drawing/Robert Rauschenberg/1953.*

In 1953, Rauschenberg exhibited seven white panels that he claims were misinterpreted as nihilistic, Neo-Dada, anti-art. Seen with the advantage of time, one can propose a few hypotheses on the many meanings of this piece: the artist's refusal to act (make a mark), choose, reveal himself in the Action Painter's sense; his suggestion that there are decisions preceding the act of painting—choice of canvas and shape of the stretcher; an invitation to the public to vent its anger by offering it an arena in which to act (the presence of messy black paintings near the white ones acting as hints); a reflection on the fact that emptiness does not exist and that even the seven white empty panels are individualized by differences of light, passing shadows of visitors, dust and dirt; and a testing of new limits for art. *The Seven Whites*, like Duchamp's Ready-mades, also suggested new functions for art, a means of asking questions about art and of stimulating the viewer's perceptions of new forms, including that of the stretcher.

The American composer John Cage, who made similar points in a piece consisting of several minutes of silence, has acknowledged that Rauschenberg's paintings came first and "my silent piece came later."[10] But independently in France around the same time, Yves Klein was proposing as art his monochrome blue paintings. Eleven identically shaped canvases in a hue of industrial blue soon to be called "Klein's blue" were shown in a Milanese gallery in 1957. In 1958 Klein was to invite the public to an exhibition in Paris called *Le Vide* ("The Void") in a gallery left entirely empty though repainted by the artist for the occasion. Although Yves Klein's "zones of immaterial pictorial sensitivity" aimed to put the viewer in a purified self-reflecting state, they, like Rauschenberg's *Seven Whites*,

suggested a multiplicity of interpretations—or misinterpretations—including the evidence of a Neo-Dada spirit in Paris.

New concerns for art similar to those of Robert Rauschenberg were raised by Jasper Johns (b. 1930), who in the 1950s lived and worked near Rauschenberg in New York. Johns began making paintings of the American flag (also of targets, numbers, letters, maps) with the surface sensuality of a de Kooning, pastiched and exaggerated by the use of encaustic. The subject was familiar, unambiguously flat, emblematic. The flag was not shown flying inside the painting; rather, it occupied, unfurled, the whole surface of the canvas. To an adult conditioned to interpret whatever he sees before looking attentively, Johns's flag paintings were utterly mystifying. Anyone young enough to be unencumbered by such habits seemed better qualified to know what a Johns painting was about. "It is a painting," a child would say, "of the American flag." Like the national anthem played in a rock tempo, Johns's *Flag* dissociated style and subject to produce in the viewer a better awareness of the painting's luscious brushwork (painting) and of the American flag's design (formal structure). Painting as a tool for seeing would be Johns's proposition, and naming rather than interpreting would be demanded of the viewer. By using relatively few themes and treating each one in a variety of materials (painting, sculpture, lithography) and colors, Johns limited his variables the better to experience their possibilities and limits and make them perceptible to the viewer.

The move toward a fresh awareness of things thus far ignored, be it the content of empty canvases, of an empty gallery, of a flag or other commonplace things in the world led artists in the United States and abroad to give up the limitations of the painter's trade—colors, brushes, canvas. Indeed, parallel to a new attitude observable in the individual accomplishments of artists who were keeping their distance from the New York Abstract Expressionists, there appears to have been in the 1950s a re-evaluation and expansion of the materials and tools of art.

It has been noted in chapter 9 that de Kooning used pasted paper to rework certain parts of his paintings; he also pasted a pair of lips from a magazine advertisement on one of his women. Newman left a line of tape on *Concord.* Pollock was known to let cigarette butts and broken glass enter his work.* He and Robert Motherwell had made collages in the 1940s. The rehabilitation of mixed-media creations seems to have taken place not only in New York but in Europe as well. Kurt Schwitters's Merz pictures were shown in a Paris gallery in 1954. In London, where Schwitters lived in the 1940s, an exhibition called *Collages and Objects* took place that same year. It included a number of English Surrealist aficionados of the collage

* Other artists of their generation, such as Marca-Relli and Esteban Vicente, also used some form of collage or more precisely *découpage.*

medium, along with works by Schwitters and objects by Marcel Duchamp. Commenting on the show from London,[11] Lawrence Alloway, the future emissary of English and American Pop Art, marveled at the results obtainable through collage, particularly through "the repetition of identical images." There were also collage shows in New York: *International Collage* at the Rose Fried Gallery, 1956; *American Collages* (including Arthur Dove's collage *The Art Critic*, 1925) at the Zabriskie, 1958; a Schwitters retrospective at the Janis Gallery, 1959; and a mammoth show, *The Art of Assemblage*, at the Museum of Modern Art, 1961, which was an historical survey of the varied materials artists had used since Picasso's first collages of 1912. Marcel Duchamp and Kurt Schwitters were generously represented. *The Art of Assemblage* was one of the rare American shows of the 1960s with a truly international character. (It also brought to the public's attention Simon Rodia's *Watts Towers*, a masterpiece of assemblage that an Italian tilesetter, using broken dishes, steel rods, colored glass, pieces of Seven-Up bottles, etc., took thirty-three years to construct in a Los Angeles slum.)

Gradually, through the 1950s, pasted paper, or pieces of cloth, cutouts, newsprint, magazine photos and street debris of all kinds began entering the painter's palette on a par with paint. The uses to which the new materials (and new "brushes") were put varied greatly from country to country and from one artist to another.

In Italy, for example, Alberto Burri tested the expressive potential of sackcloth, burnt wood and rusted metal in his abstract compositions. Lucio Fontana slashed his canvases in great arcs and dotted them with small holes, suggesting a new spatiality. In France, Jean Dubuffet (b. 1901) used paper paste for gritty textural effects that helped him get away from the "fine art" look and substitute the effect of Art Brut, a raw unaffected appearance. More sociologically inclined was a group of French artists, many from the southern city of Nice, whom the French critic Pierre Restany labeled *Nouveaux Réalistes* (New Realists). Of this group he was to write: "The New Realist is the catalyst of the expressive emergence of the object, become the mediator capable of awakening in the spectator the same emotional reaction that a work of art traditionally arouses."[12] In England, Richard Hamilton (b. 1922), in *Just What Is It that Makes Today's Homes So Different, So Appealing?* (1956), utilized and transformed magazine ads and photos to satirize the synthetic rendering of a modern interior as manipulated by the media. In this work, the word "Pop" first appeared, on a tootsie roll held by an athletic-looking male.

Meanwhile in New York, Johns and Rauschenberg were developing their object-directed consciousness. A combination painting-sculpture or "Combine" called *Monogram* by Rauschenberg consisted of a stuffed goat with a tire wrapped around its middle affixed to a painting that served as a platform. *Book* by Jasper Johns, an open book covered with encaustic,

looked tame by comparison. Hovering between the satire of Hamilton and the new expressionism of the French *Nouveaux Réalistes*, these New York artists were treating their works as puzzles that demanded of the viewer that he scan them for clues and, not finding any, experience as in life a multiplicity of confused and absurdly connected images. As in the world itself, they were not necessarily clear (Rauschenberg's images often contain blurred passages); some parts would be called "art" (art reproductions of masterpieces, paint drips) and some "life" (*Rebus* by Rauschenberg also includes political posters, paint charts, a sport photo from *Life* in horizontal line-up on the canvas), but neither was particularly revealing of the state of mind of the artist who used them. Both Rauschenberg and Johns seem to point out not—as in Surrealist creations—the marvelous illogic of dreams, but the too easily forgotten incongruities of life, such as the interruption of a television news program for a toothpaste ad.

In 1958, with a generally increased consciousness of found materials, came the discovery by European artists of Pollock's work, thanks to a traveling show organized by the Museum of Modern Art. An allegiance both to a new object-directed consciousness and to Pollock's overall chance compositions and large format is found in works by several French *Nouveaux Réalistes*. Arman, for example, in 1958, began to "accumulate" old cameras, bicycle lights, spoons, forks (and garbage), inside glass-covered boxes. Yves Klein was to use human "brushes" (nude models covered with paint) to imprint his large canvases. César began compressing automobile bodies in the form of a cube. Their work, with other New Realists, was first seen in Paris in 1960, then shown in New York in 1962, along with that by several Americans of a similar factual sensibility. But somehow a cleavage took place, and while the Americans were to be heard from again as Pop artists, few of the Europeans continued to exhibit in the United States.

In New York, Allan Kaprow, in his article "The Legacy of Jackson Pollock," similarly revealed this dual allegiance: "Pollock . . . left us," he writes in 1958, "at the point where we must become preoccupied with and even dazzled by the space and objects of our everyday life, . . . Objects of every sort are materials for the new art: paint, chairs, food, electric and neon lights, smoke, old socks, a dog, water, movies, etc. . . ."[13]

The New York gallery visitor around 1960-61 was thus confronted by other products of a new mixed-media mentality: sculpture assembled out of found materials from car bodies (John Chamberlain, b. 1927), industrial parts (Richard Stankiewicz, b. 1922; Mark di Suvero, b. 1933), wooden fragments and furniture parts (Louise Nevelson, b. 1900), all of which, when detached from utilitarian functions, revealed fresh forms with new expressive powers.* Or the gallery addict could puzzle over the new experi-

* A similar interest in found materials is also present among the Nouveaux Réalistes already mentioned (including César and Tinguely) in a group of French welders such as Viseux and Féraud. briefly in Eduardo Paolozzi, etc.

Helen Frankenthaler, *Open Wall*, 1953, oil on canvas. Collection of the artist. 53 3/4 x 131 1/8''.

Both Rauschenberg and Johns seem to point out not—as in Surrealist creations—the marvelous illogic of dreams, but the too easily forgotten incongruities of life. . . .

Robert Rauschenberg, *Monogram*, 1959, Combine painting. Moderna Museet, Stockholm. 48 x 72 x 72''.

ences proposed as art: musical scores by John Cage illustrating the act of composing; Environments by Allan Kaprow (b. 1917) combining the visual, the olfactory (disinfectant odor), the auditory (sirens and doorbells) and time (blinking lights);* Tinguely's useless machines, one of which was destined to destroy itself for the guests of the Museum of Modern Art. For sale in New York art galleries were pieces of "clothing" with messy paint drips made by the artist, Claes Oldenburg; Environments by Red Grooms, Jim Dine, and one by George Segal consisting of a life-size white plaster bus driver at the wheel of his bus, frozen in the act of his daily routine.

Perhaps the best way to appreciate the New York art world then is to compare the solemn, templelike atmosphere of an exhibition at the Betty Parsons' gallery in the late 1940s with the show called *New Mediums, New Forms* in 1960†, when the public was invited "to touch and move things, open hinged boxes, switch playing cards around, re-arrange compositions: be a participant . . . in a game with art."[14]

For several days in late November 1963, television screens repeatedly replay tapes of the last moments in the life of President Kennedy.

With the shift to color (1965-66), television images of ads for shining new cars and of the war in Vietnam are both rendered in the same electronically produced new range of colors on American screens. Dissent grows among an urban subculture and on American college campuses; hippies, yippies and peaceniks are driven into communal living outside the United States, to places where the draft is avoidable and drugs available. Yet it is a time when the whole world looks to the United States as a model, copies its life style, admires its Western films, its Pop music, loves its bad guys with the big heart, is awed by its productive capacity, its technological feats. East and West, people witness on their television screens the unforgettable sight of man's first steps on the moon (July 1969). But the assassinations of Robert Kennedy and Martin Luther King in 1968, seen as they happened on American television, are a less elevating spectacle.

The baffling nature of events, the "why?" that remains unanswered, lend relevance to Wittgenstein's positivism, to Husserl's phenomenology, to Lévi-Strauss's structuralism, to Skinner's behaviorism. These subjects are closely studied in American universities where a new artistic generation is nesting. A move away from symbolic interpretation is apparent in the new

* John Cage taught music composition at the New School between 1956 and 1958, and Allan Kaprow, a former Hofmann student, attended some of his classes. The possibility of an art synthesizing sound and visual material was explored by both artists from their respective viewpoints—music by Cage, painting by Kaprow—as well as by Rauschenberg, who included radios in one of his Combines.

† This show, when first presented in June at the Martha Jackson Gallery, was so successful that it was repeated in September-October of the same year.

literary criticism (with Roland Barthes's Le niveau zéro de l'écriture, *Robbe-Grillet's* Pour un nouveau roman *in France, and with similarly inclined writers in other countries). Underground films play down the role of interpreter and force the viewer to lend attention to cinematic form by means of a frustratingly eventless and repetitive theme, also characteristic of contemporary electronic music and of the new dance.*

Beginning in 1968, the year of student rebellions in France and elsewhere, signs of movements not yet defined ideologically and defending apparently contradictory values make their existence known through anarchical actions—bombings, hijackings, kidnappings, and break-ins—the meaning of which will some day have to be faced.

Toward the Present

If much of the new participatory art amused and entertained its New York public, it caused a malaise in the narrower circle of *cognoscenti.* Too many artists purporting to be serious exhibited in too many New York galleries works that could not be judged by any standard but novelty, and too often artists, by taking paradox and the counterpoint of taste as the basis of their art, rendered value judgments foolish and contradictory.

Various measures were taken to try to return art to seriousness and sanity. In September 1961, the New York review *Arts* modified its comprehensive coverage of the New York art scene in favor of a more selective policy. Hilton Kramer wrote:

> For the critic, the situation has become intolerable. To continue to write serious criticism (even when it is damning) of work that simply exists beyond the reach of meaningful discussion, to dignify with ideas (even with the idea of disapproval) what may be at bottom nothing more than a commercial or public relations transaction—this is really to turn the critical function into a joke and a lie. We see no reason why criticism should be pressed into the role of collaborating with an odious situation. Henceforth, so far as these columns are concerned dealers will have to come up with more than a mere show to receive the attention of our critics.[15]

During the 1960s an unprecedented number of theme shows were held in New York galleries and in museums throughout the country: *American Abstract Expressionists and Imagists,* Guggenheim Museum, 1961; *Toward a New Abstraction,* Jewish Museum, 1963; *New Directions in American Painting,* Brandeis University, 1963; *Post Painterly Abstraction,* Los Angeles County Museum, 1964; *Six Painters of the Object,* Guggenheim Museum, 1963; *Americans 1963,* Museum of Modern Art; *Three American Painters,* Fogg Museum, 1965; *Systemic Painting,* Guggenheim Museum, 1966—to name only a few. Lengthy essays in the catalogues justified on various grounds the artists selected for display.

But the most drastic measure was taken by a new wave of art critics, who on historical grounds and on the narrow basis of form evolution attempted to re-establish objective, qualitative criteria. The point of view adopted was that spelled out in several essays by Clement Greenberg— "American-type Painting," "Modernist Painting," "Post-Painterly Abstraction," in particular[16]—a point of view that has affinities with earlier attitudes of art-for-art's sake.

Briefly, Greenberg's thesis was that styles had historically evinced cyclical patterns, the painterly (emphasis on paint) and the linear (emphasis on drawing) succeeding each other in turn since the Renaissance. The Abstract Expressionist style had been painterly. Post-Abstract Expressionism would be linear or "Hard-Edge." Furthermore, since Manet, art had abandoned the realm of story-telling for a new consciousness of its specificity, namely what could be done and done alone by painters through the medium of . painting, by sculptors through the medium of sculpture. Only artists working to define this specificity would qualify as painters and sculptors. Painting would be about painting, sculpture about sculpture, and about *nothing else* either seen or experienced.

Under this definition, Modernist painting would have to be nonrepresentational to distinguish itself from illustration, and would have to emphasize flatness of surface, shape of the support, properties of the pigment to distinguish itself from sculpture, which by nature deals with forms in space.

Finally, only painters who avoided repeating what had already been done before them and who, through constant self-criticism would avoid repeating themselves, could be considered important. An ambitious young artist's first task would be to determine the situation of painting and sculpture as it was when he entered it, in order to make breakthroughs and "advance" painting and sculpture styles. Past art would necessarily have to be reinterpreted in formalist terms, ignoring the artist's alleged intention, keeping one's own subjective judgments and impressions to a minimum and looking at the structural organization of the works.

For example, at that point in the early 1960s, Pollock's breakthrough appeared to have consisted not in making of art an act of self-revelation (this was considered irrelevant to quality), but in having done away with positive versus negative shapes by means of an "all-over" drawing that enclosed nothing, and in alluding to but not quite achieving a completely nontactile or post-Cubist optical space. For Modernist painters, to abolish completely the "figure-versus-ground ambiguity," to make foreground equal background so that no illusionistic tactile space was left on the canvas (to do away with the very gestures of human sensibility, doubt, hesitation and tentativeness inherent in Abstract Expressionist painting) was, in formalist theory, a necessity of ambitious advanced painting in the 1960s.

Although criticism of the formalist kind did not stop the flow of unqual-

ifiable art in the 1960s, particularly in New York, and although its criteria of quality were frequently challenged (by Harold Rosenberg[17] and Leo Steinberg[18] in particular), it established the basis for a new way of perceiving art.

To begin to apprehend and sympathize with what went on in the arts during the 1960s required a new attitude on the part of the viewer, a willingness to refrain from impressionistic, metaphoric, associative judgments and appreciations of what was being proposed, and to learn to perceive the data artists were presenting and clarifying. Judgments of approval or disapproval must follow rather than precede analysis.

Robert Rauschenberg and Jasper Johns, who had rejected the dialectic of Abstract Expressionism, had been the first artists to demand in the 1950s that their works be looked at as if (to quote Marshall McLuhan) "the medium were the message," but Happenings, which were an attempt to keep alive the crisis content of Abstract Expressionism, were among the first art events to receive the new critical treatment.

Happenings, most popular in New York in 1960 and 1961,* were "events which, put simply, happen. Though the best of them have a decided impact . . . they appear to go nowhere and do not make any particular literary point. . . . Their form is open-ended and fluid; nothing obvious is sought and therefore nothing is won except the certainty of a number of occurrences to which one is more than normally attentive."[19] *Apple Shrine* (Kaprow) was one such Happening. "The audience threads its way through narrow passages of board and wire choked with tar paper, newspaper, rags; light changes from very dark to very bright. At the end of the maze is a large 'tranquil' space where apples are suspended from a tray and signs read apples, apples, apples, etc. There are bright bands of color hanging from the ceiling. After contemplation, the spectator winds his way out of the gallery."[20]

The tie to Jackson Pollock seemed clear. The arena of the action was no longer the canvas but living space. A moment, the duration of a Happening, was singled out for the event to develop, and that moment was not particularized in a narrative way (boy meets girl, etc.) but chosen naturally, and for no particular reason. The spectator, it was hoped, would enter into the situation as he entered into a Pollock painting and through the "ritual" enacted around him would be put in a "privileged," quasi-mystical state.

But the viewer-participant in a Happening was as mystified by and es-

* The phenomenon of Happenings, with its antecedents in Zurich-Dada and at Black Mountain College was not indigenous to the New York scene. It appeared in Japan through the activities of the Gutaï group (1958) and was kept alive by an international group, Fluxus. Ritualized, Happenings became "fêtes", organized by artists such as the Spaniard Antonio Miralda who convokes people to meet in a certain location, supplies them with accessories and leads them through paces lasting a whole afternoon and evening.

To make foreground equal background so that no illusionistic tactile space was left on the canvas . . . was, in formalist theory, a necessity of advanced painting in the 1960s.

Frank Stella, view of exhibition, September 27-October 15, 1960. Photograph courtesy Leo Castelli Gallery, New York.

tranged from events as a character in a novel by Alain Robbe-Grillet observing the activities inside a home through the blinds or *jalousie*. He was like a sociologist in the Brazilian jungle during a ritual ceremony. Unable to bring forth from his experience the necessary tools of interpretation, the viewer at a Happening was thrown back on observing what was there—objects, colors, shapes, movement, the structure of space and of time—and the reviewer on describing what he saw. The first scene of *Fotodeath*, a Happening by Claes Oldenburg (b. 1929) is thus described in *Art News*:

> a silhouette of a saluting female who keeps advancing and retreating is projected on a screen while a young well-dressed man never stops scrutinizing himself in a large mirror and in several smaller ones; a girl dressed as a girl-man enacts a ritual before another mirror of disrobing and dressing again; in dead center an earnest man of action growls and pants in a desperate struggle to choke a dummy; and a delightful caricature of a family plays at posing for a harassed photographer who cannot keep his subjects sitting upright, nor prevent them from collapsing completely. . . .[21]

Happenings had no permanent form, existing as they did in real space for a definite time, and in their wake, much "antiform" art would come about (see pages 220-223).

The "stripe" paintings of Frank Stella, which also inaugurated the 1960s, appeared to be nothing but form. Stella was given his first one-man show in 1960 at the age of twenty-four. He had recently graduated from Princeton, and it is to the credit of his intelligence that he situated himself in history so quickly that he avoided repeating what had been done and done well before him and set about "advancing" painting.

In an interview with Alan Salomon,[22] Stella indicated his keen awareness of the current New York scene. His *Coney Island* of 1958 might well be the young artist's answer to Johns's *Flag*, exhibited in New York in January of the same year. Like Johns's works, Stella's in 1960 were preconceived and planned. Like Johns's flags, which delimited the surface of the canvas with a motif of stars and stripes, Stella's nonpatriotic emblems, also seen frontally, took up the whole surface of the work. A single holistic image related to no figure inside the painting but only to the picture's framing edges was the unifying theme of Stella's first one-man show.

Pollock's free flowing arcs run through a computer, pinstripe design, radiator vents—the kind of metaphoric jump that Stella's works aroused reduced rather than enhanced their interest. And to call them a statement on the absence of choice in life from birth to death because of their programmed appearance was according to the artist to indulge in uncalled-for rêverie. "My paintings," said Stella, "are based on the fact that only what can be seen is there."[23] Indeed his paintings seemed only to be there, austere and silent presences activating the wall space behind them. Since there was no form, no texture, no visible trace of the hand "on" the surfaces to dis-

tract the viewer, the startling shapes of the stretchers no longer exclusively rectangular but sometimes notched (thus the name "shaped canvases"), the repetitive striped pattern echoed in the shape of the stretchers, the unusually thick stretchers making the canvases protrude unduly into the viewer's space, in short, the structure of the paintings, must become the focus of the viewer's attention. Objects (Stella's paintings) or events (Kaprow's Happenings), which forestalled interpretation, made no demands upon the viewer other than to perceive them attentively.

While the attention demanded by Happenings was directed at the total world of sensory experience (a continuation of the object-directed consciousness of the 1950s), the attention demanded by Stella's anti-illusionistic paintings threw one back to the formal constituents of painting: flatness of surface, shape of the support, properties of the pigment (a continuation of the canvas-oriented consciousness of some abstract painting of the 1950s). Whereas Happenings were testing new concepts of art, Stella's works were testing new limits of painting within the strictures of formalist definition. Stella was to be for a while the acknowledged leader of formalist painting and sculpture, and his icy objectivity was to strike the dominant note of the 1960s.

In 1962, on the heels of Happenings and of Stella's entrance upon the New York art scene, came Pop Art. Unlike Environments and Happenings, works by Pop artists did not equivocate as to their status. In the confusing context alluded to earlier, the reappearance in 1962 of clearly defined objects was undoubtedly welcome. By borrowing from printed imagery, comic strips (Lichtenstein), magazine photographs and ads (Warhol), signs, letters, numbers, the Pop painters acknowledged the issue of flatness as a necessity of Modernist painting. By the same token, if sculpture was in essence an object weighing on a floor, then a giant hamburger (Oldenburg) qualified eminently as sculpture. If one-image painting or sculpture was the Modernist way for art to present itself, then one frame from a comic strip (*Kiss* by Lichtenstein), one photograph (*Marilyn Monroe* by Warhol, repeated many times), one hamburger would answer this demand. If the painter's hand must be kept from showing in the work, then silkscreening, a practical reproducing process, and "Ben Day" dots, used for printing illustrations in newspapers, were tools as depersonalized as Stella's bland paint surfaces (frequently applied by assistants).

Yet, unlike Stella's works, the Pop painters' images were not abstract, but appropriated from the real world—recognizable, obvious if not overly familiar (popular). On the one hand, the Pop painters were taking the formalist thesis at face value: flatness, holistic image, objectivity. What could be seen was what was there, and in case you had difficulty in seeing it, there it was, bigger than life and/or repeated many times. But what could be seen was not the whole story, and subject matter had a particular ur-

. . . the Pop painters' images were not abstract, but appropriated from the real world —recognizable, obvious, if not overly familiar.

"New Realists" (from left to right, Peter Agostini, Tom Wesselman, Mimmo Rotella, George Segal, Andy Warhol, Robert Indiana, Claes Oldenburg), view of exhibition November 1-December 1, 1962. Photograph courtesy Sidney Janis Gallery, New York.

gency in their works. With their imagery, the painters could attack the issue of flatness and show that the viewer's perceptual habits tended to establish depth where depth did not exist. To the charge that their paintings were old-fashioned, illustrative and anecdotal, they could reply: If you see people and objects in the works it is due to your stereotyped way of looking. Look and look again and you will discover that these are abstract forms ordered by us as strictly as Stella organizes his paintings.

Oldenburg encouraged people to look at his sculpture both as forms and as familiar objects by changing the scale of the objects and, more important, by changing their consistency from hard to soft (as well as the color, either black or white). His soft rotary fans, toasters, pay phones and electric mixers are also humorous, near-abstract forms made of limp drooping cloth.

The Pop artists were the gadflies of the 1960s art world. Like Duchamp in relation to the Puteaux Cubists (see chapter 3), they might be called critics of the very formalist esthetics they were abiding by. Although they were absent from their works—produced through the use of mechanical processes—they were sharp social commentators; by taking their imagery from second-hand sources, magazine photographs, comic strips or advertising, they reminded the attentive viewer of the distorted realities stored in the mind through the media. And by frequently selecting particularly frightening imagery—the electric chair, most wanted men (Warhol), war scenes (Lichtenstein) or seductive imagery—Marilyn Monroe (Warhol), pastry cakes (Oldenburg) female nudes (Wesselman)—they expose the confusion created by media information, which tends to dull emotions and destroy the ability to distinguish meaning from form.* But their social commentary was expressed in media language and with the efficacy of media information. Pop Art received almost instantaneous worldwide recognition. As for Andy Warhol's perversely passive presence, it mesmerized a large segment of the art world of the 1960s.

That "now the world is neither meaningful nor absurd, it simply *is*,"

* The *New York Times*, February 21, 1972, "Ex-Nixon Writer Talks of Scandal," page 22: "He [Nixon's speech writer] suggested at least one reason for the climate within the White House that may have led many staff members astray—a tendency to confuse technique with substance." It might be added that "technique" and "substance," "meaning" and "form" are really nebulous entities since, as Barthes suggests for literature, there exists a third element—what he calls "l'écriture." The current attempt in all the arts to reach "le degré zéro de l'écriture" is thus seen as a way to silence the voice that inserts itself in all messages, and to bring to consciousness the way language (pictorial as well as verbal) is used. (Roland Barthes, *Le degré zéro de l'écriture*, Paris, 1953, 1972; *Writing Degree Zero and Elements of Semiology*, Boston: Beacon Press, 1970.)

became the catchall notion in artistic circles in the mid-1960s.* Phenome-
nological inquiry into this "is" went on unabated. Working within or out-
side the strictures of painting and sculpture, artists brought to the viewer's
attention a multiplicity of new sensory experiences. As is customary in sci-
entific research, including linguistics, artists tended to limit their variables
the better to isolate and make perceptible particular elements. Among for-
malist painters, a division of labor seems to have taken place.

If Stella (and Ken Noland) focused on stretcher shapes in their 1960s
works, some painters appropriated color as the realm for investigation:
Jules Olitski (b. 1922) created uninterrupted fields of complex, often sweet-
ish color with acrylic (water-based) paint sprayed over previously dyed or
stained canvases, which he cropped before stretching on long and narrow
supports of various sizes and proportions. The sensation of floating in space
created by his pulverized color was denied by the opacity of the paint seen
up close and by emphatic surface signals consisting of brushmarks close to
and parallel to the edges. He was considered the point of departure for
formalist Modernist painting. To break through Olitski or Larry Poons
(b. 1937), another Color Field painter, was an open challenge.

Ellsworth Kelly, whose pared-down geometry had come into promi-
nence in the 1950s, studied spectrum light colors by painting identically
shaped rectangles, each a different color, from a limited range of the spec-
trum. By controlling saturation, he could better keep his colors from reced-
ing or advancing vis-à-vis those next to them. He presented colors lined up
on a wall, as flat as color charts.

The old Bauhaus master Josef Albers, whose patient studies of the op-
tical effects created by the interaction of color antedated the investigatory
spirit of the 1960s, received acclaim at this time (as did Vasarely, Agam
Soto and Bridget Riley, the "Op" artists of Europe). In order to study the
way color is seen, he used square panels of masonite on which he painted
squares within squares of various colors right out of the tube, making clear
the fact that one color changes those next to it in sometimes dramatic ways,
creating color and space ambiguities known as optical effects or illusions.
The tense pulsations of his surfaces make him an impure artist in the strict
formalist sense.†

Not so Robert Ryman (b. 1930), who limited himself essentially to a
square format and to one color—white. He painted on such materials as
linen, cotton, paper, fiberglass, rolled steel. He applied one or more coats of

* This catchy phrase from Alain Robbe-Grillet's essay "Une voie pour le roman futur," in
 his *Pour un nouveau roman*, appeared in Barbara Rose's article "ABC Art" in *Art in
 America* (October-November 1965).

† The 1960s also proved favorable to Kinetic art whereby movement does not occur in the
 viewer's mind but is produced in the work itself (Pol Bury, Takis, Rickey, Schoeffer, Piene,
 Calder, etc.)

paint and used one type of brushstroke, systematically repeated for each work, compelling the viewer to a sharpened understanding of process and of the physicality of paint.

Other artists, such as Sam Gilliam (b. 1933), carried their investigation of painting beyond formalist strictures by dispensing with wooden stretchers and letting their canvas, dyed or stained, hang loosely from wall or ceiling. (A French artist from the "Support-Surface" group,* Claude Viallat, made canvas and weave the subject of his art. He presented in silkscreen what might be read as the greatly enlarged criss-crossing of canvas threads, or translated it into rope. He also gave up the rectangular stretcher and presented his work loose like tapestry or banners.)

Frank Stella moved away from the monochrome of his early works, and investigated the point at which an object on a wall stops being a painting and becomes sculpture or an object in space.

Indeed, the investigation of the medium of painting naturally led to a consciousness of its limits vis-à-vis sculpture, and therefore to a renewed consciousness of sculpture's inherent properties. And sculpture had to redefine itself vis-à-vis painting. In this respect, David Smith's *Cubi* of the 1960s, and particularly the earth-hugging, crawling structures of the Englishman Anthony Caro (b. 1924), were hailed as the point of departure for sculpture. Their clear articulation of the passage from two dimensions (drawing on an imaginary plane) to three dimensions (extension beyond a single plane), their unabashed assertion of dependency upon the earth to support their weight, and their openness of structure made them important in formalist terms. David Smith's recurring Expressionism kept him from being judged as advanced and pure as Anthony Caro.

The black modular volumes of the architect Tony Smith (b. 1912), based on a pyramid unit, were hailed for their bold self-definition as merely "shapes" in space. Like Stella's austere early canvases, Tony Smith's somber, blocklike volumes suggested little to the imagination except the dignity of their presence. There are no gymnastics of equilibrium in *Moses*, a work on the grounds of Princeton University. Still, seeing it from a distance, one appreciates a new sense of size, not monumental but scaled to the garden environment, and, going around it, one is aware of light playing on clearly defined, faceted surfaces, and of the work's changing appearance from each new angle.

Just as painters limited their variables, so did sculptors: volumes based

* This French group, now disbanded, divided among themselves the investigation of the elements of painting. More recently several of them—Louis Cane, Devade, Valensi—have become theoreticians as much as practitioners of art. Their writings (in *Les cahiers théoriques de la peinture*), couched in the difficult language of the *Tel Quel* philosophers Sollers and Kristeva, suggest a search for the elusive boundary between painting as a search for knowledge and painting as an object of consumption.

on the repetition of a single shape, or given as a single holistic shape, are the means of so-called Minimalist sculpture. Several large cubes, either closed (Robert Morris, b. 1931; Donald Judd, b. 1928), or open (Sol LeWitt, b. 1920; Robert Morris), a pavement of metal squares arranged and displayed on an empty floor (Carl André, b. 1935); serially scaled boxes (Donald Judd), neon tubes spaced out on an empty wall (Dan Flavin, b. 1933), a giant X touching floor and ceiling in an empty room (Roland Bladen, b. 1918)—these simple geometric shapes drove the viewer to a new understanding of scale as the relation between an object and its ambiance rather than (as in traditional sculpture) between the objects and human stature.

The Minimalists claim to have changed the role of the art object from an esthetic to an informative function. Indeed, Minimalist objects are essentially signs by which an idea is made perceptible, and the Minimalists are often called "conceptual." The same applies to a number of artists in France, who place their signs (striped or circled awning material) in indoor or outdoor settings (Buren, Parmentier, Mosset). The Minimalist point of view is blatantly beyond the formalist pale.

In opposition to the look but in sympathy with the "conceptual" aims of Minimalist sculpture, Process Art brought with it a whole new range of materials, some organic-looking, many previously rejected either because of their ephemeral quality (ice, dead leaves in Rafael Ferrer's pieces) or lack of dignity (felt, grease, cloth, used by Robert Morris, Joseph Beuys and Eva Hesse respectively). Eva Hesse (1936-1970) was to coat her materials in fiberglass in order to immobilize their soft, pliable quality. But many Process artists tended to show materials in their raw state, untransformed, the better to study and expose their inherent properties. One of them, for an exhibition at the Whitney Museum, mixed bulk chalk and mineral oil with paper and cloth, and the result, like a biological culture, could be seen changing in time. Or the public might be invited to witness an installation and watch a piece grow and change with each addition made daily by the artist. In fact, pieces by Process artists were rarely assembled permanently, being mounted only for the duration of an exhibit. With their parts often shown in precarious balance, they revealed the subterranean forces, stresses and tensions inherent in the materials. For example, a heavy piece of lead tubing might be propped against a wall and kept from sliding by another one placed at its base (Richard Serra, b. 1939). Or a slab might simply be placed against a wall (John McCracken).*

The common conceptual framework allying Minimalist and Process art is exemplified by Robert Morris, who, relinquishing a consistency of style in

* Robert Rauschenberg, in a complex propped sculpture of his 1973 *Venetian Series*, comments humorously on such work. It appears that Rauschenberg who once was a student of Albers at Black Mountain College did not forget the Bauhaus master's teachings in the structural properties of materials.

Their clear articulation of the passage from two dimensions to three dimensions, their unabashed assertion of dependency upon the earth to support weight, and their openness of structure, made them important in formalist terms.

Anthony Caro, *Flats*, 1964, steel painted red and blue. Photograph courtesy Andre Emmerich Gallery, New York. 3' 1 1/2'' x 7'7'' x 10'.

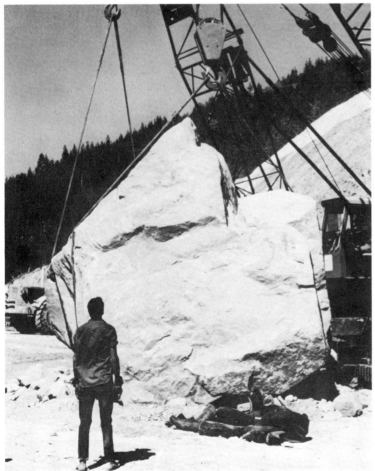

The titanic combat of man against the elements is apprehended not fictionally —from reading Moby Dick, for example —but directly either by witnessing the activity or through films and photos of the event.

Michael Heizer, Rock displacement, 1969. 68-ton granite mass being lifted on a double-goose Lo-Boy transport, Sierra Mountains, Nevada.

These simple geometric shapes drove the viewer to a new understanding of scale . . . as the relation of an object to its ambiance. . . .

Dan Flavin, *Three Sets of Tangented Arcs in Daylight and Cool White*, (partial view), 1969. Photograph courtesy John Weber Gallery, New York. Room size 114 x 296 x 447''.

With his felt pieces, Morris pointed out change as embedded in the condition of soft materials.

Robert Morris, view of exhibition, April 6-27, 1974. (On the walls, *Untitled*, felt with metal grommets, 8' high.) Photograph courtesy Leo Castelli Gallery, New York.

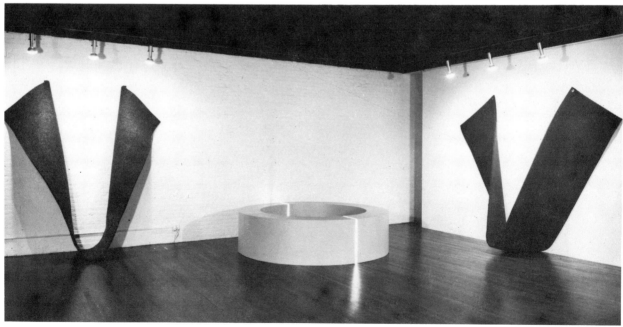

his successive moves (including Minimal and Process pieces), has created a body of work with hard-headed logic. A piece called *The I Box* of 1963, consisting of a box with a hinged door shaped like the capital letter I, revealed upon being opened a naked likeness of the artist, and gave the viewer two ways of thinking about the I. A group of identical L beams (*Untitled*, 1965) looked different depending on the way each was positioned on the floor. His *Cubes* of 1966 changed as the viewer walked about them. With his felt pieces, Morris pointed out change as embedded in the condition of soft materials. In all the described pieces, a phenomenon dealing with words, objects or situations reveals to the viewer its various semantic dimensions directly and no longer by means of metaphors. Morris's *Pace and Progress* (1969) was presented as an event consisting of the artist riding a horse along a straight path, as a photographic document of the event, and as the imprint on the ground of the horse's hooves.

Indeed, in their investigatory zeal, artists did not confine themselves to working indoors but carried on experiments in and with natural surroundings (Heizer, Oppenheim, Smithson, Long, etc.). Christo's confrontation with the elements consists in wrapping cliffs and monuments, suspending curtains across valleys, stretching a twenty-mile cloth wall eighteen feet high across the California landscape, and observing the forces of the wind destroy his ambitious undertakings. The titanic combat of man against the elements is apprehended not fictionally—from reading *Moby Dick*, for example—but directly, either by witnessing the activity or through films and photos of the event. Prior to the realization of his projects, Christo makes drawings that one might call "visionary" but for the fact that teams of engineers and technicians have been able to give them reality. Christo tests modern technology against nature and against his imagination. (Curiously, when Christo speaks of his activities, he likes to stress their anthropological and sociological aspects, the dealings with various trades, types of people and human situations that the realization of his projects entails.)

Some artists take their own bodies as subjects and make excruciating demands on them—for example, by repeating an exercise until exhaustion sets in. In 1972, at the German international show *Documenta*, a body-demonstration resulted in an artist's death.

Artists have used advanced technical "hardware" (computers, television, tape recorders), as well as films and photos to communicate the processes of their investigations. A group calling itself the Experiment in Art and Technology worked in close touch with scientists and technicians for five years on certain ambitious projects that the Los Angeles County Museum reported on in 1971. Further demonstrations of the alliance of art, technology and science were provided at the New York Jewish Museum in 1970 with a show called *Software*, and in 1968 in Kansas City with *The Magic Theater*.

The outward gratuitousness of so much experimentation, the desperate search and competition for ideas, the conflict between avant-garde artistic activity, political action and the need to make a living have caught artists all over the world in contradictions and crises. The Formalists, by remaining faithful to a narrow definition of painting and sculpture, have tended to erode the boundary between the artist and the decorator. Their large paintings and sculptures, lacking controversial narrative elements, have often been bought by business firms to fill institutional spaces. On the other hand, Germano Celant, leader of Art Povera, has said: "Art means to be able to make things, those who know how to make things are, for some time past, the architects, the designers, the technicians and the politicians, we are not artists [in that sense], that's all."[24] For Conceptualists like Celant, the art object is a material thing to be bought and sold and has nothing to do with art. The formalist art object stimulates perception, while important art must convey meaning beyond mere perception. An artist of the Art-Language group who has formulated "propositions" in writing merely requires that the viewer comprehend the language used and follow his instructions to draw on his memory, on his perception of the environment and on his ability to associate memory and perception to create in his mind an art experience.

In the light of these two conflicting viewpoints, the work of Hyper-Realists (sometimes also called Post-Pop), who use photographs and slides of mostly banal scenes as the source of highly craftsmanlike paintings "imitating" the objectivity of the camera eye, appears significant. Magnified many times, photographs can tell a great deal about the weaknesses of our perceptual processes. Unlike the naked eye, which acts selectively on the basis of experience, photographs reveal information impartially and—as was shown in the film "Blow-Up"—can sometimes fill gaps in knowledge.

Perhaps in doubt as to the survival of "art," Hyper-Realist painters, and the sculptors who recreate their human models three-dimensionally down to the last pore and eyelash, are also finding solace in belonging to a long tradition with established hierarchies as to who can best execute a given piece of work.

Of late, and working in a variety of current and not-so-current styles, painters and sculptors united by the condition of having devoted years to creating without recognition because of racist or sexist prejudice, have become outspoken in their claims to be artists.

Whether painting and sculpture are defined according to the specifics of their media, or whether, as Donald Judd has phrased it, "art is what you call art," it is clear that one issue—what is art?—has been sidestepped, while another—who is an artist?—remains an open question.

Whether an artist need or need not be a fine craftsman is not a new issue. At the turn of the century—years before Duchamp presented his first

Duane Hanson, *Tourists*, 1970, poly-
ester/fiberglass. Saul P. Steinberg Collec-
tion. Male: 5′ 2″, female: 5′ 4″.

Arakawa, *A Forgettance (Exhaustion
Exhumed)*, 1973-74, acrylic on canvas. Photo-
graph courtesy Ronald Feldman Fine Arts,
New York. 77 x 240″.

Of late, painters and sculptors, united by the condition of having devoted years to creating without recognition because of racist or sexist prejudice, are seen asserting themselves as artists through a variety of public manifestations.

"Women Choose Women," installation shot of exhibition, January 12–February 11, 1973. Photograph courtesy The New York Cultural Center.

Ready-mades—French academicians were under pressure to acknowledge that the sketch rather than a "finished" painting or sculpture ought to become the basis of selection for prizes.

As for Marcel Duchamp, whom many a young Conceptual artist today takes as a reference, although he made one statement by means of his Ready-mades, he rendered many of his ideas through imaginative *bricolage*. Witness the roto-reliefs and curio-objects of all kinds and in all sorts of materials that he fashioned over the years. His famous work *The Bride Stripped Bare by Her Bachelors, Even* exists both as an art object, *The Large Glass*, and as a document, *The Green Box*. And Duchamp's last work, *Etant Donnés* (in the Philadelphia Museum of Art), part painting, part Ready-made, part sculpture and part architecture, took the artist twenty years to produce.

Summing Up

Anti-illusionism appears to be more than a formal necessity for Modernist painting and sculpture, more than the dissolution of figure and ground into one. It evinces a loss of illusion as to art's ability to communicate individual feelings and thoughts by means of symbols and metaphors.

Metaphoric or symbolic expression has been shown to be interpretable in such multiple ways as to become meaningless, and in such contradictory ways that the ability to awaken consciousness is jeopardized. Even the response to parcels of reality presented as message-carriers expressive of society is seen to be highly ambiguous.

For the anti-illusionist, if art is to remain a means of changing human consciousness, it must go at its task using signs so clear as to be interpretable in only one way. Since factual knowledge alone answered such a demand, artists of the new sensibility proceeded to plot the limits of knowledge with the caution and diligence of a Wittgensteinian philosopher plotting the limits of language. Some of the paintings and sculptures produced in that decade pointed to what could be named: stretcher support, surface, line, paint, color, shape, material. Some pointed to what could be shown: space, scale, structure, tension, process. Other works examined the twilight zone between categories, such as painting versus sculpture, art versus non-art, feeling versus pain.

Artists have not only investigated the limits of factual knowledge but also sought ways to transmit their information as directly as possible and without distorting its meaning. Using anthropological inquiry (such as the structuralist methods of Claude Lévi-Strauss) as a model, they have pre-

sented their facts so that, through empirical observation, rather than any a priori theory, relationships and structures previously unperceived or unknown might be revealed.

Some artists have utilized modern tools of communication, up-to-date technological hardware designed to transmit information faithfully. Some, exploiting the increased knowledge of the functioning of perception, have adopted methods used in advertising, among them repetition, blown-up imagery, eye-catching colors, simple copybook forms. Many have tailored their propositions to the space in which they were to be shown in order to suggest unequivocally the relationship of the proposition to its surrounding space.

All in all, there appeared to be a cleansing, a *tabula rasa*, a new beginning—not the early twentieth-century return to prelogical instinctive expression, but the painstaking, objective questioning of what is known (as opposed to what is believed), of what can be known and therefore said. Ideally, judgments would be revised or suspended on the basis of new, experienced fact, perceptions would be awakened, a fresh awareness of beauty would be seen in the plainest of surroundings as well as in the perfected structural organization of the new paintings and sculptures.

Yet this anti-illusionism has not been overwhelmingly endorsed. Among the arguments against it is the fact that there is nothing to stop the artist in his investigatory zeal from turning the most gratuitous acts, including acts of violence, into something called art. Furthermore, the viewer, asked to perceive without interpreting, to observe without being moved, tends to obey his natural passivity and to become devoid of personal emotional responses. To watch someone carry out, or to carry out oneself, an "experiment" that inflicts pain (as has actually happened in body art of the 1970s) and to fail to suggest that the "experiment" be stopped, never to sense the comic or the ridiculous in certain artistic manifestations, is to abdicate judgment. Not surprisingly, art since the 1950s has been said to reflect a crisis of values, a confusion not unrelated to political and social phenomena.

For an artist of the Abstract Expressionist generation, a sign traced on a surface was to be understood as a reflection of the artist's identity. For the anti-illusionist artist, a sign on a surface becomes a fact added to the world of fact, altering slightly one's perception of the world and, possibly, adding to one's understanding of it. For him, a sign cannot be a reflection of who the artist is, since the existence of Freud's model of man, filled with thoughts and sensations hoarded in a private self, is unprovable and therefore (in Wittgensteinian terminology) beyond language.

NOTES Titles of French sources are given in the original French. The passages quoted have been translated by the author.

chapter 1
Moments of the New in Paris, c. 1900-1907

1. André Salmon, *Souvenirs sans fin: Première Epoque, 1903-8* (Paris: Gallimard, 1955), p. 165.
2. Arthur Rimbaud, "Voyelles," *Oeuvres* (Paris: Club Français du Livre, 1957), p. 106.
3. Dore Ashton, ed., *Picasso on Art* (New York: Viking, 1972), p. 23.
4. Maurice Raynal, *Picasso* (1922; Geneva: Skira, 1953), p. 24.
5. Roland Dorgelès, *Au Beau Temps de la Butte* (1949; Paris: A. Michel, 1963), p. 119.
6. See Anthony Blunt and Phoebe Poole, *Picasso, The Formative Years* (Greenwich, Conn.: New York Graphic Society, 1962).
7. Theodore Reff, "Harlequins, Saltimbanques, Clowns and Fools," *Artforum*, October 1971, pp. 30-43.
8. Ashton, op. cit., p. 21.
9. Francis Carco, *L'Ami des peintres* (1944; Paris: Gallimard, 1953), p. 221.
10. Albert Boime, *The Academy and French Painting in the 19th Century* (London: Phaidon, 1971), p. 17.
11. Ibid.
12. Henri Matisse, *Ecrits et propos sur l'art* (Paris: Hermann, 1972), p. 80.
13. Ibid., p. 81.
14. Ibid., p. 90.
15. Ibid., p. 195.
16. Ibid., p. 82.
17. Ibid., p. 198.
18. Ibid., p. 94, note 43.
19. Leo Stein, *Appreciation, Painting, and Poetry* (New York: Crown, 1947), p. 143.
20. Ibid., p. 153.
21. Ibid., p. 156.
22. Ibid., p. 158.
23. *Four Americans in Paris* (New York: Museum of Modern Art, 1970), p. 52.
24. Ibid., p. 38.
25. Ibid., p. 35.
26. Gertrude Stein, *The Autobiography of Alice B. Toklas* (1933; New York: Vintage Books, 1960), p. 62.
27. *Four Americans in Paris*, p. 27.
28. Gertrude Stein, op. cit., p. 43.
29. Ibid., p. 46.
30. Alfred Barr, *Matisse, His Art and His Public* (New York: Museum of Modern Art, 1951), p. 82.
31. Matisse, op. cit., p. 42.
32. Gertrude Stein, op. cit., p. 65.
33. Ibid., p. 57.

chapter 2
Moments of the New in Paris, c. 1907-1912

1. Pierre Daix, "Il n'y a pas d'art nègre dans *Les Demoiselles d'Avignon*," *La Gazette des Beaux-Arts*, October 1970, pp. 247-70.
2. Roland Penrose, *Picasso, His Life and Work* (London: Gollancz, 1958), p. 125.
3. Illustration 3A in John Golding, *Cubism: a History and an Analysis, 1907-1914*, 2nd ed. (1959; Boston: Boston Book and Art Shop: 1968).
4. Dora Vallier, "Braque, La Peinture et Nous," *Cahiers d'Art*, no. 1, 1954, p. 16.
5. Ibid., p. 14.
6. Jean Paulhan, *Braque le Patron* (Genève: Trois Colliness, 1946), p. 35.
7. Golding, op. cit., illustration 30.
8. Gertrude Stein, *Picasso* (1938; Boston: Beacon Paperback, 1967), p. 10.
9. Vallier, op. cit., p. 14.
10. Daniel-Henry Kahnweiler, *Confessions Esthetiques* (Paris: Gallimard 1963), p. 36.
11. William Rubin, *Picasso in the Collection of The Museum of Modern Art* (Greenwich, Conn.: New York Graphic Society, 1972), p. 72.
12. Vallier, op. cit., p. 14.
13. Dore Ashton, ed., *Picasso on Art* (New York: Viking, 1972), p. 167.
14. Ibid., p. 161.
15. Gelett Burgess, "The Wild Men of Paris," *The Architectural Record*, May 1910, pp. 400-14.
16. André Salmon, "Anecdotal History of Cubism," 1912, in Edward Fry, *Cubism* (London: Thames & Hudson, 1966), p. 82.
17. Guillaume Apollinaire, "On the Subject in Modern Painting," 1912, in *Apollinaire on Art* (New York: Viking, 1972), p. 197.
18. Maurice Raynal, "Conception and Vision," 1912, in Fry, op. cit., p. 95.
19. Henri Matisse, *Ecrits et propos sur l'art* (Paris: Hermann, 1972), p. 50.
20. Ibid., p. 49.
21. Ibid., p. 65.
22. Ibid., p. 72.
23. Ibid., p. 73.
24. *Henri Matisse, Exposition du Centenaire*, Paris, Grand Palais, April-September 1970, p. 76.
25. Matisse, op. cit., p. 43.
26. "Correspondance Matisse-Camoin," *Revue de l'Art*, no. 12, 1971, p. 21.
27. Alfred Barr, *Matisse, His Art and His Public* (New York: Museum of Modern Art, 1951), p. 173.

chapter 3
Moments of the New in Paris, c. 1912-1920

1. Guillaume Apollinaire, *Le Petit Bleu*, March 20, 1912, trans. in *Apollinaire on Art* (New York: Viking, 1972), p. 217.
2. Albert Gleizes and Jean Metzinger, *Du Cubisme*, (Paris: Figuieres, 1912) trans. in part in *Theories of Modern Art* (Berkeley: University of California Press, 1969), pp. 212-13.
3. Ibid., p. 216.
4. Ibid., p. 209.
5. Fernand Léger, *Fonctions de la Peinture* (Paris: Mediations, 1965), p. 21.
6. Blaise Cendrars, *Oeuvres Complétes* (Paris: Denoël, 1960-1965), vol. IV, pp. 197-98.
7. Quoted in Dora Vallier, *L'Art Abstrait* (Paris: Le Livre de Poche, 1967), p. 226.
8. Amédée Ozenfant and Charles E. Jeanneret, *La Peinture Moderne*, 1925; trans. in part in Fry, *Cubism* (London: Thames & Hudson, 1966), p. 170.
9. Jean Paulhan, *Braque Le Patron* (Geneva: Trois Collines, 1946), p. 37.
10. William Rubin, *Picasso in the Collection of The Museum of Modern Art* (Greenwich, Conn.: New York Graphic Society, 1972), p. 74.
11. Paulhan, op. cit., p. 37.
12. F. T. Marinetti, "Le Futurisme," *Le Figaro*, February 9, 1909; trans. in *Theories of Modern Art*, p. 286.
13. Boccioni, Carrà, Russolo, Balla and Severini, "Futurist Painting: Technical Manifesto," April 11, 1910; trans. in *Theories*, p. 293.

chapter 4
The New Art of Germany, c. 1896-1914

1. Wassily Kandinsky, *Rückblicke* (Berlin: Der Sturm, 1913); trans. as "Reminiscences" in *Modern Artists on Art: Ten Unabridged Essays*, Robert L. Herbert, ed., © 1964. Reprinted by permission of Prentice-Hall, Inc., Englewood Cliffs, New Jersey. p. 22.
2. Paul Klee, *Tagebücher* (Cologne: Schauberg, 1957); trans. as *The Diaries of Paul Klee*. Originally published by the University of California Press; reprinted by permission of The Regents of the University of California (Berkeley: 1968).
3. "Reminiscences," op. cit., p. 37.
4. Ibid., p. 38.
5. Catalogue of *Le Salon d'Automne*, Paris, 1906.
6. Wassily Kandinsky, *The Art of Spiritual Harmony* (1st. Engl. trans. 1914); repr. as *Concerning The Spiritual in Art and Painting in Particular* (1947; New York: Wittenborn, 1970).
7. Paul Klee, "Schöpferische Konfession" in *Tribune der Kunst und Zeit*, 1920; trans. as "Creative Credo," in Paul Klee, *Notebooks of Paul Klee, Vol 1: The Thinking Eye* (New York: Wittenborn, 1961), pp. 76-79.
8. "Reminiscences," op. cit., p. 33.

chapter 5
Art Revolutions in Russia, c. 1895-1923

1. Camilla Gray, *The Russian Experiment in Art: 1863-1922* (1962; New York: Abrams, 1970), p. 37.
2. Kasimir Malevich, *Essays on Art* (1st English trans. Copenhagen: Borgen, 1968), vol. I, p. 45.
3. Catalogue of *Le Salon d'Automne*, Paris, 1906.
4. Gray, op. cit., p. 82.
5. Vladimir Markov, *Russian Futurism: a History* (Berkeley: University of California Press, 1968), p. 150.
6. Ibid.
7. "Technical Futurist Manifesto," trans. in *Theories of Modern Art* (Berkeley; University of California Press, 1969), p. 289.
8. Waldemar George, *Larionov* (Paris: Bibliothèque des Arts, 1966), p. 70.
9. Malevich, op. cit., vol. I, p. 19.
10. Malevich, op. cit., vol. II, Appendix 1. From 1/42. Notes.
11. M. Larionov, "Malevitch: souvenirs de Michel Larionov," *Aujourd'hui Art et Architecture*, December 1957, pp. 6-8.
12. Malevich, op. cit., vol. I, note 8, p. 241.
13. Stockholm, Moderna Museet, *Vladimir Tatlin*, July-September 1968, introduction by Troels Andersen, p. 7.
14. Kasimir Malevich, *The Non-Objective World*, trans. in *Theories of Modern Art*, p. 343.
15. John Reed, *Ten Days that Shook the World* (1926; Penguin Books: 1966), p. 220.
16. Marc Chagall, *My Life* (New York: Orion Press, 1960), p. 139.
17. Gray, op. cit., p. 221.
18. Malevich, *Essays on Art*, vol. I., p. 175.
19. *Petrogradskaya pravda*, November 1918, trans. in *Art in Revolution*, Hayward Gallery, February 26-April 18, 1971, p. 78.
20. Joseph Freedman and Louis Lozowick, *Voices of October* (New York: Vanguard Press, 1930), p. 55.

chapter 6
Dada, or the Humor of Despair, c. 1915-1923

1. Hugo Ball, *Cabaret Voltaire*, first Dada publication, Zurich, May 15, 1916, in Hans Richter, *Dada: Art and Anti-Art* (New York: McGraw-Hill, 1965), p. 14-15.
2. Robert Motherwell, ed., *The Dada Painters and Poets*, 2nd. ed. (1951; New York: Wittenborn, 1967), illus. p. 241.

3. Richter, op. cit., p. 14.
4. Gabrielle Buffet-Picabia, "Arthur Cravan," *Aires Abstraites* (Geneva: Cailler, 1957), p. 91.
5. Pierre Cabanne, *Dialogues with Marcel Duchamp* (New York: Viking, 1971), p. 39.
6. John Cage, "Edgard Varèse," *Silence*, 4th ed. (1961; M.I.T. Press paperback, 1970), p. 84.
7. "Declaration of the Dadaist Revolutionary Central Council," in *Theories of Modern Art*, pp. 381-82.
8. Richter, op. cit., p. 134.
9. Ibid., p. 137.
10. Kurt Schwitters, "Merz, 1920," in *The Dada Painters and Poets*, p. 60.
11. Ibid., p. 59.
12. Richard Hamilton, "The Large Glass," *Marcel Duchamp, A Retrospective Exhibition*, Philadelphia Museum and Museum of Modern Art, 1973-74, pp. 57-67.
13. Richter, op. cit., p. 128.

chapter 7
Breton and the Surrealists, c. 1924-1940

1. Correspondence Tzara-Breton-Tzara, item 6, April 4, 1919, in *Dada à Paris*, Michel Sanouillet, ed. (Paris: Pauvert, 1965), p. 444.
2. *Dada à Paris*, item 16, December 26, 1919, p. 454.
3. Ibid., item 1, January 22, 1919, p. 440.
4. In *Dada à Paris*, p. 84.
5. André Breton, "Caractères de l'évolution moderne et ce qui en participe," *Les Pas Perdus* (1924; Paris: Gallimard, 1969), p. 153.
6. Ibid., p. 157.
7. Louis Aragon, *Paysan de Paris*, (Paris: Gallimard, 1926).
8. R.D. Laing, *The Politics of Experience* (1967; New York: Ballantine Books, 1968), p. 120.
9. André Breton, *Manifestes du Surréalisme* (1924; Paris: Gallimard, 1963), p. 37.
10. Ibid., p. 53.
11. Ibid., p. 27.
12. Ibid., p. 40, note 1.
13. André Breton, *Le Surréalisme et la Peinture* (1928; Paris: Gallimard, 1965), p. 16.
14. Breton, *Manifestes du Surréalisme*, p. 53.
15. Man Ray, *Self Portrait* (Boston: Little, Brown, 1963).
16. Breton, *Le Surréalisme et la Peinture*, p. 33.
17. André Masson, "Toward Boundlessness," in *André Masson*, Curt Valentin Gallery, New York, April-May 1953.
18. Breton, "Genèse et perspectives artistiques du Surréalisme," *Le Surréalisme et la peinture*, p. 68.
19. "Joan Miró, from an interview with James Johnson Sweeney, 1947," in *Theories of Modern Art*

(Berkeley: University of California Press, 1969), p. 434.
20. Breton, *Le Surréalisme et la peinture*, p. 70.
21. Maurice Nadeau, *History of Surrealism* (New York: Macmillan, 1965), p. 156.
22. Breton, "Genèse et perspectives artistiques du Surréalisme," *Le Surréalisme et la peinture*, p. 72.
23. Salvador Dali, *The Secret Life of Salvador Dali* (New York: Dial Press, 1942), p. 250.
24. Ibid., p. 220.
25. *New York Herald-Tribune*, December 6, 1936.

chapter 8
The Bauhaus: Utopia for a Beautiful Life, c. 1919-1932

1. Hans Wingler, ed., *The Bauhaus, Weimar, Dessau, Berlin, Chicago* (Cambridge: M.I.T. Press, 1969), p. 31.
2. Ibid., pp. 32-33.
3. Helen Schmidt-Nonne, "Interview (by Basil Gilbert)," *Bauhaus and Bauhaus People* (New York: Van Nostrand Reinhold, 1970), p. 123.
4. Wilhelm von Bode, "The Task of Art Education after the War," *Die Woche*, April 1916, in Wingler, op. cit., p. 25.
5. Johannes Itten, *Design and Form; The Basic Course at the Bauhaus* (1963; New York: Van Nostrand Reinhold, 1964), pp. 7-18.
6. Felix Klee, "My Memories of the Weimar Bauhaus," *Bauhaus and Bauhaus People*, p. 38.
7. Ibid., p. 39.
8. Johannes Itten also wrote *The Art of Color* (New York: Van Nostrand Reinhold, 1961).
9. Felix Klee, op. cit., p. 40.
10. Wingler, op. cit., p. 142.
11. Hannes Beckmann, "Formative Years," *Bauhaus and Bauhaus People*, p. 195-99.
12. Lazlo Moholy-Nagy, *The New Vision* (1928; New York: Wittenborn, 1967).
13. Paul Klee, "Creative Credo" in *The Thinking Eye* (New York: Wittenborn, 1961).
14. Paul Klee, *The Nature of Nature* (New York: Wittenborn, 1974).
15. Wassily Kandinsky, "Analytical Drawing," *50 Years Bauhaus* (Chicago: Illinois Institute of Technology, August-September 1969), p. 52.
16. Wassily Kandinsky, *Point and Line to Surface* (1926; New York: S. Guggenheim Foundation, 1947).
17. Wingler, op. cit., p. 66.
18. Walter Gropius, *The New Architecture and the Bauhaus* (New York: Museum of Modern Art, 1936), p. 56.
19. Sigfried Giedion, *Space, Time, and Architecture: The Growth of a New Tradition*, 5th ed. (1941;

Cambridge: Harvard University Press, 1967), p. 493.

20. Letter of Hannes Meyer to the Lord Mayor of Dessau, August 16, 1930, Wingler, op. cit., p. 164.
21. Wingler, op. cit., p. 189.
22. Ibid.

chapter 9
New York and Abstract Expressionism, c. 1930-1960
 1. Francis O'Connor, *Federal Art Patronage, 1933-43* (College Park, Md.: University of Maryland Art Gallery, 1966), p. 6.
 2. Dore Ashton, *The New York School* (New York: Viking, 1973), p. 7.
 3. *Art News Annual*, 1940.
 4. Thomas B. Hess, *Willem de Kooning* (New York: Museum of Modern Art, 1968), p. 18.
 5. O'Connor, op. cit., p. 32, and author's interview with Herbert Benevy.
 6. Herbert Lawrence, "The Ten," *Art Front*, February 1936, p. 12, col. 2.
 7. Thomas B. Hess, *Barnett Newman* (New York: Walker, 1969), p. 18.
 8. Holger Cahill, *Gallery of American Art Today*, exhibition catalogue, 1939.
 9. "On the American Scene," *Art Front*, April 1935, p. 8, col. 2.
10. "Jackson Pollock," *Art and Architecture*, February 1944, p. 14.
11. Stuart Davis, "The New York American Scene in Art," *Art Front*, February 1935, p. 6, col. 1.
12. Axel Horn, quoted in B. H. Friedman, *Jackson Pollock: Energy Made Visible* (New York: McGraw-Hill, 1972), pp. 37-38.
13. Hess, *Barnett Newman*, op. cit., p. 18.
14. Friedman, op. cit., p. 46.
15. David Sylvester, "Adolph Gottlieb," interview, *Living Arts*, no. 1, 1963, p. 4.
16. Ashton, op. cit., p. 143.
17. Reprinted in Irving Sandler, *The Triumph of American Painting* (New York: Praeger, 1970), p. 62.
18. Ibid., p. 65.
19. Sandler, op. cit., p. 68.
20. Letter to the *New York Times*, June 13, 1943.
21. Conversation with the author.
22. "Interview with André Breton," *View*, vol. L., no. 7, October-November, 1941, p. 2.
23. Robert Coates, *The New Yorker*, May 26, 1945.
24. "Interview with Miro," *Possibilities*, Winter 1947-48, p. 67.
25. *Max Ernst: Beyond Painting*, introduction by Robert Motherwell (New York: Wittenborn, 1948), p. v.
26. *New York Times*, May 23, 1951.

27. Hans Hofmann, *Search for the Real and Other Essays* (1948; Cambridge, Mass.: M.I.T. Press paperback, 1968), p. 43.
28. Martin Duberman, *Black Mountain: An Exploration in Community* (New York: Dutton, 1972), p. 496, note 73.
29. *Life*, October 13, 1948.
30. Conversation with the author.
31. *Possibilities*, Winter 1947-48, p. 79.
32. *Modern Artists in America* (New York: Wittenborn, 1951), p. 12.
33. Elaine de Kooning, "Hans Hofmann Paints a Picture," *Art News*, February 1950, p. 38.
34. "A Symposium at The Museum of Modern Art," *Interiors*, May 1951, p. 104.
35. *Fifteen Americans*, Museum of Modern Art, 1952, p. 22.
36. David Sylvester, "Franz Kline: an interview," *Living Arts*, vol. I, no. 2, 1963, p. 10.
37. *David Smith by David Smith*, Cleve Gray, ed., (New York: Holt, Rinehart and Winston, 1968), p. 72.
38. Ibid., p. 164.
39. "What Abstract Art Means to Me," Museum of Modern Art Bulletin, Spring 1951, p. 12.
40. *Robert Motherwell* (New York: The Museum of Modern Art and Doubleday, 1965), p. 43.
41. *The New Decade*, Whitney Museum, 1955, pp. 35-36.
42. *Art News*, June 1951, p. 47.
43. "The Ides of Art: Six Opinions on What is Sublime in Art" *Tiger's Eye*, December 1948, pp. 52-53.
44. "An Artists' Session," transcribed in *Modern Artists in America*, Robert Motherwell, ed. (New York: Wittenborn, 1951), pp. 10-22.
45. Harold Rosenberg, "The American Action Painters," *Art News*, December 1952, p. 22.

chapter 10
Roots and Routes of Today's Art

 1. Interview with the author.
 2. Harold Rosenberg, "Action Painting: Crisis and Distortion," *The Anxious Object* (New York: Horizon Press, 1959), p. 40.
 3. Ibid., p. 42.
 4. Barbara Rose, "The New American Painting," *American Art Since 1900* (New York: Praeger, 1967), p. 210.
 5. Allan Kaprow, "The Legacy of Jackson Pollock," *Art News*, October 1958, p. 26.
 6. Thomas B. Hess, "U.S. Painting: Some Recent Directions," *Art News Annual*, 1956, p. 174.
 7. "Irving Sherman, Andy Warhol," *Art Digest*, July 1952, p. 19.

8. Michael Kirby, *Happenings* (New York: Dutton, 1965), p. 33.
9. "Ellsworth Kelly," *Arts*, June 1956, p. 52.
10. John Cage, *Silence*, 4th ed. (1961; Cambridge, Mass.: M.I.T. Press, 1970), p. 98.
11. Lawrence Alloway, "Art News from London," *Art News*, November 1954, p. 54.
12. Pierre Restany, *Les Nouveaux Réalistes* (Paris: Planète, 1968), p. 58.
13. Allan Kaprow, "The Legacy of Jackson Pollock," *Art News*, October 1958, p. 56.
14. Thomas B. Hess, "Mixed Mediums for a Soft Revolution," *Art News*, Summer 1960, p. 45.
15. Hilton Kramer, "Editor's Notes," *Arts*, September 1961, p. 6.
16. Clement Greenberg, "American Type Painting," *Art and Culture* (1961; Boston: Beacon, 1968) pp. 208-29;
Clement Greenberg, "Modernist Painting," in *The New Art*, Gregory Battcock, ed. (New York: Dutton, 1973);
Clement Greenberg, "Post Painterly Abstraction,"

text for an exhibition at the Los Angeles County Museum of Art, April 23-June 7, 1964.
17. Harold Rosenberg, "Action Painting: Crisis and Distortion," pp. 37-44; also, "Mobile, Theatrical, Active," pp. 213-23, *The Anxious Object*, (New York: Horizon Press, 1959).
18. Leo Steinberg, "Other Criteria," in *Other Criteria* (New York: Oxford University Press, 1972), pp. 55-91.
19. Allan Kaprow, "Happenings in the New York Scene," *Art News*, May 1961, pp. 36-39.
20. Ibid., p. 37.
21. Jill Johnston, "Art Without Walls," *Art News*, April 1961, p. 36.
22. Alan Salomon, "An interview with Frank Stella," partially reprinted in *Museum of Modern Art Members Newsletter*, Spring 1970.
23. Bruce Glaser, "Questions to Stella and Judd," *Minimal Art*, Gregory Battcock, ed. (New York: Dutton, 1968), p. 158.
24. Germano Celant, *Art Povera* (New York: Praeger, 1969), p. 231.

BAUHAUS BOOKS (*The original German titles are here given in translation.*)
edited by W. Gropius and L. Moholy-Nagy
published by Albert Langen, Munich, 1925-30.

1. Walter Gropius, *International Architecture*, 1925 (typography and cover by L. Moholy-Nagy; jacket by Farkos Molnar).
2. Paul Klee, *Pedagogical Sketchbook*, 1925 (typography and jacket by L. Moholy-Nagy).
3. Adolf Meyer, *An Experimental House*, 1925 (typography by A. Meyer).
4. Oskar Schlemmer, *The Stage at the Bauhaus*, 1925 (title page by O. Schlemmer; typography by L. Moholy-Nagy).
5. Piet Mondrian, *Neoplasticism and the New Building*, 1925 (typography, binding and jacket by L. Moholy-Nagy).
6. Theo van Doesburg, *Principles of Neoplastic Art*, 1925 (typography by L. Moholy-Nagy; jacket by Theo van Doesburg).
7. Walter Gropius, *New Productions from Bauhaus Workshops*, 1925 (typography and binding by L. Moholy-Nagy).
8. L. Moholy-Nagy, *Painting, Photography, Film*, 1925 (photography, film, typography and binding by L. Moholy-Nagy).
9. Wassily Kandinsky, *Point and Line to Plane*, 1926 (typography by H. Bayer).
10. J.J.P. Oud, *Dutch Architecture*, 1926 (typography by L. Moholy-Nagy).
11. Kasimir Malevich, *The Non-Objective World*, 1927 (typography, binding and jacket by L. Moholy-Nagy).
12. Walter Gropius, *Dessau Bauhaus*, 1930 (typography, etc., by L. Moholy-Nagy).
13. Albert Gleizes, *Cubism*, 1928 (typography by L. Moholy-Nagy).
14. L. Moholy-Nagy, *Of Material in Architecture*, 1929 (typography by L. Moholy-Nagy).

SUGGESTIONS FOR FURTHER READING
ARRANGED BY SUBJECT

The following selection of books (listed by author or editor) and exhibition catalogues (listed alphabetically under city or country) is intended to give the reader access to more detailed bibliographical material as well as suggestions for further reading and study. The *Art Index* (1930-) lists periodicals and indexes articles by author and by subject.

General

1. Chipp, Herschel B., ed. *Theories of Modern Art: A Source Book by Artists and Critics.* Berkeley and Los Angeles: University of California Press, 1969.
2. Goldwater, Robert. *Primitivism in Modern Art,* rev. ed. New York: Vintage, 1967.
3. Gombrich, E.H. *Art and Illusion: A Study in the Psychology of Pictorial Representation.* New York: Pantheon, 1961.
4. Janson, H.W. *History of Art: A Survey of the Major Visual Arts from the Dawn of History to the Present Day,* rev. ed. Englewood Cliffs, N.J.: Prentice-Hall, 1969.
5. Panofsky, Erwin. *Meaning in the Visual Arts.* New York: Anchor, 1955.
6. *Phaidon Dictionary of Twentieth Century Art.* New York: Phaidon, 1973.

The Paris Art Scene, 1900-1920 (see also *nos. 39, 55*)

7. Apollinaire, Guillaume. *Apollinaire on Art: Essays and Reviews, 1902-1918.* New York: Viking, 1972. Note on Salons, one-man and group exhibitions; bibliography.
8. Bridgman, Richard. *Gertrude Stein in Pieces.* New York: Oxford, 1970.
9. Brion-Guerry, L., ed. *L'Année 1913: Les Formes esthétiques de l'oeuvre d'art à la veille de la première guerre mondiale,* 2 vols. Paris: Klincksieck, 1971.
10. Coquiot, Gustave. *Les Indépendants (1884-1920).* Paris: Ollendorff, 1920.
11. Haas, Robert Hartlett, ed. *A Primer for the Gradual Understanding of Gertrude Stein.* New York: Black Sparrow, 1971. Includes a 1946 interview with Gertrude Stein.
12. Jourdain, Frantz. *Le Salon d'Automne.* Paris: Les Arts et Le Livre, 1928.
13. Laude, Jean. *La Peinture française (1905-14) et "l'art nègre,"* 2 vols. Paris: Klincksieck, 1968. Bibliography.
14. Mellows, James. *Charmed Circle.* New York: Praeger, 1974. On the Steins; bibliography.

15. New York, The Museum of Modern Art. *Four Americans in Paris.* 1970. Texts on Leo, Gertrude, Michael and Sarah Stein; the Cone sisters; Gertrude Stein on Matisse, Picasso, Gris.
16. Shattuck, Roger. *The Banquet Years,* rev. ed. New York: Vintage, 1968. On Rousseau, Apollinaire, Jarry, Satie; bibliography.
17. Steegmuller, Francis. *Apollinaire: Poet among the Painters.* New York: Farrar, Straus & Giroux. 1963. Bibliography.
18. Stein, Gertrude. *The Autobiography of Alice B. Toklas.* New York: Vintage, 1960.
19. Warnod, Jeanine. *Washboat Days.* New York: Viking-Grossman, 1972. Trans. from the French.

Matisse and the Fauves (see also *nos. 2, 13*)

20. Aragon, Louis. *Henri Matisse, Roman.* Paris: Gallimard, 1971.
21. Barr, Alfred H., Jr. *Matisse: His Art and His Public.* New York: Arno, 1966. Basic text on the artist; bibliography.
22. Duthuit, Georges. *The Fauvist Painters.* New York: Wittenborn, 1950.
23. Escholier, Raymond. *Matisse, ce vivant.* Paris: Fayard, 1958.
24. Elsen, Albert. *The Sculpture of Henri Matisse.* New York: Abrams, 1972.
25. Giraudy, Danièle, ed. "Correspondance Henri Matisse-Charles Camoin," *La Revue de l'Art,* December 1971, pp. 7-34.
26. Leymarie, Jean. *Fauvism.* Geneva: Skira, 1950.
27. Los Angeles, University of California. *Henri Matisse.* 1966. Retrospective exhibition; bibliography since 1951.
28. Matisse, Henri. *Ecrits et propos sur l'art.* Paris: Hermann, 1972. A compilation of Matisse's writings, sayings, notes.
29. Müller, Joseph Emile. *Fauvism.* New York: Praeger, 1967.
30. New York, The Museum of Modern Art. *Les Fauves.* 1952-53. Text by John Rewald.
31. Paris, Musée National d'Art Moderne. *Le Fauvisme français et les débuts de*

l'expressionisme allemand. 1966. Text by
Leymarie.

32. Paris, Grand Palais. *Henri Matisse: Exposition du
centenaire.* 1970. A major retrospective;
bibliography.

33. Pleynet, Marcelin. "Le Systeme de Matisse,"
L'Enseignement de la peinture. Paris: Le Seuil,
1971.

Picasso (see also *nos. 2, 13, 53-61, 64-67, 69*)

34. Ashton, Dore, ed. *Picasso on Art.* New York:
Viking, 1972. Sayings, epigrams and
conversations.

35. Barr, Alfred H., Jr. *Picasso: Fifty Years of His
Art.* New York: Arno, 1966. Basic text;
bibliography.

36. Blunt, Anthony and Poole, Phoebe. *Picasso: The
Formative Years.* Greenwich, Conn.: New York
Graphic Society, 1962.

37. Daix, Pierre and Boudaille, Georges. *Picasso, 1900-
1906.* Paris: Bibliothèque des Arts. Neuchâtel:
Ides et Calendes, 1966.

38. Leymarie, Jean. *Picasso, the Artist of the Century.*
New York: Viking, 1973. Bibliography.

39. Paris, Grand Palais, Petit Palais. *Hommage à
Pablo Picasso.* 1967. A major retrospective of
paintings and sculpture; bibliography.

40. Penrose, Roland. *Picasso: His Life and Work.*
London: Gollancz, 1958. Bibliography.

41. Penrose, Roland and Golding, John, advisory eds.
Picasso in Retrospect. New York: Praeger, 1973.
Essays by the editors and other Picasso experts;
bibliography.

42. Reff, Theodore. "Love and Death in Picasso's
Early Work." *Artforum,* May 1973, pp. 64-73.

43. Rubin, William; Castleman, Riva and Johnson,
Elaine. *Picasso in the Collection of The Museum
of Modern Art.* New York: The Museum of
Modern Art, 1972. Notes on individual works.

44. Sabartés, Jaime. *Picasso, Portraits et Souvenirs.*
Paris: Louis Carré and Maximilien Vox, 1946.
The author was Picasso's secretary and lifelong
friend.

45. Steinberg, Leo. "Picasso's Sleep Watchers," "The
Skulls of Picasso," "The Algerian Women and
Picasso at Large." *Other Criteria.* New York:
Oxford, 1972.

46. Toronto, The Toronto Art Gallery. *Picasso and
Man.* 1964. Texts by Picasso specialists;
bibliography.

47. Zervos, Christian. *Picasso [oeuvres],* 27 vols. Paris:
Cahiers d'Art [1932-1973].

Georges Braque

48. Cooper, Douglas. *Braque: The Great Years.*
Chicago: The Art Institute, 1972. Bibliography.

49. Hope, Henry R. *Georges Braque.* New York: The
Museum of Modern Art, 1949. Bibliography.

50. Paris, L'Orangerie des Tuileries. *Georges Braque.*
1973-74. Text by Jean Leymarie; bibliography.

51. The *catalogue raisonné* of Braque's *oeuvre* is being
prepared by Editions Maeght, Paris.

Cubism, Futurism, Collage (see also *nos. 34-51, 70-90*)

52. Apollonio, Umbro, ed. *Futurist Manifestos.* New
York: Viking, 1973.

53. Berger, John. *The Moment of Cubism and Other
Essays.* New York: Pantheon, 1969.

54. Cabanne, Pierre. *L'Epopée du cubisme.* Paris: La
Table Ronde, 1963.

55. Fry, Edward. *Cubism.* London: Thames and
Hudson, 1966. With a selection of writings by
French critics on Cubism from 1905 to about
1925; bibliography; eye-witness accounts and
reminiscences, p. 182.

56. Golding, John. *Cubism: A History and an Analysis,
1907-1914,* rev. ed. Boston: Book and Art Shop,
1968. Bibliography.

57. Greenberg, Clement. "Collage." *Art and Culture.*
Boston: Beacon, 1962.

58. Henderson, L.D. "A New Facet of Cubism: 'The
4th Dimension and Non-Euclidean Geometry'
Reinterpreted." *Art Quarterly,* Winter 1971, pp.
410-33.

59. Kahnweiler, Daniel-Henry with Francis Crémieux.
My Galleries and Painters. New York:Viking,
1971. Trans. from the French.

60. Kozloff, Max. *Cubism/Futurism.* New York:
Charterhouse, 1973.

61. Los Angeles, County Museum; New York,
Metropolitan Museum of Art. *The Cubist Epoch.*
1970. Text by Douglas Cooper.

62. Martin, Marianne. *Futurist Art and Theory, 1909-
1915.* New York: Oxford, 1968. Bibliography.

63. Paris, Musée National d'Art Moderne. *Le
Futurisme, 1909-1916.* 1973. Texts by Jean
Leymarie, Guido Ballo, Cachin-Nora, Franco
Russoli, Luciano de Maria; documents;
bibliography.

64. Paris, Musée d'Art Moderne de la Ville de Paris (in
association with the Galerie des Beaux-Arts,
Bordeaux). *Les Cubistes.* 1973. Texts by Martin-
Méry, Lassaigne, Cassou; interview with Braque;
list of Cubist exhibitions; bibliography.

65. Rosenblum, Robert. *Cubism and Twentieth*

Century Art, New York: Abrams, 1966. Annotated bibliography.

66. ———. "The Demoiselles d'Avignon Revisited." *Art News*, April 1973, pp. 45-48.

67. Steinberg, Leo. "The Philosophical Brothel." *Art News*, September 1972, pp. 20-29, and October 1972, pp. 38-47.

68. Taylor, Joshua C. *Futurism*. New York: The Museum of Modern Art, 1961. Bibliography.

69. Wescher, Herta. *Collage*. New York: Abrams, 1971. Bibliography.

Section d'Or, Juan Gris, Fernand Léger, Robert Delaunay, and Postwar Purism (see also *nos. 55, 56, 61, 65*)

70. Barr, Alfred H., Jr. *Cubism and Abstract Art*. New York: The Museum of Modern Art, 1936.

71. Cooper, Douglas. *Fernand Léger et le nouvel espace*. Geneva/Paris: Trois Collines, 1949.

72. ——— and Potter M. *Juan Gris [oeuvre]*. Paris: Berggruen, 1975.

73. Delevoy, Robert. *Léger: Biographical and Critical Study*. Geneva: Skira, 1962. Bibliography.

74. Francastel, Pierre and Habasque, Guy, eds. *Du Cubisme à l'art abstrait*. Delaunay's writings; *catalogue raisonné*. Paris: SEVPEN, 1957.

75. Gaya, Nuño. *Juan Gris*. Paris: Cercle d'Art, 1974.

76. Gleizes, Albert. *Puissances du Cubisme*. Paris: Presence, 1969. Written over a number of years.

77. ——— and Metzinger, Jean. "Cubism." *Modern Artists on Art*. Englewood Cliffs, N.J.: Prentice-Hall, 1964.

78. Kahnweiler, Daniel-Henry. *Juan Gris*. rev. ed. New York: Abrams, 1968. Includes artist's writings; bibliography.

79. ———, ed. *The Letters of Juan Gris*. Privately printed; London, 1956.

80. Kuh, Katherine. *Fernand Léger*. Urbana, Ill.: University of Illinois Press, 1953.

81. Léger, Fernand. *Functions of Painting*. New York: Viking, 1973. Written over a number of years; trans. from the French.

82. London, The Tate Gallery. *Léger and Purist Paris*. 1971. Texts by John Golding, Christopher Green; writings by Léger.

83. New York, The Solomon R. Guggenheim Museum. *Jacques Villon, Duchamp-Villon, Marcel Duchamp*. 1957. Texts by René Jean, André Breton, Walter Pach.

84. ———. *Albert Gleizes, 1881-1953*. 1964. Text by Daniel Robbins.

85. New York, Leonard Hutton Galleries. *Albert Gleizes and the Section d'Or*. 1964.

86. New York, The Museum of Modern Art (in collaboration with the Philadelphia Museum of Art and The Chicago Art Institute). *Marcel Duchamp*. 1973. For Duchamp material see also *nos. 194-201*.

87. Paris, Grand Palais. *Hommage à Fernand Léger*. 1971 Texts by Leymarie and Cassou; chronology; bibliography.

88. Paris, Musée National d'Art Moderne. *Robert Delaunay, 1885-1941*. 1957. Appreciations by Princet, Apollinaire, Klee, Cendrars and others.

89. Paris, L'Orangerie des Tuileries. *Juan Gris*. 1974. Text by Jean Leymarie: artist's writings; short bibliography.

90. Vriesen, Gustav and Imdahl, Max. *Robert Delaunay: Light and Color*. New York: Abrams, 1969.

Mondrian and De Stijl (see also *nos. 56 and 65*)

91. Barr, Alfred H., Jr. *De Stijl, 1917-1928*. New York: The Museum of Modern Art, 1961.

92. Hunter, Sam. *Mondrian*. New York: Abrams, 1958.

93. Jaffé, Hans L.C. *Mondrian*. New York: Abrams, 1968.

94. ———. *De Stijl*. London: Thames and Hudson, 1970.

95. Mondrian, Piet. "Plastic Art and Pure Plastic Art." *Modern Artists on Art*. Englewood Cliffs, N.J.: Prentice-Hall, 1964.

96. New York, The Solomon R. Guggenheim Museum. *Piet Mondrian*. 1971. Texts by Wijsenbeek, Welsh and others; bibliography.

97. Seuphor, Michel. *Mondrian*. New York: Abrams, 1956. Includes "Natural Reality and Abstract Reality, an essay in dialogue form" by Mondrian.

98. Toronto, The Art Gallery of Toronto. *Piet Mondrian, 1872-1944*. 1966. Text by Robert Welsh; bibliography.

99. Wijsenbeek, L.J.F. *Piet Mondrian*. Greenwich, Conn.: New York Graphic Society, 1968. Bibliography.

Ecole de Paris, Brancusi, Chagall, Soutine

100. Chapiro, Jacques. *La Ruche*. Paris: Flammarion, 1960. About bohemian groups and ateliers in Paris.

101. Geist, Sidney. *Brancusi: a Study of the Sculpture*. New York: Grossman, 1968.

102. Giedion-Welcker, Carola. *Brancusi*. New York: Braziller, 1959.

103. Marevna. *Life with the Painters of La Ruche*.

London: Constable, 1972.

104. Meyer, Franz. *Chagall*. New York: Abrams, 1963. Bibliography.

105. New York, The Solomon R. Guggenheim Museum. *Constantin Brancusi, 1876-1957*. 1969. Text by Sidney Geist.

106. New York, The Museum of Modern Art. *Soutine*. 1950. Text by Monroe Wheeler.

107. ———. *School of Paris: Paintings from the Florence May Shoenborn and Samuel Marx Collections*. 1965. Texts by Barr, Lippard, Soby.

108. Paris, L'Orangerie des Tuileries. *Soutine*. 1973. Texts by Leymarie and others; bibliography.

109. Paris, Reunion des Musées Nationaux. *Hommage à Marc Chagall*. 1969.

Early German Expressionism, *Die Brücke, Der Blaue Reiter* (also see *nos. 123-141*)

110. Berlin, Brücke Museum.*Kunstler der Brücke an den Moritzburger Seen 1909-1911*. 1970. Text by Reidemaster; includes Heckel, Kirchner, Pechstein.

111. Brion, Marcel. *German Painting*. New York: Universe Books, 1959.

112. Great Britain, The Arts Council. London, The Tate Gallery. *The Blue Rider Group*. 1960. Text by Hans Konrad Roethel.

113. ———. *Painters of the Brücke*. 1964. Text by Will Grohmann; bibliography.

114. Ithaca, N.Y., Andrew Dickson White Museum of Art (Cornell University). *Brücke*. 1970. Text by Thomas W. Leavitt; selected bibliography; reviewed in *Artforum*, May 1970, pp. 39-43.

115. Lankheit, Klaus, ed. *The Blaue Reiter Almanac*. New York: Viking, 1974. Bibliography by Bernard Karpel.

116. Miesel, Victor H., ed. *Voices of German Expressionism*. Englewood Cliffs, N.J.: Prentice-Hall, 1970. An anthology of essays, letters, dramas and poems relating to German art, 1900-1933.

117. Myers, Bernard S. *The German Expressionists*. New York: Praeger, 1957.

118. Raabe, Paul, ed. *The Era of German Expressionism*. New York: Viking, 1974.

119. Richtie, Andrew Carduff, ed. *German Art of the 20th Century*. New York: Simon and Schuster, 1957. With essays by Werner Haftmann, Alfred Hentzen, William Lieberman.

120. Roethel, Hans Konrad. *The Blue Rider*. New York: Praeger, 1971.

121. Selz, Peter. *German Expressionist Painting*. Berkeley and Los Angeles: University of California Press, 1957.

122. Willett, John. *Expressionism*. New York: McGraw-Hill, 1970.

Kandinsky

123. Grohmann, Will. *Kandinsky*. New York: Abrams, 1958. Basic if controversial text; bibliography.

124. Kandinsky, Wassily. *Ecrits complets*. Paris: Denoel-Gonthier, 1970. The complete writings of Kandinsky in preparation at Viking.

125. ———. "On the Artist." *Artforum*, March 1973, pp. 76-78. First English translation of a 1916 text by the artist.

126. ———. "Reminiscences." *Modern Artists on Art*. Englewood Cliffs, N.J.: Prentice Hall, 1964.

127. ———. *Concerning the Spiritual in Art*. New York: Wittenborn, Schultz, 1947.

128. New York, The Solomon R. Guggenheim Museum, *Kandinsky, 1866-1944: A Retrospective Exhibition*. 1963.

129. ———. *Kandinsky in the Collection of the Solomon R. Guggenheim Museum*. 1972. Chronology; bibliography.

130. Washton-Long, Rose Carol. "Kandinsky and Abstraction." *Artforum*, June 1972, pp. 42-49.

Klee

131. Giedion-Welcker, Carola. *Paul Klee*. New York: Viking, 1952.

132. Grohmann, Will. *Paul Klee*. New York: Abrams, 1967.

133. Haftmann, Werner. *The Mind and Work of Paul Klee*. New York: Praeger, 1954.

134. ———, ed. *Paul Klee: The Inward Vision: Watercolors, Drawings, Writings*. New York: Abrams, 1958.

135. Klee, Felix, ed. *Paul Klee: His Life and Work in Documents*. New York: Braziller, 1960. Selected from posthumous writings and unpublished letters.

136. Klee, Paul. "On Modern Art." *Modern Artists on Art*. Englewood Cliffs, N.J.: Prentice-Hall, 1964. Also referred to as the "Jena lecture."

137. New York, The Museum of Modern Art. *Paul Klee*. 1941. 1946 ed. of the catalogue has bibliography.

138. New York, The Solomon R. Guggenheim Museum. *Paul Klee, 1879-1940: A Retrospective Exhibition*. 1967. Texts by Felix Klee, Will Grohmann; chronology.

139. Paris, Musée National d'Art Moderne. *Paul Klee*. 1969. Text by Françoise Cachin; basic bibliography; chronology.

140. Spiller, Jurg, ed. *Notebooks of Paul Klee, Vol. 1: The Thinking Eye*. New York: Wittenborn, 1961.

Paul Klee's teachings at the Bauhaus.

141. ———. *Notebooks of Paul Klee, Vol. 2: The Nature of Nature*. New York: Wittenborn, 1974. More of Paul Klee's teachings.

Revolutionary Art in Russia and Early Constructivism (see also nos. 52-69, 123)

142. Amsterdam, Stedelijk Museum. *Malevich*. 1970. Organized by Troels Andersen; chronology; bibliography; documents.

143. Bann, Stephen, ed. *The Tradition of Constructivism*. New York: Viking, 1974. Documents; bibliography by Bernard Karpel.

144. Barr, Alfred H., Jr. *Cubism and Abstract Art*. New York: The Museum of Modern Art, 1936.

145. Bowlt, John, ed. *Modern Russian Masters*. New York: Viking, forthcoming.

146. Chagall, Marc. *My Life*. New York: Orion, 1960.

147. Chamot, Mary. *Gontcharova*. Paris: Bibliothèque des Arts, 1972.

148. Fitzpatrick, Sheila. *The Commissariat of Enlightenment*. New York: Cambridge University Press, 1970.

149. Gabo, Naum. "The Constructive Idea in Art." *Modern Artists on Art*. Englewood Cliffs, N.J.: Prentice-Hall, 1964.

150. George, Waldemar. *Larionov*. Paris: Bibliothèque des Arts, 1966.

151. Gray, Camilla. *The Russian Experiment in Art: 1863-1922*. New York: Abrams, 1970. Bibliography.

152. Great Britain, The Arts Council. The Hayward Gallery. *Art in Revolution*. 1971. Articles by Gray, Bowlt, Frampton; documents.

153. International Exhibition Foundation. *Diaghilev and Russian Stage Design*. 1972. A loan exhibition of stage and costume designs from the collection of Mr. and Mrs. N. Lobanov-Rostovsky. Text by John Bowlt; selected bibliography.

154. Lissitzky-Kuppers, Sophie, ed. *El Lissitzky: Life, letters, texts*. Greenwich, Conn.: New York Graphic Society, 1967.

155. London, Fisher Fine Art Ltd. *Tatlin's Dream: Russian Suprematist and Constructivist Art*. 1973. Short bibliography.

156. Malevich, Kasimir. *Essays on Art*. Copenhagen: Borgen, 1968.

157. ———. *The Non-Objective World*. Chicago: Theobald, 1959.

158. ———. "Suprematism," *Modern Artists on Art*. Englewood Cliffs, N.J.: Prentice-Hall, 1964.*

159. Markov, Vladimir. *Russian Futurism: A History*. Berkeley: University of California Press, 1968.

160. New York, Leonard Hutton Galleries. *Russian Avant-Garde, 1908-1922*. 1971. Texts by Bowlt, Starr, Hutschnecker.

161. Rickey, George. *Constructivism: Origins and Evolution*. New York: Braziller, 1967. Bibliography.

162. Stockholm, Moderna Museet. *Vladimir Tatlin*. 1968. Text by Troels Andersen; bibliography; documents.

163. ———. *Poetry Must Be Made by All*. 1969. Introduction by Ronald Hunt; articles on and by Malevich, Rodchenko, Lissitzky, "Dada in Paris," "The Surrealist Revolution."

164. *V H 101*. Spring-Summer 1972. An entire issue devoted to Russian avant-garde art and architecture, 1917-34. In French.

Dada (see also nos. 163, 194-201)

165. Arp, Jean. *Arp on Arp: Poems, Essays, Memories*. New York: Viking, 1972.

166. Ball, Hugo. *Flight Beyond Time: A Dada Diary*. New York: Viking, 1974.

167. Barr, Alfred H., Jr. Fantastic Art: Dada and Surrealism. New York: Arno, 1969.

168. Ernst, Max. *Beyond Painting and Other Writings by the Artist and His Friends*. New York: Wittenborn, Schultz, 1948. Bibliography by Bernard Karpel.

169. Giedion-Welcker, Carola. *Jean Arp*. New York: Abrams, 1957.

170. Gray, Cleve, ed. *Hans Richter by Hans Richter*. New York: Holt, Rinehart and Winston, 1971.

171. Grosz, George. *A Little Yes and a Big No: The Autobiography of George Grosz*. New York: Dial, 1946.

172. Huelsenbeck, Richard. *Memoirs of a Dada Drummer*. New York: Viking, 1974.

173. Lippard, Lucy R., ed. *Dadaists on Art*. Englewood Cliffs, N.J.: Prentice-Hall, 1971.

174. Los Angeles, County Museum. *Man Ray*. 1966. Texts by Langsner, Eluard, Duchamp, Breton, Tzara, Richter, Belz and by the artist.

175. Los Angeles, University of California Art Galleries. *Kurt Schwitters: A Restrospective*. 1965. Text by Schmalenbach; artist's statements.

176. Motherwell, Robert, ed. *The Dada Painters and Poets: An Anthology*. New York: Wittenborn, 1951. Bibliography by Bernard Karpel. Rev. ed. forthcoming.

*The following information on the original publication dates of Malevich's main writings have been kindly communicated by the chief curator of the Pushkin Museum, Moscow: *From Cu-*

bism and Futurism to Suprematism, Moscow, 1916; *About a New System in Art Education*, Vitebsk, 1919; *Suprematism*, Vitebsk, 1920.

177. New York, The Solomon R. Guggenheim Museum. *Francis Picabia.* 1970. Text by William Camfield; bibliography.

178. New York, The Museum of Modern Art. *Arp.* 1958. Texts by James Thrall Soby, Richard Huelsenbeck, Robert Melville, Carola Giedion-Welcker and by the artist.

179. ———. *The Art of Assemblage.* 1961. Text by William C. Seitz; bibliography by Karpel.

180. ———. *Dada, Surrealism and Their Heritage.* 1968. Text by William Rubin; chronology by Irene Gordon; bibliography.

181. ———. *Max Ernst.* 1961. Text by Waldman. Includes "an informal life of M.E."; bibliography. A Max Ernst retrospective was held at The Solomon R. Guggenheim Museum, 1975.

182. ———. *The Machine as Seen at the End of the Mechanical Age.* 1968. Organized by Pontus Hultén; short bibliography.

183. Paris, L'Orangerie des Tuileries. *Max Ernst.* 1971.

184. Peterson, Elmer. *Tristan Tzara.* New Brunswick, N.J.: Rutgers University Press, 1971.

185. Ray, Man. *Self Portrait.* Boston: Little, Brown, 1963.

186. Richter, Hans. *Dada: Art and Anti-Art.* New York: McGraw-Hill, 1965.

187. Rubin, William. *Dada and Surrealist Art.* New York: Abrams, 1969. Extensive bibliography.

188. Russell, John. *Max Ernst.* New York: Abrams, 1967.

189. Sanouillet, Michel. *Picabia.* Paris: Le Temps, 1964.

190. ———. *Dada à Paris.* Paris: Pauvert, 1965. With documents; bibliography.

191. Schmalenbach, Werner. *Schwitters.* New York: Abrams, 1971.

192. Stockholm, Moderna Museet. *Raoul Hausmann.* 1967. Introduction by Beale Sydhoff; chronology; bibliography; texts in Swedish and in French.

193. Zurich Kunsthaus. *Dada.* 1967. Chronology; artists' biographies; travelled to the Musée National d'Art Moderne, Paris; texts in German and French.

Marcel Duchamp

194. Cabanne, Pierre. *Dialogues with Marcel Duchamp.* New York: Viking, 1971.

195. Golding, John. *Marcel Duchamp: The Bride Stripped Bare by Her Bachelors, Even.* London: Allen Lane, The Penguin Press, 1973.

196. London, The Tate Gallery. *The Almost Complete Works of Marcel Duchamp.* 1966. First European retrospective.

197. New York, The Museum of Modern Art (with the Philadelphia Museum of Art). *Marcel Duchamp.* 1973. Major retrospective; essays and remembrances; bibliography by Bernard Karpel.

198. Paz, Octavio. *Marcel Duchamp or the Castle of Purity.* New York: Grossman, 1957.

199. Sanouillet, Michel and Peterson, Elmer, eds. *Salt Seller: The Writings of Marcel Duchamp.* New York: Oxford, 1973.

200. Schwartz, Arturo. *The Complete Works of Marcel Duchamp.* New York: Abrams, 1969.

201. Tomkins, Calvin. *The Bride and The Bachelors.* New York: Viking, 1968.

Surrealism (see also *nos. 167, 180, 182, 187, 239-249*)

202. Alquié, Ferdinand, ed. *Entretiens sur le Surréalisme.* Paris: Mouton, 1968. Transcript of a week of meetings on Surrealism.

203. *Artforum*, September 1966. An issue on Surrealism.

204. Audouin, Philippe. *Les Surréalistes.* Paris: Le Seuil, 1973. Chronology.

205. Balakian, Anna. *Surrealism: The Road to the Absolute*, rev. ed. New York: Dutton, 1970.

206. Calder, Alexander. *An Autobiography with Pictures.* New York: Pantheon, 1966.

207. de Chirico, Giorgio. *The Memoirs of Giorgio de Chirico.* Coral Gables, Fla.: University of Miami Press, 1971.

208. Dali, Salvador. *The Secret Life of Salvador Dali.* New York: Dial, 1942.

209. Dupin, Jacques. *Alberto Giacometti.* Paris: Maeght, 1962.

210. ———. *Joan Miró: Life and Work.* New York: Abrams, 1962.

211. Durozoi, Gérard and Lecherbonnier, Bernard. *Le Surréalisme: Théories, Thèmes et Techniques.* Paris: Larousse, 1972. Bibliography.

212. Gershman, Herbert, S. *A Bibliography of the Surrealist Revolution in France.* Ann Arbor: University of Michigan Press, 1969.

213. Goldwater, Robert. *Space and Dream.* New York: Walker, 1967.

214. Hohl, Reinhold. *Alberto Giacometti.* New York: Abrams, 1972.

215. Jean, Marcel with Mezei, Arpad. *The History of Surrealist Painting.* New York: Grove Press, 1960.

216. Jean, Marcel, ed. *An Anthology of Surrealism.* New York: Viking, forthcoming.

217. Lippard, Lucy R., ed. *Surrealists on Art.* Englewood Cliffs, N.J.: Prentice-Hall, 1970.

218. ———, ed. *Yves Tanguy: A Summary of His Works.* New York: Pierre Matisse, 1963. With poems by Breton, Eluard; chronology.

219. Masson, André. *Le Plaisir de peindre.* Paris: La Diane Française, 1950.

220. Nadeau, Maurice. *History of Surrealism.* New

York: Macmillan, 1965. Emphasis on political aspects; includes documents, bibliography.

221. New York, The Solomon R. Guggenheim Museum. *Alexander Calder.* 1970. Text by Richard Morphet.

222. ———. *Alberto Giacometti.* 1974. Text by Reinhold Hohl; bibliography.

223. ———. *Joan Miró: Magnetic Fields.* 1972. Texts by Krauss, Rowell.

224. New York, The Museum of Modern Art. *de Chirico.* 1941. Text by James Thrall Soby.

225. ———. *Dali: Paintings, Drawings, Prints.* 1941. Text by James Thrall Soby.

226. ———. *Giacometti.* 1965. Text by Peter Selz.

227. ———. *Magritte.* 1965. Text by James Thrall Soby.

228. ———. *Matta.* 1957. Text by William Rubin.

229. ———. *Miró.* 1941. Text by James Johnson Sweeney.

230. ———, *Miró in the Collection of The Museum of Modern Art.* 1973. Text by William Rubin; bibliography.

231. ———. *Tanguy.* 1955. Text by James Thrall Soby.

232. *Opus International.* October 1970. An issue on Surrealism.

233. Paris, Grand Palais. *Joan Miró.* 1974. Texts by Leymarie, Dupin; Surrealist poems; brief bibliography.

234. Paris, Musée des Arts Décoratifs. *Le Surréalisme, 1922-1942.* 1972. Text by Waldberg; chronology; bibliography.

235. Paris, Musée National d'Art Moderne. *André Masson.* 1965. A Masson retrospective is forthcoming at The New York Museum of Modern Art, 1976.

236. Rubin, William. See *nos. 180 and 187.*

237. Waldberg, Patrick. *René Magritte.* Brussels: André de Rache, 1965. Bibliography.

238. ———. *Surrealism.* New York: McGraw-Hill, 1965.

André Breton

239. Alexandrian, Sarane. *André Breton par lui-même.* Paris: Le Seuil, 1971. With a list of Breton's writings p. 188.

240. Balakian, Anna. *André Breton: Magus of Surrealism.* New York: Oxford, 1971. Bibliography.

241. Breton, André. *La Clef des Champs.* Paris: Sagittaire, 1953.

242. ———. *Dictionnaire Abrégé du surréalisme.* Paris: Sagittaire, 1938.

243. ———. *Entretiens.* Paris: Gallimard, 1952. Transcript of a radio talk with André Parinaud.

244. ———. *Manifestos of Surrealism.* Ann Arbor: University of Michigan Press, 1969.

245. ———. *Les Pas Perdus.* Paris: Gallimard, 1969.

246. ———. *Situation du surréalisme entre les deux guerres.* Paris: Fontaine, 1945. A talk to French-speaking students of Yale University, 1942.

247. ———. *Surrealism and Painting.* Ann Arbor: University of Michigan Press, 1972.

248. ———, ed. *Anthologie de l'humour noir.* Paris: Pauvert, 1966. Texts by Swift, Sade, Fourier, Poe, Rimbaud, Roussel, Picasso, Kafka and others, with introductions by Breton.

249. *Nouvelle Revue Française,* 1967. "André Breton et le Mouvement Surréaliste." Several articles written in memory of Breton.

The German Bauhaus (see *nos. 116, 123-141*)

250. Ferrier, Jean Louis, ed. *Paul Klee: Les Années 20.* Paris: Denoël, 1971.

251. Giedion, Sigfried. *Space, Time and Architecture.* Cambridge, Mass.: Harvard University Press, 1956.

252. Gropius, Walter. *New Architecture and the Bauhaus.* New York: The Museum of Modern Art, 1936.

253. Itten, Johannes. *Design and Form: The Basic Course at the Bauhaus.* New York: Van Nostrand, 1963.

254. Laqueur, Walter. *Weimar: A Cultural History.* New York: Putnam, 1974.

255. Mies van der Rohe, Ludwig. *Writings.* New York: The Museum of Modern Art, 1947.

256. Naylor, Gillian. *The Bauhaus.* London: Studio Vista, 1968.

257. Neumann, Eckhard, ed. *Bauhaus and Bauhaus People.* New York: Van Nostrand, 1970.

258. New York, The Museum of Modern Art. *Bauhaus Weimar, 1919-1925; Dessau 1925-1928.* 1959. Organized by Herbert Bayer, Walter and Ise Gropius.

259. Pevsner, Nikolaus. *Pioneers of Modern Design.* New York: The Museum of Modern Art, 1949.

260. Roters, Eberhard. *Painters of the Bauhaus.* New York: Praeger, 1969.

261. Scheidig, Walter. *Crafts at the Weimar Bauhaus.* London: Studio Vista, 1967.

262. Scully, Vincent. *Modern Architecture: The Architecture of Democracy.* New York: Braziller, 1961.

263. Wingler, Hans M. *The Bauhaus.* Cambridge, Mass.: MIT Press, 1969. Documents; illustrations; lengthy bibliography.

264. Württembergischer Kunstverein, Stuttgart. *50 Years Bauhaus.* Documented; informative.

Reviewed by Robert Welch in *Artforum*, March 20, 1970, pp. 46-51. Show traveled to U.S. and Canada.

The American Art Scene, 1930-1940 (see also *nos. 295, 315*) *

265. American Abstract Artists. *Three Annual Yearbooks, 1938, 1939, 1946.* New York: Arno, n.d.

266. Baigell, Matthew. *The American Scene.* New York: Praeger. 1974.

267. Benton, Thomas Hart. *An American in Art: A Professional and Technical Autobiography.* Lawrence, Kansas: University of Kansas Press, 1969.

268. Graham, John. *System and Dialectics of Art.* Baltimore: Johns Hopkins University Press, 1971.

269. Greenberg, Clement. "The Late Thirties in New York," *Art and Culture*, Boston: Beacon, 1961, pp. 230-35.

270. Guggenheim, Peggy. *Confessions of an Art Addict.* New York: Macmillan, 1960.

271. ———. *Out of This Century.* New York: Dial, 1946.

272. ———, ed. *Art of This Century.* New York: Arno, 1968. With exiled artists' statements.

273. Hunter, Sam. *American Art of the 20th Century.* New York: Abrams, 1973. Bibliography.

274. Janis, Sidney. *Abstract and Surrealist Art in America.* New York: Reynal and Hitchcock, 1944.

275. ———. "School of Paris Comes to the U.S.," *Decision*, November-December 1941, pp. 85-95.

276. Kelder, Diane. *Stuart Davis.* New York: Praeger, 1971. Includes artist's writings.

277. Kramer, Hilton. *Milton Avery: Paintings, 1930-1960.* New York: Yoseloff, 1962.

278. McCoy, Garnett. *Archives of American Art: A Directory of Resources.* New York: Bowker, 1972. For documentation on American art, consult the Archives of American Art, now a bureau of the Smithsonian Institution with offices in New York, Washington, Boston, Detroit and San Francisco.

279. New York, [Coordinating Council of French Relief Societies]. *First Papers of Surrealism.* 1942. Exhibition of Americans and exiled Europeans; several important texts.

280. New York, The Museum of Modern Art. *Americans, 1942: 18 artists from 9 States.* 1942. Dorothy Miller, ed.; artists' statements.

281. ———. *Fourteen Americans.* 1946. Dorothy Miller, ed.; artists' statements.

282. New York, Whitney Museum of American Art. *The 1930's: Painting and Sculpture in America.* 1968. Text by William C. Agee; bibliography.

283. O'Connor, Francis V. *Federal Support for the Visual Arts: The New Deal and Now.* Greenwich, Conn.: New York Graphic Society, 1969.

284. ———, ed. *Art for the Millions.* Greenwich, Conn.: New York Graphic Society, 1972.

285. ———, ed. *The New Deal Art Projects. An Anthology of Memoirs.* Washington D.C.: Smithsonian Institution, 1972.

286. Rose, Barbara. *American Art since 1900: A Critical History.* New York: Praeger, 1967. Bibliography.

287. ———. "Mondrian in New York," *Artforum*, December 1971, pp. 54-63.

288. ———, ed. *Readings in American Art since 1900: A Documented Survey.* New York: Praeger, 1968. Companion volume to no. 286; excerpted writings by artists and critics with editor's comments.

289. Rosenberg, Harold. "The Thirties," *The De-definition of Art*, New York: Horizon Press, 1972, pp. 178-187.

290. Rubin, William, see *no. 187*, part V headings: "An Immigrant Movement," "Matta," "Other Surrealist Painters in Exile," "Arshile Gorky," "Surrealism and the New American Painting."

291. Sandler, Irving. "The Surrealist Emigrés in New York," *Artforum*, May 1968, pp. 25-31. See also *no. 315.*

292. Sweeney, James Johnson. "Eleven Europeans in America," *The Museum of Modern Art Bulletin*, September 1946, pp. 1-39.

293. Wolfe, Judith. "Jungian Aspects of Jackson Pollock's Imagery," *Artforum*, November 1972, pp. 65-73.

American Abstract Expressionism, Action Painting. New York School, First Generation (see also *nos. 273, 278, 286, 288, 318-52*)

294. *Artforum*, September 1965. Special issue devoted entirely to the New York School. Articles by Leider, Fried, Alloway, Kozloff, Sandler, Rose and others; a 1960s perspective.

295. Ashton, Dore. *The New York School: A Cultural Reckoning.* New York: Viking, 1973.

296. Goodall, Donald and Kasanin, Mary. *Partial*

*Pertinent information can also be found in the following periodicals of the time: *The Nation, Partisan Review, The New Republic, Commentary, The Marxist Quarterly, Parnassus, Art Front, View, V.V.V.*

Bibliography of American Abstract Expressionist Painting, 1943-1958. Los Angeles: University of Southern California Department of Fine Arts, 1958.

297. Greenberg, Clement. *Art and Culture.* Boston: Beacon, 1961.

298. Gruen, John. *The Party's Over Now: Reminiscences of the Fifties. New York's Artists, Writers, Musicians and their Friends.* New York: Viking, 1972. Muckraking but lively.

299. *It Is.* A Periodical, 1958-65. Starting with second issue, had a subtitle *Magazine for Abstract Art.*

300. Karpel, Bernard, ed. *Annals of Abstract Expressionism.* New York: Viking, forthcoming.

301. Kozloff, Max. "American Art and the Generation of the Second World War," Part II of *Renderings.* New York: Simon and Schuster, 1968.

302. Kramer, Hilton. "Thirty Years of the New York School." *New York Times Magazine*, October 12, 1969, pp. 28-31, 89-102, 109.

303. Los Angeles, County Museum. *New York School: The First Generation: Paintings of the 1940s and 1950s.* 1965. Maurice Tuchman, ed.; statements by artists and critics; bibliography.

304. Mc Darrah, Fred. *The Artist's World in Pictures.* New York: Dutton, 1961. A visual record of the New York artists' community since 1945.

305. Motherwell, Robert; Reinhardt, Ad and Karpel, Bernard, eds. *Modern Artists in America.* New York: Wittenborn, Schultz, 1951. Includes artists' session at Studio 35 and the Western Round Table on Modern Art.

306. New York, Samuel Kootz Gallery. *The Intrasubjectives.* 1949. Text by Kootz; show traveled to France.

307. New York, The Metropolitan Museum of Art. *New York Painting and Sculpture: 1940-1970.* 1969. Selection and text by Henry Geldzahler; reprints of essays by Rosenberg, Rosenblum, Greenberg, Rubin, Fried; controversial selection of artists; biographies; bibliography.

308. New York, The Museum of Modern Art (International Program). *The New American Painting as Shown in Eight European Countries.* 1958. Introduction by Barr; artists' statements; critical notices by Europeans. ((See also *nos. 318-52.*)

309. O'Doherty, Brian. *American Masters: The Voice and the Myth.* Photographs by Hans Namuth. New York: Random House, 1973. Includes texts on de Kooning, Pollock, Rothko.

310. O'Hara, Frank. *In Memory of My Feelings: A Selection of Poems.* New York: The Museum of Modern Art, 1967. Illustrated by the author's friends, many of them Abstract Expressionists.

311. *Possibilities 1.* New York: Wittenborn, Schultz, 1947. A periodical, only one issue published.

312. Rosenberg, Harold. *The Anxious Object.* New York: Horizon Press, 1966.

313. ———. *The Tradition of the New.* New York: Horizon, 1959.

314. ———. "Tenth Street: A Geography of Modern Art." *Discovering the Present: Three Decades in Art, Culture, and Politics.* Chicago: University of Chicago Press, 1973, pp. 100-109.

315. Sandler, Irving. *The Triumph of American Painting: A History of Abstract Expressionism.* New York: Praeger, 1970. Biographies; bibliography.

316. *The Tiger's Eye: On Art and Letters.* A periodical. Began with October 1947 issue; no longer published.

317. "U.S. Art." *XXème Siècle*, June 1973. Special issue on new American art before 1960.

American Abstract Expressionism: The Artists (see also *nos.* 294-317)

318. Ashton, Dore. *Philip Guston.* New York: Grove Press, 1959.

319. Buffalo, New York. Albright-Knox Art Gallery. *Paintings of Clyfford Still.* 1959. Statement by the artist.

320. Drudi, Gabriella. *Willem de Kooning.* Milan: Fabbri, 1972.

321. Friedman, B.H. *Jackson Pollock: Energy Made Visible.* New York: McGraw-Hill, 1972. Bibliography.

322. Gray, Cleve, ed. *David Smith by David Smith.* New York: Holt Rinehart and Winston, 1968.

323. Greenberg, Clement. *Hans Hofmann.* Paris: Georges Fall, 1961.

324. Hess, Thomas B. *Willem de Kooning.* New York: Braziller, 1959.

325. ———. *De Kooning Drawings.* Greenwich, Conn.: New York Graphic Society, 1972.

326. ———. *Barnett Newman.* New York: Walker, 1969.

327. Hofmann, Hans. *Search for the Real and Other Essays*, rev. ed. Cambridge, Mass.: M.I.T. Press, 1967.

328. Hunter, Sam, ed. *Hans Hofmann.* New York: Abrams, 1963. Five essays by the artist.

329. Krauss, Rosalind E. *Terminal Iron Works: The Sculpture of David Smith.* Cambridge, Mass.: M.I.T. Press, 1971.

330. London, Whitechapel Gallery. *Rothko*. 1961. Text by Bryan Robertson.
331. New York, The Solomon R. Guggenheim Museum. *Philip Guston*. 1962. Text by H.H. Arnason.
332. ———. *David Smith*. 1969. Text by Edward Fry.
333. New York, The Jewish Museum. *Ad Reinhardt: Paintings*. 1967. Texts by Lippard and Hunter.
334. New York, The Museum of Modern Art. *Willem de Kooning*. 1968. Text by Thomas B. Hess.
335. ———. *Arshile Gorky: Paintings, Drawings, Studies*. 1962. Text by William C. Seitz.
336. ———. *Hans Hofmann*. 1963. Text by Seitz.
337. ———. *Robert Motherwell*. 1965. Text by Frank O'Hara.
338. ———. *Barnett Newman*. 1971. Text by Thomas B. Hess.
339. ———. *Jackson Pollock*. 1956-57. Text by Sam Hunter.
340. ———. *Jackson Pollock*. 1967. Text by Francis V. O'Connor.
341. ———. *Mark Rothko*. 1961. Text by Peter Selz.
342. New York, The Whitney Museum of American Art (with The Solomon R. Guggenheim Museum). *Adolph Gottlieb*. 1968. Texts by Robert Doty and Diane Waldman.
343. New York, The Whitney Museum of American Art. *Franz Kline, 1910-1962*. 1968. Text by John Gordon.
344. O'Connor, Francis V. *Catalogue Raisonné of Jackson Pollock*. New Haven, Conn.: Yale University Press, forthcoming.
345. O'Hara, Frank. *Jackson Pollock*. New York: Braziller, 1959.
346. Paris, Musée National d'Art Moderne. *Rothko*. 1971. Text by Donald McKinney.
347. Philadelphia, Institute of Contemporary Art (University of Pennsylvania). *Clyfford Still*. 1963. Text by Ti-Grace Sharpless.
348. Reinhardt, Ad. "Writings," *The New Art: A Critical Anthology*. Ed. Gregory Battcock. New York: Dutton, 1966, pp. 199-209.
349. Robertson, Bryan. *Jackson Pollock*. New York: Abrams, 1960.
350. Rosenberg, Harold. *Gorky*. New York: Horizon Press, 1962.
351. ———. *De Kooning*. New York: Abrams, 1974.
352. Schwabacher, Ethel K. *Arshile Gorky*. New York: Macmillan, 1957.

Roots and Routes of Today's Art: The Ideas (see also *nos. 273, 286, 288*)

353. *Artforum*. An American periodical, June 1962-
354. *Art-Language*. An English periodical, May 1969-
355. *art press*. A French periodical, December 1972-
356. *Art Week*. An American West Coast periodical, 1972-
357. *Avalanche*. An American periodical, Fall 1970-
358. Barrett, Cyril. *Op Art*. New York: Viking, 1970.
359. Barthes, Roland. *Le Degré zéro de l'écriture*. Paris: Le Seuil, 1953.
360. ———. *L'Empire des signes*. Paris: Sentiers de la Création, 1970.
361. Battcock, Gregory, ed. *Idea Art: A Critical Anthology*. New York: Dutton, 1973. Mostly reprints of articles by American critics and artists from 1969 to 1972.
362. ———, ed. *Minimal Art: A Critical Anthology*. New York: Dutton, 1968. Mostly reprints of articles by American critics from 1965 to 1967.
363. ———, ed. *The New Art: A Critical Anthology*, rev. ed. New York: Dutton, 1973. Mostly reprints of articles by American critics from 1958 to 1971.
364. Berger, René. *Art et communication*. Paris: Casterman, 1972.
365. Burnham, Jack. *Beyond Modern Sculpture: The Effects of Science and Technology on the Sculpture of this Century*. New York: Braziller, 1968.
366. Calas, Nicolas and Calas, Elena. *Icons and Images of the Sixties*. New York: Dutton, 1971.
367. *Data*. An Italian periodical, September 1971-
368. Ehrmann, Jacques, ed. *Structuralism*. New York: Anchor Press, 1970. Includes "Structural Analysis in Art and Anthropology" by Sheldon Nodelman.
369. *The Feminist Art Journal*. An American periodical, April 1972-
370. Foucault, Michel. *The Order of Things: An Archeology of the Human Sciences*. New York: Pantheon, 1971. Trans. from the French.
371. Fry, Edward, ed. *On the Future of Art*. New York: Viking, 1970. An anthology of essays sponsored by The Solomon R. Guggenheim Museum.
372. Kaprow, Allan. *Assemblage, Environments and Happenings*. New York: Abrams, 1966.
373. Kirby, Michael. *Happenings*. New York: Dutton, 1965.
374. Kultermann, Udo. *The New Painting*. New York: Praeger, 1969.
375. ———. *New Realism*. Greenwich, Conn.: New York Graphic Society, 1972.
376. ———. *The New Sculpture: Environments and Assemblages*. New York: Praeger, 1968.
377. Lévi-Strauss, Claude. *Le Cru et le cuit: Mythologiques*. Paris: Plon, 1964.
378. ———. *La Pensée Sauvage*. Paris: Plon, 1962.
379. ———. *Structural Anthropology*. New York: Basic

Books, 1963. From the French, *Anthropologie Structurale*, Paris: Plon, 1958.

380. ———. *Les Structures élémentaires de la parenté*. Paris: Presses Universitaires, 1949.

381. Leymarie, Jean, ed. *Art Since Mid-Century: The New Internationalism*. Greenwich, Conn.: New York Graphic Society, 1971. 2 vols. Trans. from the French, *Depuis 45* in three volumes.

382. Lippard, Lucy R. *Pop Art*. New York: Praeger, 1966. With contributions by Alloway, Marmer, Calas.

383. *Magazin Kunst* (formerly *Kunst*). A German periodical, first quarter 1960-

384. Marcuse, Herbert. *Eros and Civilization*. Boston: Beacon, 1955.

385. ———. *One-Dimensional Man*. Boston: Beacon, 1964.

386. McLuhan, Marshall. *Gutenberg Galaxy: The Making of Typographic Man*. Toronto: Toronto University Press, 1967.

387. ———. *Understanding Media: The Extensions of Man*. New York: McGraw-Hill, 1964.

388. Merleau-Ponty, Maurice. *Phenomenology of Perception*. London: Routledge, 1962. From the French, *Phénomenologie de la Perception*. Paris: Gallimard, 1945.

389. ———. *Signs: Studies in Phenomenology and Existential Philosophy*. Evanston, Ill.: Northwestern University Press, 1964.

390. Meyer, Ursula, ed. *Conceptual Art*. New York: Dutton, 1972.

391. Millet, Catherine. *Textes sur l'art conceptuel*. Paris: Templon, 1972.

392. Müller, Grégoire. *The New Avant-Garde*. New York: Praeger, 1972.

393. New York. *The New Art Scene*. Photographs by Ugo Mulas; text by Alan Salomon. New York: Holt, Rinehart and Winston, 1967.

394. Nochlin, Linda. *Women as Sex Objects: Studies in Erotic Art, 1730-1970*. New York: Newsweek, 1972.

395. Pears, David. *Ludwig Wittgenstein*. New York: Viking, 1970.

396. *Peinture: Cahiers Théoriques*. A French periodical, 1971-

397. Pellegrini, Aldo. *New Tendencies in Art*. New York: Crown, 1966.

398. Pitcher, George, ed. *Wittgenstein: Philosophical Investigations*. Notre Dame, Ind.: University of Notre Dame Press, 1968.

399. Pleynet, Marcelin. "Peinture et 'Structuralisme'," *L'Enseignement de la peinture*, Paris: Le Seuil, 1971, pp. 186-200.

400. Popper, Frank. *Kinetic Art*. Greenwich, Conn.: New York Graphic Society, 1968.

401. Restany, Pierre. *Les Nouveaux Réalistes*. Paris: Planète, 1968.

402. Revault d'Allonnes, Olivier, ed. *Esthétique et marxisme*. Paris: Union Générale d'Editions, 10/18, 1974.

403. Rickey, George. *Constructivism: Origins and Evolution*. New York: Braziller, 1967.

404. Rosenberg, Harold. *Artworks and Packages*. New York: Horizon Press, 1969.

405. ———. *The De-definition of Art*. New York: Horizon Press, 1972

406. Russell, John and Gablik, Suzi. *Pop Art Redefined*. New York: Praeger, 1969. Artists' statements and criticism.

407. Sims, Lowery. "Black Americans in the Visual Arts: A Survey of Bibliographic Material and Research Sources," *Artforum*, April 1973, pp. 66-70.

408. Tomkins, Calvin. "E.A.T." *The New Yorker*, October 3, 1970, pp. 83-133.

409. ———. "Maybe a Quantum Leap." *The New Yorker*, February 3, 1972, pp. 42-67. (See also *no. 201*)

410. *VH 101*. A French periodical, Spring 1970- . No. 1: Artists' writings. No. 2: Theory.

411. Wittgenstein, Ludwig. *Tractus Logicus Philosophicus*. New York: Humanities, 1961.

Roots and Routes of Today's Art: The Artists *

412. Bern Kunsthalle. *Live in Your Head. When Attitudes Become Forms: Works-Concepts-Situations-Information*. 1969. Organized by Harald Szeeman; texts by Burton, Müller, Trini, Szeeman. Includes Beuys, André, Yves Klein, Kosuth, Long, Merz, Morris, Serra.

413. Bourdon, David. *Christo*. New York: Abrams, 1971.

414. Coplans, John. *Ellsworth Kelly*. New York: Abrams, 1972.

415. ———. *Roy Lichtenstein*. New York: Praeger, 1972.

416. ———. *Andy Warhol*. Greenwich, Conn.: New York Graphic Society, 1971. With contributions by Mekas, Tomkins.

417. Crone, Rainer. *Andy Warhol*. New York: Praeger, 1970.

418. Forge, Andrew. *Robert Rauschenberg*. New York: Abrams, 1969. Printed over photographs.

*For additional information see exhibition catalogues of Venice and São Paulo Biennales.

419. Fried, Michael. *Morris Louis.* New York: Abrams, 1970.

420. Great Britain, The Arts Council. The Hayward Gallery. *Anthony Caro.* 1969. Text by Michael Fried. (A Caro retrospective was held at the New York Museum of Modern Art, 1975. Text by Rubin.)

421. Johnson, Ellen. *Claes Oldenburg.* Baltimore: Penguin, 1971.

422. Kassel, *Documenta V*, 1972. International in scope; bibliography. Includes conceptual artists and hyperrealists. See also *Documenta I*, 1955; *II*, 1959; *III*, 1964; *IV*, 1968.

423. La Jolla, Museum of Contemporary Art. *Arman.* 1974. Text by van der Marck.

424. London, The Tate Gallery. *Richard Hamilton.* 1970. Text by Richard Morphet; bibliography.

425. London, Institute of Contemporary Art. *Cybernetic Serendipity.* 1968. Organized by Reichardt, Dowson, Schmidt; texts on computer paintings, machines and environments; notes on cybernetics; bibliography.

426. ———. *Man, Machine and Motion.* 1955. Organized by Richard Hamilton.

427. Los Angeles, County Museum. *American Sculpture of the Sixties.* 1967. Maurice Tuchman, ed.; texts by Alloway, Ashton, Coplans, Greenberg, Kozloff, Lippard, Monte, Rose, Sandler. Includes Calder, Andre, Bladen, Caro, Chamberlain, di Suvero, Flavin, Judd, LeWitt, Nevelson, Nakian, Oldenburg, Rauschenberg, Rickey, Segal.

428. ———. *Art and Technology: A Report on the Program at the Los Angeles County Museum, 1967-1971.* Includes descriptions of projects by 76 artists.

429. New York, The New York Cultural Center. *Women Choose Women.* 1973. Texts by Lippard, Amaya.

430. New York, The Solomon R. Guggenheim Museum. *Amsterdam, Paris, Düsseldorf.* 1972.

431. ———. *Jean Dubuffet.* 1973. Text by Rowell; artist's writings.

432. ———. *Guggenheim International Exhibition.* 1971. Texts by Waldman, Fry. Includes artists from England, Italy, Japan, Holland and the United States.

433. ———. *Eva Hesse.* 1972. Text by Pincus-Witten; artist's writings.

434. ———. *Roy Lichtenstein.* 1969. Text by Waldman.

435. ———. *Morris Louis, 1912-1962.* 1963. Text by Alloway.

436. ———. *Robert Ryman.* 1972. Text by Waldman.

437. ———. *Younger European Painters.* 1953. Text by Sweeney. Includes Burri, Hartung, Mathieu, Poliakoff, Riopelle, Soulages, Vasarely.

438. New York, The Jewish Museum. *European Painters Today.* 1969. Text by Mathey. Includes Arman, Bacon, Bury, Fontana, Klein, Magritte, Matta, Piene, Raynaud, Riley, Tapies, Vasarely.

439. ———. *Jasper Johns.* 1964. Texts by Salomon, Cage.

440. ———. *Yves Klein.* 1967. Texts by McShine, Descargues, Restany; artist's writings.

441. ———. *Primary Structures: Younger English and American Sculptors.* 1966. Text by McShine. Includes André, LeWitt, Judd, Smithson, Bladen.

442. ———. *Robert Rauschenberg.* 1963. Text by Salomon.

443. ———. *Software.* 1970. Texts by Burnham, Nelson.

444. New York, Knoedler and Co. *Tony Smith.* 1971. Text by Friedman. Interview with Lippard.

445. New York, The Metropolitan Museum of Art. *New York Painting and Sculpture: 1940-1970.* (See no. 307).

446. New York, The Museum of Modern Art. *The Art of The Real: USA 1948-1968.* 1968. Text by Goossen. Includes André, Judd, Kelly, LeWitt, Louis, McCracken, Martin, Morris, Noland, Poons, David Smith, Tony Smith, Smithson, Stella.

447. ———. *Information.* 1970. Text by McShine. Includes Acconci, André, Art-Language Press, Beuys, Buren, Gilbert and George, Heizer, Kosuth, Morris, Venet.

448. ———. *Jasper Johns: Lithographs.* 1970. Text by Castleman.

449. ———. *Ellsworth Kelly.* 1973. Text by Goossen.

450. ———. *Claes Oldenburg.* 1970. Monograph by Rose; bibliography.

451. ———. *The Responsive Eye.* 1965. Text by Wm. Setiz. Includes Albers, Stella, Vasarely, Riley, Kelly, Poons.

452. ———. *Frank Stella.* 1970. Text by Rubin.

453. New York, The Whitney Museum of American Art. *American Pop Art.* 1974. Text by Alloway; bibliography.

454. ———. *Anti-Illusion: Procedures/Materials.* 1969. Texts by Monte and Tucker.

455. ———. *Contemporary Black Artists in America.* 1971. Text by Doty.

456. ———. *Helen Frankenthaler.* 1969. Text by Goossen.

457. ———. *Robert Morris.* 1970. Text by Tucker.

458. ———. *Louise Nevelson.* 1967. Text by Gordon.

459. ———. *Jules Olitski.* 1973. Text by Kenworth

Moffett. Catalogue published by the Boston Museum of Fine Arts.

460. Oldenburg, Claes. *Notes in Hand.* New York: Dutton, 1971.

461. ——— and Williams, Emmet. *Store Days.* New York: Something Else Press, 1967.

462. Paris, Centre National d'Art Contemporain. *Hyperréalistes Américains, Réalistes Européens.* 1974. Texts by Abadie, Becker, Restany, Clair; bibliography.

463. ———. *George Segal.* 1972. Texts in French by van der Marck, Judd, Kaprow and others; artist's statements.

464. ———. *Tinguely.* 1971. Chronology; bibliography.

465. Pasadena, Art Museum. *Allan Kaprow.* 1967. Text by Demetrion, artist's statement; interview.

466. Restany, Pierre. *Yves Klein.* Paris: Hachette, 1974.

467. Ridgefield, Conn., The Aldrich Museum of Contemporary Art. *26 Contemporary Women.* 1971. Organized and with text by Lucy R. Lippard.

468. Rose, Barbara. *Helen Frankenthaler.* New York: Abrams, 1971.

469. Spies, Werner, *Josef Albers.* New York: Abrams, 1970.

470. Stockholm, Moderna Museet. *Amerikansk pop-konst.* 1964. Texts by Hultén, Salomon, Falhström, Klüver, Geber; bibliography.

INDEX of Names in the Text

(Index of artists whose works are reproduced appears on page ix.)